Presences of Nature

British Landscape 1780–1830

Ye Presences of Nature in the sky
And on the earth! Ye Visions of the hills!
And Souls of lonely places!

William Wordsworth (1770–1850)
The Prelude, Book I, lines 464–6

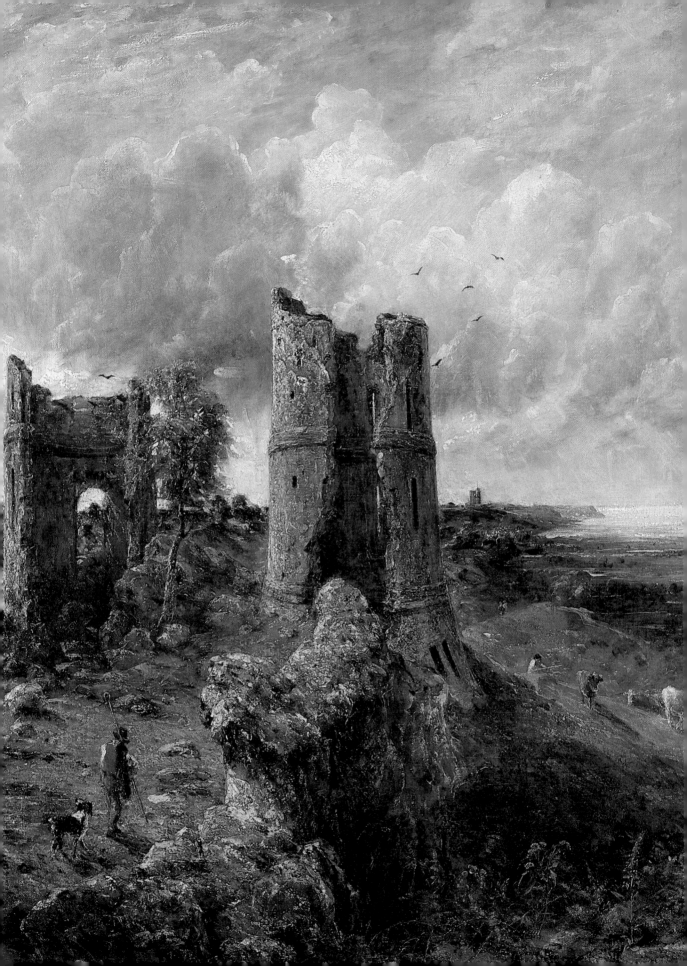

Presences of Nature

British Landscape 1780–1830

Louis Hawes

Yale Center for British Art
New Haven 1982

1. (III.30) Constable, *Hadleigh Castle* (detail)

Copyright © 1982 by the Yale Center for British Art

Designed by Stephanie Hallin
Filmset in Monophoto Bembo and printed in
Great Britain by Jolly & Barber Ltd, Rugby

Produced and distributed by Yale University Press on
behalf of the Yale Center for British Art

ISBN 0–300–02920–6 (cloth)
 0–300–02931–4 (pbk)

Contents

Acknowledgments

During the process of selecting the exhibition and preparing this catalogue, I have received continual encouragement and cheerful co-operation from the entire staff of the Yale Center. I am particularly grateful for the many stimulating and useful discussions I enjoyed with Malcolm Cormack, Curator of Paintings, who also closely read drafts of the catalogue, making numerous suggestions for improving it. I also benefited much from illuminating conversations with Malcolm's colleague, Susan Casteras. The Curator of Prints and Drawings, Patrick Noon, was ever helpful in all kinds of ways, as was his former colleague, Andrew Wilton. Similarly, Joan Friedman, Curator of Rare Books, and Anne-Marie Logan, Head Librarian and Photo Archivist, along with their friendly staff, could not have been more helpful. Warm thanks also go to Timothy Goodhue, the Registrar, and Laura Prete, who patiently and efficiently handled all my photograph orders. In addition, Joy Pepe nobly edited the manuscript and performed many other organizational tasks. The previous Director, Edmund Pillsbury, helped in a number of ways during the early stages of my work on the exhibition, including arrangements to see Mr Mellon's private collections in New York and Upperville, Virginia, where Beverly Carter was exceedingly helpful. The present Director, Duncan Robinson, offered much appreciated encouragement during the final stages of my work. I also very much value the frequent contact I enjoyed with several Resident Fellows in the late 1970s, namely, Charles Rhyne, John Murdoch, Michael Liversidge and Harold Shapiro. Further, I profited much from numerous discussions with various faculty members and graduate students of the Yale Art History Department, most particularly, Professor Robert Herbert. Finally, I should like to acknowledge a debt to several British scholars whose writings on various aspects of British landscape have deepened my grasp of the subject: Graham Reynolds, Lawrence Gowing, Michael Kitson and John Gage. Above all, I cannot sufficiently express the debt to my wife, Diana, for her enduring patience and understanding while the work was in progress.

The award of a generous Resident Fellowship for 1978–9, from the Yale Center, was indispensable to the realization of this exhibition, and I shall long remain most grateful. These acknowledgments would be incomplete without an expression of my admiration and gratitude for the remarkable creator of the Yale Center collection, Mr Paul Mellon, who in a relatively short time amassed the most important assemblage of British art outside the Tate Gallery.

Foreword

One of the most vital artistic developments within the Romantic movement in late Georgian England was the emergence of landscape as a dominant genre, attracting most of the stronger talents of the time. Some recent scholars have rightly termed the situation a major cultural phenomenon within western civilization. The 1973 Tate Gallery exhibition, *Landscape in Britain 1750–1850*, revealed many interesting and significant aspects of this singularly rich vein of British art. In fact, the riches are sufficiently inexhaustible to sustain a whole series of probing exhibitions. At the Yale Center there exists among the vast landscape holdings an abundance of works dating from the late eighteenth and early nineteenth centuries. Christopher White's splendid inaugural show, *English Landscape 1630–1850* (YCBA, 1977), by no means exhausted this crucial segment of the collection (and contained no oils). It appeared worthwhile to attempt an exhibition focused entirely on the period when British landscape truly came into its own, a time that coincided with the turbulent years of the French Revolution and Napoleonic wars, as well as with the Industrial Revolution. It also appeared desirable to include both oils and watercolors, hung together, thus accenting their frequently comparable aims.

The exhibition is devoted to paintings of actual scenery, arranged according to commonly accepted topographical classifications: Mountain Landscapes, Coastal Scenes, Ruin Landscapes, Rural Landscapes and Townscapes. I have added a perhaps less familiar type of landscape, one which prominently includes active laborers, because the 'working landscape' assumed a certain importance during the Romantic era, though such works were never as plentiful as other kinds of landscapes. Within each section, the works are hung (and reproduced) more or less chronologically, the exceptions being made in the interest of providing juxtapositions that are provocative or illuminating. Indeed, a chief virtue of thematic arrangement in an art exhibition is that it invites the viewer to make close comparisons (and contrasts) between pictures of similar subjects, however different in approach. This, in turn, can lead to a heightened sense of the distinctive individuality of various works within a section, and conversely, bring out the traditional aspects of others. I should add, however, that when more than one work by a given artist appears in a section, they appear together, chronologically.

The landscape themes selected embrace a major segment of what British painters and watercolorists produced during the late Georgian era (*c.* 1780–

1830), in many ways the richest and most creative period in the history of British landscape. In construing these themes, I have tried to avoid being over strict, always alert to the danger of 'hardening of the categories'. But neither are they so loosely construed as to become almost meaningless. The exhibition does not attempt to include all the major landscape themes which occupied artists of the time. Some, such as seascapes and country house views, are missing because they have appeared in fairly recent shows at Yale (1978 and 1980 respectively). However, an important aspect of marine painting does receive prominence in the coastal scene section of the present exhibition. Moreover, one or two rural landscapes include a country house in the distance. Two other themes, historical landscape and exotic landscape (e.g., views of the South Seas), are omitted partly because the Yale collections are somewhat less rich in such works (of the relevant period), though there are several of great interest. Furthermore, space limitations prevent a show any larger than it already is. No exhibition should try to be all things to all people. The present one necessarily reflects the strengths of Yale's landscape holdings of the late Georgian era. Of course, some gaps are inevitable in any collection, but happily, this portion of the Mellon collection is really quite representative of a great deal that British painters produced during that remarkably fertile period. Certainly not all the landscapes in the show are masterpieces; still, the average level of quality is high. The formidable size of the collection has permitted ample selectivity.

The last fifty years of the Georgian era (1780–1830) provide the time span of the exhibition – chosen because that intensely active half century saw more innovative and fruitful developments in British landscape than did any other period of whatever length. Moreover, at no other time were so many significant landscapes produced (in various media). That era, indeed, is one of the great epochs in British cultural history. The splendid literary achievements of the English Romantics also date largely between 1780 and 1830, which in fact is the traditional time span assigned the Romantic movement by literary scholars. The six sections of the Introduction include numerous relevant quotations from Romantic poets. Somewhat more than half the paintings date between 1790 and 1815, a particularly dynamic if turbulent period. While the cut-off point, 1830, is strictly observed, it seemed desirable to include a few important works slightly predating 1780.

Abbreviations

BI	British Institution
BM	British Museum
Cambridge	Fitzwilliam Museum
JCC	*John Constable's Correspondence*, ed. R. B. Beckett (Ipswich, 1962–8) 6 vols.
JC: FDC	*John Constable: Further Documents and Correspondence*, ed. L. Parris, C. Shields, I. Fleming-Williams (Ipswich, 1975)
NG	National Gallery (London, unless otherwise stated)
NCM	Norwich Castle Museum
NGS	National Gallery of Scotland
OWS	Old Water-Colour Society (Society of Painters in Watercolours)
Oxford	Ashmolean Museum
RA	Royal Academy
TB	Turner Bequest (British Museum and Tate Gallery)
TG	Tate Gallery
V&A	Victoria & Albert Museum
YCBA	Yale Center for British Art

I. Mountain Landscapes

The sounding cataract
Haunted me like a passion: the tall rock,
The mountain, and the deep and gloomy wood,
Their colours and their forms, were then to me
An appetite; and a love,
That had no need for a remoter charm,
By thought supplied, nor any interest
Unborrowed from the eye. – That time is past
.　　.　　.　　.　　.　　.
I have felt
A presence that disturbs me with the joy
Of elevated thoughts; a sense sublime
Of something far more deeply interfused
.　　.　　.　　.　　.
Of all the mighty world
Of eye, and ear, – both what they half create
And what perceive; . . .
Wordsworth (1798)

Are not the mountains, waves, and skies, a part
Of me and of my soul, as I of them?
Byron (1816)

FOR THE first time in western culture, mountain scenery became a dominant interest with many landscape painters, writers and tourists during the Romantic era, in Britain no less than in central Europe. Turner and Byron leap to mind, but a whole host of contemporaries effectively tackled this hitherto neglected theme. Curiously, this enthusiasm was of surprisingly recent origin. As Marjorie Nicolson has shown in her classic study, *Mountain Gloom and Mountain Glory* (1959), Europeans from classical antiquity to the end of the seventeenth century were for the most part either indifferent or positively hostile to mountains. On the infrequent occasions when Roman and medieval writers mentioned mountains they typically employed such negative adjectives as inhospitable, barren and insolent. Even as late as the seventeenth century, mountains were often dismissed as 'Nature's Shames and Ills', her

'Warts, Wens, Blisters, Imposthumes'.[1] In the Romantic era, however, mountains were suddenly glorious presences inspiring awe, reverence or heady self-identification. They were magnificent 'temples of Nature built by the Almighty, earth's natural cathedrals, or natural altars . . . with their clouds resting on them as the smoke of a continual sacrifice'.[2]

Between the late seventeenth and early nineteenth century, particularly in England, there occurred a profound change in thought, feeling and values concerning natural scenery in general and mountains in particular. In the case of the latter, this came about partly through the impact of new theological views regarding the presumed appearance of the earth before the Biblical Deluge. Challenging the orthodox position that mountains were deformed refuse resulting from the Flood, was a growing affirmative view, first articulated by George Hakewell in the much-expanded 1635 edition of his *Apologie of the Power and Providence of God*, where he argues that mountains were antediluvian creations of God no less than the rest of paradise. The book, however, which had the broadest and most lasting impact was Thomas Burnet's *Sacred Theory of the Earth* (1684; six editions by 1726). Time and again the author shows an excited responsiveness to nature at her most vast, wild and irregular – to an extent never remotely approached in earlier literature. This was not without paradox, for, theoretically, Burnet continued to hold the post-diluvian view of mountains as confused 'ruins of a broken world' caused by the Deluge. But emotionally, he was attracted to mountains. He felt 'rapt' and 'ravished' by alpine scenery, while his imagination (or 'phansy') seemed to expand greatly when he was in the presence of 'wild, vast, indigested Nature'. In other words, he was carried away by what the following century would term the 'Sublime' in nature. This is the aspect of his long treatise that most affected later writers such as Shaftesbury, Addison, Thomson and Burke. In an oft-paraphrased passage, Burnet especially emphasized that 'whatsoever hath but the Shadow and Appearance of the INFINITE, as all Things have that are too big for our Comprehension, they fill and overbear the Mind with their Excess, and cast it into a pleasing kind of Stupor and Admiration'.[3]

The rapidly developing taste for the Sublime – a kind of 'Aesthetics of the Infinite' (Nicolson's apt phrase),[4] wholly distinct from the Beautiful – was concurrent with the impact of Burnet, and indeed they mutually reinforced one another. The first major English formulation of the Sublime was made by the critic, John Dennis, in several works published between 1693 and 1704.[5] Though much stimulated by Longinus, Dennis developed his views beyond his predecessor's 'Rhetorical Sublime' (with its primary concern for expressing 'Great Thoughts' in an 'Elevated Style' designed to 'transport', the audience) in a direction that came to be termed by many the 'Natural Sublime', being more oriented to the effect which overpowering natural phenomena have on our sensibilities. Dennis's most revealing remarks on mountains were made in a journal-letter to a friend written when he crossed the Alps in 1688. He stressed how he experienced paradoxical dual feelings, such as 'delightful horror' or

'terrible joy', and goes on to exclaim that nature's 'careless, irregular and boldest strokes are most admirable. For the Alps are works which she seems to have design'd and excut'd too in Fury . . . I am delighted, 'tis true, at the prospect of Hills and Valleys . . . but transporting Pleasure follow'd the sight of the Alps'.[6]

Dennis' greater contemporary, Shaftesbury, wrote an even more rhapsodic account of crossing the Alps, in 1686, subsequently published in *The Moralists* (1709). In words which strikingly anticipate the awesome effect superbly captured by Turner in his formidable watercolor, *The Passage of Mount St Gothard* (1804; Pl. 2), he exclaims 'See! with what trembling steps poor mankind tread the narrow brink of the deep precipices, from whence with giddy horror they look down . . . Here thoughtless men, seized with the newness of such objects, become thoughtful . . . Here space astonishes; silence itself seems pregnant, whilst an unknown force works on the mind, and dubious objects move the wakeful sense. Mysterious voices are either heard or fancied.'[7]

Three years later, in 1712, Addison published in *The Spectator* his great essay, 'The Pleasures of the Imagination', which contained a section on the 'natural Sublime', including a passage which closely paraphrased the above-quoted words of Thomas Burnet, a passage we shall quote below in connection with Turner. Addison's essay reached a wide audience. On the other hand, poetry of the time offered conspicuously few references to mountain scenery, until the appearance of James Thomson's *Seasons* (1726–30), above all, 'Winter' (1726). Before then, one can only point to a few tamely pastoral 'hill poems', such as Denham's *Cooper's Hill* (1642) or Dyer's *Gronger Hill* (1726), which present nature in a 'Virgilian' mode and owe more to Milton's *L'Allegro* than to actual scenery.[8]

By the time Burke's *Essay on The Sublime and Beautiful* appeared in 1757, a positive regard for mountain grandeur had become fairly widespread among British writers. Among British artists, however, this was not yet the case. For one thing, landscape – apart from emulations of Claude Lorrain and Gaspar Dughet on the one hand and country house views on the other – was still a underprivileged genre in England before the 1760s. What few examples included any mountains at all presented them as safely distant, horizon forms, rendered in a highly generalized way, as seen in John Wootton's *Classical Landscape: Sunset* (1754) at Yale. Even Richard Wilson, raised in rugged Wales, allowed mountains only background importance, with the notable exception of his stark, close-up view, *Llyn-y-Cau, Cader Idris* (c. 1774; Pl. 3), painted late in his career.[9] This was no less true of landscape painting on the continent before the final quarter of the century. Ludwig Aberli's alpine view, *Lake Brienz* (1769; Basel), for example, is wholly conventional both in compositional layout and in its profusion of foreground incident; the mountains, moreover, are not the least awesome, appearing more as background adornment for a picturesque lake. Salomon Gessner's occasional alpine views, such as his *Reichenbach Falls above Meiringen* (1771; Private Collection), are still tamer, dominated by

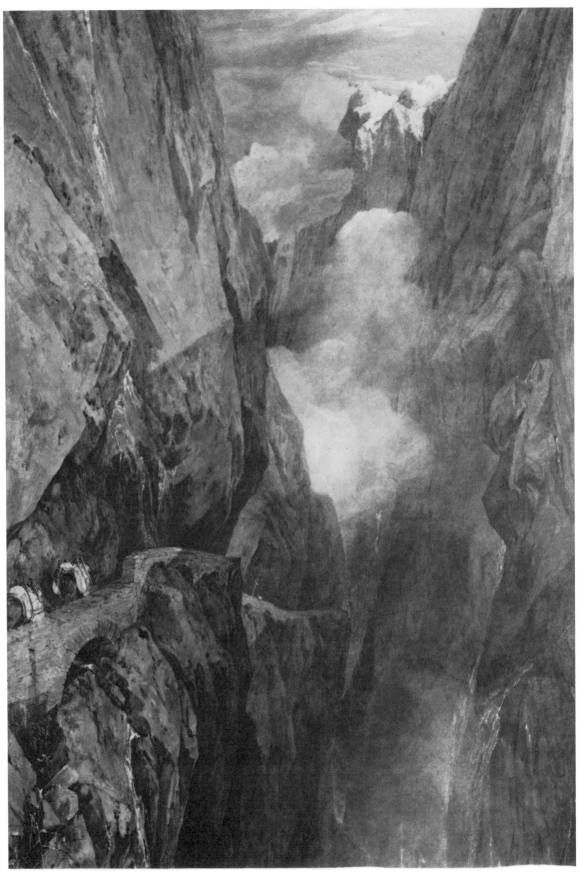

2. Turner, *The Passage of Mount St Gothard* (Abbot Hall Art Gallery, Kendal)

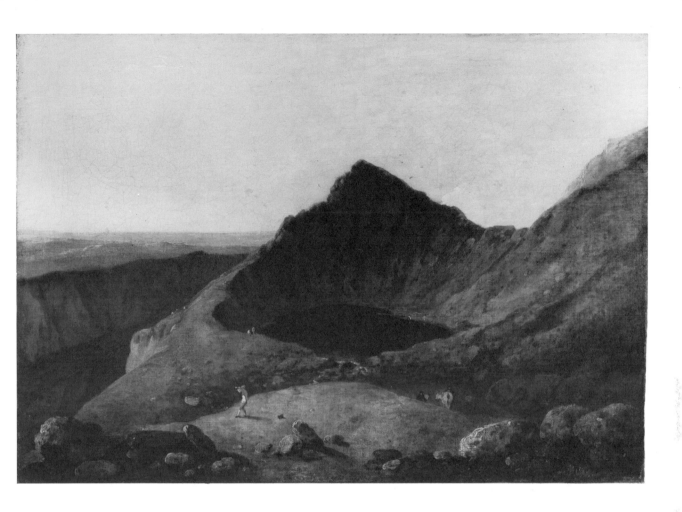

3. Wilson, *Llyn-y-Cau, Cader Idris* (Tate Gallery, London)

conventionally pastoral foregrounds. Even Caspar Wolf's much more adventurous mountainscapes of the mid and late 1770s, while far bolder in effect, continue to emphasize the Picturesque more than the Sublime, in most cases.

The first artist who captured in a compelling way the awesome scale and breathtaking grandeur of the Alps was the English watercolorist William Pars (1741–82), who accompanied Lord Palmerston to Switzerland in 1770. The following year he exhibited no fewer than seven alpine views at the Royal Academy (four of them featuring glaciers); a number of these are now in the British Museum.[10] His *Valley of Chamouny and Mont Blanc* (1770; BM) magnificently embodies the 'mountain glory' and almost ungraspable massiveness of Europe's highest peak. There is nothing quite comparable in literature until Shelley's 'Mont Blanc' (1816), the final stanza of which begins 'Mont Blanc yet gleams on high: – the power is there/The still and solemn power of many sights'.[11] In his most daring view, *The Rhone Glacier and Source of the Rhone* (1770), Pars transports the viewer into the wilder heights of alpine topography, boldly confronting him with a vast glacier descending nearly head-on. Three dwarfed climbers look on a desolate, alien world totally void of man's imprint. There is no attempt to pastoralize or soften the foreground, the artist leaving

5

it presumably as he saw it. The few earlier Swiss prints of glaciers, such as Matthaus Merian's *Grindelwald Glacier* (1642) or J. M. Füssli's *Rhone Glacier* (1706), either impose a conventional foreground of enframing tree clumps or portraying the glacier in a highly stylized manner, or both. Par's novel approach is truly impressive in its audacious, unflinching directness, as well as in its total grasp of alpine scale.

The richest harvest of watercolors of Swiss mountain scenery came from John Robert Cozens, who twice toured Switzerland, in 1776 and 1782. Experiencing the Alps through Cozens's eyes and poetic temperament is even more 'transporting' than it was in the case of Pars. The mountain world is yet vaster and more all-encompassing. At times, he takes us almost above the timber line, immersing us in an unrelentingly non-human, menacing realm of towering rock and alien ice, as in his unprecedented and unforgettable view, *Between Chamonix and Martigney: The Aiguille Verte* (*c.* 1778–80; Pl. 4), based on a study made during his first tour (1776). Certainly there are no softening, picturesque props here; instead, we face an engulfing, icy wilderness with no easy exit – a harsh, uninhabitable world of seemingly insurmountable mountains which, however, rivet our attention and stir our imagination. The work conveys a

4. Cozens, *Between Chamonix and Martigney* (Victoria & Albert Museum, London)

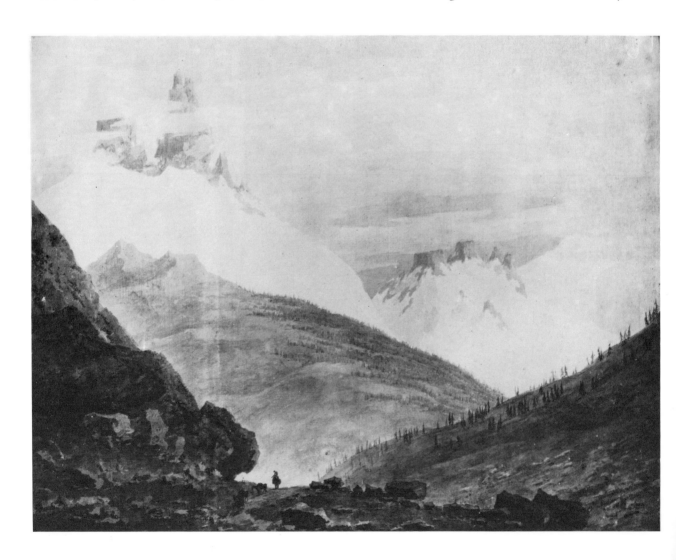

strong sense of the Sublime. A characteristic compositional tactic is the beyond-the-frame effect created by the prominent slope on each side rising right out of the picture, irresistibly impelling our mind to continue it indefinitely.

Eighteenth-century poetry offers nothing comparable to this work or others by Cozens, Pars or Francis Towne. We must wait until the appearance of Byron's and Shelley's poems some four decades later. Lines from *Childe Harold in Italy* (Canto III, 1818), in particular, come to mind.

> Above me are the Alps
> The palaces of nature whose vast walls
> Have pinacled in clouds their snowy scalps
> And throned eternity in icy halls
> Of cold sublimity where forms and falls
> The avalanche – the thunderbolt of snow!
> All that expands the spirit, yet appalls,
> Gathers around these summits, as to show
> How earth may pierce to heaven, yet leave vain
> man below.[12]

Perhaps Cozens's best known alpine landscape both in his day and ours is his *Pays de Valais* (c. 1780; Pl. 5, Cat. I.1), which exists in at least seven versions. Here we are out of the harsher upper reaches of the Alps, gazing down on a vast, serene valley flooded with luminous atmosphere. Human shelter is readily accessible on the left foreground ledge behind three horsemen. But however much nature appears more inviting here than in the above work, the grand impression of immensity is still as sublime as in other mountainscapes by Cozens. The beautifully rendered luminous sky, with its descending rays of sunlight, infuses a dynamic mood throughout the whole scene. As in a number of Cozens's watercolors, the sky is among the most expressive of any found in eighteenth-century landscape, and is part of the reason for Constable's oft-quoted reference to the artist as 'the greatest genius who ever touched landscape' in the medium of watercolor.

A third English watercolorist who painted some very remarkable alpine views at this time is Francis Towne, who was rediscovered only in our century. No account of early Romantic mountain painting, however brief, can afford to omit mention at least of Towne's most stunning watercolor, *The Source of the Arveyron* (1781; Oppé Coll.). This small but arresting work is indeed the most extraordinary and original view of a glacier made by any artist in the eighteenth century. Even more than in Cozens's views, we experience a sense of overpowering immensity that is truly staggering. The composition is utterly unbounded on all sides, and the great masses we confront, already formidably vast, are actually only fragments of what more than ever strikes the imagination as indefinitely extending masses, indescribably mammoth. Edmund Burke himself would be at a loss to do justice to the work. There is no more concentrated example in art of the 'Aesthetics of the Infinite'. We are further struck by

Towne's formal means, noting the drastic simplification and flattening out of the upper mountainside, together with the radical use of flat washes of subtly varying tone and density. The scene is totally devoid of any human presence. It could be an image of earth before the advent of man, or after human history, for all we know. Although it is not the first portrayal of a glacier, the effect is such that we feel Towne is painting something that no human eyes ever saw before. Certainly the work is unlike any earlier mountainscape, and even strikes one as being almost unconditioned by past art.

The painting of British mountain scenery similarly became at this time a significant new interest with a growing number of artists. Richard Wilson anticipated this interest with his famous view, *Snowdon from Llyn Padern* (c. 1766; versions at Nottingham and Liverpool), which presents, however, the distant mountain from a conventionally Claudean foreground. More unusual is his smaller but innovative *Llyn-y-Cau, Cader Idris* (c. 1774; Pl. 3, TG). The viewer abruptly faces at close range a stark, barren mountainside (with a rugged secondary peak) totally devoid of any softening, 'interceding' foreground *à la* Claude or Gaspard. The artist has created a roughly lozenge-shaped, platform-like foreground which neatly echoes the crater lake beyond. This format, however, does recall in part that of his earlier and equally original view, *Lake d'Agnano with Vesuvius* (early 1760s?; versions at Yale and Oxford). Several scattered figures animate the austere Welsh scene, though they are unobtrusive and the mood remains harshly desolate – and emphatically removed from the growing taste for picturesqueness. Wilson has painted this raw mass of earth and rock with a correspondingly severe, unembellished directness. Could Claude have seen it, he might well have found it repellent, even ugly – at least in the context of a finished picture. Wilson's mode of portrayal enhances the feeling of sublimity generated by the formidable scene. Anticipating Cozens, Towne and Wright, he maximizes the impression of a vast, incommensurable mass by showing only a segment of the whole which rises up and out of the picture on the right. He also lifts the viewer out of the traditional, safe vantage point in a valley or lakeside (as in his *Snowdon*), suspending him instead high up in the midst of a raw mountainous world, unlike anything in earlier European landscape painting.

Some of the most notable late eighteenth-century paintings of Welsh and English mountain scenery were produced by Gainsborough, Wright and De Loutherbourg, of whom only the last was primarily a landscape painter. Focusing first on Gainsborough, the eldest, we note that he did not take up the mountain theme until the final five or six years of his life, a time when he was exploring several new directions. Motivating factors were a trip to the West Country in 1782 and above all, a tour of the Lake District (his only one) the following year. The former trip may possibly owe something to the appearance and immediate popularity of William Gilpin's first publication on picturesque scenery, his *Wye Tour* (1782). Moreover, Gilpin's *Lakes Tour*, while not actually published until 1786, was known during the preceding decade

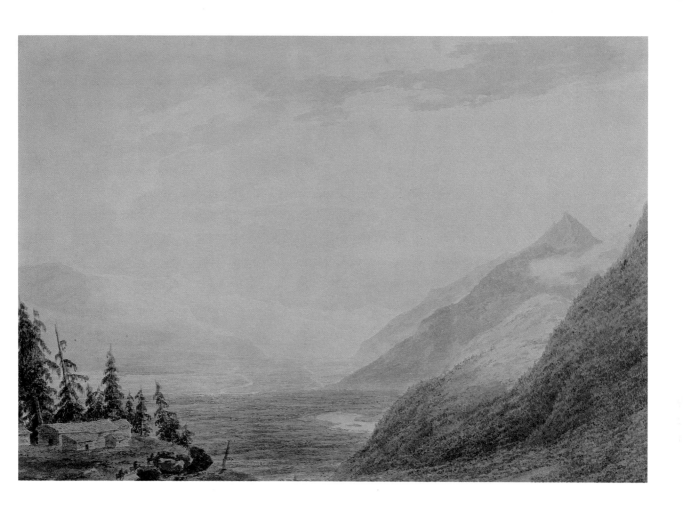

through a number of manuscript copies which circulated among various gentry 5. (I.1) Cozens, *Pays de Valais*
with landscape interests, including, one suspects, Gainsborough's friend and
patron, Uvedale Price, Sr. In any case, the artist painted at least six large moun-
tain landscapes in his last years, though all of them were so generalized that
they cannot be even loosely identified with any specific British scenery. Indeed,
as Ellis Waterhouse has observed, most of them are conceived somewhat 'on
the model of the sublimities of Salvator and Gaspard'.[13] This applies to the im-
pressive late example, *Mountain Valley with Figures and Sheep* (*c.* 1787–8; Pl. 6
Cat. I.5) in which the mountain forms and distant, Italianate-looking architec-
ture recall Gaspard more than any Lake scene. Like the others, it is a studio com-
pilation blended of fancy, generalized memories of the Lakes, and echoes of
Gaspard, painted with a lightness of touch and subtlety of color and atmosphere
rivalling Watteau. Its evanescent, 'poetic' light effects and soft, broad brush-
work enhance the impression of an airy dream-world. 'With particulars he had
nothing to do,' Constable remarked of Gainsborough's late work, adding that
'his object was to deliver a fine sentiment – and he has fully accomplished it.'[14]

While mountains remain essentially background elements in most of Gains-
borough's landscapes, they assume a primary importance in much of the later

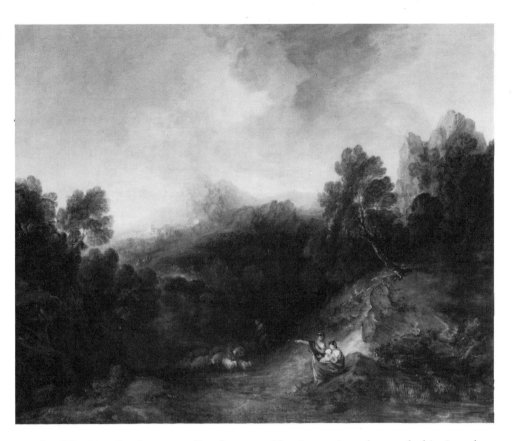

6. (I.5) Gainsborough,
*Mountain Valley with Figures
and Sheep*

work of De Loutherbourg, a flamboyant Alsatian artist who settled in London in 1771. His keen interest in British mountain scenery was awakened by a tour to the Lakes (via Derbyshire) in the summer of 1783, the very same time as Gainsborough's visit – in fact, the two friends must have known of each other's tour, even if they did not cross paths. During the next four years, De Loutherbourg exhibited at the Royal Academy seventeen views of the Lake District and Derbyshire, most of them featuring mountain scenery. Even Dovedale becomes an awesome mountainous scene in the throes of a 'sublime' storm, as presented by De Loutherbourg in a large, dramatic picture of 1784, now in the York Art Gallery. In 1786 the artist toured the most mountainous portion of northern Wales, and the following year exhibited two large paintings of Snowdon, including *Snowdon from Capel Curig* (1787; Pl. 7, Cat. I.6). Although we view the distant mountain from an eye-catching, rustic foreground, nevertheless, the sprawling grandeur, majestic scale and rugged contours of the formidable peak (the highest in Wales or England) powerfully dominate our attention. As in a number of other landscapes, De Loutherbourg here effectively combines in one picture elements of the Picturesque (in the foreground) with a main motif that his age deemed inherently Sublime – an awesome, towering mountain. Like many later Romantics, he indulges in the liberty of exaggerating the height and steepness of the mountain.

The remarkable impact which English and Welsh scenery made on this continentally trained artist is reflected in his bold and unusual claim that no

aspiring English landscape painter need travel to the continent in order to complete his artistic education, for he would do better to 'stay in England and simply study the native landscape'.[15] Not many of De Loutherbourg's major contemporaries would have voiced such an opinion, at least not before war with France closed off much of the continent to Englishmen for years. A broadly comparable view, however, was staunchly put forth in the first British treatise on landscape painting, J. H. Pott's important but neglected *Essay on Landscape Painting* (1782), which stressed the special visual appeal of British scenery, lauding it as incomparably varied and upholding it as fully sufficient for the interests of any landscape painter.[16]

Joseph Wright, who painted several striking views of his native Peak District in the 1780s, such as *Matlock Tor* (*c.* 1780; YCBA) or its daytime sequel at Cambridge (*c.* 1785), visited the Lake District in the summers of 1793 and 1794, and these tours inspired nearly a dozen paintings of that region during the following two years (shortly before his death in 1797). None was exhibited and only half of them are known today. They have received less than their due from modern scholars, including Benedict Nicholson.[17] Wright's *Derwentwater with Skiddaw* (*c.* 1795; Pl. 8, Cat. I.7) is arguably the most original of the group, especially in its wonderfully dynamic weather effect, at once so arresting and so believable. Moreover, he does not at all strain for a fashionable picturesqueness, in refreshing contrast to many of his contemporaries, above all Ibbetson (see the latter's *Langdale Pikes from Lowood, c.* 1801–5?; Pl. 9, Cat. I.13). Wright's *Skiddaw* along with one or two other Lake District views such as his daringly simplified *Ullswater* (*c.* 1795; Private Collection), is a significant achievement among British mountainscapes painted before Turner, and deserves to be better known.

Unquestionably the artist who contributed the richest outpouring of mountain paintings (and watercolors) during the Romantic era is Turner. No continental artist rivals him in this respect. Yale is especially rich in his alpine

7. (I.6) De Loutherbourg, *View of Snowdon from Capel Curig*

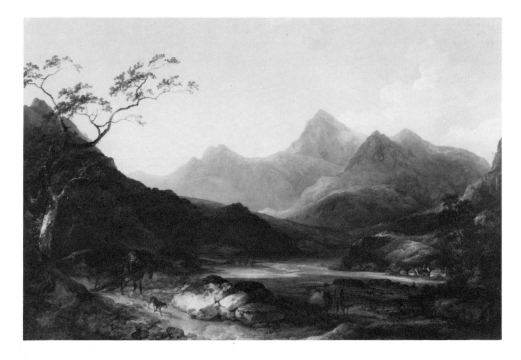

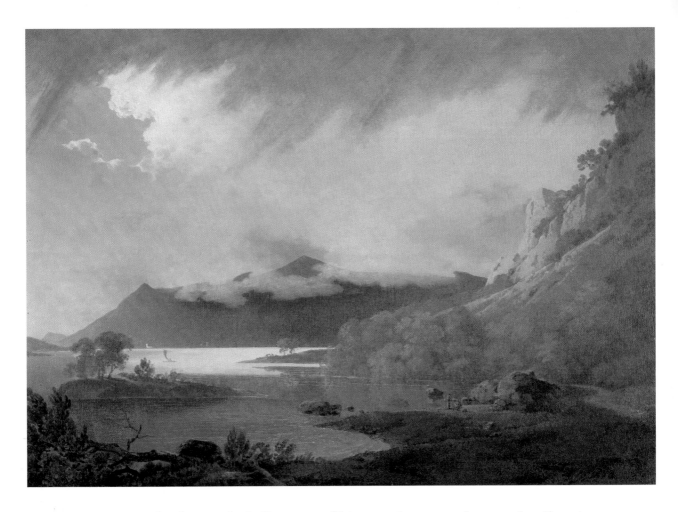

8. (I.7) Wright, *Derwentwater with Skiddaw*

landscapes, including two of his most important large-scale efforts in water-color made soon after his first tour of the Alps in 1802. His *Glacier and Source of the Arveyron, Chamonix* (Pl. 10, Cat. I.16), exhibited in 1803, boldly places the viewer in the midst of a vast mountain wilderness, fiercer than anything seen in earlier art. The scene is dense with jagged forms stated with an aggressive force-fulness – not only in the case of the mountains and glacier, but also the battered foreground trees which rise up and out of the picture in a startling way. Wild-ness reigns unmodified, and the mood of the whole scene is one of sublime desolation. The work is a world apart from the cosy, touristic views of Switzer-land which the popular Swiss artists, Gabriel Lory Sr. and Jr., continued to pour forth at the time.

If Turner's awesome glacier scene embodies the Sublime in alpine scenery,[18] his *Lake Geneva with Mont Blanc* (c. 1803–5; Pl. 11, Cat. I.17) is a complementary embodiment of the Beautiful. Indeed, its graceful foreground trees silhouetted against a calm morning sky hint at Claude's mode of pastoral beauty. On the other hand, the casual informality of the bathers and laborers, along with the profusion of cattle and sheep, injects an earthy quality that is Turner's own. Moreover, his beguiling color scheme – richer than that employed in most of

12

9. (I.13) (facing) Ibbetson, *Langdale Pikes from Lowood* (detail)

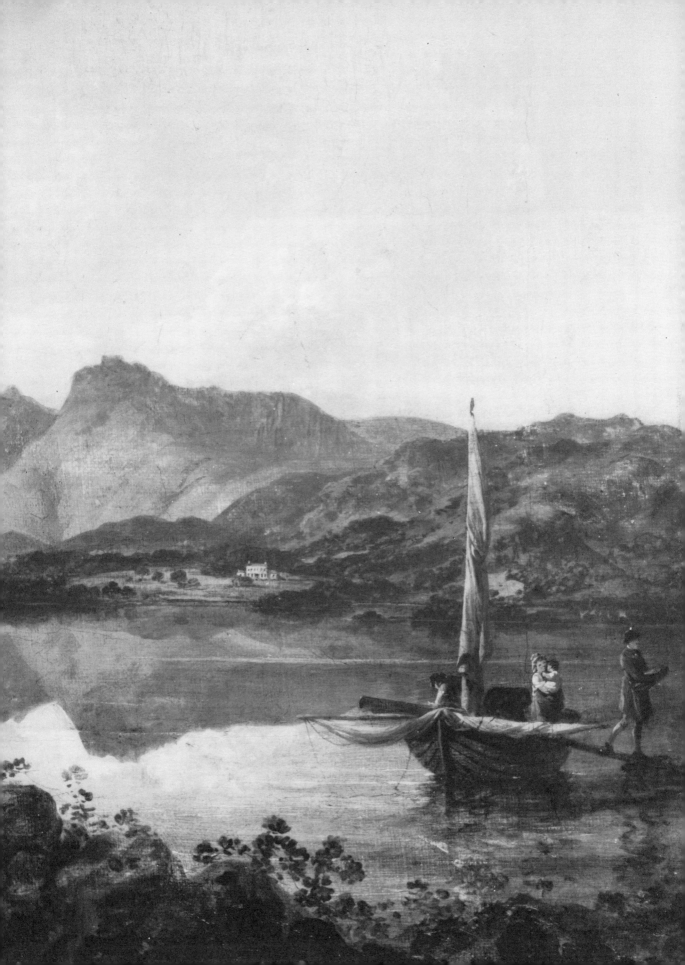

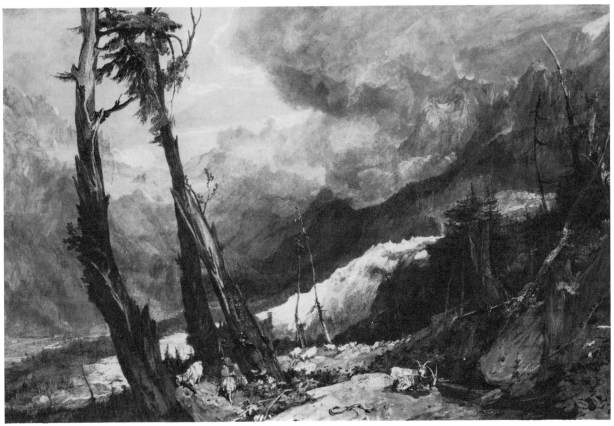

10. (I.16) Turner, *Glacier and Source of the Arveyron*

11. (I.17) Turner, *Lake Geneva with Mont Blanc*

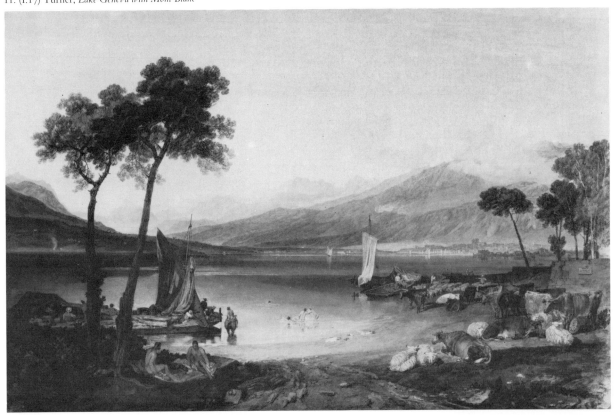

his earlier watercolors – is wider in range, higher-keyed and stronger in certain hues than that of any Claude. The result is a vision of Swiss mountain lake scenery that is grounded in a specific scene without being narrowly topographical and at the same time one which exhibits an imposing grandeur without being conventionally 'classical' in the usual formulaic way. The unusually large scale of both watercolors, we should add, together with their compositional richness and elaborate finish, probably reflect Turner's desire to raise the status of watercolor nearer to that of oil painting – a cause he furthered more effectively than any other artist.[19]

Chateau de St Michael, Bonneville, Savoy (1803; Pl. 23, Cat. I.15) is one of Turner's two earliest exhibited oil paintings of alpine scenery, the other being *Bonneville Savoy, with Mont Blanc* (1803; Private Collection). Both are artfully composed and relatively undramatic views of distant mountains seen from a low-lying, stable vantage point. In fact, the compositional structure of the Yale painting probably owes something to Poussin's *Landscape with a Roman Road* (1648; Dulwich), which was exhibited at a sale in London in 1802.[20] Moreover, when Turner visited the Louvre in the late summer of 1802 he showed more interest in Poussin than in any other old master. He did not, in fact, produce a painting of Swiss scenery that rivalled the expressive intensity and compositional daring of some of his early Swiss watercolors until he painted the formidable *Fall of the Rhine at Schaffhausen* (1806; Boston), followed four years later by his horrific *Fall of an Avalanche in the Grisons* (1810; TG).

Turner's dazzling watercolor, *Upper Falls of the Reichenbach* (c. 1810–15; Pl. 12, Cat. I.18), based upon a watercolor sketch made during his 1802 tour, shows his continuing interest in awesome scenes and situations expressive of the Sublime. In the apt words of Addison, 'Our Imagination loves to be filled with an object, or to grasp at any thing that is too big for its Capacity. We are

12. (I.18) Turner, *Upper Falls of the Reichenbach*

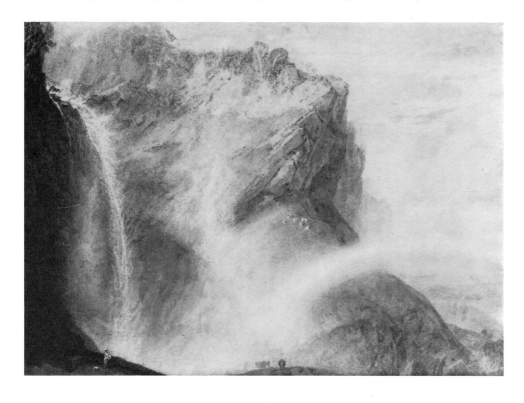

flung into a pleasing Astonishment at such unbounded Views, and feel a delightful Stillness and Amazement in the Soul at the Apprehension of them.'[21] Accentuating this effect is the fact that we view the scene from a rather precarious, radically minimal foreground, high above a valley; moreover, the massive outcropping rock forms comprise only one segment of a still vaster mass of earth which we must imagine extending beyond the frame to the left and behind us. Earlier writers on the Sublime, above all John Baillie in his 1747 essay, touched on this particular effect, emphasizing that 'Vast Objects occasion vast Sensations . . . When the Object is uniform, by seeing *Part*, the least Glimpse gives a full . . . Idea of the *Whole* . . . Where an Object is *vast* and at the same Time *uniform*, there is to the Imagination no Limits of its Vastness, and the Mind runs out into Infinity, continually *creating* as it were from the *Pattern*.'[22] In addition to this heady experience, we are further captivated by the luminous presence of a softly glowing rainbow, rendered with much subtlety and delicacy. No other landscape painter quite rivals Turner in achieving such effects.[23]

Turner's greatest English contemporary, Constable, was notably unenthusiastic about mountain scenery during most of his career. His friend and biographer, C. R. Leslie, reported hearing him say that 'the solitude of the mountains oppressed his spirits'.[24] He preferred scenes which were more suffused with human associations, especially farm scenery, so typical of his native Suffolk. Only during the years 1806–9 did he produce a few oil paintings of mountains, inspired by a two-month tour of the Lake District in the autumn of 1806. Most of these remain untraced, and none is in the Mellon Collection at Yale,[25] which is rich in the artist's rural landscapes and studies (cited in a later section of this book). Constable did produce a sizeable number of on-the-spot watercolor sketches of the Lakes, many of them exhibiting an impressive sweep and vigor reminiscent of Girtin.

The majority of early nineteenth-century British landscape painters, especially watercolorists, took a strong interest in mountain scenery – indeed, far too many to even begin to discuss in a brief introduction. Never before did mountains so attract artists, and the variety of mountainscapes was truly remarkable. This enthusiasm persisted well into the Victorian era and then steadily waned. In closing this section, I should like to single out a neglected but masterful work by Copley Fielding, his *Scene on the coast, Merionethshire, storm passing off – Landing cattle on the Sands* (1818; Pl. 24, Cat. I.21), a large canvas exhibited at the British Institution early in 1819. This truly overpowering mountain landscape shows that the aesthetic of the Sublime was still very much operative at the end of the Georgian era, and in fact manifests itself here more dramatically than ever. Never had Welsh mountain scenery appeared in art on so sublimely formidable a scale or under such volatile skies and stirring luminary conditions. Also striking is the unexpected juxtaposition of full-blown mountain sublimity and prominent foreground shipping, plus the battered tower of Dolbadern Castle (relocated), adding a touch of ruin sentiment. Copley Fielding, one might say, has here given us a kind of climactic statement of the 'high' Romantic mountainscape.

II. Coastal Scenes

MORE THAN any earlier artists, British painters of the Romantic era made the coastal scene a major theme in art. Their priority in this respect is perhaps not surprising in a country where no place is more than seventy miles from the seashore. Dutch marine painters of the seventeenth century, to be sure, preceded the British in exploiting some of the possibilities of this richly diverse subject, which unites aspects of both landscape and seascape. However, coastal scenes never occupied so prominent a place in Dutch art as they came to occupy in British Romantic art. Moreover, the latter offers a much greater variety than had ever been seen before. A relevant factor is that a widespread taste for the seashore (in post-classical times) first developed in England, rather than on the continent. This came about during the second half of the eighteenth century, initially fostered by growing medical opinion attributing singularly beneficial effects to sea bathing.[1] One result was a rapid growth of seaside resorts, such as Scarborough, Margate and Brighton. Another factor promotive of an interest in coastal scenery – though of the rockier kind – was the widespread vogue for the Picturesque, which directed British eyes to certain kinds of scenery deemed eminently picturable, including the nation's rugged coasts no less than her famed mountain lakes.

Britain's unusually long and remarkably varied coastline is unmatched in northern Europe for richness of appeal. Throughout the past two centuries, Englishmen have felt peculiarly attracted to a shore, 'watching the retiring and returning waves, and attending to the bursting thunder of the surge', as Ann Radcliffe wrote in 1797.[2] To the Byronic soul, 'There is a rapture on a lonely shore . . . by the deep sea, and music in its roar.'[3] Also, many stretches of coasts of 'the island kingdom' held a wealth of associations for the English. As William Daniell and Richard Ayton observed in the Introduction to their monumental *Voyage Round Great Britain* (1814–25), illustrated with 308 aquatinted coastal scenes by Daniell: 'So many associations flattering to our pride are connected with every view of our seas and shores, that it is singular that so much remains to be said on such a subject, with the recommendation of novelty.'[4]

Notably few coastal scenes were painted by British artists before the mid eighteenth century. Indeed, few paintings of any existing scenery in Britain, apart from country house views and topographical townscapes, were produced before mid-Georgian times. In the late 1740s and 50s, Charles Brooking occasionally painted a beach scene, usually with fishermen. All the extant examples

show the continuing impact of the seventeenth-century Dutch marine painting, a tradition which had been strong in England since the arrival of the Van de Veldes in 1673. In fact, Brooking accepted commissions to copy Dutch marines, a good example being his *Coast Near Scheveningen with Fishing Pinks on the Shore* (*c*. 1750s; YCBA and copy at Greenwich), which reproduces with a minor omission a panel by Simon de Vlieger now in the Wallraf-Richartz Museum, Cologne. Moreover, some of the more conservative marine painters of the Romantic era, such as Thomas Luny, Nicholas Pocock and William Anderson, perpetuated Dutch traditions in both their coastal scenes and sea paintings well into the nineteenth century.

A different seventeenth-century tradition operated in several paintings of coasts by two of the reigning landscape masters in mid eighteenth-century England, Wootton and Lambert. The former's *Classical Landscape: Sunset* (1754; YCBA), a purely imaginary view, clearly adapts a compositional layout derived from Claude Lorraine (e.g., *Marriage of Rebecca and Isaac*, 1648; NG): a shadowy, stage-like foreground flanked by trees, leading to a broad body of water beyond which is a serene and misty horizon of gently sloping mountains surmounted by a luminous sky. George Lambert, who painted numerous 'ideal', pastoral landscapes in a Claudean or Gaspardesque mode, could on occasion evoke the art of Salvator Rosa, as in his *Mouth of an Estuary* (*c*. 1750s?; Birmingham City Art Gallery) with its criss-crossing storm-blasted trees and general mood of wild, 'sublime' nature.

A new direction in coastal scenes was pioneered by Gainsborough in 1781 when he exhibited, *Coast Scene: Selling Fish* (Pl. 13, Grosvenor Estates). Instead

13. Gainsborough, *Coast Scene: Selling Fish* (Grosvenor Estates)

of showing a broad, low beach receding into the distance, as earlier Dutchmen nearly always had, he introduced a rugged coast of shallow depth under windy, overcast skies, though not so dramatically rugged or theatrically stormy as in a typical Vernet of the time. The rocky topography is presumably imaginary, not corresponding to any part of the coast known to Gainsborough; yet, both it and the other elements in the picture, such as the vivid figures, are fully convincing – more so than we find in some of the artist's purely pastoral landscapes of the same period (his final years). One feels that a good deal of observation of sea, sky and fishing boats ultimately lay behind this work. As Horace Walpole remarked on viewing the picture at its Royal Academy *debut*, the scene is 'so natural that one steps back for fear of being splashed'. [5] A similarly composed (in reverse) and closely contemporary windy shore scene of the same size is in the National Gallery, Washington (formerly Mellon-Bruce Collection), namely, *Fishermen Setting Out* (c. 1781). This type of close-up, rugged coastal scene, with a few prominent, energetic figures, was soon taken up and eagerly exploited by George Morland, as seen in his well-known *Seashore – Fishermen Hauling in a Boat* (1791; V&A), the setting of which is closely modelled on that of the above Grosvenor painting.

Fishermen Dragging Nets (1781; Anglesey Abbey) is another impressive example of Gainsborough's new mode of coastal scene, this time including a desolate tower ruin. The result is a kind of double subject picture which anticipates De Loutherbourg's and Turner's penchant for coasts with castle ruins, especially in the years 1798–1802. Gainsborough's *Coast Scene with Shepherd and Flock* (c. early 1780s; YCBA) also strikes a novel note in the context of contemporary coastal painting, with its combination of marine and pastoral elements.

Just why Gainsborough took a sudden interest in seacoasts during the early 1780s is not known. He did purchase a Bakhuizen seascape in 1781, but that was in December, several months after he exhibited his first two coastal scenes at the Academy (and painted a third). In any case, it was during these years that he expanded the range of his subject matter, perhaps to show himself to the world as more than a portrait painter. He began painting his first mountain landscapes at that time, as well as his first 'Fancy Pictures'. His interest in seacoasts, however, was short-lived, limited to some half-dozen examples, all datable between 1780 and 1783.

Gainsborough's colorful contemporary and friend, De Loutherbourg, produced a number of highly dramatic, rocky coast scenes toward the end of the century, such as *Smugglers Landing in a Storm* (1791; Victoria Art Gallery, Bath) or his equally large and impressive *Shipwreck* (1793; Pl. 14). Both of these strongly recall a typical stormy coast by Claude Joseph Vernet, the foremost eighteenth-century French landscape and marine painter, who was particularly admired by English collectors at that time. A more original work by De Loutherbourg is *Launching a Fishing Boat from the Shore at Brighthelmstone* (1784), painted for the first Earl Grosvenor as a pendant to Gainsborough's above-

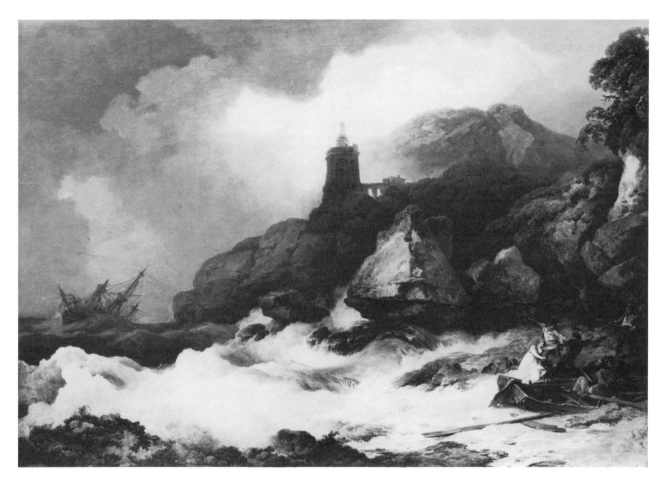

14. De Loutherbourg,
Shipwreck (Southampton
Art Gallery)

mentioned *Coast Scene: Selling Fish* (Pl. 13). This is a surprisingly naturalistic
picture for an artist who more often lived up to his nickname, 'Mystagogue
of the Sublime'. The close-up viewpoint and casualness of the composition
actually anticipates to a degree some of Constable's studies of shipping at
Brighton Beach made forty years later. This previously underrated work, and
several others by the painter, show that on occasion De Loutherbourg relied
heavily on direct observation of nature, supported most likely by on-the-spot
pen sketches. Here he is not in the least under the spell of Vernet, a prime
inspiration for his best-known rocky coastal scenes; neither does he owe much
to Dutch masters.

De Loutherbourg was also fond of painting stormy coasts dominated by a
time-worn castle silhouetted atop a rugged promontory, such as seen in a pair
of coasts exhibited at the Royal Academy in 1801, *Harlech Castle, North Wales*
and *Conway Castle from the Ferry* (Private Collection). His large version of
Conway Castle, viewed from the west (1801; ex Agnew's), may well have
stimulated Turner's still more formidable rival version of *c.* 1803 (Grosvenor
Estates).

Particularly admired in the final decade of the century were George Mor-
land's many picturesque landscapes and genre scenes, including numerous

20

stormy coasts. As noted earlier, more than a few of his coastal scenes are popularizing exploitations of the type pioneered by Gainsborough in the early 1780s, such as the aforementioned example in the Victoria & Albert Museum (1791) or his *Seacoast with Smugglers* (1793) and *Stormy Coast with a Wreck* (c. 1790s), both in the Glasgow Art Gallery. Morland makes his busy, robust figures a more eye-catching component of the scene than does Gainsborough. He is less derivative in his *Smuggling off the Isle of Wight* (c. 1799?; ex Mellon Collection) painted perhaps during his half-year stay on the isle (hiding from creditors) in 1799, though its style and quality of execution is not incompatible with a somewhat earlier date. The focus is on the unloading of contraband goods from a beached boat under a threatening sky. Rugged cliffs loom awesomely above the scene, intensifying the dramatic effect. The touch is both lively and deft, and the color admirably fresh, the artist being at his best here. The work compares favorably with the above-mentioned smuggling scene in Glasgow.

Smuggling was rampant in England throughout the eighteenth century and well into the next, especially all along the southern coast, from Sussex to Cornwall. Already by the 1740s, an estimated twenty thousand smugglers operated on the southern coast alone, dealing mainly with illegal tea and secondarily with brandy and other spirits. About three times as much tea was smuggled into England as entered legally. Less than five percent was confiscated by the government, due to inadequate numbers of customs officials and guards as well as to widespread corruption. The subject was much in the public mind, and small wonder that it cropped up in art of the time.[6] De Loutherbourg had devoted a large painting to this timely theme in 1791, the previously cited work at Bath. Another large and interesting example was until recently in the Mellon Collection, *Smugglers in a Rocky Cove*, a work long ascribed to William Marlow, but persuasively reattributed to Edmund Garvey by Michael Liversidge in a lecture at the Yale Center in September 1978. He identified the picture as the one Garvey exhibited at the Royal Academy in 1808, under the title, *View in Portland Island with Smugglers*. The weather is less stormy than in the above Morland, but the topography is even more rugged and forbidding. The artist applies his thick, broad strokes and patches of paint with a boldness that appears more forced than convincing. Still, the picture is not without a certain power, albeit within the limits of a somewhat old-fashioned (by 1808) compositional layout blended of Vernet and early Turner.

Another kind of coastal scene frequently painted during the early Romantic era is the shipwreck off a rocky coast, though Yale possesses very few examples. An island kingdom, England has always been especially dependent on the sea, both for her economy and her defense. Throughout the eighteenth and nineteenth centuries her navy and merchant fleets were second to none, and the popular dictum, 'Britannia rules the waves', was literally true. But this also meant that shipwrecks were an all too frequent occurrence. During the long war with France (1793–1815), especially, the spectre of shipwreck became a particularly obsessive horror for the seafaring British. Indeed, far more 'sons of

Albion' died at sea during those turbulent years than did the citizens of any other country. The early historian of shipwrecks, Sir John Dalywell, summed up the situation in the Introduction to his *Shipwrecks and Disasters at Sea* (1812). 'In a country such as Britain, where every individual is either immediately or remotely connected with the fortune of the sea, the casualties attendant on the mariner must be viewed with peculiar interest . . . Shipwreck may be ranked among the greatest evils which men can experience . . . one against which there is least resource, where patience, fortitude and ingenuity are unavailing, except to prolong the struggle with destiny, which, at length, proves irresistible . . . Perhaps not less than 5,000 natives of these islands yearly perish at sea.'[7] If Dalywell's figure is not an exaggeration, it would mean that the number of Britons lost at sea each year in late Georgian times was about five times higher, in proportion to the population, than the number of British killed in auto accidents today. One factor was that the great increase in shipping during the eighteenth century was not accompanied by a substantial increase in ship safety. Moreover, longer and more frequent voyages brought a demand for greater speed which in turn often led to the smaller merchant ships being over-rigged to achieve it. Then too there were the 'coffin ships', insured above their value by owners who privately hoped they would founder – and such hopes were all too often realized. On top of this, by the end of the eighteenth century the dwindling supply of seasoned oak resulted sometimes in merchant vessels being built of unseasoned timber, to the detriment of their seaworthiness. In view of these factors, among others, it is hardly surprising that shipwrecks were so ever-present a fear in the England of Lord Nelson and Turner, or that sea disasters provided so compelling a theme for more than a few British Romantic painters and poets.[8]

Surprisingly, there are comparatively few shipwreck paintings by British artists before the 1790s, despite the frequency of maritime disasters or the prominence of the subject in some of the most widely read eighteenth-century poems, such as Thomson's *Seasons* (1726–30) or above all, Falconer's *The Shipwreck* (1762; 24 English edn. by 1830). A taste for this subject, however, began to emerge in the later 1750s and 60s among various English collectors who took a fancy to the work of Vernet, including his numerous shipwrecks. His 'British' successor, De Loutherbourg, occasionally worked resourceful variations on his highly wrought shipwrecks, the most impressive being *The Shipwreck* (1793; Pl. 14) cited earlier. Off a purely imaginary rocky coast of sublime wildness, a ship has foundered and a few survivors have struggled ashore only to be attacked by brigands, who in turn are set upon by several gallant heroes rushing out from the rocks just in time. Few other shipwreck paintings rival the packed melodrama of this one. One recalls the artist's extensive experience in the 1770s as a designer of stage scenery as well as his sensational proto *gesamptkunstwerk*, the 'Eidophusikon' (1781–2; burnt down in 1801), a series of movable panoramic scenes with spectacular lighting, sound effects and musical accompaniment. In fact, one of the most dramatic pictorial

episodes in the Eidophusikon was 'Storm and Shipwreck' (1781), which he showed again in 1786 under the new title, 'Storm at Sea with the loss of the Haslewell East Indiaman', referring to a widely discussed recent disaster that occurred on the rocks of Purbeck Island in the English Channel.

The most formidable shipwreck paintings by any European artist of the Romantic era is surely Turner's large *Shipwreck* of 1805 (TG) and his equally imposing *Wreck of a Transport Ship* (*c.* 1810; Fundaçao Calouste Gulbenkian, Lisbon). Unlike earlier shipwreck paintings, which almost always introduce a nearby coast, Turner's are set in the open seas, with no hopeful sight of land. He also immerses the viewer in the midst of the catastrophe, suspending him above the frantic would-be survivors who overcrowd the few lifeboats that founder in a wildly raging sea, while nearby the capsizing hulk is about to go under. Wordsworth's lines come to mind:

> That hulk which labors in the deadly swell
> This rueful sky, this pageantry of fear![9]

Desperate rescue operations are under way, but Turner suspensefully leaves the outcome in doubt. There is a kind of you-are-there immediacy which is just as overpowering for the spectator as say, Goya's *The Third of May, 1808* (1814; Prado Museum). The two works are also remarkable for their unprecedentedly illusionistic rendering of a churning sea. These intensely compelling shipwrecks arguably have no close rivals in the history of art.[10]

One of the earlier watercolorists to paint coastal shipwrecks was Francis Nicholson. His exhibits at the Old-Water Colour Society in London included a shipwreck off the Scarborough coast on three occasions, 1805, 1808 and 1811. A watercolor of this subject (Pl. 15, Cat. II.2) is a possible candidate for one of the versions, though likelier possibilities are two larger versions of the same scene at the Victoria & Albert Museum, one dated 1803. Unlike De Loutherbourg and Vernet, who set most of their shipwrecks in generalized, imaginary settings, Nicholson placed his before an actual, well-known spot on the northeastern coast. Instead of a rocky foreground, we find a broad, stable pier safely accommodating a number of spectators. While several men and women gesticulate frantically toward the stricken ship, there is no strong narrative element such as is often found in the shipwrecks of the above two artists. A highly dramatic event is reinforced by a dramatic compositional layout, involving a low, close-up viewpoint – the foot of the enormous 'castle cliff', which powerfully looms above the scene, generating a sense of sublime awe. The work is quite different from his subsequent large watercolor of a shipwreck, *Storm* (1813; Stourhead), which is much more reminiscent of De Loutherbourg and especially Morland. The coastal shipwreck, however, was not the only type of seacoast which engaged Nicholson. He also painted less overtly dramatic stretches of the coast near Scarborough, such as the pleasing distant view of the fashionable spa now in the Victoria & Albert Museum (*c.* 1806) or the two watercolors at Yale of Yorkshire fishing villages viewed

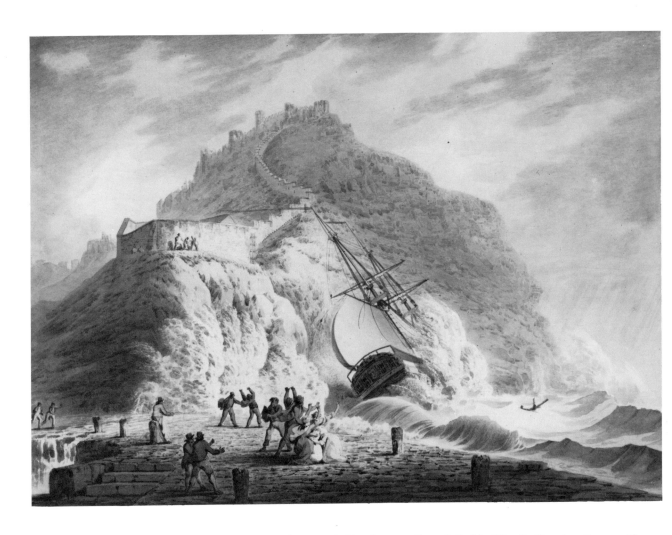

15. (II.2) Nicholson,
Scarborough: Shipwreck

from the beach, *Staithes, Yorkshire* (*c.* 1800?) and *Robin Hood's Bay* (*c.* 1810–15?).

Another variety of coastal scene which attracted painters and especially watercolorists at this time was the bathing resort, above all several located on the southern coast such as Margate, Ramsgate, Brighton and Weymouth. All of these had recently become fashionable destinations of increasing numbers of Britons imbued with the prevailing medical opinion about the beneficial effects of sea bathing. While the Yale collection is not rich in late Georgian examples, it does possess a singularly interesting if unexpected effort by Benjamin West, his *Bathing Place at Ramsgate* (*c.* 1788; Pl. 41,Cat. II.3) one of the earliest oil paintings of a resort beach by a major artist. West shows us a kaleidescopic cross-section of social types and ages, grouped before the distinctive 'bathing machines' devised by Benjamin Beale of Margate a generation earlier, and which became *de rigeur* for all self-respecting seaside resorts by the 1780s. A particularly bold and novel effect results from the brash presence of a massive cliff in the immediate foreground, its bright, flat surface almost masonry-like.

About a decade later, the precocious young watercolorist, Thomas Girtin, produced several novel coastal scenes. Two, in fact, are among the most

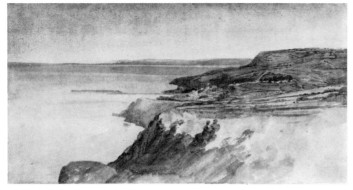

16. (II.4) Girtin, *Lyme Regis, Dorset* 17. (II.5) Girtin, *An Unidentified Estuary*

'modern' seacoast views produced by any artist of the time: *Lyme Regis, Dorset* (*c.* 1797; Pl. 16, Cat. II.4) and *An Unidentified Estuary* (*c.* 1797; Pl. 17, Cat. II.5). Both are panoramic, bird's-eye views of receding coasts, completely empty of human figures and notably audacious in their radical simplifications of nature. With the former watercolor, the choice of viewpoint and resulting composition may owe a debt to John Robert Cozens' *Coast at Fano* (1783; Private Collection; sketch, 1782, Whitworth Art Gallery). Girtin had gained an intimate familiarity with Cozens' art during his three winter's work at Dr Monro's 'academy', 1794–7. The Dorset view appears to be a finished work, though it rivals a sketch in its freedom of execution. The Tom Girtin Collection (London) contains a particularly expressive on-the-spot watercolor sketch of a northern coast, *Tynemouth* (*c.* 1800), which again is a forcefully simplified, open-ended composition, consisting of a laterally expansive estuary at low tide beyond which is a floating bar-like cliff stretching horizontally across the sheet, with a powerfully stormy sky overhead.

John Crome delighted in the Dutch-like coast at Yarmouth, Norfolk: a flat, sandy beach strewn with fishing boats and gear, dominated by a large wooden pier projecting far into the sea, as seen in his large *Yarmouth Jetty* (*c.* 1807–9; Pls. 40 and 104, Cat. II.6), a scene he drew and painted several times from nearly the same viewpoint. A smaller version is also at Yale. All these are generally dated *c.* 1807–8, and comprise his earliest coastal scenes. They are closely contemporary with the earliest beach scenes of his young Norwich rival, Cotman (recently returned from London), who exhibited three views of the coast at Cromer and one of Yarmouth at the Norwich Art Society in 1808. Whether one artist has priority here is uncertain; likelier than not there was mutual stimulus. It is true, however, that one of Crome's two known paintings of the jetty viewed from the north, the superb painting in the Norwich Castle Museum (*c.* 1808–9 or possibly later), plays up more than usually a variety of flat, geometric shapes, particularly the silhouetted rectangular sails, which recalls Cotman's love of pattern.

Crome's modestly scaled, beautifully painted *Fishing Barge near a Shore* (*c.* 1808–9?; Mellon Collection) is a variation on the old Dutch theme, 'boats becalmed off a shore', except that the main motif is not a sailing vessel but a

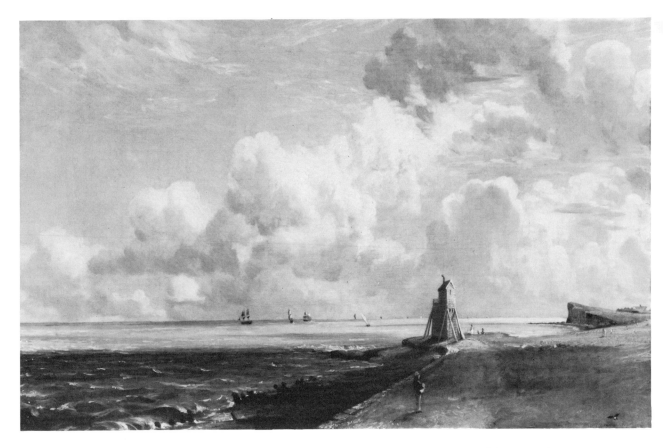

18. (II.19) Constable,
Harwich Lighthouse

mundane barge. On the skimpy, irregular shoreline, a fisherman bent over two large baskets adds to the workaday mood of this simple and utterly natural-looking scene. Toward the end of his life, Crome exhibited a more panoramically conceived coastal scene, *Yarmouth Beach and Mill: Looking North* (1819; Private Collection) which rivals Constable's contemporary *Lighthouse at Harwich* (c. 1819–20; TG; a version attributed to Constable at Yale, Pl. 18, Cat. II.19), in its high-keyed luminosity and sense of airiness.

One of the wilder coasts of western Scotland inspired William Daniell's watercolor, *Loch Scavig, Isle of Skye* (c. 1815; Pl. 19, Cat. II.15), made in connection with his ambitious eight-volume *Voyage Round Great Britain* (1814–25), though no print of it was included in the publication. Daniell began his unprecedentedly extensive series of coasts about the same time Turner commenced his Southern Coast project, and ended up producing a staggering total of three hundred and eight watercolors which he engraved and published himself, making it the largest undertaking of the kind at that time. Certainly its comprehensiveness is unrivalled and the variety of views is truly astonishing. Moreover, the selection of scenes is refreshingly unhackneyed and includes many visually arresting coastal areas never previously represented. In the example at Yale, Daniell captures well the awesome ruggedness of the spot, which Sir Walter Scott described as 'a scene so rude, so wild . . ., yet so sublime in barrenness'.

26

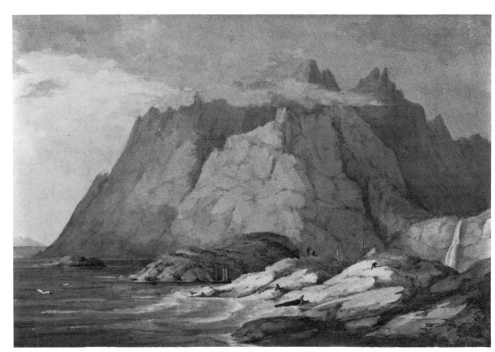

19. (II.15) Daniell, *Loch Scavig, Isle of Skye*

20. (II.12) Turner, *Margate*

21. (II.9) Turner, *Harlech Castle, from Tygwyn Ferry*

22. (II.8) Varley, *Harlech Castle and Tygwyn Ferry*

23. (I.15) Turner, *Château de St Michael, Savoy*

Contemporary with Daniell's published series of coastal scenes was the smaller but even more celebrated series of engraved views published by W. B. Cooke, *Picturesque Views on the Southern Coast of England* (1814–26). This handsome publication comprised forty plates after Turner watercolors with forty vignettes after works by De Wint, Owen, Clennell, Prout, Collins and a few others. Turner began working on the commission in 1811. Five of the original watercolors are at Yale, including one of the earliest, *Weymouth, Dorset* (c. 1811; Pl. 59, Cat. II.11) as well as the similarly composed but more brightly luminous *Margate* (Pl. 20, Cat. II.12) of a decade later. Turner's southern coast watercolors, not unexpectedly, are more expressive than Daniell's, thanks in part to the dynamic skies and weather effects he frequently introduces. He was no less acutely aware of the crucial importance of the sky in landscapes (and marines) than was Constable.

Turner, especially in his earlier years, also showed a special interest in coasts which included a dramatic castle ruin, whether near-by or distant. *Harlech Castle, from Tygwyn Ferry, Summer's Evening Twilight* (Pl. 21, Cat. II.9), ex-

29

hibited at the Royal Academy in 1799, is a handsome example, and contrasts interestingly with De Loutherbourg's predictably *sturm und drang* approach to the same castle in his 1801 version (cited above). It also provides an interesting comparison with John Varley's watercolor view of the castle made in 1804 (Pl. 22, Cat. II.8), taken from nearly the same viewpoint, though at low tide. The latter is much less evocative, being essentially a straightforward topographical statement, albeit painted with a good deal of Girtinian breadth. Other important early examples of Turner seacoasts with castle ruins are *Dunstanborough Castle, N. E. Coast of Northumberland. Sunrise after a Squally Night* (1798; National Gallery of Victoria, Melbourne), *Pembroke Castle, South Wales: Thunder Storm Approaching* (1801; Private Collection) and *Conway Castle* (*c.* 1803; Grosvenor Estates). Then too there are countless coastal sketches and 'pencil roughs' contained in the uniquely massive quantity of intact sketchbooks which have happily survived (now in the BM). The endlessly varied coast of England, Wales and Scotland remained a life-long fascination for the artist, not surprising in view of his profound love of the sea from early life onward as well as his dual professional interest in landscape and marine themes. The way many of us today envision the British coast owes something to Turner.

In the mid 1820s, Turner's continuing interest in coastal scenes found another outlet in a special series, *The Ports of England*, consisting of twelve watercolors made for engraving – six published by Thomas Lupton in 1826–8 and the remainder issued in 1856 (under the title, *Harbours of England*, with a text by Ruskin). They include some of the artist's finest seacoasts of the time, such as *Scarborough* (*c.* 1825; BM) and *Dover* (*c.* 1825; BM). Both of these exhibit Turner's growing tendency – especially in his watercolors – to render a middle-distant cliff or hill as a filmy, almost apparitional shape, as though its mass were partially 'transubstantiated' by light. Scarborough's Castle Hill, for instance, seems to hover in suspension; certainly it is anything but a heavy, dense, gravity-bound mass. The beginnings of Turner's 'late style' are already under way here.

During the later 1820s and the early 1830s, Turner was much occupied with producing the largest series of watercolors he ever undertook, made for Charles Heath's *Picturesque Views in England and Wales* (1827–38), a comprehensive pictorial survey of British scenery, comprising ninety-six engravings after the artist's works. Views of Britain's endlessly varied coasts form a prominent part of his ambitious series – about one seventh of the total. They include such spirited works as *Holy Island, Northumberland* (*c.* 1825–8; V&A) and *Folkestone Harbour and Coast to Dover* (1829; Pl. 25, Cat. II.13), with its prominent, well-observed figure group dominating the foreground, as often the case throughout the series. In the Yale watercolor, the activity pertains to the smuggling 'trade', which was again rampant in the 1820s, following the mass discharge of seamen after Waterloo and consequent unemployment. We see 'fishermen' digging up casks of smuggled spirits under orders from Revenue

Officers, a timely subject which Turner included in a number of coastal scenes. The artist was no less knowing about the ways of smugglers than he was about most other aspects of maritime England.

Turning to the medium of oil, one finds surprisingly few shore scenes by Turner from the 1820s, but one of the strongest is *Port Ruysdael* (Pl. 26, Cat. II.14), exhibited at the Royal Academy in 1827. Turner pays tribute to his favorite Dutch landscape painter not only in the imaginary title but above all in the compositional layout of the work, which strongly recalls Jacob van Ruisdael's *A Rough Sea* (*c.* mid 1650s; Private Collection). On the other hand, the ominous sky – full of immense, threatening clouds – is pure Turner. Less subtly illusionistic than some of his earlier skies, such as that in *The Dort* (1818; YCBA), it presages the more overtly 'phantasmagorical' skies in certain of his later works, such as *The Parting of Hero and Leander* (1837; NG).

The painting of coastal scenes in England appears to have peaked in the decade of the 1820s. Even so staunch a landlubber as Constable became for a while an avid sketcher of the coast at Brighton in the mid 1820s. While his summer visits to Brighton were prompted by the health needs of his consumptive wife, the resulting on-the-spot oil sketches include some of the freshest and most vigorous ones he ever produced, such as *Brighton Beach with Colliers*

25. (II.13) Turner, *Folkestone Harbour and Coast to Dover*

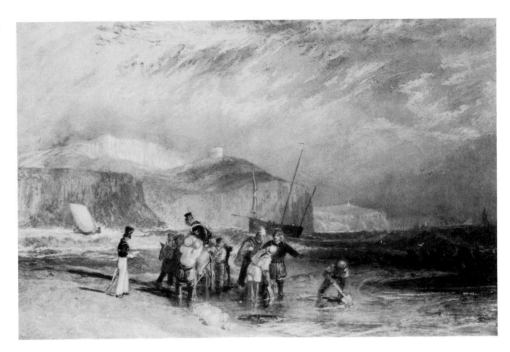

26. (II.14) Turner, *Port Ruysdael*

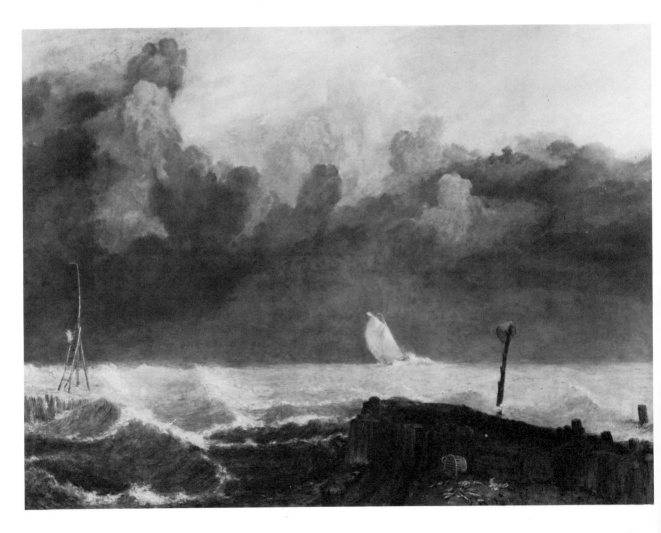

(1824; V&A) or the more panoramic *Brighton Beach* (V&A) of the same year. The latter consists merely of three radically simplified, superposed, horizontal zones – beach, sea and sky – and anticipates some of Whistler's coastal scenes. His *Seascape with Rain Clouds near Brighton* (c. 1824–6; RA Diploma Gallery), so striking in its almost stroboscopic illusion of falling rain, foreshadows Courbet's *Seascape* (1866; Johnson Collection, Philadelphia) to a remarkable degree, though the resemblance may be coincidental.[11] The Yale Center owns the appealing sunset coastal scene, *Hove Beach* (1824; Pl. 27, Cat. II.20). This type of subject, however, never became a major, lasting concern of the artist, and he exhibited only one six-foot seacoast in his lifetime, *Chain Pier, Brighton* (1827; TG), shown at the Royal Academy in 1827. But that impressive work, with its magnificent skyscape – one of the most powerful he ever painted – can hold its own with any contemporary or earlier European coastal scene. A fascinating comparison can be made with Turner's off-shore version of the same subject, *Brighton from the Sea* (c. 1829; Petworth), which we might regard in part as another of Turner's pictorial answers to the work of a rival.[12]

A younger British painter who was particularly drawn to coastal scenery during the 1820s was the precocious Richard Parkes Bonington. His delightful paintings and watercolors of northern French coasts and harbors are sufficiently numerous as to constitute a virtual speciality within his oeuvre. Some of the finest examples are in the Wallace Collection, London, such as *On the Coast of Picardy* (1826), admirable in its subtle balancing of tones and deftness of touch –

27. (II.20) Constable, *Hove Beach*

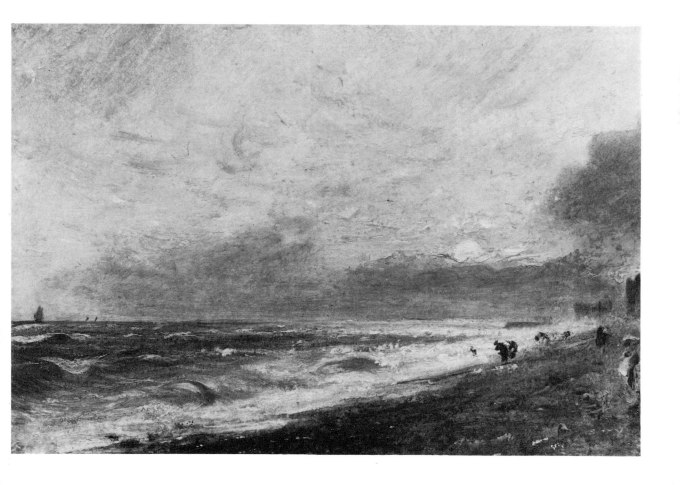

the kind of work well deserving of Delacroix's highly enthusiastic praise of Bonington (quoted below). One of his most original beach scenes is the early upright composition, *Coast of Normandy* (*c.* 1823; Louvre), its radical simplicity and extensive palette-knife work in the sky (which occupies four-fifths of the picture) giving the work a distinctly 'modern' look. Among his few sizable coastal scenes is the one at Yale, *A Fish Market, Boulogne* (*c.* 1824), especially pleasing in its glowing luminosity and subtly arranged planes. The choice of subject and even the handling of the ambitious figure group in the foreground strongly recall Crome's slightly earlier *Fishmarket, Boulogne* (1820; Private Collection), though Bonington, working in Paris, would presumably not have known that work.

Among Bonington's numerous watercolors of coasts, the superb *Sailing Vessels in an Estuary* (*c.* 1828; YCBA), beautifully exemplifies his famed virtuoso facility of execution. Such works fully merit Delacroix's perceptive remark that 'Nobody in the modern school, and probably nobody before him, possessed the lightness of execution, which particularly in watercolor makes his work, as it were, diamond-like; charming and seducing the eye, independently of the actual subject.'[13]

Bonington could be very Turnerian at times, as in his late and unusually evocative *Sunset in the Pays de Caux* (1828; Wallace Collection), with its wonderfully spreading light effect. He painted this moving work not long before he succumbed to consumption shortly before his twenty-sixth birthday. Several British watercolorists picked up on certain aspects of his works, notably Thomas Shotter Boys, William Callow and James Holland, albeit often in a slightly prosaic way.

Coastal scenes remained a lively interest with many British artists of the early Victorian era, as witness many noteworthy examples by Cox and Copley Fielding (in their later years), Stanfield and E. W. Cooke, and the above cited followers of Bonington – not to mention many remarkable seacoasts by Turner in his later years. But the 'heroic' phase of pioneering innovation came largely between the 1780s and the 1810s, which was also the case with mountain landscapes and ruin scenes, our next topic.

III. Ruin Landscapes

> Great Thoughts stir within me at the sight of ruins. Everything gradually crumbles and vanishes. Only the world remains. Only time endures . . . I am walking between two eternities.
>
> <div align="right">Diderot (1767)</div>

BOTH ACTUAL ruins and paintings of ruins have long aroused in viewers' minds thoughts and feelings about their own advancing mortality and the inevitable transience of everything they make, or indeed of 'all earthly things'. We sense 'a secret conformity between destroyed monuments and the brevity of our existence', wrote Chateaubriand in 1802.[1] Ruins underscore 'the spoiling hand of time', and as Sir Walter Scott noted in Kenilworth (1821), 'impress on the musing visitor the transitory value of human possessions'. At no time did Europeans respond more to 'time-battered towers' and 'mould'ring, mossy walls' than during the early Romantic era, and in no place more than in England, with its great abundance of medieval ruins. In almost every county of Britain one readily encounters 'time-shook piles', whether decaying castles or, even more frequently, crumbling abbeys – the latter the legacy of Henry VIII's drastic dissolution of all the monasteries in his realm in 1535–40. By the second half of the sixteenth century, Britain suddenly possessed nearly six hundred ecclesiastical ruins, which of course became more and more 'time-worn' in the following centuries and also increasingly appropriated by nature's ever-encroaching foliage, much to the delight of 'the picturesque eye' in the late eighteenth century. In our more prosaic era, the Ministry of Public Building and Works has stripped bare most of these ruins, robbing them of their picturesque effect. The Romantics expected and usually found their 'tott'ring battlements' to be 'dressed with the rampant ivy's unchecked growth'.[2] Or as Robert Southey phrased it in *The Ruined Cottage* (1799):

> So Nature steals on all the works of man,
> Sure conqueror she, reclaiming to herself
> His perishable piles.[3]

Besides finding that condition more picturesque, many Romantics also felt that creeping vegetation on a ruin brought the stones to life.

Ruins also stimulate our imagination, irresistibly tempting us to recreate in our mind's eye the original state of the building along with the kinds of activity which once may have filled it. Thomas Whately emphasized this aspect of 'ruin

sentiment' in his highly influential *Observations on Modern Gardening* (1770; five editions by 1793):

> All remains excite an enquiry into the former state of the edifice, and fix the mind in a contemplation on the use it was applied to . . . they suggest ideas which would not arise from the buildings, if entire. The purposes of many have ceased . . . the memory of the times, and of the manners, to which they were adapted, is preserved only in history, and in ruins; and certain sensations of regret, of veneration, or compassion, attend the recollection . . . Whatever building we see in decay, we naturally contrast its present to its former state, and delight to ruminate on the comparison.[4]

Many British writers and especially artists of the late Georgian era felt particularly attracted to ruins that were in a fairly advanced state of decay and which appeared at least partially returned to nature, or in other words, ruins that were part art, part nature. In such a state ruins were all the more stirring to our imagination and feelings. Again it is Thomas Whately who best articulated this idea when he wrote, 'No circumstance so forcibly marks the desolation of a spot once inhabited, as the prevalence of nature over it.'[5] Many abbey ruins and battered castles throughout Britain were admirably fitted to this preference, and examples in art are legion. The German scholar, Georg Simmel, in a penetrating essay on ruins (1922), singled out the telling quality of this kind of ruin:

> The charm of the ruin resides in the fact that it presents a work of man while giving the impression of being a work of nature . . . The upward thrust, the erection of the building, was the result of the human will, while its present appearance results from the mechanical force of nature, whose power of decay draws things downwards. However, in so far as one can speak of ruins, and not just of piles of stones, nature does not allow the work to fall into the amorphous state of its raw material. A new form is created . . . Nature has used man's work of art as the material for its own creation, just as art had previously taken nature as its raw material.[6]

The nature-incrusted ruin was also admired for the way it harmonized intimately with its setting. Again, Georg Simmel phrases it best:

> A ruin is easily assimilated into the surrounding countryside . . . it takes root like any tree, whereas a palace, or country house, or even a peasant's cottage, no matter how well they may be adapted to the character of the countryside, always suggest another order of reality.[7]

On the other hand, a completely bare ruin – stripped of all its vines, mosses, lichens and so forth – is in effect not very unlike a recently destroyed building, rather than 'a ruin' as the Romantics understood the term. Overgrown remains present a much more compelling appearance of venerable age and the effects of unstoppable time. Regarding the significant difference between old, 'seasoned'

ruins and recently destroyed buildings, the contemporary art historian, Jean Starobinski, offers several valuable comments worth keeping in mind:

> The poetry of ruins is always a reverie before the encroachment of oblivion. It has been pointed out that for a ruin to appear beautiful, the act of destruction must be remote enough for its precise circumstances to have been forgotten: it can then be imputed to an anonymous power, a featureless transcendent force – History, Destiny. We do not muse calmly before recent ruins, which smell of bloodshed: we clear them away as quickly as possible and rebuild . . . The poetry of ruins is the poetry of what has partially survived destruction, though remaining lost in oblivion . . . Its melancholy resides in the fact that it has become a monument of lost significance.[8]

A particular kind of ruin which especially attracted later eighteenth-century poets and some Romantic artists (as we shall see later) is the battered tower, above all when it looms impressively over a desolate scene as a lonely, poignant survivor of a once-formidable fortress. Typical of numerous eighteenth-century characterizations of such a ruin are the following lines from John Dyer's *A Country Walk* (*c.* 1727):

> See yonder hill, uprising steep,
> Above the river slow and deep.
>
>
>
> On whose high top there rises great,
> The mighty remnant of a seat.
> An old green tower, whose batter'd brow
> Frowns upon the vale below.[9]

Dyer also worked the tower-ruin image into his more celebrated poem, *Gronger Hill* (1726), this time intensifying the 'sublime' aspect:

> And ancient towers crown his brow,
> That cast an awful look below;
> Whose ragged walls the ivy creeps,
> And with her arms from falling keeps;[10]

Many writers of ruin poems exploited the image of 'towers that wear the mossy vest of time'.[11] Such 'sad relics of departed pomp' were much more evocative than intact towers. A typical use of this image occurs in Samuel Rogers' 'Pleasures of Memory' (1792):

> Mark yon old Mansion frowning thro' the trees,
> Whose hollow turret wooes the whistling breeze.
>
>
>
> As the stern grandeur of a Gothic tower
> Awes us less deeply in its morning-hour,
> Than when the shades of Time serenely fall
> On every broken arch and ivied wall;[12]

The time-struck turret or ruinous Gothic tower was indeed a frequently recurring image in eighteenth and early nineteenth-century ruin poems, valued in good part because it stirred a train of potent associations. In his sonnet, 'Bamborough Castle' (1789) – dealing with an imposing coastal ruin which also attracted the eyes of Girtin and Turner – William Lisle Bowles opens with the following lines:

> Ye holy towers that shade the wave-worn steep
> Long may ye rear your aged brows sublime,
> Though hurrying silent by, relentless time
> Assail you and the wintry whirlwind sweep.[13]

In several other sonnets, such as 'Netley Abbey' (1789), Bowles observes that ruins inspire meditation 'on this world's passing pageant' and 'the lot of those who once full proudly in their prime' lived out their brief lives in 'this short-lived scene of vanity and woe'.[14] As noted earlier, some of the principal associations aroused by decaying castles and abbeys concerned the stirring contrast between their present state of desolation and a former one of magnificence and flourishing activity.

Classical ruins, to be sure, also fascinated the British at this time,[15] though they inspired rather fewer poems and far fewer paintings and watercolors than did the vast array of medieval ruins ready-at-hand. These introductory comments concentrate on the latter not only because Yale's holdings from the late Georgian period are markedly richer in paintings and watercolors of English medieval ruins than of classical remains, but equally because that predominance reflects the actual situation in artistic production of the time.[16] Regarding associations, one can say that on the broadest level both classical and medieval ruins arouse such associated ideas as transience, mutability and mortality – often mixed with a sense of awe. However, when we turn to more specific associations, interesting differences emerge between the ruins of antiquity and the Middle Ages (and pictures of them). For example, decayed abbeys evoked various Christian associations much more than national ones. Visitors to Tintern Abbey did not usually think about the rise and fall of empires, whereas tourists gazing at the Roman Forum or the Colosseum, or at the ruins of Baalbek or Palmyra, very much had that in mind. Typical is the Comte de Volney's exclamation about the ruins of Palmyra, voiced in his widely read *Ruins or Meditations on the Revolutions of Empires* (1791):

A mournful skeleton is all that subsists of this opulent city, and nothing remains of its powerful government but a vain and obscure remembrance! . . . The palaces of kings are become the lair of wild beasts, and obscene reptiles inhabit the sanctuary of the gods. What glory is here eclipsed, and how many labours are annihilated! Thus perish the works of men, and thus do nations and empires vanish away![17]

Like many of his contemporaries, Volney liked to moralize about the ruins of

once-proud empires, saying that they can teach us to 'scorn to amass vain grandeur and useless riches' and thus 'curb the wild sallies of cupidity . . . which has produced all the evils that have desolated the globe'.[18] He also adds the disconcerting question: 'Who . . . can assure me that their present desolation will not one day be the lot of our country?'[19] The British poets, James Thomson and Lord Byron, also mused and moralized similarly before the ruins of Rome, in *Liberty* (1748) and *Childe Harold* (1812–18) respectively, and likewise raised the uneasy question of a possible parallel between the fate of ancient empires and that of the current British Empire.[20] Such anxieties about the fate of all empires were rarely generated by medieval ruins; rather, they pertain mainly to various ancient city-ruins, each associated with a particular empire, and each offering 'a lesson' for the present.

Ruined castles and abbeys became a staple subject with a good many Georgian artists, whether their approach be topographical, picturesque, or a combination of the two. Straightforward topographical views predominated during the earlier half of the eighteenth century, as well exemplified by the prodigious series of ruin depictions which Samuel and Nathaniel Buck made and engraved largely between 1720 and 1753, subsequently reissued in a three-volume work, *Buck's Antiquities* (1774). This factual, reportorial mode persisted well into the latter half of the century, kept alive by such topographical draughtsmen as Heironymous Grimm, Moses Griffith, Francis Grose and – on a higher level – Thomas Hearne. A distinctly picturesque approach – stressing variety and contrast of color, light and shade, sudden variation of shape, rough textures and above all, rich and shadowy foregrounds flanked with assorted trees or rambling, irregular shrubbery infusing a certain cosy or quaint look and feeling – came to predominate in the later eighteenth century, especially in the later work of Paul Sandby and much of the production of Michael Angelo Rooker, Edward Dayes, Julius Caesar Ibbetson and many others as well as the earliest ruin scenes of Girtin and Turner. The Picturesque had become a bandwagon vogue by the early 1790s, though various reactions to it soon began to appear, refreshingly evident in a number of works which Turner and Girtin produced toward the end of the decade and beyond.

The ruin scenes reproduced in this catalogue provide a representative cross section of the resourcefully varied approaches to the subject made by late Georgian artists in Britain. In composition, they range from close-up views of portions of ruins (exterior or interior) to distant prospects, with numerous examples of the 'grand motif' of the entire ruin set in the middle distance. There is also much variety of effect, depending on whether the artist pursues a more or less straight topographical approach or one that invests the scene with either a picturesque or sublime cast, or combination thereof. Joseph Farington's close-up, interior view of Caernarvon Castle (*c.* 1780? Pl. 72, Cat. III.2), one of the most impressive castle remains in Britain, strikes one as being a forthright, faithful representation, though presented from a viewpoint that plays up the 'picturesque irregularity' of the battered, overgrown battlements flanking the

28. (III.3) De Cort,
Chepstow Castle

still largely intact Eagle Tower, thus setting up an arresting contrast. Henry de Cort's *Chepstow Castle* (c. 1790s; Pl. 28, Cat. III.3) offers an exterior view of the entire fortress, though viewed from the narrow western end of the castle, in contrast to the more popular view of the long northern side, usually taken from the river embankment opposite the ruin as in John Inigo Richard's notable version (c. 1775?) at Cardiff. The large, aging foreground tree is most probably a studio addition, the inclusion of which was standard practice with many landscape painters, and here it does add to the picturesque effect of the scene. In contrast, Girtin's *Guisborough Abbey* (c. 1802; Pl. 29, Cat. III.19), his only known surviving oil painting, offers a sweeping panoramic distant prospect of a solitary ruined tower. The masses are so severely simplified and boldly brushed on that the forceful, bald effect might justly be termed anti-picturesque.

Joseph Wright's highly dramatic *Cottage on Fire at Night* (c. 1790; YCBA), which includes the shadowy corner of a formidable castle ruin on the left

40

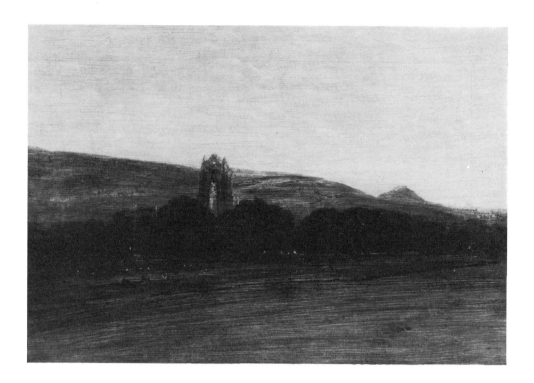

(under a full moon), would probably have struck many viewers of the time as smacking somewhat of the sublime, especially the element of terror present in the situation. Indeed, it amply exhibits several attributes which Edmund Burke singled out as producing a sublime effect, such as sudden and abrupt light and dark contrasts, danger and obscurity. Wright's admirers must have liked this composition, as the artist painted six versions of it, four of them extant today. A different sense of the sublime, one not in the least theatrical, comes to mind when we look at Girtin's imposing *Warkworth Castle* (1798; Pls. 30 and 31, Cat. III.17 and 18). The artist boldly confronts us with a vast, sprawling, partly ruinous fortress which looms majestically above a dark and radically simplified embankment (steeply sloping), generating an impression of awesome grandeur and lingering power. Such an approach sharply contrasts with the mainstream picturesque handling of castle ruins which continued to dominate British art throughout Girtin's brief lifetime.

A type of ruin which particularly attracted some of the foremost landscape painters around the turn of the century, including Turner, Girtin, Cotman and Varley, is the solitary ruined tower or decayed castle keep, powerfully silhouetted against a luminous sky and viewed from a low, rather distant vantage point. We have already stressed how this stirring image equally fascinated various late Augustan and early Romantic poets. In art, notable examples by Turner, in his earlier years, include *Dolbadern Castle* (1800; RA) and the large watercolors, *Warkworth Castle* (1799; V&A) and *Pembroke Castle* (1801; Private Collection). Impressive examples in the Mellon Collection are Cotman's dramatic *Aberystwyth Castle* (1801; Pl. 32, Cat. III.22), John Varley's evocative *Dolbadern Castle* (1802; Pl. 33, Cat. III.21) and Girtin's only extant oil painting,

41

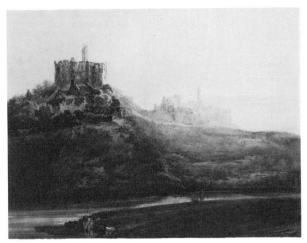

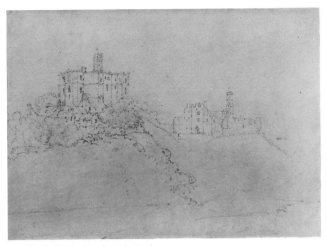

30. (III.17) Girtin, *Warkworth Castle*

31. (III.18) Girtin, *Warkworth Castle*

Guisborough Abbey (*c.* 1801; Pl. 29, Cat. III.19). As Adele Holcomb has noted, these artists invested the tower ruin with a kind of heroic presence, in some of their strongest early works.[21] Persisting through centuries, these still imposing bastions were seen, felt and represented as commanding the scene around them, however battered and moss-covered. Pioneering this type of ruin scene was Girtin, whose awesome compositions, *Holy Island Castle* (*c.* 1796–7; Metropolitan Museum) and the previously mentioned *Warkworth Castle* (*c.* 1797–8; Pls. 30 and 31, Cat. III.17 and 18), just slightly pre-date Turner's earliest examples. Girtin, however, never invested his castle ruins with so dark and brooding a mood as that of Turner's *Dolbadern Castle* (1800). Only Constable's later remarkable tower ruin scene, *Hadleigh Castle* (1829; Pls. 1 and 132, Cat. III.30), his most sublimely conceived picture, rivals Turner's work in intensity of mood, and indeed surpasses it in overall impact and pictorial richness.

The tower ruin landscape has a few partial forerunners in earlier British art, but only a few, and it is difficult to say whether they were directly influential. Wilson's *Dolbadern Castle and Llyn Peris* (1760s; National Gallery of Victoria, Melbourne), for instance, focuses on a lonely tower ruin (albeit quite distant) silhouetted against the sky; however, the elaborate, conventionally Claudean/ picturesque foreground dominates the composition, giving the whole picture a quite different effect from that of the above ruin scenes. The same applies to his monumental *Okehampton Castle, Devonshire* (1774; Birmingham City Art Gallery). Somewhat closer to the visual impact and mood of the tower-ruin landscapes of Girtin and Turner is Wilson's *Landscape with Castle Ruin overlooking a River* (*c.* 1770; Manchester City Art Gallery), one of the artist's most powerful and original ruin paintings. Here a crumbling but still imposing fortress resting atop a bluff looms formidably above a winding river foreground, its presence all the more vivid and stirring thanks to a glowing sky which sets off its rugged, 'time-shook' tower and walls. The effect of this emphatically silhouetted ruin, and the way it spreads the light, is not unlike that embodied in several of Turner's versions of Norham Castle. There is so far no

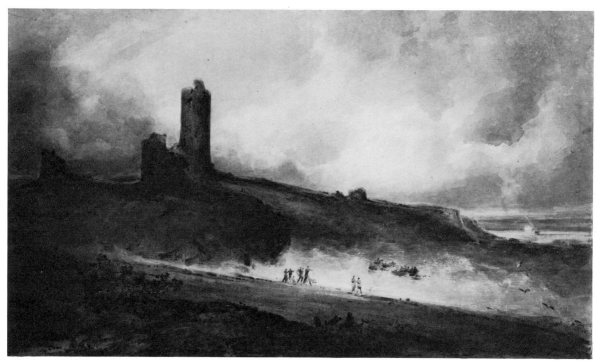

32. (III.22) Cotman, *Aberystwyth Castle*

33. (III.21) Varley, *Llanberris Lake, with Dolbadern Castle*

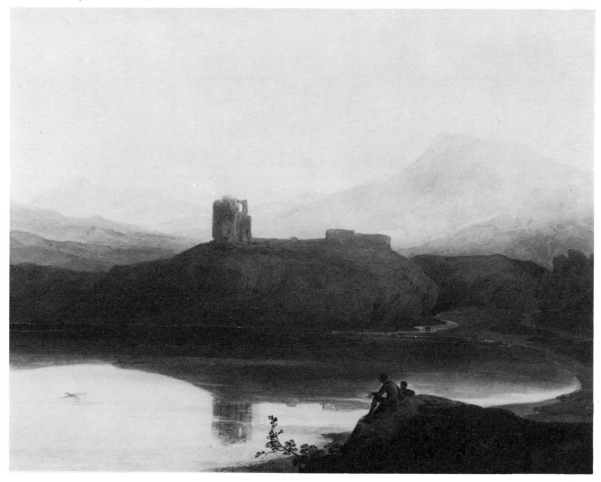

evidence, though, that Turner or Girtin knew the picture; on the other hand, Turner was especially interested in Wilson in the late 1790s. A further possible stimulus was John Robert Cozens, much of whose work was accessible to both Turner and Girtin in the mid 1790s at Dr Monro's 'Academy'. Relevant here is Cozens' hauntingly evocative rendering of a solitary, upright fragment of a once grand Roman building poignantly cast against a softly luminous sky, *Sepulchral Remains in the Roman Campagna* (*c.* 1783; Indiana University Art Museum), painted for William Beckford, one of Turner's early patrons.

Girtin played a further pioneering role in introducing a second type of ruin scene which caught on in the early years of the nineteenth century: the close-up fragment of an abbey facade rising nearly the whole height of the composition and viewed from a low vantage point, thus heightening its apparent scale. Major examples are *Guisborough Priory* (1801; NGS) and *Fountains Abbey* (1798; Graves Art Gallery). This choice of ruin motif and compositional format appealed especially to the young John Sell Cotman, as seen in such works as *Croyland Abbey* (1804; NCM) or several versions of Byland Abbey made between 1804 and 1811 (a fine copy of one at Yale), as well as half a dozen versions of Castle Acre Priory made between 1804 and 1815 (one at Yale, Pl. 34, Cat. III.24). Cotman's exquisite pencil drawing of the richly decorated and precariously fragile late Gothic facade-fragment of Howden church in Yorkshire, made in 1803 (Pl. 35, Cat. III.23), closely recalls Girtin's *Guisborough Priory* of two years earlier, especially in the way it presents the lofty free-standing ruin from almost exactly the same oblique viewpoint and same low

34. (III.24) Cotman, *Castle Acre Priory*

35. (III.23) Cotman, *Howden Church, Yorkshire*

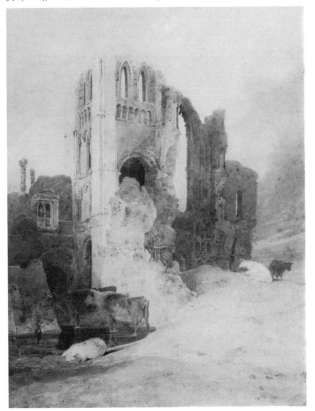

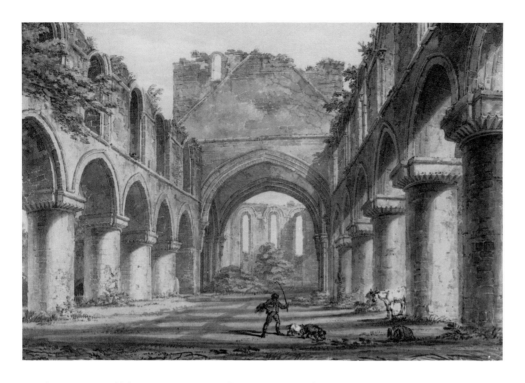

36. (III.8) Dayes, *Buildwas Abbey, Shropshire*

angle. As is well known, young Cotman greatly admired Girtin's work.

British artists were also keen about interior views of ruinous abbeys and castles, and again proved resourcefully varied in their approaches. Sometimes they place the viewer in or near the center of an abbey nave, looking towards the east end, which results in a highly balanced composition of receding arcades, as seen in a number of similar views of Buildwas Abbey in Shropshire by such artists as Sandby, Rooker, Dayes and Farington. Dayes' view at Yale (*c.* mid 1780s?; Pl. 36, Cat. III.8) typically shows the roofless, pasture-like ground level, lined with massive columnar piers and arches supporting a fragmentary clerestory tufted with foliage, as the abode of cattle and pigs. The young Turner also employed this architectural-vista format – though one involving an off-center viewpoint and including portions of overhead ruins – in two early views of the interior of Tintern Abbey: *Inside of Tintern Abbey* (1794; V&A) and *Transept of Tintern Abbey* (1795; BM and Oxford). This effective close-up format was actually used slightly earlier by Edward Dayes in his *Interior of Tintern Abbey looking West* (*c.* 1790; eng. 1792?). The younger artist, however, especially in the latter composition, is already beginning to convert Dayes' topographical-picturesque mode into visual poetry through his seemingly magical handling of light. Girtin produced a view closely based on Dayes' composition around 1793–4 (Colnaghi's in early 1970s). Shortly after the turn of the century Cotman made a similar view of this renowned abbey (*c.* 1800–2; Bacon Collection), though taken from the southeast rather than northwest corner of the choir (facing west), making it in effect a mirror reversal

of the Dayes and Girtin views. From that angle much less creeping foliage is visible. A prototype for this interior ruin format which was probably known to these artists is Piranesi's famous print, *Hadrian's Villa, Tivoli: Central Room of the Larger Thermae* (1770; Hind 93) from his *Vedute di Roma* series. It also exhibits a rich interplay of dramatic light and shade contrasts which would have caught the eye of Turner especially.

One also frequently encounters such asymmetrically composed interiors of ruined abbeys and castles, as John Webber's *Goodrich Castle on the Wye* (1788; Pl. 37, Cat. III.6) or Girtin's *St Cuthbert's Cathedral, Holy Island* (1797; Pl. 38, Cat. III.16). In both we view a portion of a complex ruin at very close quarters, literally immersed in the engulfing 'spoils of time'. The angular view makes it intriguingly difficult to orient ourselves in the ruin. This makes the towering but crumbling remains look and feel utterly incommensurable, as they extend in all directions – right and left, above and behind – actively tempting our imagination to complete them. Turner's precociously early *Malmsbury Abbey* (1792; NCM), showing a ruin that is truly 'age-worn to shapes fantastic',[22] has a similar effect. This is equally true of John Crome's *Interior of Tintern Abbey* (c. 1805; NCM), his only surviving finished watercolor of a ruin, as well as of Cotman's *Llanthony Abbey* (1804; TG), to mention only two further examples.

The painting of ruins abated somewhat in the 1820s, compared to the peak years, c. 1780s to 1810s. The decline of the aesthetic of the Picturesque, beginning in the 1810s, was probably a factor. Nevertheless, some of the finest ruin scenes of the late Georgian era appeared in the 1820s, such as a number of Turner's watercolors, including his magically luminous *Norham Castle on the Tweed* (c. 1823; BM) or the light and airy *Barnard Castle, Northumberland* (c. 1825; Pl. 39, Cat. III.28) at Yale, one of the earlier works made for his England and

37. (III.6) Webber, *Goodrich Castle on the Wye*

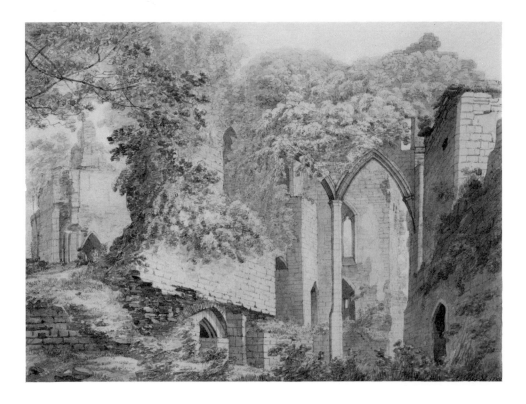

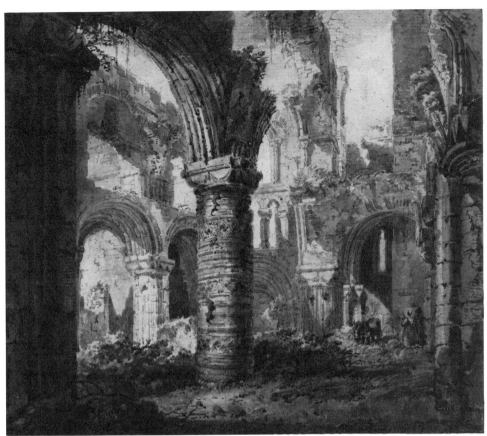

38. (III.16) Girtin,
*St Cuthbert's Cathedral,
Holy Island*

39. (III.28) Turner,
Barnard Castle

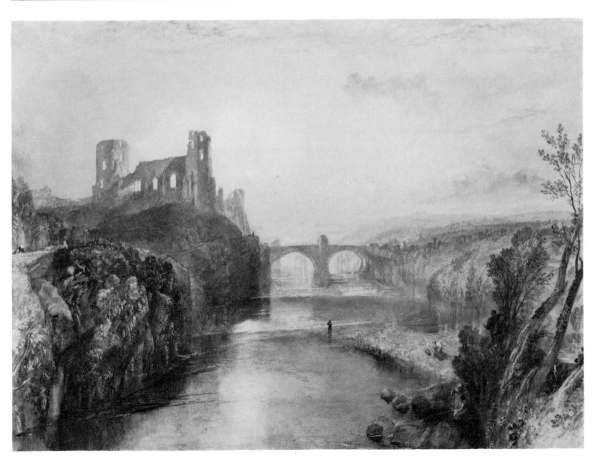

Wales series, which was particularly rich in ruin scenes. The Yale Center also owns one of the most powerful ruin landscapes in all British art, Constable's *Hadleigh Castle* (1829; Pls. 1 and 132, Cat. III.30), the artist's only large-scale oil painting of such a subject executed shortly after the death of his young wife in November 1828, and exhibited at the Royal Academy the following year. No other finished work by Constable is so intensely expressive, and indeed, as a ruin scene it has few peers in European art. In such circumstances, a ruin provided a fitting symbol of his shattered home life and melancholy sense of irreparable loss. The picture made a decisive impact on the young American landscape painter, Thomas Cole, who resided in London from 1829 to 1831. He saw the picture at the Royal Academy in 1829 and again the following year when he visited Constable's studio; his *Ruined Tower on a Mediterranean Coast* (1838; Albany Institute of History and Art) is compositionally a mirror-reversal of *Hadleigh Castle*. In the mid 1830s, Constable made a large and powerfully stirring watercolor of England's most celebrated prehistoric ruin, *Stonehenge* (1835; RA, 1836), a work that is arguably the most impressive representation ever made of that much-depicted ruin. While these two paintings are the only two ruin scenes he ever exhibited, they unquestionably rank among the most unforgettable ruin images in western art.

40. (II.6) (facing) Crome, *Yarmouth Jetty* (detail)

IV. Rural Landscapes

> The immediate aim . . . is to increase the interest for, and promote the study of, the Rural Scenery of England, with its endearing associations, its amenities . . . abounding as it does in grandeur and every description of Pastoral Beauty.
>
> Constable (1833)

> England is a garden. Under an ash-colored sky, the fields have been combed and rolled till they appear to have been finished with a pencil instead of a plough . . . Rivers, hills, valleys, the sea itself, feel the hand of a master. The long habitation of a powerful and ingenious race has turned every rood of land to its best use, has found all the capabilities . . . What they told me was the merit of Sir John Soane's Museum, in London – that it was well packed and well saved – is the merit of England – it is stuffed full, in all corners and crevices.
>
> Emerson (1856)

NEVER WERE England's abundant meadows, heaths and farmlands more beloved by her native landscape painters than during the time of Constable. 'The breezy freshness, the serenity, and cheerfulness' of such scenes, especially in the morning, wrote the artist in 1833, 'never fail to impart a kindred feeling to every living thing.'[1] Above all he loved the countryside on a spring or summer morning, when nature's bounty was 'still gemmed with morning dew' and everything looked 'silvery and sparkling', inviting one to 'wander o'er the dewy fields where freshness breathes'.[2] But Constable was only one of many English landscapists who delighted in painting the 'gentle declivities and luxuriant meadow flats' of their homeland. Rural England in the Romantic era – before the accelerated onslaught of industrialism and 'railway mania' of the 1830s and 40s – was still genuinely rural.

'The poetry of earth,' especially in the context of rural scenery, became a prime concern with British painters and poets at this time. Certainly some of the most characteristic landscapes of Crome, Constable, Turner (in earlier years), Girtin, Cotman, De Wint, Cox, Palmer and others dealt with this kind of scenery. The rural landscape, of course, is not an English invention. Seventeenth-century Dutch painting is rich in examples, a number of which had already entered British collections by 1800, providing invaluable inspiration for the Romantics. But the English produced a larger and much more varied harvest of rural landscapes, thanks in part to the fact that the British Isles

themselves offer a much greater variety of rural scenery than does Holland.

As with the other themes discussed in previous sections, the painting of rural nature, in Britain, did not become a major interest with numerous artists until the later eighteenth and early nineteenth centuries, though significant pioneering work was already done by Gainsborough in the late 1740s. In fact, his *Cornard Wood* (1748; NG), so precociously naturalistic in detail and at the same time so artfully composed, remains one of the foremost masterpieces of the genre. His *Wooded Landscape with seated Figure* (c. 1747; TG; formerly called 'Dedham Vale') is the type of early Gainsborough that Constable preferred to the less 'real' later landscapes. About the same time, Gainsborough also produced his wonderfully rhythmic, panoramic composition, *River Scene with Figures* (c. 1747; NGS), in which elements of French rococo art are fused with Dutch influences and direct observation. In his famous *Landscape with a Woodcutter courting a Milkmaid* (1755; Woburn Abbey), the artist combines his love of rustic scenery with a rococo taste for the pastoral and bucolic (with erotic overtones). Happily, Yale possesses two fine rustic landscapes by Gainsborough from the 1750s: *River Landscape and Weir* (c. 1752–3) and *Farm Buildings with Figures* (c. 1755). The painter executed all of these at a time when the reigning masters of landscape in England – Wootton, Lambert and Wilson – most often painted 'ideal' landscapes, frequently inspired by Claude and/or Gaspar Dughet, or occasionally by Rosa. There are, to be sure, a few significant exceptions, such as George Lambert's remarkable *Hilly Landscape with a Cornfield* (1733; TG) and his equally notable *Extensive Landscape with Gentlemen on a Hill* (1733; YCBA).

One of the few contemporaries of Gainsborough who possessed a strong feeling for the rural scenes was George Smith of Chichester, who painted a number of small pictures of Sussex country scenes at various seasons, often including rustic cottages and busy peasants. Dutch and Flemish influence is apparent, but the intense degree of picturesqueness is Smith's own. His special mode of rural landscape reached a fairly wide audience through William Woollett's prints after a number of his works.

Despite his strongly classical bent, Richard Wilson in his maturity occasionally produced views of Welsh countryside which reflect a profound sympathy for rural nature unadorned. His large *Valley of the Dee* (c. 1762; NG), with its lovingly rendered foliage and weeds along with a pastoral figure group which seems perfectly natural to the scene, is a prime example, even though the ground plane has undergone some geometric simplification. Certainly it has more the 'look and feel' of a Welsh river valley than its pendant, *Holt Bridge on the River Dee* (c. 1762; NG), which Wilson has altered to the point that it looks more like a variation on his popular composition (in reverse), *Tivoli: Temple of the Sibyl and the Campagna* (1760s; several versions). This is not unlike the contrast between Wilson's large *Dinas Bran, near Llangollen* (1770–1) at Yale and his smaller, strongly Claudean version now at Cardiff, the composition of which clearly adapts that of Claude's *Landscape: Narcissus* (1644; NG). Other

41. (II.3) West, *The Bathing Place at Ramsgate*

examples of British rural scenes which Wilson has not tried to assimilate to the Roman Campagna include his *Near Moor Park* (1765–7; Collection of the Marquis of Zetland), *Richmond Park: Penn Ponds* (*c.* 1760s?; National Museum of Wales, Cardiff), *Hounslow Heath* (*c.* 1770; TG), which Constable and Crome would surely have admired, and his less well-known *Pool with Figures on a Hillock* (*c.* 1775; Private Collection) which strikingly anticipates a Crome heath scene. This aspect of Wilson is very much underplayed in most of the literature on the artist.[3]

During the final quarter of the eighteenth century, a steadily growing number of landscape painters and watercolorists tried their hand at rural scenery, though none pursued it to the extent of De Wint or Constable. Among those who were primarily oil painters, the versatile De Loutherbourg in particular made numerous paintings of pastoral or bucolic scenes. Admittedly, these were over-shadowed by the artist's more flamboyantly dramatic pictures and stage sets. One of his earliest major efforts in the pastoral genre was his large Berchem-like *Romantic Landscape* (1767; Walker Art Gallery, Liverpool), a brilliantly

52

executed work exhibited at the Paris Salon that year and praised by Diderot – four years before he emigrated to London where he became chief scene painter at David Garrick's Drury Lane Theater. Also worth mentioning here is *Landscape with Travellers* (c. 1778–80; V&A), which is more simply rural in character, rather than 'pastoral' in the eighteenth century, arcadian sense. His contemporary *Landscape with a Rainbow* (1778) at Yale, which delightfully combines a proto Morland-like rustic scene on the left with a strikingly silhouetted corner of an elegant country inn (and its ornate sign) on the right. The picture is further enlivened by the boldly executed, dynamic sky, with its dazzling rainbow. For his time, De Loutherbourg showed an unusual degree of interest in weather effects, as further evidenced by the titles of some half dozen of his Academy exhibits. A good late example of the artist's rural mode is his *Evening, with a Stage Coach* (1805; Pl. 42, Cat. IV.7). The scene is set in Blackheath, immediately south of Greenwich Hill, an area at that time still thoroughly rural and abundantly picturesque, which De Loutherbourg has duly played up.

Joseph Wright of Derby is another major late eighteenth-century oil painter important in the present context. Although he is particularly known for his many spectacular portrayals of Vesuvius erupting – at least twenty-seven versions – he also painted a number of quiet rural scenes inspired by his native Derbyshire. His two undramatic daytime views of Dovedale, *View of Dovedale* (1786; Keddleston) and *Dovedale in Sunlight* (c. 1784–8; Private Collection) come to mind, each of them exhibiting a radically empirical approach. The same applies to his *View of the Boathouse near Matlock* (c. 1786; Pl. 43, Cat. IV.2),

42. (IV.7) De Loutherbourg, *Evening, with a Stage Coach*

43. (IV.2) Wright, *View of the Boathouse near Matlock*

except for the obvious studio addition of the tall, criss-crossing trees on the right. We should also cite his well-known *Landscape with a Rainbow – View near Chesterfield* (c. 1794–5; Derby Art Gallery; an anonymous watercolor copy at Yale), painted only two years before his death. No British artist before Wright gave quite such prominence, in a large finished picture, to the full arc of a rainbow – an evanescent phenomenon that was to attract various romantics of the next generation, especially Turner and Constable. Wright correctly makes the sky within the arc slightly lighter than that without, something which most artists (along with the public) overlooked until the appearance of Luke Howard's and Thomas Forster's meteorological treatises in the early nineteenth century. But given Wright's lively curiosity about natural phenomena and his strongly empirical bent, one is not surprised.

England's most Bohemian artist of the late eighteenth century, George Morland, was particularly fond of painting picturesque country scenes, often with the figural element so prominent that we tend to view them more as outdoor genre scenes than as rustic landscapes. Among his few truly rural landscapes are

Landscape with a Stream (1790s; Glasgow Art Gallery), *Landscape with Peasants Resting* (1790s; ex Nettlefold Collection) and several winter scenes of the same decade, including a large one at Yale, *Winter Landscape with Skaters* (c. 1790s). However, in one of his earliest (and also largest) public exhibitions, at the Free Society in 1782 (when he was only nineteen years old), Morland included fifteen rural landscapes among his twenty-five exhibits – most of them untraced today. Judging from the titles in the catalogue, several showed a marked interest in weather effects, unusual at the time: *Landscape with a Shower of Rain on a Heath, Burst of Lightning with Wind and Rain* and *Fog in September*. In his maturity, the financially harrassed artist found it rewarding to concentrate on cottage scenery, stables, tavern yards, blustery coasts and shipwrecks.

Morland's contemporary and friend, Julius Caesar Ibbetson, also had an eye for rural scenery, though rather surprisingly, only a small portion of his eighty-one exhibits at the Royal Academy between 1785 and 1815 fall into this category. Moreover, these date from the last ten years of that three-decade span. His preferred subjects were picturesque rustic genre scenes, seacoasts, castle ruins and, from 1799, Lake District scenes. Many of the latter include foregrounds with one or more figure groups, true to the artist's taste for overt human activity. A representative early example of his approach to rural scenery is *Child's Hill, Hendon* (1787; Private Collection). As often with Ibbetson, a debt to seventeenth-century Dutch sources is evident. Indeed, in his earlier years, he even made a number of faithful copies after Dutch works for various dealers, and a few of these were reportedly passed off subsequently as originals. In his maturity, the painter was sometimes referred to as 'the English Berchem'. The Georgetown University Art Gallery owns an earthy farmyard scene which typically includes a group of slightly idealized rustics in the foreground, reminiscent of Francis Wheatley's popular rural scenes. Ibbetson's robust little *Departure of a Coach* (1792; YCBA), a genre scene rather than a landscape, delightfully exhibits the artist's lively figure style.

Some of the foremost watercolorists of this time, such as J. R. Cozens, Pars and Towne, did not include English rural scenery in their repertory. They concentrated on Italian and Swiss views, although Towne did produce a number of Welsh and Lake District scenes in 1777 and 1786 respectively. Their elder contemporary, Paul Sandby, on the other hand, explored the whole gamut of landscape themes, including rural nature. His spacious, panoramic *View of Maidstone from near the foot of Boxley Hill* (Pl. 44, Cat. IV.6), probably the work of that title exhibited at the Royal Academy in 1802, handsomely exemplifies the large-scale view of English scenery (often in gouache) which Sandby indulged in during the latter part of his long sixty-year career. His earlier *View at Charlton, Kent, with Woodmen* (c. 1785–95?), also at Yale, contains a number of flamboyantly picturesque, aging trees which he so delighted in, and is further notable for its glowing sunset sky. Sandby even made a few gouache studies of sunsets, such as the fine one in the British Museum (c. 1790?), a highly skilled effort, at once convincing and evocative. A review of the titles of works he

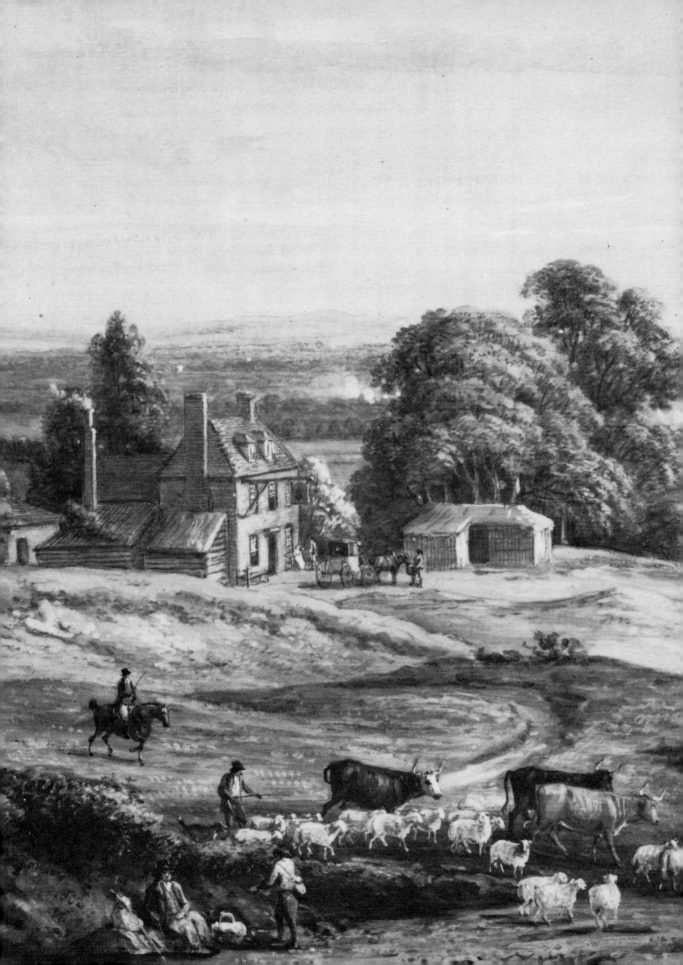

exhibited at the Royal Academy between 1769 and 1809 indicates, despite the vagueness of some titles, an enduring interest in portraying rural scenery throughout those four decades.

During the first quarter of the nineteenth-century rural landscape flourished as never before in England. A great many painters and watercolorists, both major and minor, explored and resourcefully exploited its endless possibilities. One thinks especially of various Turners, Constables, Cromes and De Wints, particularly from the 1810s, 'the decade of Naturalism'.⁴ However, it was Thomas Girtin who, slightly earlier than the artists just mentioned, made pioneering contributions to this type of landscape in some of his watercolors around 1800. The bold, sweeping breadth and unprettified, earthy quality of such works as the famous *View on the Wharfe, near Farnley, Yorkshire* (1801; Sir Edmund Bacon Collection) and *Landscape with a Stormy Sky* (1802; National Museum of Wales, Cardiff) had a beneficial impact on Constable as well as on the watercolorists, Varley, Cox, De Wint, Francia and others. The daring simplicity of his close-up composition, *On the Wharfe* (*c*. 1798; V&A) anticipates (and influenced?) the structure of some of Turner's views of comparable scenes, such as *On the Washburn* (*c*. 1815; YCBA). Girtin's *Trees and Pond near Bromley, Kent* (1798; Pl. 45, Cat. IV.11) similarly exhibits a structure like that of his contemporary *On the Wharfe*, though differs in its conspicuous lack of any human figure or animal – unusual in finished watercolors (or oils) by any artist before 1800. The *Valley of the Conway* (1800; Pl. 46, Cat. IV.12) subtly embodies

44. (IV.6) (facing) Sandby, *View of Maidstone* (detail)

45. (IV.11) Girtin, *Trees and Pond near Bromley*

46. (IV.12) Girtin, *Valley of the Conway*

Girtin's low-angle, panoramic response to a broad and deep valley, gracefully articulated by a winding river which effectively reinforces the illusion of deep recession. Again, the artist's simplification of natural forms along with his broad, liquid touch indicates the extent of his emancipation from the still reigning aesthetic of the Picturesque – save for the minor vestige of picturesqueness evident in the small pair of rickety branches in the foreground. Rural scenes, however, are not particularly frequent in Girtin's oeuvre, a large part of which involves scenery wherein architectural elements, whether intact or ruinous, are prominent.

Peter De Wint, who owes much to Girtin, was very strongly attracted to rural scenery, especially the spacious fields and flatlands around Lincoln, where he lived for many years. He loved grainfields and harvest scenes, and never more so than during the 1810s. Between 1810 and 1816 he exhibited at the Royal Academy or Old Water-Colour Society at least ten landscapes which were either cornfields, hayfields or harvest scenes. In some of these, such as the large oil, *A Cornfield* (1815; V&A), laboring figures are sufficiently prominent to warrant including the work in the next section on landscapes with laborers. Others give full rein to the open countryside, whether farmed or otherwise. *Wooded Landscape with a Cart* (c. 1813?; V&A) is an imposing example in oil, and may very well have been the large canvas exhibited at the British Institution in 1813. Unfortunately, the public took little notice of De Wint's fine oils. Among his more admired watercolors, dealing with rural subjects, the large *Gleam of Sunshine after a Rain* (c. 1820–5; Usher Gallery, Lincoln) offers an unforgettable portrayal of rural Lincolnshire, and its refulgent luminary effect is beautifully managed. The gracefully curving contours of the winding road and foreground pool make this watercolor one of De Wint's most rhythmic compositions. Like virtually all of the artist's work, the picture had its inception in an actual scene – closely based on an outdoor sketch in the artist's 1816

sketchbook (Private Collection) – but at the same time there is a hint of both Gainsborough and early Turner.

Harvest Time (*c.* 1816; Pl. 47, Cat. IV.28), another strong early effort by De Wint, preserves much of the spontaneity and freedom of an outdoor sketch, though it appears to be a finished work. In technique, it recalls work in the 1816 sketchbook as well as another early De Wint, the oft-exhibited *The Old Bridge* (*c.* 1813–15?; YCBA). There is a remarkable freshness of vision evident in a number of these totally uncontrived early achievements by the artist, which one finds rarely equalled in the rural scenes by contemporary watercolorists.

Turner was never more drawn to rural nature than during the years between 1806 and the late 1810s when he resided much of the time at his Thameside houses – first at Hammersmith (1806–10), then at Twickenham (from 1811). He owned a boat which he rowed up and down the river, mainly between Hammersmith and Walton, frequently stopping to make sketches, including a considerable number in oil (on millboard), panoramic in format, such as the superb *Thames near Walton Bridges* (*c.* 1807; TG). About this time the artist also painted several finished landscapes of nearby rural areas, such as the marvelously atmospheric, early morning scenes, *Ploughing up Turnips near Slough* (1809; TG) and *Dorchester Mead, Oxfordshire* (1810; TG), which are among the most naturalistic works he produced. Both of these appeared at the artist's own 'Turner Gallery' in Harley Street. Probably his best known or most admired work in this vein is *Frosty Morning* (1813; TG), which was a highlight of the 1813 Royal Academy exhibition.

Among the many watercolors by Turner which might be mentioned in the present context is Yale's *On the Washburn* (*c.* 1815; Pl. 48, Cat. IV.30), the study for which is also at Yale (Pl. 49, Cat. IV.31). This close-up, intimate rural scene is one of many Yorkshire views painted by the artist during or following his late summer visits – especially in the 1810s – to his generous patron and close

47. (IV.28) De Wint, *Harvest Time*

48. (IV.30) Turner, *On the Washburn*

49. (IV.31) Turner, *Sketch for On the Washburn*

friend, Walter Fawkes of Farnley Hall (near Leeds). The watercolor is one of Turner's most naturalistic efforts, however faded today. It is also one of the few Yorkshire views, along with *Rocky Pool with Heron and Kingfisher* (c. 1815; City Art Gallery, Leeds), which completely excludes human figures, the only living occupant being a kingfisher jauntily perched on the largest rock. The sketch, which states all the essentials, was made on-the-spot and actually is a leaf from the *Large Farnley Sketchbook* (TB CXXVIII), datable *c.* 1815. More typical of the watercolors Turner made for exhibition or sale during the second decade is *Lulworth Castle, Dorset* (c. 1820; Pl. 50, Cat. IV.32), essentially a rural scene dominated by a bucolic foreground. It originally formed part of a series of forty watercolors engraved for W. B. Cooke's *Picturesque Views of the Southern Coast of England* (1814–26), and was the one slightly inland scene included.

Many of Turner's Yorkshire watercolors could be cited here, save for limited space. His rural interests peaked at Farnley during the mid 1810s, paradoxically the very time he was engaged in producing, back in London, his half dozen most Claudean emulations, such as *Dido Building Carthage* (1815; NG) and *The Decline of the Carthaginian Empire* (1817; TG). But a few of his major efforts in oil at this time reflect his naturalist bent, particularly *Raby Castle* (1818; Walters Gallery, Baltimore), with its highly illusionistic sky, and above all, *Dort or Dordrecht* (1818; YCBA), despite its compositional debt to Cuyp's *The Maas at Dordrecht* (c. 1660; National Gallery, Washington). After about 1820, Turner's interest in rural landscape clearly waned. His most ambitious later series of watercolors, for example, those engraved for *The Picturesque Views of England and Wales* (1826–38), contained notably few instances of such scenes, priority being given to coastal scenes, harbors, mountain scenery, castle and abbey ruins, and townscape. In general, his taste for dramatic scenes, historical landscape, continental subjects and marines became even more pronounced.

The delightfully rural scenery of the Stour Valley in East Anglia – known as

50. (IV.32) Turner, *Lulworth Castle, Dorset*

'Constable Country' even in the artist's lifetime – provided the subjects for a full half of Constable's work. No one has better expressed the special value which such scenes held for the artist than Constable himself:

> The sound of water escaping from Mill dams . . . Willows, Old rotten Banks, slimy posts, & brickwork. I love such things – Shakespeare could make anything poetical . . . As long as I do paint I shall never cease to paint such Places. They have always been my delight . . . But I should paint my own places best – Painting is but another word for feeling. I associate my 'careless boyhood' to all that lies on the banks of the Stour. They made me a painter (& I am grateful) that is I had often thought of pictures of them before I had ever touched a pencil . . .[5]

Today, many Britons and Americans tend to envision British rural scenery at least partly through Constable's eyes. This was not the case in his lifetime, when his impact on contemporary artists and connoisseurs was quite limited. Since his death, his way of seeing and representing nature has met with increasing favor throughout the world. Pictures such as the ever-popular *Corn-field*, his first work to enter the National Gallery, come quickly to mind, but Constable's taste for the pleasantly rural 'home scenery' surrounding his native East Bergholt on the Suffolk–Essex border shows itself already in some of his earliest surviving works in oil such as *Dedham Vale* (*c.* 1802; Pl. 51, Cat. IV.21). He painted this shortly after announcing in a letter of May 1802 that his student exercises were over and that now his chief aim was to achieve 'a pure and unaffected representation' of nature. 'There is room enough for a natural painture. The great vice of the present day is *bravura*, an attempt at something

51. (IV.21) Constable, *Dedham Vale*

52. (IV.22) Constable, *View toward the Rectory, East Bergholt*

beyond the truth.'[6] A truth-to-nature approach is apparent in this work and several contemporary views by the artist, all generally assumed to have been painted in the open air. However, the degree of finish as well as the rather studied composition – e.g., the foreground tree clump and seated Gainsborough-like figure beneath it – suggest to this writer that the Yale painting and some of the others may have been painted in the studio or at least finished there. This applies especially to the small upright *Dedham Vale* (1802; V&A), which, as long recognized, adapts the compositional structure of Claude's *Landscape with Hagar and the Angel* (1646; NG), the first sight of which (c. mid 1790s) Constable considered 'an important epoch in his life'.[7] A likelier candidate as an early open-air oil study is *Valley Scene with Trees* (1802; V&A), which appears more empirically forthright and immediate, without being uncomposed. Moreover, its color is fresher. Constable's outdoor oil sketching in any case, had not yet become a constant, habitual practice this early, remaining sporadic until about 1808–9, when it became the norm for him.

View towards the Rectory, East Bergholt (1813; Pl. 52, Cat. IV.22), a small but arresting oil sketch made in the summer of 1813, shows a favorite view of Constable's at the time, painted no less than three times that summer. The scene held special associations for the artist, as his fiancée, Maria Bicknell, stayed at the rectory with her uncle, the Rev. Dr Rhudde, when she visited East Bergholt. The same scene reappears two years later in the background of a finished landscape, *Golding Constable's Kitchen Garden* (1815; Christchurch Mansion, Ipswich), a precociously naturalistic effort painted from an upper-floor win-

dow at the back of the family house. This small but stunning work and its closely related pendant, *Golding Constable's Flower Garden* (1815; Christchurch Mansion, Ipswich) – showing an immediately adjacent scene, also from a window – are two of the artist's most assured and attractive pictures from the first half of his career, and indeed rank high among all rural and naturalistic landscapes produced by British artists during the second decade.

After his marriage, late in 1816, Constable returned infrequently to his native Stour valley, but soon began exploring the most rural area near London, Hampstead Heath, where he rented a summer house beginning in 1819. *A View from Hampstead Heath, looking toward Harrow* (1821; Pl. 53, Cat. IV.23) is one of at least a half dozen vigorously executed, on-the-spot oil sketches made from nearly the same spot overlooking Harrow in the distance, all datable 1821. The sketch differs a little from the others in the way the foreground is closed off on the right by a group of tall trees. Curiously, none of these exuberant sketches inspired a larger, finished composition, as far as we know, in striking contrast, say, to the artist's seminal oil sketch, *Branch Hill Pond, Hampstead* (1819; V&A) which spawned at least five finished versions in subsequent years. His earliest

53. (IV.23) Constable, *A View from Hampstead Heath*

finished Hampstead views, however, were not of Branch Hill Pond. Among
them is the panoramically composed *Hampstead Heath: The House called 'The
Salt Box' in the Distance* (*c.* 1820; TG) and the even fresher, more boldly con-
ceived *Hampstead Heath* (*c.* 1820; Cambridge). Both of these contain remark-
ably illusionistic cloudy skies, even before the artist waged his two intensive
sky sketching campaigns at Hampstead in the autumn of 1821 and 1822.

The small *Hampstead Heath* (*c.* 1820–2; Pl. 54, Cat. IV.26), while much less
well known than the above, is impressively bold in its naturalistic directness
and refreshing absence of picturesque *staffage*. The unexpected straight-edge
rendering of the left-hand horizon (an actual ruled line) with its deftly-touched
tiny figures, is a striking note, however unusual for Constable. These qualities,
along with uninhibited, painterly sketchiness of the execution, make this work
one of the more 'modern-looking' of Constable's finished landscapes of the
time. Quite similar in effect is the breezy and expansive *The Spaniards, Hamp-
stead* (1822; The Johnson Collection, Philadelphia).

Constable was certainly not the first artist to paint Hampstead Heath – see,
for example, Richard Corbould's busily picturesque view of 1807 (ex Colonel
Grant) – but he became the area's special interpreter. No one else painted the
Heath nearly as often, nor captured so compellingly its distinctive appearance
and atmosphere under all variety of weather and luminary conditions. This
pleasantly rural area came to hold a place in Constable's heart almost equal

to that of his native Stour valley. Moreover, he thought very highly of his Hampstead views.

Basil Taylor rightly stressed in his 1973 book on Constable that the artist considered rural landscape his primary theme, and was in fact the first full member of the Royal Academy to make a specialty of that genre. To excel in that sphere, the artist felt, was a high calling, no less worthy of admiration than excellence in history painting. As he declared in a letter of 1824, 'I hold the genuine – pastoral – feel of landscape to be very rare & difficult of attainment – & by far the most lovely department of painting as well as of poetry.'[8] Three years earlier he had spoken of 'the feeling of a country life' as the 'essence of Landscape'.[9] Constable's views not only ran counter to the established hierarchy of genres still upheld at the Royal Academy as late as Lawrence's presidency (1820–30), but also offended accepted rules of The Picturesque as preached by William Gilpin, who held a low opinion of farm scenery, Constable's delight.[10] This is not to ignore the fact that Gilpin's writings carried less weight in the 1820s than during the years 1780–1810. A number of Constable's strongest and best known rural landscapes of the 1820s, such as *The Hay Wain* (1821; NG), *The Leaping Horse* (1825; RA) or *Dedham Vale* (1828; NGS), richly and powerfully embodied the above convictions. Such works, indeed, are among the most vital (and invigorating) images of rural scenery painted since Rubens's splendid landscapes of the later 1630s. Constable's vision of the Stour Valley has made a lasting impact on posterity, becoming a part of western heritage, just as has Samuel Palmer's vision of Shoreham.

Constable's older contemporary, John Crome, likewise felt strongly attracted to rural scenery, especially the open countryside around his native Norwich. Further, he delighted in heaths, most particularly Mousehold Heath, which he painted a number of times. The most impressive example is the large picture in the Tate Gallery (*c.* 1818–20?), formidable in its sweeping spaciousness and captivating in the way the colorful clusters of flourishing weeds in the foreground (seen very close up) abruptly contrast with the desolate, moor-like rolling fields in the distance. Crome is truly at his best and most original here, even if the treatment of the distance recalls Cotman's two earlier superb watercolors of Mousehold Heath made around 1810 (BM and NCM). A more Dutch-derived heath scene is Crome's earlier *Mousehold Heath: Mill and Donkeys* (*c.* 1810–12?; TG), in which the darkly shadowed windmill, isolated atop a hill, dramatically stands out against a glowing sunset sky, strongly reminiscent of Rembrandt's famous *The Mill* (*c.* 1650; National Gallery, Washington), a great favorite with many British Romantics. In contrast to Constable, who occasionally painted variations on the same scene, with differing climatic, luminary and tonal effects, Crome was satisfied with painting one picture of a given view, with the notable exception of Yarmouth Jetty.[11]

Crome was also much drawn to woodland scenes, especially around 1810, as evidenced by numerous oils and drawings, such as *On the Skirts of the Forest* (*c.* 1810?; V&A) or *Woodland Scene with Sheep* (*c.* 1810?; Viscount Mackintosh

of Halifax).[12] A particularly strong example, pungently rural in appearance and mood, is *The Beaters* (NGS), dated 1810. The dense clump of mature and aging trees, ambitiously varied as to species, is marvelously recreated on the canvas. Moreover, the three chatting countrymen fit into the foreground in a wholly believable way. Hobbema perhaps comes to mind – he was a favorite of Crome's and was copied by him – but there is in *The Beaters* a frank earthiness and ruggedness of touch which is Crome's own. Also, the Norwich master does not employ his figures in so overtly anecdotal a way.[13] Neither does he derive his composition directly from Dutch landscape, the way he does in *Hautbois Common* (c. 1810–12?; Metropolitan Museum), with its picturesquely winding road leading through a grove of oaks to a half hidden, rustic cottage in a small sunlit clearing. The artist here is indulging in the rural picturesque *à la* Hobbema, which Patrick Nasmyth equally exploited in certain works of the 1810s and 1820s. Perhaps Crome's best-known and loved rural landscape is *Poringland Oak* (c. 1818), which introduces a welcome note of recreational pleasure in the foreground – a group of boys bathing, a rare activity in the artist's work. For a change, Crome has used a somewhat richer palette than usual in this very well-preserved picture, a work that is also notable for its brightly luminous sky (and Cuypian clouds). The intensity of observation informing the representation of the oak rivals that of some of Caspar David Friedrich's solitary oaks, minus any intended symbolism.

Crome's younger Norwich contemporary, John Sell Cotman, was also attracted to Mousehold Heath, which inspired two similar finished watercolors of great power, both simply entitled *Mousehold Heath* (BM and NCM), and both painted around 1810. In Cotman's austere hands, the heath takes on the look of a severely desolate, barren and lonely moor, in contrast to Crome's more inviting heath, softened by scattered foliage and flowering weeds. Few rural landscapes of the time could be more anti-picturesque. Of course the heath itself was no garden of Eden, and probably possessed at least some of the austerity of Cotman's rigorously simplified views. In any case, it was a type of scenery that lent itself especially well to the artist's distinctive style, in which natural forms were represented largely in terms of simplifying flat tones.

Among the many masterful watercolors resulting from three successive summer visits to Yorkshire in 1803–5 are several close-up woodland scenes, such as *Greta Woods* (1805; formerly Dr L. S. Fry), in which the flattened foliage has almost the appearance of Rorschach blots. No other landscapes of the time, in any media, are even remotely like these Cotmans. The large Cotman collection at the Yale Center includes a watercolor study (probably at least begun on-the-spot) of a similar woodland scene in North Yorkshire, *In Rokeby Park* (1805), a work often exhibited. Unfortunately, Cotman's Greta and Rokeby watercolors, arguably the high point of his career, found little favor with his contemporaries.

One of Cotman's few farmland scenes, *A Ploughed Field* (c. 1807; City Art Gallery, Leeds), not only ranks high among his finest work but is one of the

most original interpretations of such scenery in British art. As in his slightly later Mousehold Heath views, the composition could not be less conventionally picturesque in its uncompromising openness and stark simplicity. The artist's imperious simplifications of nature, intensified by his flat-tone style, have long appealed to twentieth-century eyes, in contrast to the indifferent response of Cotman's day. Partly because of the unpopularity of his early work, perhaps, the artist somewhat modified his style after the first decade. Another factor was his increased interest in architectural topography, greatly encouraged by his Yarmouth patron Dawson Turner. He still produced much fine work, but not many watercolors which possess quite the subtlety and originality of his best work made between 1803 and *c.* 1807 (when he was only in his early and mid twenties!).

Back in London, around 1805–6, a group of young landscape painters in the circle of John Varley produced a number of remarkable outdoor oil sketches, mostly on or near the Thames. This group included W. H. Hunt, William Havell, William Mulready and above all, the precocious fourteen-year-old John Linnell. The latter's completely assured oil sketch, *At Twickenham* (1806; TG) would be a noteworthy work by any mature artist, let alone a youngster. In its utter directness of vision – seemingly unmediated – it can hang beside some of the boldest early oil sketches of both Turner and Constable without embarrassment. In the following decade, Linnell painted several finished landscapes of a radically naturalistic character, such as *Kensington Gravel Pits* (1812; TG), an unprecedentedly bold laboring scene. A few years later he painted one of the most attractive rural scenes of his early career, *The Newbury Canal* (1815; Cambridge). While somewhat reminiscent of certain seventeenth-century Dutch landscapes in subject and viewpoint, the work is nevertheless a conscientiously naturalistic effort, closely based on an outdoor watercolor study (at Colnaghi's in 1973). The painting is another worthy exemplar of 'the decade of Naturalism', even if the mode of naturalism here is more literal in its descriptive detail than what we find in contemporary rural landscapes by Constable, De Wint or Turner. Not surprisingly, the artist achieves a freer naturalism in his many open-air watercolor sketches, such as *Primrose Hill* (1811; Cambridge) or the pencil study at Yale which he used in preparing the finished watercolor, *Pike Pool, Derbyshire* (1814), also at Cambridge.

In the summer of 1814, Linnell toured Dovedale (Derbyshire), accompanied by the publisher, Samuel Bagster. He sketched a series of views of this much-visited area, mainly in connection with Bagster's plan to bring out a new illustrated edition of Isaak Walton's and Charles Cotton's *The Compleat Angler*, which duly appeared the following year. Two of the sketches formed the basis for a pair of small oil paintings, both entitled *Dovedale, Derbyshire* (1814; Pls. 55 and 56, Cat IV.18 and 19). One is an upstream view, near the massive rocky outcrops called 'The Brothers', while the other is a downstream view, taken from a spot nearby. William Delamotte had earlier exploited precisely this type of pairing in two open-air oils, both entitled *On the Isis, Waterperry* (1805–6; Pls. 58

55. (IV.18) Linnell, *Dovedale, Derbyshire*

56. (IV.19) Linnell, *Dovedale, Derbyshire*

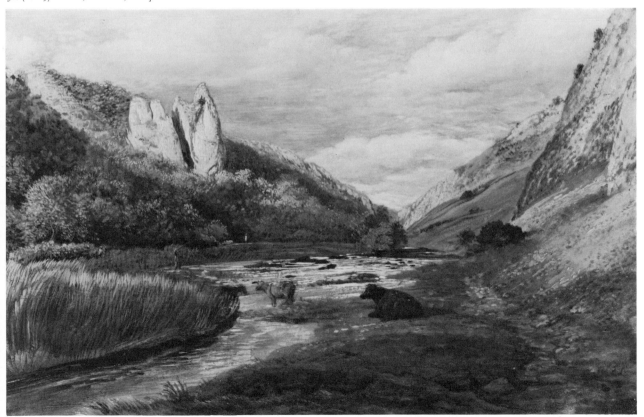

and 61, Cat. IV.16 and 17). Linnell unobtrusively includes an active angler in each view, perhaps prompted by Bagster, but in any case appropriate to the dale's age-old reputation as one of the best trout-fishing grounds in England. These two sunny views of Dovedale are much more matter-of-fact than Wright of Derby's moody, moonlit painting of the same spot (with 'The Brothers') made in 1786 (Allen Memorial Museum, Oberlin). A degree of awe invests the earlier nocturnal view. The young Linnell is satisfied with offering straight, unevocative representations of the site.

Some of Linnell's early landscapes do evoke a mood, as for example the sunset pastoral scene, *Evening Landscape with Boys Fishing* (1818; Pls. 57 and 145, Cat. IV.20). A calm, lyrical mood pervades the inviting scene, warmed by the soft glow of the setting sun. Some of the present effect, however, may result from the artist's retouching of the picture in 1856. But he captures a similar mood in *Summer Evening, Boys Bathing* (c. 1820–5?; Harris Art Gallery,

58. (IV.16) Delamotte, *On the Isis, Waterperry, Oxfordshire*

57. (IV.20) (facing) Linnell, *Evening Landscape with Boys Fishing* (detail)

71

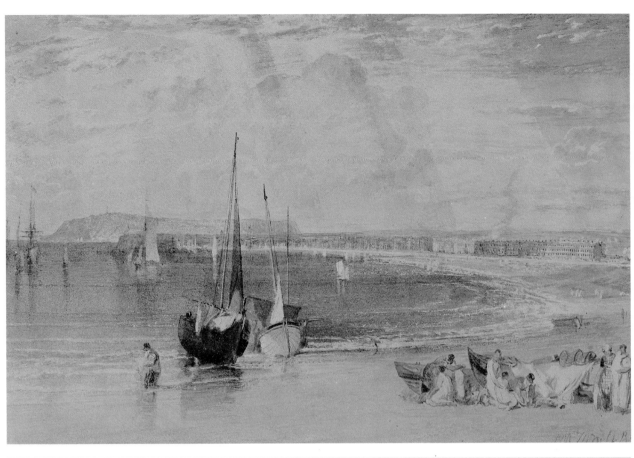

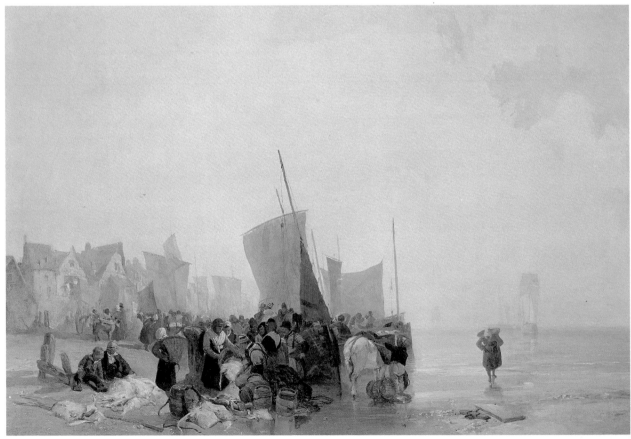

Preston). Linnell could also be emphatically picturesque, as seen in his *Land-scape with Figures* (1816; Mellon Collection), a small, highly finished woodland scene, again on panel. Here he shows his enthusiasm for aging trees with enormously girthy and sometimes knotty, twisting trunks – an arboreal preference he shares with Paul Sandby.

A remarkably original approach to rural scenery emerged in the mid 1820s in the small but intense, mixed-media works that Samuel Palmer painted at Shoreham, Kent, between 1825 and 1832. He created a new kind of pastoral landscape, far more imaginative and poetically suggestive than the many earlier shepherd scenes exhibiting a conventionally Claudean mode. In them 'energy overcomes type and time'.[14] For Palmer, the Darwent Valley around Shoreham was a veritable earthly paradise, an English Canaan – 'a wavy sea of plenty' overflowing with milk and honey. It was in this 'Valley of Vision' that the young painter, who had been much affected by contact with Blake during

61. (IV.17) Delamotte, *On the Isis, Waterperry, Oxfordshire*

59. (II.11) (facing) Turner, *Weymouth, Dorset*

60. (II.23) (facing) Bonington, *Fish Market, Boulogne*

73

the poet's last three years (1824–7), 'beheld as in the spirit, such nooks, caught such glimpses of the perfumed and enchanged twilight – of natural mid-summer . . . passed thro' the intense purifying separating transmuting heat of the soul's infabulous alchemy'.[15] The six early drawings of 1825 at Oxford, including the oft-reproduced *Valley Thick with Corn*, already embody most effectively Palmer's intensely personal vision. Robert Melville perceptively pointed out twenty-five years ago that the painter's singular linear patternings of pastoral imagery unsettles his 'seemingly Virgilian sense of beauty, dignity and orderliness of rural occupations, and turns them into signs and portents. It is as if Palmer were anxiously preparing the Shoreham valley for divine inspec-tion, and somewhat overdoing [it] . . . He was, I think trying to set Shoreham within the ambience of the Twenty-Third Psalm.'[16] Slightly later pictures also come to mind, such as Yale's gleaming *Moonlight Scene with a Winding River* (*c.* 1827) or Lord Clark's famous *Cornfield by Moonlight* (*c.* 1830; Private Collec-tion) and the Tate's *Hilly Scene* (*c.* 1826–8), so imbued with child-like wonder.

Palmer frequently articulated his exuberant responsiveness to the manifold visual delights of pastoral scenery, as in the following passage from a letter to Linnell in December 1828:

> Nature, with mild reposing breadths of lawn and hill, shadowy glades and meadows, is sprinkled and showered with a thousand pretty eyes, and buds, and spires, and blossoms gemm'd with dew, and is clad in living green. Nor must be forgotten the motley clouding: the fine meshes, the aerial tissues, that dapple the skies of spring; nor the rolling volumes and piled mountains of light; nor the purple sunset blazon'd with gold and the translucent amber.[17]

One thinks of such works as *The Bright Cloud* (*c.* 1831–2; TG) or the wonder-fully exuberant *In a Shoreham Garden* (*c.* 1829; V&A), a brightly colored image of bursting vitality and irrepressible springtime juvenescence. These are truly pictorial paeans to benign Nature's abundant fruitfulness. There is nothing comparable to the garden scene in later art until Van Gogh's blossoming apple trees painted at Arles in 1888. One senses a Blakean spirit of excess, true to Palmer's own comment that 'Excess is the essential vivifying spirit, vital spark, embalming spice . . . of the finest art.'[18] He paid special tribute to the poet's inspiring presence when he wrote that to walk with Blake 'was to perceive the soul of beauty through the forms of matter'.[19]

During the 1820s, Palmer was the central figure in a small group of young, like-minded artists who called themselves 'The Ancients', and whose motto was 'Poetry and Sentiment'. The group included Edward Calvert, George Richmond and Francis Oliver Finch, all of whom looked on Blake as their spiritual leader. Palmer had first met the poet in October 1824 (introduced by Linnell), and he accounted the event a major revelation. Two years before that he had come in contact with Linnell, and eventually became his son-in-law in 1837. The older artist set Palmer to studying the prints of Durer and Van Leyden, which he felt helped save him from 'the pit of modern art'. In 1828,

62. (IV.35) Palmer, *Ancient Oaks, Lullingstone Park*

Linnell commissioned Palmer to make a number of nature studies, including some of a group of ancient oaks in Lullingstone Park. The on–the–spot example (Pl. 62, Cat. IV.35) is surely one of the most striking tree studies in western art. In his own words, he really came to grips with 'the grasp and grapple of roots, the muscular belly and shoulders, the twisted sinew'[20] of the formidably vast and venerable trees – the central one wildly irregular in shape. The serene yet slightly eerie (in tonality) *Valley of Vision* (c. 1829; Pl. 63, Cat. IV.36) also shows the artist at his best, being a rich blend of naturalistic observation and subjective, visionary 'seeing'. One recalls another of his many quotable comments (again from 1825): 'Sometimes landscape is seen as a vision, and then seems as fine as art: but this is seldom, and bits of nature are generally much improved by being received into the soul.'[21] This applies to many of his finest works, which often have a revelatory character. No landscape painting of the time was more heart-felt, 'pure' or intense. A remark of 1830 well applies to his Shoreham work as a whole: 'If the painter performed each new work with that thirsting of mind and humility of purpose with which he did his first, how intense would be the result.'[22]

Most of Palmer's Shoreham pastorals were in a sense pictorial 'Songs of Innocence', devoid of harsh realities or anything smacking of 'evil'. When the unruly agitation accompanying the slow passage of the Reform Bill (1831–2) spread even to his own Promised Land – manifest in nocturnal rick burnings – the artist simply could not deal with it. His sense of a benign, paradisial realm was suddenly undermined, and he never regained it. He returned to London in 1832, making only occasional visits to Shoreham, and even these came to an

75

63. (IV.36) Palmer, *The Valley of Vision*

end two years later. Once severely disrupted, his seven-year intoxication with the Darwent Valley soon subsided. There was a lessening of his capacity for impassioned excess together with a lessening of his imperious transformative power over 'cloggy corporal substance'. His style became more descriptive and 'prosy' – more within the usual range of normal visual experience. Only in a few late watercolors and related etchings, illustrating Milton's *Il Penseroso* and *L'Allegro* (commissioned by Ruskin's solicitor, L. R. Valpy in 1864), do we find a glimmer of his early powers.

The foregoing artists all made interesting and significant contributions to the rich field of rural landscape, certainly one of the central branches of landscape as a whole. Other artists played a role, of course, but limited space necessitates selectivity. Those discussed include the majority of the most important masters in the present context.

v. Landscapes with Laborers

By the end of the eighteenth century, England's thriving agriculture no less than her burgeoning industry was widely conceded to be the most advanced in Europe. Even French enthusiasts of agricultural and commercial reform looked to England for new ideas. British success with crop rotation and improved methods of stock breeding were the envy of foreign visitors, who were also dazzled by the country's unrivalled industrial productivity, along with the awesome steam-powered machinery which facilitated it. British landscape painters and draughtsmen of the time were not indifferent to this aspect of their environment, and a growing number of landscapes featured some kind of laboring activity in the foreground. Agricultural work predominates, especially in the case of oil paintings. Specifically industrial scenes, such as foundries and textile mills, were occasionally the subject of prints, but curiously were not plentiful among the work of major oil painters – Wright's *Cromford Mill* (*c.* 1783; Private Collection) and De Loutherbourg's *Coalbrookdale by Night* (1801; Science Museum, London) being probably the two best known of the few examples.[1]

During the mid eighteenth century, painters such as Wootton, Lambert and Wilson typically populated their paintings of rural scenery with pastoral figures, such as lounging shepherds, cowherds or milkmaids and sometimes a traveller or two, true to a pastoral tradition persisting from the previous century and associated mainly with Claude and Gaspar Dughet. Characteristic examples are Wootton's pair, *Classical Landscape: Morning* and *Classical Landscape: Evening* (*c.* 1730s–40s; YCBA). Ease, rather than toil, is the note struck. Even when a rustic is performing some rural task, he usually appears to carry it out cheerfully, as John Barrell has recently observed.[2] Toward the end of the eighteenth century, however, one encounters a growing number of landscapes which include figures seriously at work, and their mood, when inferrable, is now seldom that of the carefree rustic of the Virgilian-Claudean pastoral tradition. By the 1780s, Barrell points out, rural laborers were beginning to be thought of as a class: 'the rural poor'.[3]

Paul Sandby was one of the first notable British landscape painters to show a fondness for introducing into many of his foregrounds rural laborers busily engaged at their assigned tasks. His predecessors and most of his contemporaries, when they included laborers, usually showed them either resting, eating, chatting or in transit. Like Constable in the next century, Sandby liked to show them at work, as we find them for instance in his austerely naturalistic *Pit-head*

of a Coal-Mine with a Horse Gin (c. 1786; National Museum of Wales) or his *Welsh Stone Quarry* (c. 1775–80?; Princeton Art Museum). Often, he sets the action near a horse-drawn cart, again, like Constable. His large watercolor, *The Timber Wagon* (c. 1792–4?; Whitworth Art Gallery) and his colorful gouache, *View at Charlton, Kent* (c. 1785–90?; YCBA) are representative examples. Also striking is his fine aquatint, *Iron Forge between Dolgelli and Barmouth* (1776), included in his *XII Views in North Wales* (1776), the earliest important series of aquatints produced in England. Unlike Wright's two iron forge paintings of the early 1770s, Sandby's view very much emphasizes a picturesque landscape setting. His interest in industry was still alive at the end of his life when in 1809, at the age of 84, he exhibited at the Royal Academy, *View of an Iron Forge on the River in Cumberland* (untraced).

Sandby's younger contemporary, George Robertson, similarly responded to the early industrial landscape, and toward the end of his rather short life made a series of six oil paintings of Coalbrookdale which were engraved and published by the Boydells in 1788. *Ironworks for Casting Cannon*, one of the six fascinating views, exhibits a dense assemblage of blast furnaces and chimneys which still appear picturesquely contained within a green and rugged setting. Not so picturesque is his moonlit view of a much vaster ironworks in Wales, *Nant-y-Glo Ironworks* (c. 1788; National Museum of Wales), which confronts the viewer with a sprawling, infernal world already meriting Blake's famous phrase, 'those dark Satanic mills'. Its menacing note anticipates not only De Loutherbourg's blazing *Coalbrookdale by Night* (1801) but also various later nineteenth-century representations of industry such as Francis Nicholson's smokey and sulphurous *Near Shifnal* (1820; engr. 1821) or Thomas Allom's truly hellish *Lymington Ironworks* (engr. 1832).

De Loutherbourg was among the first major oil painters who occasionally introduced laboring figures into his landscapes. He exhibited five such works at the Royal Academy between 1782 and 1786. An impressive sixth example is his *View near Matlock, Derbyshire* (1785; Pl. 105, Cat. V.2). Prominently occupying the foreground are two stalwart workmen and a comely but unsentimentalized woman laborer who momentarily pause during their work beside a rushing stream and underneath a daringly situated, rickety wooden conveyer. Very few contemporary artists, including continental ones, portrayed laboring scenes on this large a scale. After 1786, De Loutherbourg did not again exhibit a land-scape involving the theme of labor until 1801, when he showed at the Royal Academy the above-cited night-time view of Coalbrookdale's spectacular fur-naces. Four years later, he included among the eighteen color aquatints featured in his important publication, *Romantic and Picturesque Scenery of England and Wales* (1805), a much less horrific, even rather picturesque daytime view of the Madeley furnaces and open coke works near Coalbrookdale, seen from a view-point nearly opposite that of the 1801 painting.

Julius Caesar Ibbetson was another oil painter (and watercolorist) who tried his hand at industrial scenes – mining and quarrying operations in his case – and

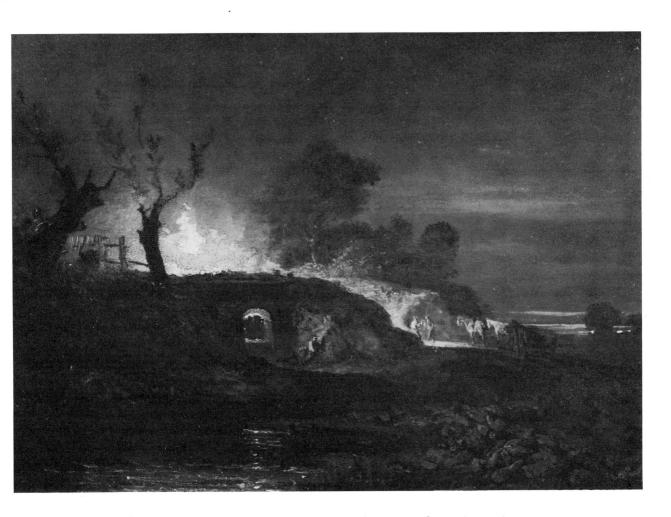

at rural scenes featuring men at work. Dated examples range from the early 1780s, such as his De Loutherbourg-like *At the Chalk Pit* (1783; ex Mitchell Gallery) to his soberly naturalistic *Threshing Scene at Shaws near Masham, Yorkshire* (Temple Newsam, Leeds) of 1812, which he exhibited at the Royal Academy that year. One of his most rigorous laboring scenes is the currently untraced oil, *Parys Copper Mines at Anglesey* (1792; J. Leger Gallery in 1930), which anticipates some of the effect of William Havell's more daring and much more sublimely scaled view of the same scene (*c.* 1804–14; Marquess of Anglesey Collection). Several of Ibbetson's many picturesque rustic landscapes include a prominent horse gin operating near a run-down, half overgrown pit-head (examples at Wolverhampton and Georgetown, Md.).

The theme of workers in a landscape is by no means absent from Turner's immense, encyclopedic range of landscape subjects. One of the earliest instances is a small, intriguing oil, *Limekiln at Coalbrookdale* (Pl. 64, Cat. V.7) of *c.* 1797. The nocturnal setting, of course, very much accentuates the dramatic, fiery glow from the kiln. Unlike so many of Joseph Wright's night scenes, as well as his own contemporary nocturns, *Fishermen at Sea* (1796; TG) and *Moonlight, a Study at Millband* (1797; TG), this work does not include a full moon within the

64. (V.7) Turner, *Limekiln at Coalbrookdale*

picture, serenely contrasting with a man-made light source. The night-time setting – something of a novelty for this particular type of subject – sets it apart from the occasional kiln scene by Sandby, Ibbetson, Munn, Francia and others which exhibit a less 'romantic' or more matter-of-fact daytime setting. Several laborers are visible, but for the moment are resting. Turner did not again paint a kiln scene in oil, but a year or two later he made a watercolor of a kiln at night, this time with a rising moon, namely, *A Limekiln by Moonlight* (*c.* 1799; Herbert Art Gallery, Coventry). A pair of workers busy themselves in the foreground, but the artist's primary concern here appears to be the interplay of the two light sources as underscored by an early note attached to the original backboard: 'to show the effect of moonlight on fire light made from the view of a lime kiln in Surrey when the moon was visible'. Turner made no further finished representations of this particular subject, though one encounters an occasional pencil sketch.[4]

Rural laborers also appear early on in Turner's work, such as *Autumn-Sowing Grain* (*c.* 1796; YCBA) or the contemporary (and perhaps its pair) *Ploughing* (*c.* 1796; Huntington Art Gallery, San Marino, Calif.). Specifically agricultural workers, however, are not particularly common in Turner's work as a whole – certainly less so than in Constable's and De Wint's many landscapes of farm scenery. Turner shows more interest in boatmen, carters, ditchers, washerwomen, fish cleaners and so on, not to mention illicit 'workers' such as smugglers and wreckers. In fact, I know of only one post-1796 example which prominently features a ploughman – the archetypal working countryman – namely, a wash drawing model for an unpublished plate intended for the *Liber Studiorum*, entitled 'Ploughing, Eton' (*c.* 1810–15; BM).

Turner's watercolor, *Dartmoor: the Source of the Tamar and Torridge* (*c.* 1813; Pl. 65, Cat. V.8), offers a forthright, unpicturesque view of a stark moor en-

livened by several groups of diverse laborers deftly depicted. It dates from a time when the artist moved closer to a naturalistic approach, as in his *Frosty Morning* (1813; TG) or the dozen small outdoor oil sketches on paper of Devon scenery made probably the same year and now in the British Museum. The distancing of the laborers in *Dartmoor* is a characteristic shared with many rural laboring scenes by a variety of artists working in the 1810s – 'the decade of naturalism' – and exemplified in the present exhibition by works of Cox, De Wint and Constable.

In his large and delightfully fresh watercolor, *Haymaking* (c. 1812–13?; Pls. 88 and 160, Cat. V.15), Cox, like Turner, places the viewer on the bank of a low-lying, weed-lined stream, above which looms a sloping hill which in Cox's case is populated by haymakers gathering up recently cut grain. Cox manages his composition without resorting to any eye-catching, picturesque effects, any more than did Turner. His haying scene provides an interesting comparison with the large De Wint composition, *Landscape with Harvesters* (1815; V&A), wherein the viewpoint is from the brow of a gentle ground swell facing a deep and broad expanse. We are somewhat closer to De Wint's hay-makers, including one who is enjoying a 'stolen moment' of relaxation in the foreground. The scene is utterly believable and at the same time holds together well as a composition. There is no forcing of effect nor any obvious 'pictur-esquing' of the foreground. It well exemplifies the significant naturalistic trend in English landscape of the second decade of the nineteenth century.

Constable's *Ploughing Scene in Suffolk* (1814; Private Collection), a fine replica of which (by the artist) is at Yale (Pl. 66, Cat. V.14), is another landscape from the mid 1810s notable for its naturalist tendencies. As so often, the artist selects a favorite view near his native East Bergholt looking toward the Stour valley.

66. (V.14) Constable, *Landscape: Ploughing Scene in Suffolk*

He tells us that he added the ploughman after the picture was underway, and found it 'a great help'.[5] His attitude toward the ploughman is presumably inferrable to some extent from the lines quoted from Bloomfield's *Farmer's Boy* (1800) which he appended to the title of the work in the Royal Academy catalogue: 'But unassisted through each toilsome day / With smiling brow the ploughman cleaves his way.' Whether the thought ever crossed the artist's mind that possibly the ploughman's brow did not always or even often wear a smile is anyone's guess. In any case, as a staunch Tory – like his father, who was a prosperous landowner – he was not apt to be a warm supporter of laborers as a class, though he may very well have felt favorably toward some individuals.

In 1816, Constable painted another ploughing scene, *Spring: East Bergholt* (V&A), a robustly executed 'finished sketch' in oil (on board), which included his father's windmill where the artist worked as a boy. He must have felt a special fondness for both of these ploughing scenes, as he included a mezzotint of each (by David Lucas) in his subsequent publication of prints, *English Landscape Scenery* (1830–3). The print of *Spring* was accompanied by a fascinating commentary by Constable, one which included his extraordinary passage on 'the natural history of the skies'.[6]

Working men, fully engaged, appear in the foregrounds of some of Constable's best known pictures such as *Boat-building near Flatford Mill* (1814; V&A) and *View of Dedham* (1814; Boston Museum of Fine Arts), which apparently were painted largely on-the-spot, most unusual in the case of finished landscapes. Even more celebrated studio pictures (with such figures) soon followed, including his *Scene on a Navigable River (Flatford Mill)* (1817; TG), *The White Horse* (1819; Frick Collection), his first 'six footer', and the superb early view of Hampstead Heath in the Fitzwilliam Museum (*c.* 1820) – not to mention a number of major works of the 1820s, like *A Boat Passing a Lock* (1824; Private Collection). The artist liked to keep his laborers at work much of the time, with 'stolen moments' at a premium. This is not to imply that he rarely paints or sketches landscapes with figures at leisure or enjoying themselves, which indeed he does; however, in most cases the figures are other than workmen. Granted, one need not make too much of this.[7] Most workmen, in the course of a working day, spend more time working than resting, and one might argue that Constable was simply being 'true to life'. Moreover, his basically empirical approach, at least during the 1810s and early 1820s, does not particularly invite us to ask whether he felt sympathy, indifference or fear toward rural laborers. In later life he developed anxieties (some severe) about numerous concerns, including the Great Reform Bill which he dreaded.

We do not find in Constable's work, any more than in De Wint's or Cox's, specifically industrial scenes in the sense of iron works, textile mills, mining operations and so on. True, his beloved Stour Valley does not present such scenes, but he surely was not unaware of them elsewhere in England. Like most contemporary landscape painters, he was apparently not drawn to that kind of scene, preferring (in his case) pastoral and farmland scenery, which was still far

more prevalent throughout the land, anyway. As mentioned earlier, a work such as De Loutherbourg's fiery *Coalbrookdale at Night* is a very unusual production in the context of major works by major artists of the Romantic era. Just why that should be remains puzzling. In any case, most painters of landscape during that time delighted most in rural, coastal or mountainous scenery, with or without (oftener the latter) laboring activity. Indeed, we in turn should delight in the fact that so many gifted landscapists abounded in the early nineteenth century, offering us a supremely rich pictorial survey of the incomparable face of Regency England just before the severely rapid and unplanned industrial expansion and 'railway mania' of the 1830s and 40s ensued, creating vast blighted areas of 'Black Country' in the Midlands, parts of the North, and southern Wales during Victorian times.

VI. Townscapes

Earth has not anything to shew more fair;
Dull would be he of soul who could pass by
A sight so touching in its majesty:
This City now doth like a garment wear
The beauty of the morning; silent bare,
Ships, towers, domes, theatres, and temples lie
Open to the fields, and to the sky;
All bright and glittering in the smokeless air.
 Wordsworth (1802)

A mighty mass of brick, and smoke, and shipping,
 Dirty and dusky, but as wide as eye
Could reach, with here and there a sail just skipping
 In sight, then lost amidst the forestry
Of masts; a wilderness of steeples peeping
 On tiptoe through their sea-coal canopy;
A huge, dun cupola, like a foolscap crown
 On a fool's – and there is London Town!
 Lord Byron (1819)

When a man is tired of London, he is tired of life . . .
I think the full tide of human existence is at Charing Cross.
 Dr. Johnson

WORDSWORTH's celebrated sonnet, *Composed upon Westminster Bridge* (quoted above) expressed feelings which many contemporary Englishmen held for their capital city. Never was London more impressive than during the late Georgian era, before it burgeoned into 'the great wen' of Victorian times. And never were painters, watercolorists and topographical draughtsmen more interested in recording the London scene, especially along the Thames. But views of many cities, towns and villages throughout Britain – in all media – poured forth in great profusion during that artistically fertile era.

Before discussing individual works, we should comment briefly on townscape during the generation before 1780. A particularly high standard of townscape painting was established in England during the extended visit of Canaletto, who resided in London from 1746 until 1755, except for two brief return trips

67. Canaletto, *The Thames from the Terrace of Somerset House*

to Venice in 1751–2 and 1753. His way of seeing London made a lasting impact on contemporary and later English view painters and connoisseurs.[1] Two of his most influential views were made from the terrace of Somerset House, one looking east toward St Paul's and the other looking west toward Westminster (Royal Collection, Windsor Castle), both from the same vantage point. Happily, Yale possesses small replicas of the pair by the artist himself (Pl. 67). Paul Sandby, for one, adopted the same viewpoint in a pair of watercolors made in the 1770s (Private Collection), giving more prominence, however, to the foreground terrace.

Canaletto's most original river view of the metropolis, *London and the Thames from Richmond House* (1746; Duke of Richmond & Gordon), was actually his first such commission. We look on the scene from an upper-floor window of Richmond House, which affords a dynamic, oblique view of the broad curving river. The nearly square format, unusual among Canaletto's London paintings, tends to heighten the novelty of the composition. One of his most colorful London views is *Westminster Bridge from the North* (*c.* 1746–7; YCBA). The foreground portion of the river is very much enlivened by a dazzling array of elegant processional barges which formed part of the annual Lord Mayor's Procession – the one time of year when the Thames exhibited a festive look not unlike Venice on Ascension Day, and doubtless all the more enticing to the eye of the visiting Venetian.[2] Canaletto here adopts an arbitrary bird's-eye viewpoint over the center of the river, directly facing Charles Labelye's recently completed bridge (only the second one to span the Thames), which is strictly parallel to the picture plane. Some four or five years later, he produced two variants of this composition, both *c.* 1750–1 and in private collections.

Like many view painters of his day and even later, Canaletto rarely tackled a street scene, though he did produce a very striking representation of one of the busier areas of London, *Charing Cross with Northumberland House* (c. 1752–3; Duke of Northumberland Collection). The artist's precision is such that London historians have identified nearly all the shops on the left. At the same time, one delights in the expressive vigor of the whole picture.

Among the relatively few British contemporaries of Canaletto who painted townscapes, the only one who gave the Venetian any serious competition was Samuel Scott (c. 1702–72). Before Canaletto arrived in England, Scott was primarily a marine painter, and was even called 'the English Van de Velde', but from the later 1740s on he turned more and more to London Thameside views and came to be called by some 'the English Canaletto'. His views proved so successful that he kept a repertory of drawings from which patrons ordered pictures, a practice which frequently led to replicas or variants of the same scene – in some cases a sizable number (not all autograph). Horace Walpole, who owned eight Scotts, held a markedly high opinion of the artist, describing him as 'not only the first painter of his own age, but one whose works will charm in every age'.[3] The Yale Center offers a wealth of London views by Scott, including some of his finest, such as *A View over the River towards Westminster* (c. 1750?), which is much breezier than any Canaletto and more charged with strong light and dark contrasts. Another imposing work at Yale, and one of his last, is *The Thames and the Tower of London on the King's Birthday* (1771), almost certainly the picture exhibited at the Royal Academy in 1771 – the only work he showed at the recently founded institution. Both these paintings exhibit viewpoints that Canaletto had not used, and the same holds for most of Scott's other London views. One of the few exceptions is his *View of Westminster from near York Water Gate* (c. 1750–5?; Sotheby, June 25, 1965, Lot 84), which adopts the viewpoint of Canaletto's painting of the same site (c. 1746; Mrs Charles Wood Collection). Also, Scott's close-up view, *Westminster Bridge* (c. 1750), of which three versions exist, surely owes something to Canaletto's *London seen through an Arch of Westminster Bridge* (1746–7; Duke of Northumberland Collection) in the way it similarly focuses on a semi-circular vista framed by an arch of the bridge. Canaletto's use of this format is even bolder, but Scott achieves a more monumental effect. A revealing difference between the two artists in that the Englishman does more justice to the moist atmosphere of his country than does the Venetian, who was used to a sunnier land. Scott's cloudy skies, in particular, are rendered with a convincing softness, while at the same time his buildings are just as precisely delineated as Canaletto's, and his shipping still more exact – as one would expect from an ex-marine specialist.[4]

Even more softly atmospheric are the London views of Scott's gifted pupil, William Marlow (1740–1813), as seen in the handsome pair of oval views in the Guildhall, London, *Blackfriar's Bridge and St Paul's Cathedral, Morning* and *Near Westminster Bridge, Evening*, possibly the pair exhibited with those titles at the Society of Arts in 1774 (or else autograph replicas). Both are unusually atmos-

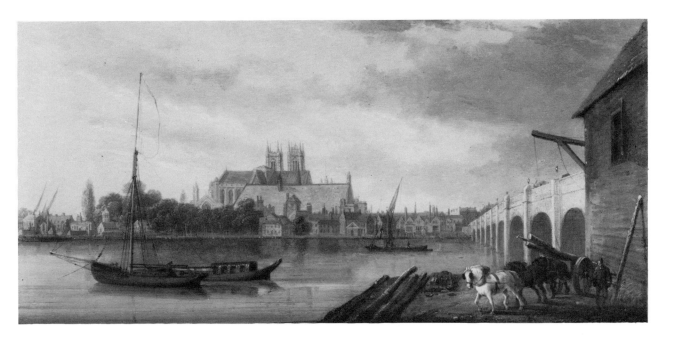

68. (VI.9) Anderson,
*Westminster Bridge from
the East*

pheric and luminous for the period. Thematically, each exploits an interesting contrast between a distinctly mundane foreground of busy laborers and a glorious architectural vista in the distance, dramatically silhouetted against a glowing sky. Early in the next century, William Anderson was to introduce a similar contrast in some of his Thames views (see Pls. 68 and 69, Cat. VI.9 and 8).

Marlow produced London views throughout most of his active career, even though he devoted much of his time after his 1765–6 tour of France and Italy to continental views, in contrast to Scott, who never left England. In fact, he showed at least twenty London views at the Society of Arts and the Royal Academy between 1762 and 1796, producing in addition replicas or variants of many of them, sometimes with assistance. This is not counting numerous views of the Thames just beyond London, as well as several views of provincial cities and towns, such as Worcester, York and Folkestone.

While most of Marlow's London views feature the Thames, a few portray street scenes, and one of the finest is, *A View of Whitehall* (*c.* 1775; Pl. 70, Cat. VI.1), possibly the picture with that title exhibited at the Society of Arts in 1775. The artist adopts a ground-level viewpoint, making the viewer feel he is standing on an extension of the foreground, which heightens the sense of immediacy. We look northward, down the unusually broad thoroughfare toward Charing Cross and Le Sueur's equestrian statue of Charles I (just visible).[5] The street is alive with characteristic activity, running the gamut of social classes from fashionably dressed strollers to hard-working street pavers (close to a sidewalk dandy). Various buildings are identifiable, above all the splendid Banqueting Hall by Inigo Jones on the right, part of it brightly highlighted by the morning sun. The whole scene is suffused with misty atmosphere which increasingly softens the already subtle hues of the buildings according to

69. (VI.8) (following page)
Anderson, *London Bridge from
the East* (detail)

87

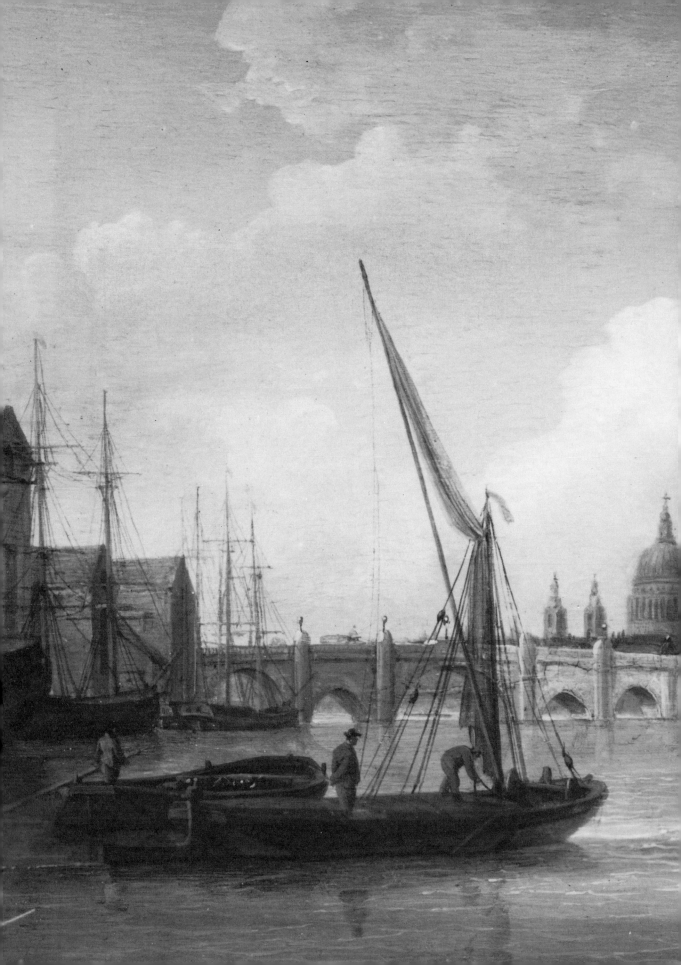

their distance – Marlow doing even more justice to English atmosphere than did his teacher.

Other noteworthy street scenes by Marlow include *Ludgate Hill, Looking towards St Paul's Cathedral* (*c.* 1775; Bank of England), which boldly juxtaposes a foreground of motley shops with the sublimely grand cathedral immediately beyond, and the playful, almost surreal variant of this scene, *Capriccio: St Paul's and a Venetian Canal* (*c.* 1775?; TG). Such capricci are rare in British townscape, but be that as it may, this one comes off quite effectively.

A different kind of townscape, one emphasizing crowds of merchants, shoppers and scurrying servants, was inspired by areas like Covent Garden and Smithfield Market. The former, London's first square (laid out by Inigo Jones in 1631), particularly attracted artists during Georgian times, and one of the more striking early paintings is at Yale, Peter Angillis's colorful view of 1726. He shows the spacious piazza packed with vivid, telling incident, including humorous situations worthy of Hogarth, but dating over a decade before the latter's first important compositions with urban settings, *The Four Times of Day* (1737–8; Private Collection). Unlike so many topographical panoramas of London, with their predominant architectural emphasis, Angillis's view – like most subsequent representations of Covent Garden – overwhelmingly stresses the rich and exuberant life of the great piazza, which had become a daily marketplace in 1671. The artist does, however, include Jones's boldly simple but finely proportioned St Paul's Church, as will most later artists when dealing with the same subject. Joseph van Aken's slightly later *Covent Garden* (*c.* 1727–30; London Museum), while involving a different viewpoint, is quite similar in character, especially the varied figure groups.

The most impressive eighteenth-century painting of Covent Garden is Samuel Scott's splendid morning view of *c.* 1752 (Duke of Bedford; an unfinished version of the 1750s in the London Museum). We view the scene, as it were, from a second storey window, looking west toward Jones's church. The more distant half of the crowded piazza is brightly illuminated by the low-angle sun, leaving the bustling foreground in deep shadow. The noisy, robust market is in full swing, and a kaleidescopic array of everyday marketplace activities meets the eye. The vividly observed, diversified crowd possesses a Bruegel-like, encyclopedic comprehensiveness. Humorous situations are not lacking, such as the upturned handcart in the right foreground, which has led to instant blows. John Collet's less crowded view of the 1770s (London Museum), populated with Hogarthian type figures, adopts nearly the same viewpoint as Scott's.

Early in the next century, Rowlandson produced a large and impressive watercolor of Covent Garden (*c.* 1810; Christie's, June 2, 1978) again, a teeming multitude has center stage (viewed from a third floor level), but the surrounding buildings are now allotted somewhat greater prominence. By then, additional permanent shops had appeared, greatly lessening the open space of the piazza. The mood of the scene has become even more intensely mercantile. Setting it

70. (VI.1) (preceding page) Marlow, *A View of Whitehall*

71. (VI.27) (preceding page) Turner, *High Street, Edinburgh*

90

apart from most earlier representations, however, is the radically off-center viewpoint, far to the left, aligned with a deeply plunging street perspective which strongly solicits our eye. About the same time, Rowlandson also made two similarly straightforward but spirited watercolor views of Smithfield Market (Guildhall Library and Private Collection), though here, the more distant and lightly drawn buildings are merely background elements.

Close-up portrayals of crowded streets or corners, as we all know, formed part of Hogarth's wide-ranging repertory of edifying subjects from contemporary urban life, or as he termed them, 'modern moral subjects'. The previously cited *Four Times of Day* series offers the earliest significant examples. *Night*, in particular, is an arresting performance in every way, as well as being among the first of the few urban night scenes by any major eighteenth-century artist. In the mid 1750s, he painted a fascinating village street scene, *Canvassing for Votes*, the third picture in his four-part Election series (1754; Soane Museum, London), and one of his most effectively composed outdoor settings. Then too, there is the famous pair of prints, *Beer Street* and *Gin Lane* (1751), two of his most overtly moralizing works, setting forth the good effects of beer drinking and the devastating effects of gin drinking. In all these works, however, the prominent figural element completely dominates, such that we cannot consider them townscapes in the usual sense; rather, they are urban genre scenes, usually with a strong message.[6] As such, they need not concern us further, wonderful as they are. This type of close-up, crowded street scene never became a staple subject with late Georgian landscape painters and watercolorists.[7] Neither did these artists focus on the seamier side of London or the provincial towns, preferring to show their more attractive aspects. This no doubt reflected the taste of most patrons (and publishers of engraved townscapes). A telling pictorial survey of some of the gloomier working class and impoverished areas of London, with their growing masses of 'urban poor', appeared only with Gustave Doré's unforgettable and sometimes unnerving illustrations for *London: A Pilgrimage* (1872). See, for example, *Houndsditch* and *Wentworth Street, Whitechapel* – images of the most oppressive poverty – or *Bluegate Fields*, so sinister in mood, and the inferno-like *Over London by Rail*. There is nothing comparable by late Georgian artists. One factor, of course, was that such areas were smaller and fewer in Regency times than in Victorian times. To many of us today, the London of 1810 or 1820 was a handsomer city than the London of 1870 – or at least a larger portion of it was. It is also true that Doré's generation was more aware of urban squalor (understandably) and more interested in representing it. His illustrations of London's darker side – by far the strongest in the series – offer a fitting visual analogue to parts of Henry Mayhew's eye-opening work, *London Labour and the London Poor* (1851–2; enl. edn. 1861–2).[8]

To return to the later eighteenth century, the prolific watercolorist, Paul Sandby, stands out as one who showed a recurrent interest in townscape, including an occasional close-up street scene, though he rarely exhibited any of these. Two of his better known Thameside views of London comprise the pair:

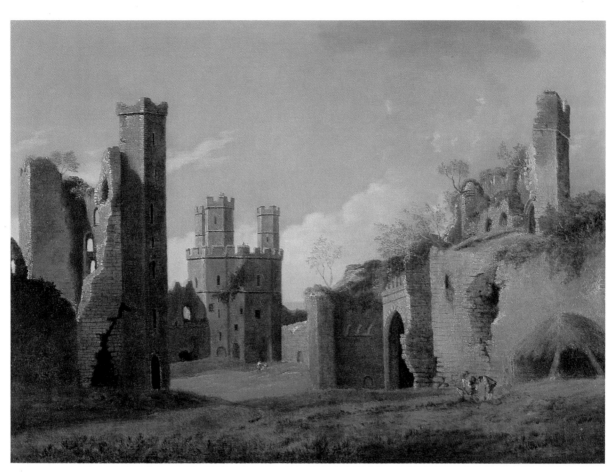

part of the Antique Aqueduct that conveyed water to M.t Palatine

2 the Collosseo

London and St Paul's from the Terrace of Old Somerset House and *Westminster from the Terrace of Old Somerset House* (c. 1770s; Brinsley Ford, Esq.). As mentioned above, these sweeping panoramas were made from nearly the same viewpoint as Canaletto's magnificent pair of large views at Windsor Castle, painted almost three decades earlier. Various lesser artists and followers of Canaletto and Sandby, such as William James, exploited a similar vantage point, the view having become a standard one, not surprisingly.

One of the more interesting street scenes by Sandby is his *Beaufort Buildings, looking north toward the Strand* (c. 1760?; BM). The artist immerses the viewer in a totally urban, man-made world, enclosed on three sides by handsome Georgian buildings, with a variety of pedestrians populating the broad and spotless sidewalks. Bright morning sunlight illuminates the buildings on the left, while the unseen rooftops of the right-hand buildings cast a picturesquely irregular shadow on the surface of the street. The handling of perspective is rigorously consistent throughout the scene. We know that Sandby not infrequently used a camera obscura, such as actually appears in the superb watercolor, *Roslin Castle, Midlothian* (c. 1770; YCBA), and quite conceivably he used one here.

No discussion of later eighteenth-century townscape can afford to omit mention of the prolific topographical draughtsman, Thomas Malton (1748–1804), justly famed for his ambitious series of a hundred aquatinted views of London buildings and streets, *A Picturesque Tour through the Cities of London and Westminster* (1792–1801), based on watercolors made since the early 1780s. Much of his work focuses on a particular celebrated building, such as his *Whitehall, with the Banqueting House* or *The Strand, with Somerset House* (the original watercolors of each in the V&A), though both of these also include lively street activity. The architectural detail of the buildings is remarkably faithful. His *Picturesque Tour* is indeed the most reliable architectural survey of London around 1800 that we have. The Yale Center owns several of the original watercolor models for the prints, such as *The Great Courtyard of Carlton House* (c. early 1790s?). The low, sharply oblique viewpoint and deeply plunging perspective is typical of Malton, whose involvement with perspective, incidentally, included the offering of evening classes on the subject at his house in Long Acre – one of his pupils being Turner (c. 1789–90).

Malton's anthology of London scenes also includes several squares, most notably Grosvenor, Cavendish and Hanover Squares, all published in 1800. The first of these, an oblique corner view, strongly recalls the compositional layout of Edward Dayes's watercolor of Grosvenor Square, a print of which appeared thirteen years earlier. Moreover, Malton's *North Side of Cavendish Square* (1800), another oblique corner view, is compositionally a mirror reversal of Dayes's (and his own) Grosvenor Square, but more scrupulously accurate in architectural detail.

Far less familiar today than Malton, James Miller (*fl.* 1773–91) was nevertheless a gifted townscape artist who exhibited numerous London views at the Society of Arts as well as a few at the Royal Academy. His most ambitious and

72. (III.2) (facing) Farington, *Caernarvon Castle*

73. (III.14) (facing) Jones, *The Claudean Aqueduct*

74. (VI.2) Dayes,
Queen's Square

delightful urban scene is the large watercolor, *View towards Hanover Square,*
showing Holles Street and part of Oxford Street (*c.* 1780; Birmingham City Art
Gallery). The whole scene throbs with bustling activity, and its surging vitality
is yet further enlivened by the compelling suggestion of a stiff breeze blowing
down the street. For sheer vividness and verve, the work has few rivals among
contemporary street scenes. His *West of Temple Bar* (1772; Guildhall) is almost
equally fascinating for similar reasons. Miller was also effective in representing
a suburban riverside street scene, as seen in his lively *Cheyne Walk, Chelsea*
(1776; V&A), where his awareness of Paul Sandby's work is more evident. One
hopes that more of his work will come to light in the future.

The influential watercolorist, Edward Dayes (1763–1804), was far from
being a specialist in townscape like Malton and Miller, but in 1786–7 he pro-
duced a set of four impressive views of London Squares: Queen Square, Blooms-
bury Square, Hanover Square and Grosvenor Square. All were engraved
between 1789 and 1791. *Queen's Square*, dated 1786 (Pl. 74, Cat. VI.2) was
exhibited at the Royal Academy in 1787. Dayes shows us the open and airy
square from the south, looking toward the then completely open northern side
which offered a refreshing, unimpeded vista of distant Hampstead. More than
one eighteenth-century writer praised the square in part for affording this
'Prospect'. The ably drawn, scattered figures – of diverse 'stations' in life – fit
into the scene in a fully believable way. In all four views, Dayes makes effective
use of light and dark contrasts. The set must have proved popular, for in
addition to the engraved version, the artist made enlarged versions in oil of
each square.

Continuing to loom large among London views (in all media) of the late

75. (VI.4) Farington,
*Westminster Abbey and
Old Westminster Bridge*

Georgian era are Thameside scenes, especially those focusing largely or partly
on either London Bridge or Westminster Bridge, with paired views not un-
common. See, for example, William Anderson's attractive little pair (Pls. 68
and 69, Cat. VI.9 and 8; YCBA), dating from 1815, and of particular interest
for the way each view juxtaposes a mundane, workaday foreground with a
noble architectural vista beyond. An unusual upright view of part of West-
minster Bridge with the Abbey and Hall was painted by Joseph Farington

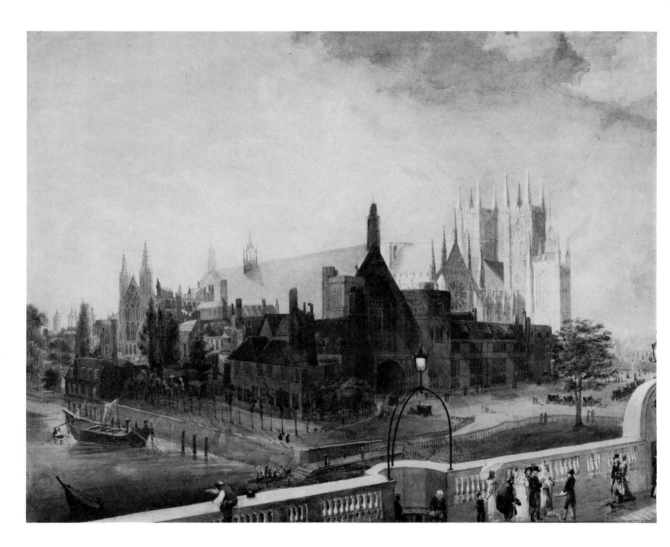

76. (VI.5) Gendall, *North-east View of Westminster Hall and Abbey*

around 1792 (Pl. 75, Cat. VI.4), a time when he was busy preparing Thames views for Boydell's lavish two-volume publication, *History of the River Thames* (1794–6). To a greater extent than one usually finds in contemporary views of the same scene, the distant Abbey appears enveloped in a soft, pearly haze.

A striking contrast to Farington's above view is John Gendall's dramatic and beautifully executed watercolor, *North-east View of Westminster Hall and Abbey* (1818; Pl. 76, Cat. VI.5). In no earlier work does this rich complex of medieval buildings appear so majestic. Moreover, the immensely skillful luminary effects quite dazzle the eye, making one wonder why this neglected Exeter artist is not better known.

The interesting if minor townscapist, Daniel Turner (*fl.* 1782–1807), virtually specialized in Thameside London views. Yale owns several of his small paintings, the two best being *Lambeth Palace with a View of Westminster Bridge* (1802; Pl.77, Cat. VI.6) and *York Watergate and the Adelphi from the West* (*c.* 1800–2; Pl. 78, Cat. VI.7). The Adelphi picture offers an unusually close-up, low-level, oblique view of massive riverside buildings that almost burst the

77. (VI.6) Daniel Turner, *Lambeth Palace with a View of Westminster Bridge*

78. (VI.7) Daniel Turner, *York Watergate and the Adelphi from the West*

restricted picture space. The effect is one of unrelenting urban density, to an extent rarely matched in earlier townscapes. The collection of Mr Paul Mellon contains a tiny, charming pair of London views by Daniel Turner, *Westminster Bridge* and *London Bridge* (*c.* 1795–1800), in which the viewpoint of each is from within a shadowy wooden warehouse open to the river. The abrupt contrast between the enclosed, utilitarian foreground and the exalted architecture in the distance provides a delightfully arresting effect, novel for its time in the context of London views. However, a partial forerunner for the format is Paul Sandby's *Windsor Castle from Isherwood's Brewhouse in Datchet Lane* (*c.* 1770–5?; Windsor Castle), showing a half-covered, barnyard-like area in the foreground opening out to a distant view of the Royal castle set atop a lofty hill and veiled in mist.

One of the grandest bridge views around 1800 in the Yale Center is William Daniell's large watercolor, *London Bridge* (*c.* 1803; Pl. 79, Cat. VI.10), which the artist himself engraved for his impressive set of six large color prints, *Views of London* (1805). Like earlier artists – and also like Monet in his famous Waterloo Bridge paintings made at the end of the century – Daniell chose an elevated viewpoint, with the off-center bridge spanning the river at a fairly steep angle. Actually, the composition recalls that of Henry Barker's print, *Blackfriar's Bridge*, a bird's-eye view showing the bridge receding at about the same angle. Daniell probably also had seen J. C. Stadler's celebrated large color print (1802) after N. R. Black's watercolor, *View of London from Albion Place, Blackfriar's Bridge* (1798; London Museum), which compositionally is a virtual mirror

98

reversal of Henry Barker's view. Conceivably, Stadler's print may even have prompted Daniell to produce his watercolor and print, which is both more daring and more empirically convincing. Equally impressive is Daniell's contemporary watercolor, *Westminster Bridge from the Terrace of Somerset House* (1804; Sabin Gallery, 1958), which appeared at the Royal Academy in 1804, soon afterward engraved for his *Views of London*. This too is a bird's-eye view, but contrasts with *London Bridge*, being a distant view of Westminster with much space allotted the river and its multitude of shipping.

A remarkable innovation in late Georgian townscape painting was the development of the large-scale, circular panorama. The pioneering example was Robert Barker's *Edinburgh from Carlton Hill*, exhibited in that city in 1788 and shown in London a year later. Barker followed this with his even more ambitious *London from Albion Mills, Southwark*, exhibited early in 1792 at Leicester Square. This proved a great success with both the public and artists. Sir Joshua Reynolds himself, Northcote reports, 'was a prodigious admirer of the invention . . . and went repeatedly to see it'.[9] His successor as President of the Royal Academy, Benjamin West, actually went so far as to call it 'the greatest improvement in the art of painting that had yet been discovered', adding that Barker could quote him.[10] In 1793, Barker constructed in Leicester Square a permanent exhibition hall of considerable size in which he displayed a succession of full-circle panoramas on a regular basis, including several continental subjects such as Athens, the Bay of Lisbon and Elba. After Barker's death in 1806 his son, Henry Barker, continued to exhibit panoramas until his retirement in 1824, when he turned over the 'Panorama Building' to John Burford, who in turn showed still further panoramas until as late as 1861, indicating the long duration of the vogue. The peak years, however, were around the turn of the century. As Constable observed in a letter of May 1803, 'Panoramic painting seems to be all the rage. There are four or five now exhibiting.'[11] One might term this new mode of view painting the cinerama of late Georgian times. Unfortunately, none of the panoramas have survived.

The most important London panorama at this time was Thomas Girtin's *Eidometropolis*, exhibited in the Great Room, Spring Gardens, from August 1802 to the end of the year. The dimensions of this full-circle panorama are estimated to be 18×108 feet, or a surface area of 1944 square feet. It was said to have been painted in oil, unlike most previous panoramas which were in tempera; however, modern scholars generally believe the medium was tempera, perhaps with some oil used for certain parts. In any case, Girtin doubtless had some assistance. The artist took his viewpoint from the roof of the British Plate Glass Mfg. Co., just to the southwest of Blackfriar's Bridge. This was not far from the viewpoint Robert Barker chose for his 1792 panorama – the roof of the Albion Mills. Nine studies survive (six in the BM), datable *c.* 1800–1. The panorama itself was most probably executed in 1801, at the end of which year Girtin made a six-month visit to Paris, initially prompted by plans to prepare a Paris panorama, but his declining health and

early death intervened.[12] In a newspaper advertisement, Girtin singled out 'the elegance of Blackfriar's Bridge' as a special feature of his panorama. A pen and wash study for the bridge (BM) shows the same viewpoint that Nathaniel Black had used in his watercolor (RA 1798; engr. by Stadler, 1802).

The *Eidometropolis* attracted much interest and praise. Viewers were struck not only by the compelling illusionism of the architecture but also by the subtle suggestions of a smoke-laden, misty atmosphere – a refinement absent in earlier panoramas, and one greatly enhancing the total illusion. The *Monthly Magazine and British Register* for September 1802 declared the work:

> may fairly be placed in the very first class in this new and extraordinary appropriation of perspective to painting. The artist, it seems, did not take the common way of measuring and reducing the objects, but trusted to his eye, and has by this means given a most picturesque display . . . The view towards the east appears through a sort of misty medium arising from the fires of the forges, manufactures, etc. which gradually lessen as we survey the western extremity . . . The whole is in harmony, and the eye is not hurt by spots. The water is pellucid and, contrary to what we have seen in pictures of this description, varies in color . . . On the whole, we consider it the connoisseur's panorama.[13]

Equally enthusiastic, the *Morning Herald* claimed three months later that the work, 'both in magnitude and effects, stands unrivalled', adding that 'in viewing this magnificent concern, the connoisseur stands enraptured . . . seeing his native place the glory of the world, so finely and truly portrayed'.[14]

Girtin's apparently 'state-of-the art' panorama vanished some time in the nineteenth century, last mentioned around 1825, when it was sold, supposedly to a Russian nobleman. With some imaginative effort, we can at least partly visualize it through his surviving studies. Also, his Sketching Club colleague, Louis Francia, published in 1803 a semi-circular print of the *Eidometropolis*, which however distortedly compressed Girtin's full-circle composition.

Before leaving London views for a look at provincial townscapes, we should touch on the important matter of distant prospects of the metropolis. From the early seventeenth century artists have proved particularly fond of the grandly expansive, distant view of London available from Greenwich Hill. The Yale collections contain such a view by an anonymous Flemish painter working around 1680, a little before the construction of Wren's great Royal Hospital, which further enriched the scene. A more interesting view is *A View from One Tree Hill in Greenwich Park* (1779; Pl. 80, Cat. VI.14) by the now little-known John Feary. The picture effectively combines a distant prospect of the mist-veiled city with a Zoffany-like 'conversation piece' in the foreground. The foremost watercolorist of the time, John Robert Cozens, also painted this view – one of the very few English subjects in his oeuvre, comprised mainly of Italian and Swiss scenes. *London from Greenwich Hill* (c. 1791; Pl. 81, Cat. VI.16) is one of six known versions by the artist, implying it was one of his more admired

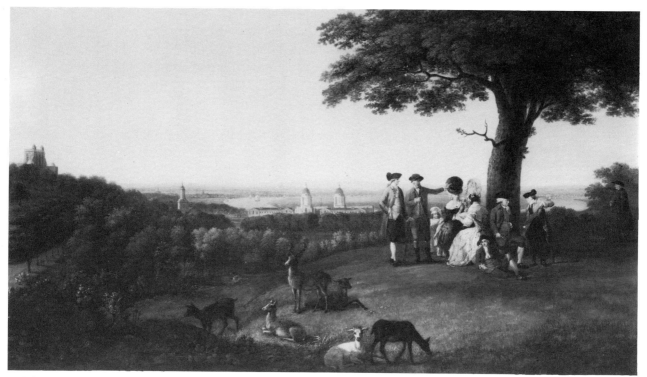

80. (VI.14) Feary, *A View from One Tree Hill in Greenwich Park*

81. (VI.16) Cozens, *London from Greenwich Hill*

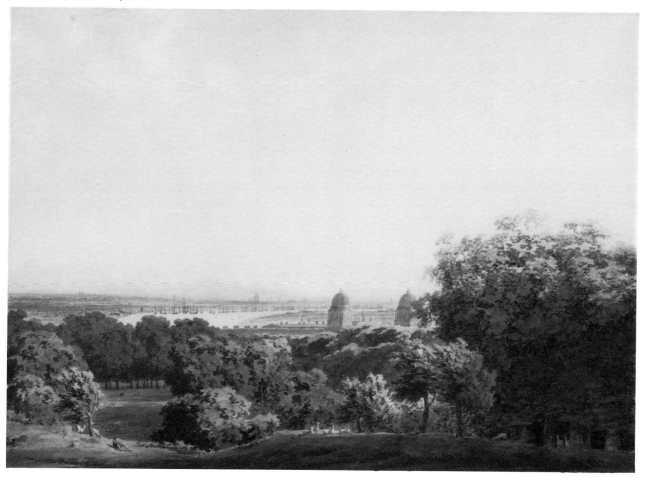

compositions. Cozens invites us to spread our attention throughout the receding vista before us, characteristically refraining from inserting any prominent figure group in the foreground. The seated, shepherd-like figure on the left is tiny in scale and hardly noticed, whereas the immediate foreground is refreshingly uncluttered and open at each end.

The large painting, *London from Greenwich Park* (1816; Pl. 85, Cat. VI.15) by George Samuel, thematically recalls Feary's view in the way it combines a prospect with the portrayal of fashionably dressed figures in the foreground. The latter group, indeed, is a Regency counterpart of Feary's very Georgian group, though smaller in scale. As Allen Staley has observed, the figures 'seem to breathe the same air as the characters in Jane Austen's novels',[15] such as *Emma*, which appeared that very year (1816). Strongly echoing earlier art is the pair of prominently silhouetted trees in the left foreground. These carefully rendered trees, however, are not mere stock props, being highly individual in shape, their long, curving trunks and sinuous branches creating distinctive patterns and seeming to possess a life of their own – not unlike some of Caspar David Friedrich's trees. In fact, they almost steal the show. Samuel exhibited the picture both at the Royal Academy (1816) and the British Institution (1817); certainly its quality makes one hope that more work by this neglected artist will resurface. We know that he was quite prolific.

Probably the best known painting of this view is Turner's *London* (TG), exhibited at his own gallery in 1809, with the following lines (by the artist) appended to the title in the catalogue:

> Where burthen'd Thames reflects the crowded sail
> Commercial care and busy toils prevail
> Whose murky veil, aspiring to the skies
> Obscures thy beauty, and thy form denies,
> Save where thy spires pierce the doubtful air,
> As gleams of hope amidst a world of care.

An engraving of this work appeared in the artist's *Liber Studiorum* (5th number, 1811), making the picture more widely known. We notice right away that the artist has omitted any foreground tree clump or lolling figures, inviting us to concentrate immediately on both the middle-distant buildings of Jones and Wren, and the sprawling London skyline, dominated by St Paul's. He has also introduced a dynamic weather effect in the sky, which energizes the whole scene. Rather surprisingly, this is Turner's only significant London view in oil, apart from his *Burning of the Houses of Lords and Commons* (two versions, both 1835), a very special subject. Moreover, watercolor views of his native city are conspicuously infrequent, in contrast to his many views of provincial cities and towns. Unlike Constable or Wordsworth, Turner did not draw heavily on the world of his upbringing in his creative efforts, favoring instead the endlessly varied experiences gained from his extensive life-long travel. For all his notorious competitiveness, he never painted any of the Thameside portions of

London celebrated by Canaletto, Scott, Marlow, Sandby, Girtin, Daniell and others.[16] He did, however, return to the London-from-Greenwich prospect in a watercolor of *c.* 1825 (Private Collection) including this time a foreground dominated by a number of lively figures on a sizeable scale.

British townscape, of course, is not limited to London views, however dominant in numbers. Cities, towns and villages throughout Britain caught the eyes of artists, especially during the late Georgian era. As mentioned in previous sections, the fact that the Napoleonic wars closed the continent to English tourists and artists for over two decades (1793–1815), except for a brief interval in 1802, most probably intensified this interest, just as it almost certainly heightened interest in other kinds of native scenery.

Edinburgh, 'the Athens of the North', became the beautiful city it is today largely during the later eighteenth and early nineteenth centuries, and many of the leading landscape painters and topographers of the time, English no less than Scottish, readily responded with a wide variety of attractive views. Turner, for one, following his 1801 Scottish tour exhibited at the Royal Academy in 1802, *Edinburgh New Town, castle, &c. from the Water of Leith*, probably the watercolor of that title in the Graves Art Gallery, Sheffield. He followed this in 1804 with the very large watercolour, *Edinburgh from Calton-hill* (BM), shown at the Royal Academy that year.[17] In 1818, he painted two more Edinburgh views in watercolor as part of a group of ten Scottish scenes commissioned by the publisher, Robert Cadell, as design for prints illustrating Sir Walter Scott's *Provincial Antiquities of Scotland* (1819–26). The Yale collections contain *High Street, Edinburgh* (Pl. 71, Cat. VI.27), one of Turner's liveliest and most delightful street scenes. It does full justice to the architectural richness and bustling vitality of the famous street, described by Scott as 'the most magnificent in Great Britain'.

Turner's other Edinburgh watercolor of *c.* 1818, a bird's-eye view from Calton Hill, is known only through George Cooke's engraving included in Scott's publication. Around 1825, the artist designed two title page vignettes for the same work, each with an Edinburgh view in miniature. In the 1830s, he produced three more watercolor views of the city, each engraved for a volume of Scott's collected works. However, he never produced a view in oil.

The long-lived Yorkshire watercolorist, Francis Nicholson, made several worthy Edinburgh views early in the century, such as *Edinburgh from Calton Hill* (*c.* 1811; Pl. 82, Cat. VI.28), possibly the work of that title shown at the Old Water-Colour Society in 1811. While it may owe something to Turner's earlier watercolor of the same title (BM), which he would have seen at the Royal Academy in 1804, his closer viewpoint changes the emphasis. Nicholson gives much more prominence to the grandly impressive North Bridge (built 1763–72) connecting High Street (Old Town) with Princes Street (New Town). Rising in the filmy distance are some of the tall buildings distinctive to the north side of Old Town, along with the formidable Royal Castle resting atop the massive rocky mound – the whole scene well-deserving of Wordsworth's apt phrase, 'Stately Edinburgh throned on crags'.

103

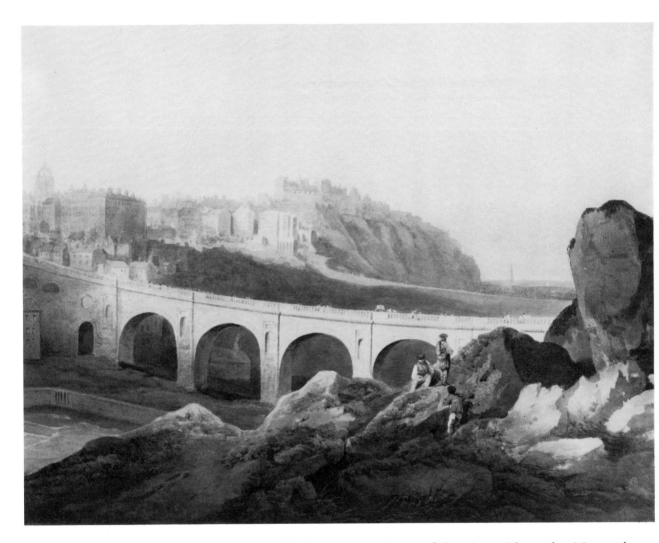

82. (VI.28) Nicholson,
Edinburgh from Calton Hill

The leading Scottish landscape painter of the time, Alexander Nasmyth, painted numerous views of his native city, ranging from an early watercolor, *Edinburgh from near St Anthony's Chapel* (1789; NGS), which very much recalls Thomas Hearne's masterful *Edinburgh from Arthur's Seat* (1778; ex Nettlefold Collection, a study at Yale), to a group of imposing oil paintings dating from the early and mid 1820s. Yale's large *Edinburgh from the West* (c. 1821), probably the picture exhibited at the British Institution in 1822, is essentially a picturesque rural scene with an urban horizon. His smaller, slightly more distant prospect of the city (c. 1822–6; Pl. 173, Cat. VI. 29), again viewed from the west, presents a more open and less conventional foreground – one graced by the presence of a charming group of fashionably dressed strollers. Nasmyth exhibited at the Royal Academy views of Edinburgh's two proudest streets, High Street and Princes Street, in 1824 and 1826 respectively. The former (Collection of Her Majesty the Queen & H.R.H. The Duke of Edinburgh) is one of the most fascinating townscapes in British art and very much deserves to be better known. The artist brilliantly represents the full tide of Old Town

Edinburgh life, coming to a head at the western, Lawnmarket end of 'the Royal Mile'. The kaleidoscopic array of lively, endlessly varied figures comprises a comprehensive cross-section of the local population, shrewdly observed and persuasively rendered. One also delights in the beautifully simulated weathered surfaces of the buildings as well as in the softly luminous, moist atmosphere enveloping the scene.

Alexander Nasmyths' equally gifted son, Patrick, was apparently less drawn to the city of his birth, tending to prefer English scenes. True, unlike his father, he spent most of his mature career in and around London. However, we know of at least two Edinburgh views he painted in the 1810s; *Edinburgh from Ravelston Quarry*, exhibited at the Royal Academy in 1815 (present location unknown) and *Edinburgh from the North West* (1819; S. Graham Laidlaw).

Another British city which inspired a variety of interesting townscapes was Bath, again, a large Georgian town which has managed to preserve much of its eighteenth-century appearance. One of the earliest series of Bath views by an important artist was John Robert Cozen's set of eight hand-washed etchings published in 1773. These views, the artist's earliest surviving works, are extremely rare today, and Yale is fortunate in possessing a full set (exhibited at the Center in the fall of 1980). While they are not in the style we associate with Cozens, they nevertheless effectively portray the singular architectural beauties of Bath. Six of the series are moderately distant prospects of different portions of the town, while two, *The Circus* and *Queen Square* are 'interior' views, the latter quite original in its choice of viewpoint and handling of the foreground.

The previously discussed topographer, Thomas Malton, also made a series of Bath views beginning in 1777. In 1780, he sent eight such views to the Royal Academy and four years later published a set of engravings. Typical examples include *Milsom Street* and *Queen Square from the East*, which compositionally anticipates some of Dayes's London squares of 1786–7. In general, his Bath views are similar in character to his London views.

One of the handsomest views of Bath extant is Thomas Hearne's superb watercolor, *View of Bath from Spring Gardens* (1790; Pl. 83, Cat. VI.17), very likely the view appearing at the Royal Academy in 1792. Looming majestically above the Avon River on the left is part of John Wood's elegant South Parade, brightly illuminated by the mid-morning sun, and reached from the river by a picturesquely half-hidden steep stairway. Robert Adam's beautiful *Pulteney Bridge* (1771) provides a worthy focal point for this rich and ambitious composition, while ascending tiers of Georgian buildings gracefully articulate the distance. Hearne's view possesses a degree of grandeur not at all present in Malton's earlier view made from nearly the same spot.

Curiously, no major landscape painters of the early nineteenth century produced any notable Bath townscapes. There is none, for example, by Turner, Girtin, Cotman or De Wint, though they all painted other towns. Even Bath's two most successful landscapists, the brothers Benjamin and Thomas Barker, showed virtually no interest in painting views of their own

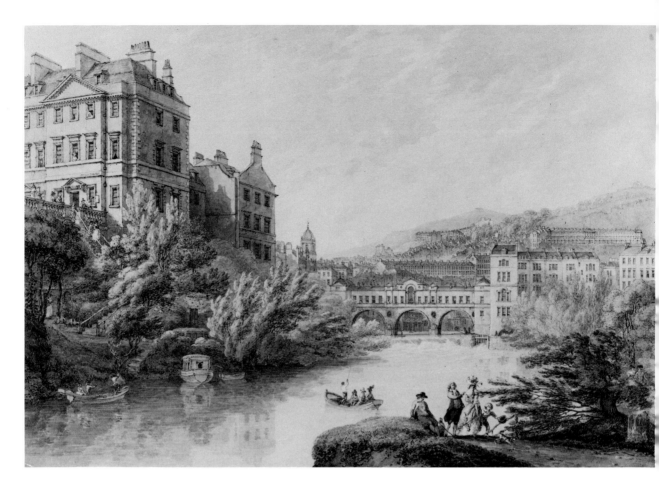

83. (VI.17) Hearne, *View of Bath from Spring Gardens*

city, the one exception being the former's view from Smallcombe Villa looking over Bath, exhibited at the British Institution in 1820. One possible factor is Bath's decline as a fashionable spa, beginning already in the 1790s. By the 1820s, its great days were entirely in the past.

David Cox, on the other hand, did take to Bath, making several visits between 1810 and 1840. In 1817, he painted a series of watercolor views which were engraved and published in 1820 under the title, *Six Views of the City of Bath*. The same year he exhibited at the Old Water-Colour Society his *Bath from Beacon Hill* (location unknown), presumably one of the 1817 views, or else worked up from one. Cox's Bath views compare more than favorably with others of the time, and his published set of prints much excels its earlier rival issued by John Claude Nattes, *Bath Illustrated* (1806).

The two university towns, Oxford and Cambridge, attracted their share of townscape topographers. Many of the views, understandably, focused on the architecture of the individual colleges, rather than being townscapes in the usual sense, and thus will not concern us here. A street, however, which did inspire many views in the later eighteenth and nineteenth centuries was the High Street, Oxford. The finest of these is Turner's painting of 1810 (Loyd Collection), exhibited at his gallery that year and again at the Royal Academy

in 1812, the same year an engraving appeared. His conscientiously accurate view celebrates the most impressive portion of 'The High', beginning with All Souls College on the right, opposite University College, and terminating with the Carfax Tower. Adding to the interest is the strong light and dark contrast between the sunlit north side of the street and the shadowy south side. Turner took special pains with the work, as we know from his eleven surviving letters to the man who commissioned it, James Wyatt (an Oxford picture dealer). The artist also painted for Wyatt a distant prospect of the town, *Oxford from the Abingdon Road* (Private Collection), which appeared at the Royal Academy in 1812 and was engraved six years later. An expansive, pastoral foreground dominates the composition, one that is sweepingly open-ended. Wyatt apparently wanted Turner to add a large tree to the foreground, but the artist replied, 'Respecting the venerable Oak or Elm you rather puzzle me . . . fancy to yourself how a large tree would destroy the character! That *burst* of flat country with uninterrupted horizontal lines throughout the Picture as seen from the spot we took it from!'[18]

Some of the most appealing early nineteenth-century views of Oxford appeared in Rudolph Ackermann's lavish volume, *The History of the University of Oxford* (1814), containing sixty-eight color aquatints after watercolors by Augustus Pugin, Frederick Nash, Frederick Mackenzie and William Westall. Pugin's *High Street* (V&A), recalls Turner's, which he surely knew, except that his viewpoint is further east and his style more detailed – in fact, almost photographic. Some of his thirty views of the city are of far less famous streets, such as his rigorously objective *Parks Road*, or his more interesting, close-up view, *Magpie Lane*, showing a jaunty row of picturesque, gable-roofed houses and shops in glaring sunlight, abruptly contrasting with a stately late Gothic tower at the end of the lane. Another interesting departure from the usual Oxford view is Nash's *Old Magdalen Bridge*, which combines a foreground scene of everyday traffic with a view of some of Oxford's most distinguished buildings on the horizon.

Ackermann followed up his Oxford publication with an equally admirable one on Cambridge the very next year, 1815. This contained sixty-four color aquatints after watercolors by the same four view painters mentioned above. One of the more arresting views is Mackenzie's *Pembroke Hall Etc. from a window at Peterhouse*, delightful in its piquant interplay of varied rooftops and chiaroscuro contrasts. Much of the Cambridge series, however – like that of Oxford – comprises views of individual university buildings, rather than townscapes. The following year, 1816, Ackermann appropriately published a picture book on the principal public-school towns, including Eton, Harrow, Winchester and Rugby, with color prints after views of Pugin, Mackenzie and Westall.

Early in his life, in 1794, Turner made three small watercolors of Cambridge: one of Clare College and two of King's College Chapel (the west end and the choir), of which two are untraced today; the extant one is *West End of King's*

College Chapel (King's College Collection). The artist never made any considerable view of Cambridge. Perhaps what he required was a Cambridge counterpart of Oxford's James Wyatt.

Among the relatively few large Cambridge views painted in oil at this time, is Thomas Malton's *King's Parade, Cambridge* (c. 1799; Mr Paul Mellon). The composition may well be the same or at least similar to that of a watercolor (location unknown) which Malton showed at the Royal Academy in 1799 under the unwieldy title, *The East End of the Senate House, Public Library, King's College Chapel, Cambridge* – one of five Cambridge views exhibited that year (all watercolors). Typical of the artist's style, all the buildings are crisply delineated and all look in absolutely pristine condition, as though just completed. Impeccably dressed gentlefolk in elegant, light carriages (reined to well-groomed horses) journey down the well-scrubbed street. No street in a seventeenth-century Dutch townscape could be more spotless or tidy. King's Parade, the heart of Cambridge, is the counterpart of Oxford's High Street, and appropriately, this view is the pendant of Malton's *High Street, Oxford* (c. 1799), also in the Mellon Collection.

Various cathedral towns also inspired a variety of views in Georgian and later times, if to a lesser extent than the above towns, but limited space prevents discussion of them here. Moreover, Yale's holdings are thin (except for prints) for the years 1780–1830. One cathedral town, however, which we should at least mention is York – not for views of its great Minster but of its old and unusual stone bridge over the Ouse River, amidst various venerable buildings.

84. (VI.18) Girtin, *The Ouse Bridge, York*

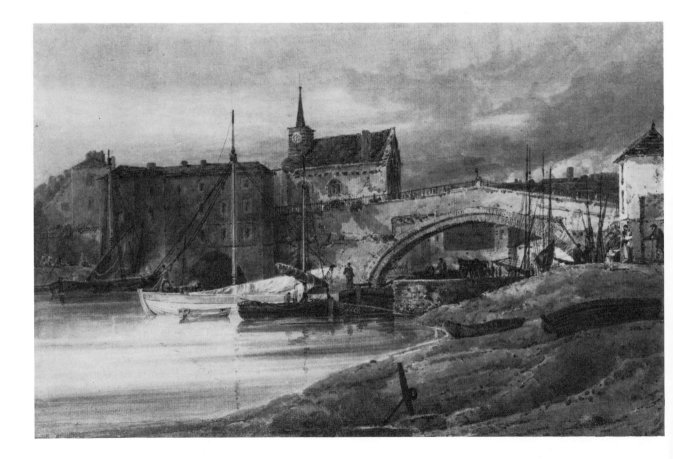

85. (VI.15) Samuel, *London from Greenwich Park*

Some of the foremost watercolorists of the early nineteenth century, along with many lesser artists, painted the famous bridge. Perhaps the finest view is Girtin's watercolor (1800; Pl. 84, Cat. VI.18), which beautifully renders the varying tones and textures of the weathered masonry. The foreground is unburdened with the eye-catching, picturesque staffage resorted to in many of the other views. A subtle naturalism is the dominant quality, despite the faded color. Girtin loved the subject, and had already painted it at least four times in 1796–7, from different viewpoints.

Another town with a unique bridge which attracted artists at this time was Monmouth.[19] Samuel Prout's large watercolor, *Monnow Bridge, Monmouth* (c. 1813–15; Pl. 86, Cat. VI.20) is certainly one of the more formidable representations of this venerable structure. We view the bridge and daringly attached old house from a very low angle and at close quarters, with the result that the massive architecture seems to loom above us in an awesome way. There is a suitable breadth of handling in the execution. Prout no doubt had taken more than a few discerning looks at both Girtin and the early Cotman.

86. (VI.20) Prout, *Monnow Bridge, Monmouth*

87. (VI.26) Turner, *Leeds*

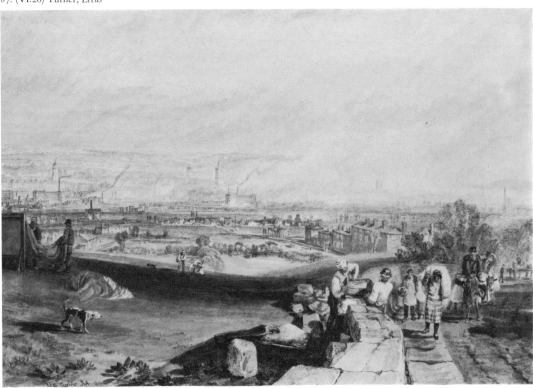

Finally, the rapidly growing industrial cities of the Midlands and the North began to receive some attention from townscapists, if minor ones. An exception is Turner, whose superb panoramic view, *Leeds* (1816; Pl. 87, Cat. VI.26), is one of the richest images in British art of a sprawling industrial town in full operation. Smoke belches from the tall chimneys of countless brick factories, and a variety of workmen busy themselves in the foreground. The picture, however, is not a grimy scene but a beautiful one by any standards, thanks to the artist, who 'seems to paint with tinted steam, so evanescent and so airy', as Constable described some later Turners.[20] One wishes Turner had tried his hand at a comparable view of Birmingham or Manchester or Sheffield. His glorious watercolors, *Newcastle-on-Tyne* (*c.* 1823; BM), *Coventry* (*c.* 1830; BM) and *Nottingham* (*c.* 1831; BM) do not stress the industrial aspect of those cities. One of his very few later finished watercolors of an industrial town which does play up its industrial aspect is *Dudley, Worcestershire* (*c.* 1832; Lady Lever Art Gallery, Port Sunlight). As observed previously, few major works by major artists of the Romantic era deal with specifically industrial scenes in the modern sense (i.e., factories, machinery, etc.), a subject largely left to lesser artists, and generally handled in the medium of prints. Turner, Constable and their chief contemporaries in the field of landscape gave priority to 'the Beauties' of England, Wales and Scotland – while they lasted – and expressed them in ways that were fresh and revealing.

88. (V.15) (preceding page) Cox, *Haymaking* (detail)

I. Mountain Landscapes

John Robert Cozens (1752–97)
I.1. Pays de Valais (*c.* 1780–5)
Watercolor over faint pencil with touches of red-brown ink on bodycolor 14⅛ × 20½ (36.2 × 52)
B1975.4.1902 PLATE 5

This alpine composition, one of seven extant versions out of eight originally commissioned, is Cozens's best known Swiss view. It was clearly 'a good breeder', to borrow Richard Wilson's apt phrase. All versions derive from a large, squared-off pencil outline sketch, included in the album, *28 Sketches by J. Cozens in Italy 1776–78* (No. 15; Soane Museum). It is inscribed, 'Approach to Martinach Pais de Vallais Aug 30 – 1776', identifying the scene as the Rhone valley southeast of Sion, looking toward Martigny (Savoy). There also exists a small monochrome wash version (Leeds City Art Gallery) which Andrew Wilton considers a second study (*The Art of Alexander and John Robert Cozens*, YCBA, 1980; 50). This version, however, is one of a group of eleven monochrome drawings (ten of them alpine scenes) of uniform size and style, which A. P. Oppé had plausibly suggested was a 'souvenir series' for a patron, made up of 'later repetitions'. (*Alexander & John Robert Cozens*, 1952; 126, 129). Cozens first toured part of the Alps with Payne Knight in August and September 1776, before travelling on to Italy where he remained until the spring of 1779. Three years later he crossed the Tyrolean Alps on a second tour of Italy (with William Beckford), returning in September 1783.

Cozens was not the first Englishman to paint the Alps – William Pars having preceded him by six years – but a number of his Swiss watercolors, including *Pays de Valais*, are arguably the first to capture in a truly compelling way the grandeur and sublime immensity of Europe's highest mountains. Enhancing the sense of awesome vastness in the present work is Cozens's choice of vantage point. We do not view the scene from a conventionally 'safe' foreground, set in a valley, but rather are part way up a mountain at a point where we can both look down into a vast space and also up at the still higher reaches of the mountain, its dizzying height suggested by the steep slope rising out of the picture on the right, inviting our imagination to complete it.

Cozens worked within a highly restricted color range of blues, greens, and greys, combined and gradated with such resourcefulness and subtlety that we never wish for a richer chromatic effect. The foreground consists of hundreds of separate, tiny touches, whereas broad, thin washes of vaporish tones establish distant forms. A particularly striking feature is the luminous atmosphere, lending enchantment to the view and enlivened by a dramatic array of descending shafts of sunlight. These dynamic light rays are far more subtly rendered than those in his father's oft-cited *Sun breaking through Clouds* (*c.* 1746; BM) which, however, may have prompted the idea of including such an effect.

John Robert Cozens (1752–97)
I.2. Monte della Madonna, near Arqua (*c.* 1783)
Watercolor over pencil 10 3/16 × 14¾ (26 × 37.5)
B1975.3.1001 PLATE 89

Cozens first saw this majestic mountain scene in June 1782, during his second visit to Italy, when he was part

89. (I.2) Cozens, *Monte della Madonna, near Arqua*

113

of the elaborate entourage of William Beckford, then on his second Grand Tour. On the 19th of the month, he made a pencil outline sketch of the scene (p. 250 of the first Beckford Sketchbook, Whitworth Art Gallery, Manchester). A pencil tracing of this sketch, by the artist, appears in the 'Beaumont Album' of tracings at Yale, and is informatively inscribed: *Monte della Madonna near Arqua the residence of Petrarch from the Hill the Convent surrounded by fir & cypress Euganean Hills | June 19*. The richly worked watercolor, on coarse laid paper, is fully characteristic of the large set of finished watercolors Cozens made for Beckford late in 1783 and early the following year.

The nearly symmetrical foreground and almost axial placement of the main mountain sets this work apart from most of Cozens's Swiss alpine views, such as *Pays de Valais* (1780–5; No. I.1) or *Between Chamonix and Martigny: The Aiguille Verte* (c. 1778–80), which are more asymmetrically composed. Also, the somewhat clumsy, resting figure in the lower right contrasts with the tiny, discretely unobtrusive figures which Cozens normally introduces in his finished works, but can be matched in certain watercolors, particularly *Sepulchral Remains in the Roman Campagna, with a Sleeping Shepherd* (c. 1783; Indiana University Art Museum). The lofty, snowcapped peaks in the distance are imaginary, but like the dynamic sky, they dramatically enhance the scene.

John 'Warwick' Smith (1749–1831)
I.3. The Val d'Aosta (1784)
Watercolor over pencil $19\frac{1}{2} \times 28$ (49.5×71.1)
Inscr. *JS* (monogram) *1784*, lower left
B1975.3.987 PLATE 90

Thanks to the Earl of Warwick's sponsorship, Smith enjoyed a five-year study visit to Italy in 1776–81, a most opportune time, as his stay overlapped that of John Robert Cozens, William Pars, Thomas Jones and Francis Towne, to mention only four among the large colony of English artists which flourished at that time in the Piazza d'Espagna section of Rome. On his return to England, Smith painted a great many Italian and alpine views during the remainder of his life, along with views of English and especially Welsh scenery. The present imposing watercolor was inspired, however freely, by scenery he saw on his way to and/or from Italy. The size of the view is unusually large for its date; none of the above contemporaries had yet produced watercolors quite so large. However, there worked in Rome at that time a noted Swiss artist, A. L. R. Ducros, who made even larger watercolor views in

90. (I.3) Smith, *The Val d'Aosta*

Italy during the 1780s, though whether Smith could have seen or heard of any by 1784 is uncertain.

The formidable rocky mound in the center of the view, topped by an intact castle (imaginary?), looms over the scene in a way that late eighteenth-century viewers would have found sublime. The wind-blown, triangular foreground has the appearance of a largely invented area, a not uncommon practice then. Smith painted a slightly larger variant of this composition in 1803 (V&A), replacing the foreground figures with three savagely storm-blasted tree stumps. His *Tivoli, looking toward Rome* (YCBA), possibly dating from about the same time, exhibits a very similar compositional layout. Smith was less arbitrarily manipulative of natural phenomena in some of his smaller watercolors, both Italian and British. He never exhibited at the Royal Academy, but in his later years, between 1805 and 1823, he showed 159 works at the Old Water-Colour Society, where he served as President in 1814, 1817 and 1818.

Charles Gore (1729–1802)
I.4. Chamonix Glacier (c. 1778–9 or later)
Watercolor over pencil, pen and black ink
$9\frac{15}{16} \times 16\frac{1}{4}$ (25.4×42.6)
Inscr. *Chamouny Glaciere*, upper right
B1977.14.9731 PLATE 91

Gore depicts, with some liberties, the famous 'Mer de Glace', which descends to the valley of Chamonix in Savoy, France. The viewpoint is not far from the one Carl Ludwig Hackert used in his color print of the scene (1781). The contours of Gore's mountain differ considerably from Hackert's, and Gore does not include any gaping tourists with parasols or any picturesque log hut, such as figure prominently in Hackert's work.

Rather, the accent is on jagged peaks and rugged terrain, devoid of paths and 'viewing stations', being populated only by scattered, straggly evergreens. The sense of an alien wilderness prevails – a 'wild scene of Nature's true sublime', in George Keate's words (*The Alps*, 1763) – and in this respect, the work anticipates some of the effect of Turner's much more overpowering watercolor of the same glacier (No. I.16).

This watercolor probably dates from Gore's two-year residence in Switzerland, 1778–9. A later date is not impossible, but to our knowledge the gifted amateur did not make a second visit to the Savoy Alps. While in Switzerland, Gore likely came in contact with Carl Hackert, the brother of Jacob Philipp, a close friend of Gore since the mid 1770s. A specialist in Swiss scenes, Carl Hackert spent the final years of his life (1778–96) in Switzerland. His 1781 print presumably derives from a watercolor or sketch made slightly earlier; thus, it is uncertain whether his or Gore's view was done first. In either case, Gore's effort is rather precocious in its empirical directness and avoidance of picturesque clichés in the foreground. We should keep in mind, however, that the watercolor, like most of Gore's work, is more a study than a fully finished work made for sale or exhibition. Moreover, as Gore was in the habit of working from nature as much as possible (since the early 1770s), the watercolor was probably either painted or begun on-the-spot.

Gore, who had been in close contact with Payne Knight in 1777 (in Italy), probably met John Robert Cozens, and may even have seen some of his work. The present watercolor, however, relates much more to Carl Hackert's work than to any of Cozens's early alpine views. The artist never exhibited any of his work in England. After moving to Weimar in 1791, where he was a prominent member of the Ducal Court, he became a close friend of Goethe, who devoted several enthusiastic paragraphs to him in his essay 'Jacob Philipp Hackert' (1811). Most of his surviving work – over a thousand drawings and watercolors – is in the Thüringische Landesbibliothek.

Thomas Gainsborough (1727–88)
I.5. Mountain Valley with Figures and Sheep
(*c.* 1787–8)
Oil on canvas $48 \times 58\frac{3}{4}$ (122 × 149)
B1981.25.295 PLATE 6

Gainsborough produced at least six large mountain landscapes in oil during the 1780s, a time when he was exploring other new subjects (for him), such as coastal scenes and 'Fancy' pictures. His tour of the West Country in 1782 and above all his tour of the Lake District the following year spurred this new interest, though in all six mountainscapes the topography is so generalized that they cannot be even loosely identified with existing scenery, in contrast to the mountain paintings of De Loutherbourg or Wright of Derby and others. The artist, we know, was not interested in painting accurate views of a given spot. The distant buildings, indeed, look more like they are part of a timelessly classical Italian hill town – a vision probably inspired by Gaspard Dughet. Still, the Lake tour stimulated Gainsborough, and at one point on his tour he wrote amusingly to a friend that he was visiting the Lakes 'to show that your Grays and Dr. Brownes are tawdry fan-painters. I propose to mount all the Lakes at the next Exhibition in the great stile . . .' (W. T. Whitley, *Gainsborough*, 1915; 215). The next year, however, he had a row with the Royal Academy over the hanging of a picture and never exhibited there again. Some or most of his mountain landscapes probably appeared at his private exhibitions at Schomberg House (his home), held annually between 1784 and 1788.

The artist probably consulted one or more of his studio sketches of imaginary mountain scenes, made in the early and mid 1780s, such as *Wooded Upland Landscape with Herdsman, Cow and Dog* (early 1780s; Mrs M. G. Turner).

Philippe Jacques De Loutherbourg (1740–1812)
I.6. View of Snowdon from Capel Curig
(a morning) (1787)
Oil on canvas $52\frac{7}{8} \times 79$ (134.3 × 200)
Inscr. *P. J. De Loutherbourg 1787*, on rock, bottom center
B1977.14.49 PLATE 7

De Loutherbourg made a sketching tour of Wales, including Snowdonia, in 1786. The present work is the

91. (I.4) Gore, *Chamonix Glacier*

larger of two views of Snowdon – the highest peak in either Wales or England – which the artist exhibited at the Royal Academy in 1787. Indeed, it is the largest mountain landscape he is known to have painted. The other work, *View of Snowdon from Llanberis Lake with the castle of Dolbadern*, is in the Musée des Beaux Arts, Strasbourg. Capel Curig lies some seven miles northeast of Snowdon, which from several directions presents the appearance of a rugged peak, seemingly higher than its 3,560 feet – though not quite so steep as seen here. Not an artist who felt particularly bound to topographical accuracy, De Loutherbourg (an ex-scene painter) used the same contour for the upper half of Snowdon in both pictures, while varying the flanking mountains. Rather than one view being strictly accurate, both to an extent are composites, but effectively handled in a way that is believable. The dark and stormy Strasbourg painting, however, smacks somewhat of Rosa and Dughet in parts, whereas the Mellon painting evokes the Picturesque, especially in the foreground. Perhaps the artist intended one as a 'sublime' version of Snowdon and the other, a 'picturesque' one – aesthetic categories very current at the time.

Compared to the very generalized, rather dreamlike mountain landscapes which De Loutherbourg's eminent friend, Gainsborough, was painting about the same time, the present work seems very much down to earth and persuasive empirically, albeit endowed with a moderate degree of picturesqueness. His final view of Snowdon, that engraved for his *Romantic and Picturesque Scenery of England and Wales* (1805), involves much more arbitrary manipulation of nature. On the whole, the Mellon painting is De Loutherbourg's most impressive mountainscape, and a worthy successor to Wilson's grand *Snowdon from Llyn Padern* (1766; versions at Nottingham and Liverpool).

Joseph Wright of Derby (1734–97)
I.7. Derwentwater with Skiddaw in the Distance
(1795–6)
Oil on canvas $22\frac{1}{4} \times 31\frac{1}{2}$ (56.5 × 78.7)
B1981.25.720 PLATE 8

This dynamic mountain landscape is one of at least six extant Lake District views which Wright painted in his last years, following two brief summer tours of the region prompted by his friend, the Rev. Thomas Gisborne. Another seven Lake views are recorded but remain untraced. None of these mountainscapes was exhibited or engraved, and all of them passed into obscurity until the publication of Benedict Nicolson's oeuvre catalogue in 1968. The present work is the most impressive of the surviving group and interestingly

contrasts with the many conventionally picturesque views of the Lakes made by contemporaries such as Farington (No. I.8), De Loutherbourg or Ibbetson (No. I.13). The rugged cliff on the right, not present in the actual scene, recalls a similarly situated rock mass in Wright's earlier *Matlock Tor* (*c.* 1780; YCBA). The unstressed foreground is kept largely open, unencumbered by any stock picturesque tree, though an inconspicuous fallen tree trunk appears on the left. A particularly striking feature is the highly active, cloud-filled sky, including a variety of cloud forms at different elevations and conveying a sense of weather as a continuous process unfolding before one's eyes. Executed with consummate skill, the sky is both empirically plausible and emotionally stirring. Wright had earlier made a number of cloud studies in monochrome wash (1774–5), and in fact was one of the first British artists to do so (examples in the BM and Metropolitan Museum).

The picture as a whole, rather underrated by Nicolson (along with all the Lake views), is surely one of the more vigorous, unhackneyed representations of a Lake District scene painted before Turner's *Buttermere Lake* (1798; TG). Its precocious weather effect gives the work a nineteenth-century look, in contrast to several slightly earlier Westmorland views by Wright, such as *Head of Ullswater Lake* (*c.* 1794–5; Private Collection), with its conventional foreground. No study for this work or any of the other Lake paintings has so far appeared, though a few mountain drawings exist which are unrelated to surviving pictures.

Joseph Farington (1747–1821)
I.8. View of Skiddaw and Derwentwater (*c.* 1780)
Watercolor over pencil $19\frac{1}{4} \times 25\frac{7}{8}$ (48.9 × 65.9)
B1975.4.2012 PLATE 92

Previously entitled 'Landscape with Mountains', Farington's large, meticulously executed watercolor is unquestionably a view of Skiddaw from the southwest shore of Derwentwater, and may well have been the work exhibited at the Royal Academy in 1780 with the above title. The artist had resided in the Lake District for four years (1776–80), returning in December 1780 to London, where he had earlier trained under Wilson (1763–5). All six of Farington's Academy exhibits in 1780 were Lake scenes, which remained his favorite subject until the mid 1780s. His Lakeland views are among the earliest of any by a noted artist, predating those by Gainsborough, De Loutherbourg, Wright of Derby and Ibbetson. Compositionally, the work is thoroughly conventional, especially in the way the elaborate foreground is enclosed on both sides by prominent trees. The artist will continue to use this tra-

92. (I.8) Farington, *View of Skiddaw and Derwentwater*

ditional foreground layout in many later works, including a number of his well-known Thames views for Boydell, such as *View up the River from Millbank* (engr. 1793). This is not to imply that he never paints openended foregrounds, which he does.

The Yale Center owns an undated volume of forty-three numbered watercolors and drawings of the Lake District by Farington. Number six is a finished watercolor variant of the present work, inscribed 'Skiddaw and Derwentwater'. The volume was probably assembled in connection with the enlarged, 1816 edition (with forty-three prints) of his now rare *Views of the Lakes, etc., in Cumberland and Westmorland* (orig. edn. 1789; 20 Pls.).

Derwentwater, which partly borders the delightful town of Keswick, was and still is often considered perhaps the most beautiful of the Lakes, and Skiddaw the most serenely majestic of British mountains. Farington's

version of the mountain accents this quality. Joseph Wright's later and very different view, *Derwentwater with Skiddaw in the Distance* (1795–96; No. I.7), provides a revealing contrast.

Francis Towne (1740–1816)
I.9. Coniston Lake, Lancashire (1786)
Watercolor, pen and brown ink on two joined sheets
$6\frac{1}{8} \times 18\frac{3}{4}$ (15.5 × 47.75)
Inscr. *F. Towne delt. 1786*
 Verso of artist's mount: *N⁰ 25 A View of the Lake of Coniston in Lancashire drawn on the Spot by Francis Towne August 15th 1786*
B1977.14.6293 PLATE 93

Occupying two pages from a dismantled sketchbook, Towne's Lakeland view is one of at least 58 he made during his only tour of the Lake District, in August 1786, his last important sketching tour. His usual practice since at least his 1777 Welsh tour was to draw the outlines directly from nature (usually in brown ink), and apply the color back at his inn, or sometimes at a later period. The present work comes from the larger of two sketchbooks used on the tour, which Towne presented to his travelling companion and patron, John Merivale. A number of views from this sketchbook were detached and separately mounted at an early date. The Yale Center also owns the superb two-page panorama, *Windermere Lake*, from the same sketchbook.

Towne was particularly partial to panoramic views, as seen here, where the width is three times the height. Fully characteristic of the artist's highly distinctive style are the prominent contour lines, the restricted range of color (applied in thin, flat washes), the marked simplifications of natural phenomena and the sense of carefully adjusted compositional and tonal balance.

93. (I.9) Towne, *Coniston Lake, Lancashire*

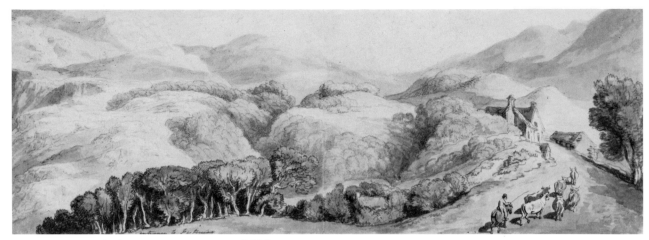

94. (I.10) Rowlandson, *Entrance to Festiniog, North Wales*

In the 1780s and 90s, the Lake District attracted ever-growing numbers of artists 'in search of The Picturesque'. Towne, however, was rarely under the spell of this vogue. In the present drawing, forms are so simplified and flattened that the effect is hardly one of quaint picturesqueness. He emphasizes the majestic magnitude of the distant mountain – Coniston Old Man – and conveys a mood of imperturbable serenity. Conversely, he de-emphasizes man's presence, admitting only an inconspicuous pair of tiny figures in the far left and a few largely hidden houses. Natural scenery, as sifted by his selective vision and modified by his idiosyncratic style, is much the dominant note.

Between 1762 and 1815, Towne exhibited 56 works in London (Society of Arts, Free Society, RA and BI); most of these were oils, many of them untraced today. In 1805, he held a remarkable one-man watercolor exhibition at Spring Gardens, comprising 191 works made over the preceding 30 years. Forty-seven of these watercolors were Lake District views, and No. 86 was *Coniston Lake, Lancashire*, most probably the present work.

Thomas Rowlandson (1756–1827)
I.10. Entrance to Festiniog, North Wales (1797)
Pen and watercolor over pencil $5\frac{5}{8} \times 16\frac{5}{16}$ (14.4×41.5)
Inscr. *Entrance to Festiniog*, lower left, in the artist's hand
B1977.14.344 PLATE 94

This delightful panoramic view of heaving mountain masses resulted from Rowlandson's tour of Northern Wales in 1797, made with his close friend, Henry Wigstead. Three years later a print of this work appeared in Wigstead's *Remarks on a Tour to North and South Wales, in the Year 1797*, along with twenty-one other etched views, most of them after Rowlandson. The Yale Center owns three other watercolors made on the same tour, including *Caernarvon Castle, North Wales*, similarly engraved for Wigstead's *Tour*. In his Introduction, Wigstead touched on the special lure of Welsh scenery:

> The romantic and picturesque scenery of North and South Wales, having within these few years been considered highly noticeable and attractive, I was induced to visit this Principality with my friend Mr. Rowlandson . . . We left London in August 1797, highly expectant of gratification; nor were our fullest hopes in the least frustrated. (v–vi)

Compositionally, the work is remarkably similar to one of Francis Towne's finest Welsh watercolors, *Mountainous Landscape near Devil's Bridge, Mid Wales* (1777; Courtauld Gallery), likewise a two-page panorama executed in pen outline and a few pale colors. The resemblance may be coincidental, as very few of Towne's watercolors were exhibited in London before his large one-man retrospective of 1805. In style and mood, to be sure, Rowlandson's art is wholly distinct from Towne's. Festiniog is eight miles northeast of Port Madoc. The mountain on the left is not (as sometimes claimed) Snowdon, which is ten miles northwest, but Moelwyn Mawr.

John Webber (c. 1750–93)
I.11. Thurshouse Tor from the River Manifold, Derbyshire (1789)
Blue and grey washes over pencil
$18\frac{1}{4} \times 13\frac{1}{4}$ (46.4×33.6)
Inscr. *J. Webber del: 1789*, lower right;
 . verso: *7 Thurshouse Tor*
B1977.14.5782 PLATE 95

Webber made this view of one of the more spectacular tors in the Peak District during a tour of Derbyshire in

95. (I.11) Webber, *Thurshouse Tor*

1789. The site is immediately west of Dovedale, where the artist made a number of watercolor views, four of which are at Yale. Webber took keen interest in the curious shapes of the massive rock formations prevalent in that region, an interest which was fanned by his touring companion, William Day, a professional geologist and amateur artist. The rather low, close-up viewpoint accentuates the towering grandeur and sublime vastness of the tor and neighboring cliff, which in turn fill the viewer with a heady sense of incommensurable masses on a gargantuan scale. In no other recorded Webber drawing does nature appear so superhumanly scaled. Furthermore, no other draughtsman has better conveyed the awesomeness of Derbyshire scenery at its most rugged, which a contemporary writer, William Bray, characterized as abounding in rocky outcrops of 'every wild and grotesque variety of height and shape' (*Sketch of a Tour in Derbyshire and Yorkshire*, 1778; 81).

George Morland (1764–1804)
I.12. Rocky Landscape with Two Men on a Horse
(1791)
Oil on panel $9\frac{7}{8} \times 11$ (25 × 30.25)
Inscr. *G. Morland 1791*, lower left
B1981.25.453 PLATE 96

This small but spirited mountainscape is one of several which Morland painted in the 1790s, others including *View in Westmorland* (1792; Chrysler Museum, Norfolk, Va.) and *Travellers resting in a Mountainous Landscape* (1794; ex Abbiss Phillips Collection). Morland produced relatively few paintings of mountain scenery, and did not exhibit any. Pure landscape, in fact, was not a strong enthusiasm of the artist. Nevertheless, the present work and the others cited make attractive pictures, executed with much verve and painterly dash. They preserve much of the vigor and spontaneity of an oil sketch, though they are unquestionably finished works. Probably they were improvised from imagination, as the painter is not known to have visited Wales, the Lakes or Scotland. One senses in a general way the stimulus of Gainsborough.

Julius Caesar Ibbetson (1759–1817)
I.13. Langdale Pikes from Lowood, Windermere Lake (*c*. 1800–6)
Oil on canvas 14 × 19 (35.5 × 48.25)
B1981.25.373 PLATES 9 (detail) and 97

Ibbetson first visited the Lakes in 1798 and 1799, taking up residence there between 1800 and 1806, at Ambleside and Troutbeck, successively. He exhibited fourteen Lakeland mountain scenes at the Royal Academy during the years 1799–1806, plus two further views in 1811 and a final one the following year at the British Institution. Three of these depicted Windermere, from various viewpoints (all exhibited in 1804), but their specific titles do not fit the present work, which nonetheless surely dates from that period. The view is from Lowood, located near the northern end of England's largest lake, on the east shore, about a mile south of

96. (I.12) Morland, *Rocky Landscape with Two Men on a Horse*

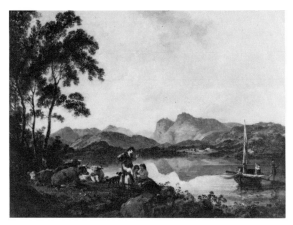

97. (I.13) Ibbetson, *Langdale Pikes from Lowood, Windermere Lake*

doned. One can also see why Ibbetson was called 'the English Berghem' – independently of the fact that the northern end of Windermere was actually likened to a Berghem landscape by Gilpin in his *Lakes Tour* (1786). 'The scenery,' he wrote, 'puts us in mind of Berghem . . . whose imagination could not have formed a better background' (I, 149–50). Wright of Derby's earlier Lake paintings, such as *Derwentwater with Skiddaw* (1795–96; No. I.7), to our eyes, offer a more original and expressive approach to Lakeland scenery, but Ibbetson's many views suited popular taste of that time.

Paul Sandby Munn (1773–1845)
I.14. Mountain Valley (*c.* 1802–4)
Watercolor over pencil $8\frac{3}{8} \times 13\frac{5}{16}$ (21.2 × 34)
B1975.3.2061 PLATE 98

Munn's watercolor has very much the appearance of a direct study from nature, with the immediate foreground left partly bare. If the mountains are Welsh, then the work dates from the artist's 1802 tour of Wales, made with John Sell Cotman; but if it is a Lake District scene, then the watercolor results from Munn's 1804 tour of the north of England. Its style owes much to both Girtin and Cotman. The artist had direct contact with Girtin, being a member of the Sketching Club from 1799 (and its secretary under

Ambleside and six miles southeast of the Langdale Pikes. The latter comprise Harrison Stickle (2400 feet) and Pike o'Stickle (2323 feet), and their distinctive, immediately recognizable profiles strikingly reflect themselves on the smooth surface of the calm lake.

Like many Lake views of the time, the foreground is picturesquely 'tree-clumped' on one side (often on both), while assorted cows and milkmaids relax in the center, in a way William Gilpin would have con-

98. (I.14) Sandby Munn, *Mountain Valley*

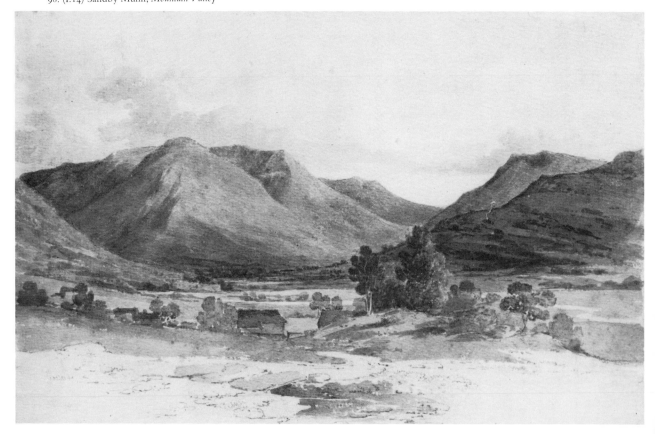

Cotman's presidency in 1801). The work is closest to various Cotman watercolors of the time, such as *Plas y Nant, near Snowdon* (1802; ex T. Bodkin) or *Llangollen* (*c.* 1802; Oppé Collection), the difference being that Munn's view strikes one as a more straightforward, uncomplex record of a scene. Later on, Munn's style became closer to Cristall's.

Munn exhibited twenty-nine watercolors at the Royal Academy (1799–1805), mainly Welsh and Lake District views, and forty works at the Old Water-Colour Society (1806–15), nearly all views in the Lakes and Derbyshire. He showed nothing after 1815. Between 1802 and 1813, he made drawings for eight plates in John Britton's *Beauties of England and Wales*. He settled in Hastings as a drawing master by the 1810s, and, after 1832, largely gave up painting for music.

Joseph Mallord William Turner (1775–1851)
I.15. Château de St Michael, Bonneville, Savoy
(1803)
Oil on canvas 36 × 48 (91.5 × 122)
B1977.14.75 PLATE 23

This grand alpine landscape, along with its pair, *Bonneville, Savoy, with Mont Blanc* (1803; Private Collection), comprise Turner's first sizeable oils of a Swiss scene, following close upon his tour of the Alps in the summer of 1802, during the brief peace of Amiens. He exhibited both works at the Royal Academy in 1803. There exist three studies relating directly to the present work: an on-the-spot 'pencil rough,' indicating the contours of the distant mountains, contained in the 'France, Savoy and Piedmont' sketchbook (TB LXXIII–46a); a rough compositional study in watercolor (TB LXXX–H); and a comparatively finished watercolor study (Courtauld Gallery). The painting closely follows this final study, introducing, however, a pair of Swiss peasant women in the foreground as well as some flowering plants on the far right. Also, the decaying towers of the abandoned château are more emphatic.

As Butlin and Joll have pointed out (*J. M. W. Turner*, 1977; 33), the compositional structure of the foreground, with its plunging road perspective, was probably inspired by Poussin's *Landscape with a Roman Road* (1648; Dulwich), which Turner most probably had seen either when it belonged to Noel Desanfans (till 1802) or when it was exhibited for sale in 1802. He enthusiastically spoke of this particular Poussin in his 'Backgrounds' lecture (first delivered in 1811), lauding it as 'a powerful specimen of Historic landscape'. He also much admired several Poussins at the Louvre during

his visit of 1802. The formidable sense of mountain grandeur, however, along with the compelling effect of light and atmosphere, is already very much Turner's own.

Joseph Mallord William Turner (1775–1851)
I.16. Glacier and Source of the Arveyron, going up to the Mer de Glace (1803)
Watercolor 27 × 40¼ (68.5 × 102.5)
B1977.14.4650 PLATE 10

While Turner was not the first to paint Mont Blanc's most formidable glacier and its accompanying 'wild' mountain scenery, no one before him produced so forceful and at the same time so compellingly 'real' a representation of it. The work must have seemed to contemporaries almost uncomposed, in the context of established compositional conventions of that day. In no way does Turner try to tame this sublime alpine wilderness, in which uncontainable natural energies burst forth all over. The artist gives us unbridled 'mountain glory,' and this becomes all the more apparent when we view the work beside his serenely pastoral and 'beautiful' *Lake Geneva with Mont Blanc* (No. I.17) of nearly the same size and date.

Turner exhibited the watercolor at the Royal Academy in 1803, along with three other alpine views, all deriving from his first tour of Switzerland made the previous year. His 'St Gothard and Mont Blanc' sketchbook (TB LXXV) contains various sketches of the area, but none directly relate to the present work. There does exist a chalk sketch on a loose sheet (TB LXXIV–L) which shows the central motif. Turner's print of this scene, *Source of the Arveyron*, published in 1816 in the twelfth number of his *Liber Studiorum*, involves a different vantage point, and is based on a watercolor of 1809 (Taft Museum, Cincinnati). Unless a directly related study is now lost, Turner composed this view largely from memory. No doubt his lively imagination came into play as well, though it was an imagination still rooted in direct experience.

Joseph Mallord William Turner (1775–1851)
I.17. Lake Geneva with Mont Blanc (*c.* 1803–5)
Watercolor with scraping out 28⅞ × 43⅞ (73.4 × 113.6)
Inscr. *J M W Turner. RA*, lower left; *JMWT* on boat, center left
B1977.14.6301 PLATE 11

If Turner's *Glacier and Source of the Arveyron* (1803; No. I.16) fully embodies the Sublime in its forceful representation of an awesome alpine scene, his *Lake*

Geneva equally richly embodies the Beautiful in its artfully composed and pleasurable impression of pastoral serenity. The corner tree clumps enframing the gracefully curving foreground and, more particularly, the silhouetting of the two tall trees on the left against a luminous morning sky recall the art of Claude, so admired by Turner. On the other hand, the profusion of cattle and sheep, together with the mundane activity of the several figure groups, give the foreground an earthy character more reminiscent of Aelbert Cuyp.

This elaborately composed view derives from two black and white chalk sketches contained in the 'Calais Pier' sketchbook (*c.* 1802–5; TB LXXI, 20, 32). Both are very rough, abbreviated compositional studies, most probably made in the studio; moreover, they pertain only to the middle and far distance. There also exists a third study, less directly related, in the 'France, Savoy, Piedmont' sketchbook (1802; TB LXXIII, 35). Unless there was also a foreground study, now lost, Turner composed that zone while painting the large finished version, relying on his well-stocked visual memory for natural phenomena.

Unlike his *Glacier and Source of the Arveyron* which appeared at the Royal Academy in 1803, just before Walter Fawkes acquired it, this equally large and impressive alpine scene rather surprisingly was not exhibited at the Royal Academy, apparently passing directly into Fawkes' rapidly growing Turner collection. Whether the artist may have shown the work in his own private 'Turner Gallery,' opened in 1804, remains uncertain. It did appear before the public in 1819, when Fawkes showed his large watercolor collection (over sixty Turners) at his Grosvenor Place town house.

enough to accommodate two sheep and a solitary, deftly rendered shepherdess.

The work derives directly from a somewhat larger watercolor sketch (Courtauld Gallery), on a sheet taken from his 'St Gothard and Mont Blanc' sketchbook (TB LXXV), used on the artist's 1802 tour of Switzerland. As was often the case, Turner enlarged the scale of nature in the finished version and uses a wider range of color, very subtly gradated. He also reduced the considerable foreground slope to a mere sliver. The work markedly contrasts with his large view of the same falls exhibited at the Royal Academy in 1804 (Cecil Higgins Art Gallery), which presents the scene frontally, in a near symmetrical composition. The disposition of the main masses in the Yale watercolor curiously recalls that of his early Lake District watercolor, *Falls of Lodore and Derwentwater* (*c.* 1801; Private Collection), made about a year before his Swiss tour. By 1819, the present work had passed into the collection of Walter Fawkes, who may have commissioned it, and who also owned the large upright version of 1804.

Joseph Mallord William Turner (1775–1851)
I.19. Patterdale (*c.* 1810–13)
Watercolor and scratching out 11 × 15 (27.9 × 39.3)
Inscr. *JMW Turner RA PP*, lower left
B1975.4.1618 PLATE 99

Turner offers here a very dramatic rendering of the old church and surrounding countryside of Patterdale, which lies at the foot of Helvellyn, the third highest mountain in the Lake District. He invests the scene with a terrific storm, complete with a dazzling bolt of lightning, not unlike the one energizing his earlier

Joseph Mallord William Turner (1775–1851)
I.18. Upper Falls of the Reichenbach (*c.* 1815)
Watercolor heightened with white over pencil
11 × 15½ (27.9 × 39.3)
B1977.14.4702 PLATE 12

This dramatic view of the famous waterfall in the Bernese Oberland, is one of the most luminous and daringly composed of Turner's watercolors from the 1810s. One is especially struck by the superbly evanescent rainbow and brilliantly executed waterfall. Also, the high, oblique viewpoint plays up the sublime vastness of the rock mass next to the falls, which not only extends deeply into the picture but also beyond the frame on the left – as it were 'behind' the viewer. The main masses are audaciously off center, while the vertiginous foreground is radically minimal, just

99. (I.19) Turner, *Patterdale*

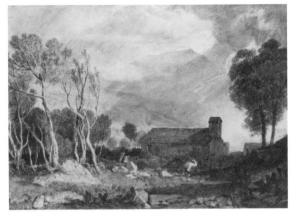

'sublime' mountainscape, *The Lake of Thun, Switzerland* (*c.* 1806; Private Collection; engr. 1808 for the *Liber Studiorum*). Despite his love of mountain scenery, Turner did not paint very many finished watercolors or oils of the Lake District, in contrast to a number of his contemporaries. The present work appears to be the first such scene he had painted since his *Falls of Lodore and Derwentwater* (Private Collection) of 1801, not counting two country house views of Lowther Castle in Westmorland painted in 1810. The work is his only Lakeland view which does not include a lake or waterfall, and contrasts with his earlier watercolor, *Patterdale* (*c.* 1797–8; untraced), which featured Ullswater in the middle distance. A print of this lost work appeared in Mawman's *Excursion to the Highlands of Scotland and English Lakes* (1805; 209). The present watercolor derives from his 1797 tour of the Lakes, though the only two extant Patterdale sketches, in the 'Tweed and Lakes' sketchbook (1797; TB XXXV; 44, 45), do not record this scene. Apparently the work was never publicly exhibited in Turner's lifetime.

The church represented is typical of the small, unpretentious places of worship built in the Lakes, having a somewhat homemade appearance – 'built first and architected after', as a local phrase had it. It was pulled down to make way for a new church soon after Turner painted it.

100. (I.20) Cristall, *Mountainous Landscape*

Varley's more panoramic, almost Friedrich-like view of receding, mist-veiled mountain ridges entitled *Sunrise from Cader Idris* (1804; Miss Scott-Elliot, C.V.O.). Cristall was very much a part of the Varley circle during the first decade of the century.

The present watercolor is as much a cloud study as a mountain view, and relates to several undated cloud sketches in watercolor by Cristall, including three in the National Gallery of Scotland, one of which is entitled *A Cloudy Sky over a Ridge*.

Joshua Cristall (1768–1847)
I.20. Mountainous Landscape (*c.* 1802–20)
Watercolor over pencil $10\frac{1}{16} \times 15$ (25.4 × 38.1)
B1975.4.1107 PLATE 100

Cristall made a number of watercolor sketches of mountainous scenery particularly during the first half of his career, before he moved to Goodrich, Hereford. Most if not all of them derive from his several trips to mountain regions, namely, Wales in 1802, 1803, 1820 and 1831; the Lake District in 1805; and Scotland in 1818. Precise dating is difficult. Several were exhibited in the large Cristall retrospective held at the Victoria & Albert Museum in 1975 (see Basil Taylor, *Joshua Cristall*, 1975; Nos. 130–2, 134, 146). The present sketch, presumably made on the spot, is unusual in its viewpoint, being from the desolate upper reaches of a mountain ridge, looking down on a dense mass of bright clouds and a distant mountain peak. The novel effect of looking down on clouds makes the viewer feel all the more elevated. Cristall, to be sure, was not the first watercolorist to make a view from part way up a mountainside: witness Thomas Hearne's arresting *View from Skiddaw over Derwentwater* (1777) at Yale or John

Anthony Van Dyke Copley Fielding (1787–1855)
I.21. Scene on the coast, Merionethshire, storm passing off – Landing cattle on the Sands (1818)
Oil on canvas $53\frac{1}{4} \times 78\frac{1}{4}$ (135.2 × 198.8)
B1973.1.16 PLATE 24

This large oil by Copley Fielding, who was primarily a watercolorist, is one of his most expressive landscapes. Seldom if ever has Welsh mountain scenery presented so 'sublime' an appearance in the work of any British artist. Fielding exhibited this stirring scene in northern Wales, near Tremadoc, early in 1819 at the British Institution, where it formed a striking contrast with his equally large but thoroughly Claudean exercise in pastoral beauty, *Caernarvon Castle* (1818; National Museum of Wales), showing the versatile range of his art. The previous year he had shown a watercolor with the same title at the Old Water-Colour Society. The sublime effect partly results from the vast scale of the mountains – greater than in actuality – and partly from the extremely dramatic sky, with its spectacular spreading light effect. While the mundane objects in the foreground, including an unexpectedly large two-masted boat and a group of cattle, offer relieving contrast to

the majestic mountains, they do not undermine the overall sense of sublimely engulfing spaces. Surely, here is 'mountain glory' with a vengeance.

The dark palette and broad brushwork strongly recall some of Turner's earlier works, such as *Dolbadern Castle* (1800; RA) and particularly *Trout Fishing on the Dee* (1809; Cincinnati Art Museum). Fielding, indeed, frequently painted works reminiscent of Turner. I have so far found no sketches or studies for this work, though most likely it was based on some preparatory material gathered during his 1808 tour of Wales. Besides making the mountains vaster than they actually are, Fielding relocates the battered tower of Dolbadern Castle — in reality miles inland — thus adding a touch of ruin sentiment to mountain sublimity.

George Fennel Robson (1788–1833)
I.22. Loch Coruisk, Isle of Skye (*c.* 1826–32)
Watercolor, body color, scraping and gum 17 × 25 (45.1 × 65.4)
B1977.14.6254 PLATE 101

No late Georgian landscape painter loved Scottish mountains more than George Fennel Robson, who exhibited a great many Highland scenes at the Old Water-Colour Society between 1813 and 1833. He first visited Scotland in 1810, when he made views for his *Scenery of the Grampian Mountains* (1814), comprising forty soft-ground etchings after his work. He soon became highly renowned for his pictorial celebrations of 'the sublime scenery of the Scottish Alps'. The present work is one of six views of Loch Coruisk he exhibited at the Old Water-Colour Society between 1826 and 1832, though just which one remains uncertain. He appended to three of the versions lines from

101. (I.22) Robson, *Loch Coruisk, Isle of Skye*

Sir Walter Scott's *Lord of the Isles* (1814), referring specifically to the 'rude and wild' mountain ridges around Loch Coruisk, 'so sublime in barrenness' (Canto III, stanzas 13–14). The largest version is in the Victoria and Albert Museum, and prominently includes in the foreground the fourteenth-century Scottish heros, Robert the Bruce, Ronald and a follower. In the Yale version the only signs of life are a few inconspicuous goats.

The jagged, sharp ridges of the Cuillin mountains dramatically stand out against a glowing sky in a way that is strikingly similar to Francis Danby's almost surreal *Mountains with Afterglow* (*c.* 1824–5; Private Collection); however, Robson's awareness of that unexhibited watercolor would seem less than likely. Compositionally, *Loch Coruisk* is particularly close to Danby's slightly later watercolor, *Llynydwal, North Wales* (*c.* 1827–8?; Whitworth Art Gallery). Actually, Robson had already boldly exploited this compositional format — an amphitheater-like array of steep mountains — in his early watercolor, *Loch Avon* (*c.* 1810–12; untraced), reproduced in his *Scenery of the Grampian Mountains* (1814). His early mentor, John Varley (with whom he was in close contact between 1804 and *c.* 1808/9), had several times used a basically similar compositional layout, though less boldly. See, for example, his *Lynn Ogwen, North Wales* (*c.* 1804; Lupton Collection). Also ultimately Varley-like is the generalized treatment of the more distant mountains as well as the rather arbitrary but effective tonality.

Sir Edwin Landseer (1802–73)
I.23. A Highland Landscape (*c.* 1824–35)
Oil on board 8 × 10 (20.3 × 25.4)
Inscr. *EL*, lower left
B1981.25.400 PLATE 102

Popularly known as a painter of animals, often with human-like traits, Landseer here shows his fine gift for landscape. Such works remained unknown to the public in his lifetime, and even in our century were seen by very few until the Landseer retrospective at the Royal Academy in 1961. Over a hundred small landscapes were in the artist's studio at the time of his death. Most of those surviving today deal with Scottish Highland scenery. The artist first visited the land of Sir Walter Scott in 1824, a tour highlighted by a stay at the great novelist's home, Abbotsford. Landseer completely fell under the spell of Scotland and paid return visits almost every fall. From 1825 on, he generally stayed at Glenfeshie in the Cairngorms, as a guest of his intimate friend, the Duchess of Bedford.

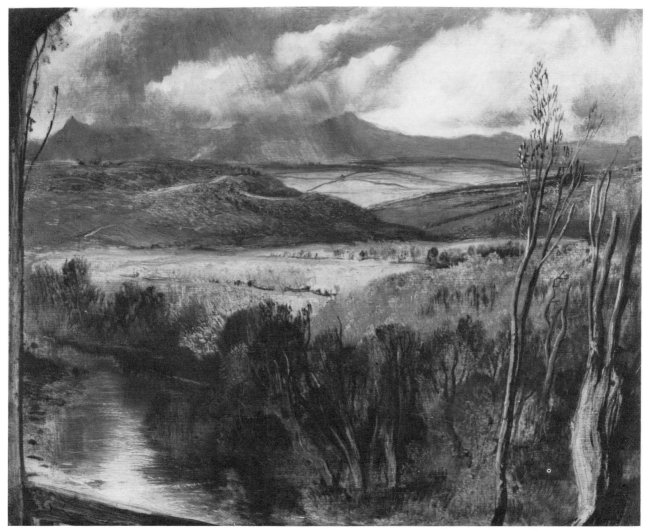

102. (I.23) Landseer, *A Highland Landscape*

Judging from the few dated Highland views, the majority of the landscapes appear to have been painted between 1824 and 1835. Landseer's style changed very little between the early 1820s and the late 1830s, his best period. The Yale mountain view is similar to both *A Highland Valley* (Private Collection) of 1824 and *The Eagle's Nest* (V&A) of 1833. As in a number of others, there is a complete absence of human figures and animals. The precise locale remains unidentified, but is most likely somewhere in or near the Cairngorms.

As Richard Ormond observed in his recent *Sir Edwin Landseer* (1981), all of the landscapes 'were painted very rapidly . . . and it is impossible to believe that they were not painted out-of-doors in front of the motif' (p. 91). Some of them, such as *Loch Avon* (c. 1833; TG), with its forceful light and dark contrasts, evoke a powerful sense of drama and suggest a general awareness of Turner, short of any close dependence. A rather unusual feature of the present work is the immediate foreground, especially the vertically sliced, enframing tree on the far left, rising the full height of the composition.

II. Coastal Scenes

John 'Warwick' Smith (1749–1831)
II.1. Bay Scene in Moonlight (1787)
Watercolor $13\frac{3}{8} \times 20$ (34 × 50.8)
Inscr. *J Smith 1787*, lower right
B1977.14.4383 PLATE 103

A taste for moonlit rocky coasts existed both on the continent and in England during the later eighteenth century, as evidenced by the popularity of examples by Vernet, Volaire and Wright of Derby. On the other hand, very few watercolor specialists before Smith painted a moonlit coast. The locale of the present work has never been identified and very likely is a partly invented, composite view, freely inspired by recollec-

tions of actual rocky coasts seen either on his Italian tour of 1776–81 or on his numerous tours of Wales, five of which occurred between 1784 and 1788. The huge, rugged rock masses looming darkly on the right and the severe barrenness of the rest of the foreground give the scene an eerie, forbidding aspect which contrasts with a number of calm, moonlit coasts by the above artists.

Part of the power of the work resides in the dramatically illuminated sky, despite the fact that the clouds are rather crudely modelled. The reflected moonlight on the slightly rippled water surface is highly accomplished. Smith is also masterly in his rendering of the two boats, especially their sails. The presence of draped

103. (II.1) Smith, *Bay Scene in Moonlight*

female figures seems a bit anomalous, but they do give a sense of scale.

Francis Nicholson (1753–1844)
II.2. Scarborough: Shipwreck at the Foot of the Castle Cliff (c. 1808–11)
Watercolor $11\frac{3}{4} \times 16\frac{1}{2}$ (29.8 × 41.9)
Inscr. Verso: *Francis Nicholson Scarborough*
B1977.14.5456 Plate 15

Scarborough was not only a fashionable spa in Nicholson's day but also the scene of many a shipwreck. Nicholson, like Vernet and De Loutherbourg before him, places his stricken ship close to a rugged coast populated with frantically gesturing onlookers, but he is less theatrical than his predecessors, refraining from introducing such sensational effects as lightning bolts flashing through a highly wrought, turbulent sky. Moreover, we view the event safely from a broad, stable pier, rather than from a precarious, rocky outcrop, such as he will later exploit in his more Vernet-like shipwreck of 1813, painted for Sir Richard Colt Hoare of Stourhead (and still there). Curiously, no British or continental artist painted an open-sea shipwreck before Turner's *Shipwreck* (TG) of 1805.

Nicholson exhibited a Scarborough shipwreck scene on three occasions at the Old Water-Colour Society: 1805, 1808 and 1811. Two of these are probably the large watercolors in the Victoria & Albert Museum, one of them dated 1803. Another large version was recently on the London market (Christie's, March 16, 1982, Lot 73). The present work is essentially a scaled-down variant of the 1803 version, with an entirely different figure group in the foreground. A lithograph of this composition, but without a shipwreck, was published by Nicholson in his *Six Views of Scarborough*, 1822.

Benjamin West (1738–1820)
II.3. The Bathing Place at Ramsgate (c. 1787–8)
Oil on canvas $14 \times 17\frac{1}{2}$ (35.5 × 44.5)
B1976.7.159 Plate 41

West's painting is one of the earliest known representations of an English bathing resort by a major artist. Sea-bathing had rather quickly come into vogue in England during the later eighteenth century, a half century before it did on the continent. Ramsgate, on the southeast coast near Dover, was one of the leading seaside spas, along with Margate, Brighton, Weymouth and, in the north, Scarborough. It possessed such obligatory attractions as an assembly hall, reading room and lending library, coffee houses and, of course,

bathing facilities. West's lively view includes several of the fashionable, horse-drawn 'bathing machines' which had become *de rigeur* for any self-respecting coastal spa. The dominant interest, however, lies in the skilfully varied figures who reflect the wide spectrum of social types attracted to places like Ramsgate. The massive cliff on the right, with its flat, masonry-like surface, adds a bold and novel touch. The work probably derives to some extent from a sketch made on a visit to Ramsgate, though I have not yet come across one. Pertinent, however, is an on-the-spot pencil sketch by West at Yale, *Margate Bathing Machines*, dated 1767, which depicts an earlier form of the 'machine' (a dressing hut on wheels devised by the Quaker, Benjamin Beale, of Margate). Whether West visited nearby Ramsgate that year (1767) is not known. In any case, the style of the costumes in the painting points to the 1780s.

The painter must have been fond of this work, as he hung it on one of the walls of his London house for many years. William Burch engraved it in 1789, and two years later this print version appeared in *Delices de la Grande Bretagne*.

Landscapes occupy only a small portion of West's large oeuvre, which mainly comprises historical, mythological and religious subjects, in keeping with the academic hierarchy of genres which West upheld no less than Reynolds. Yet, we should not forget that some twenty of the artist's exhibits at the Royal Academy between 1785 and 1808 were landscapes. The young Constable felt that the best advice he ever received on chiaroscuro, in the context of landscape, came from West, above all his comment, 'Aways remember, sir, that light and shadow never stand still' (C. R. Leslie, *edn. cit.*; 14).

Thomas Girtin (1775–1802)
II.4. Lyme Regis, Dorset (c. 1797)
Watercolor $8\frac{3}{4} \times 17\frac{1}{8}$ (22 × 43.2)
B1975.3.150 Plate 16

This expansive bird's-eye view of the receding, irregular coastline near Lyme Regis in southwest England is one of the most attractive of Girtin's few coastal scenes. Francis Hawcroft has suggested in his bicentennial exhibition catalogue, *Thomas Girtin* (V & A, 1975; 39) that it may have been the work shown at the Royal Academy in 1798 under the title, *Coast of Dorsetshire*. However, part of the foreground does not appear altogether finished – according to standards of that time – making this writer favor the earlier opinion that *The Coast of Dorset near Lulworth Cove* (c. 1797–8; City

Art Gallery, Leeds), a decidedly finished work, has a stronger claim. In any case, the present watercolor – made or begun on-the-spot? – resulted from the artist's tour of southwest England in 1797.

Girtin's high vantage point, which affords a panoramic vista, is not often encountered in turn-of-the-century coastal scenes by his contemporaries. However, he may have been stimulated by John Robert Cozens's similarly composed view, *The Adriatic Coast near Rimini* (*c.* 1783–4; Besterman Collection), the study for which – in Volume I of the Beckford Sketchbooks (Whitworth Art Gallery) – he could have seen at Dr Monro's house, where he was employed to copy Cozens and other masters in the mid 1790s. Like the Cozens seacoast, a work of sweeping simplicity, Girtin's Dorset coast is completely free from any of the picturesque staffage so popular at the time. In this, it sharply contrasts with his contemporary *Windmill by the Coast* (*c.* 1797; Lady Lever Art Gallery), which is still conventionally picturesque.

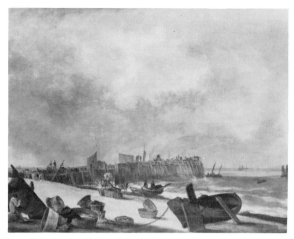

104. (II.6) Crome, *Yarmouth Jetty*

Thomas Girtin (1775–1802)
II.5. An Unidentified Estuary (*c.* 1797?)
Watercolor $11\frac{1}{8} \times 17\frac{1}{2}$ (28.3 × 44.5)
B1975.3.1024 PLATE 17

As in his *Lyme Regis, Dorset* (No. II.4), Girtin adopts a high vantage point, resulting in a vast panorama. The lateral expansiveness of the ground plane recalls certain landscapes of the seventeenth-century Dutch artist, Phillips Koninck, though the resemblance may be fortuitous. Again, the artist offers a view that is emphatically devoid of any stock picturesque elements, such as corner tree clumps, nearby quaint cottages or busy figural activity (often amidst shaggy animals). The immediate foreground is left nearly blank, with only a thin wash over it, suggesting the watercolor is not entirely finished and is perhaps an on-the-spot study.

The precise locale represented remains a mystery. Various suggestions have been made, including Porlock (Somerset) and Sandsend (Yorkshire). The style of the watercolor points to a date around 1797–8, as Christopher White observed in *English Landscape 1630–1850* (YCBA, 1977; 66). Such a dating links the work with Girtin's 1797 tour of Dorset and Devon. Moreover, its compositional layout is very similar to that of *Coastal Scene* (Earl of Harewood), which is datable 1798.

John Crome (1768–1821)
II.6. Yarmouth Jetty (*c.* 1808–9)
Oil on canvas $39 \times 49\frac{3}{4}$ (99.1 × 126.4)
B1973.1.8 PLATES 40 (detail) and 104

The present work is the largest of at least three surviving versions of nearly the same view which Crome painted probably between 1807 and 1810. One of the others is at Yale, while the remaining one (the smallest) is in the Norwich Castle Museum. A pencil study of the jetty (including several horse carts) is in the British Museum, perhaps datable *c.* 1806–7. This large version differs from the other two mainly in showing more of the sloping sandy beach, with an entirely different arrangement of boats, baskets and fishermen upon it. Also, the cloudy sky is allotted much more space and the handling of color throughout is more subtle than in the smaller Yale version. Unfortunately, the painting is not in the best condition. The surface paint is quite thin; indeed, the beach partially shows through the stern of the foreground boat. A three-quarter size replica of this large version, formerly attributed to Crome, is in the Williamson Art Gallery at Birkenhead. It is a nearly exact copy, save for the presence of a bulky fishing boat on the left, and an anchor (in place of two baskets). This boat once appeared in the Yale painting, but was painted over, leaving a faint shadow still visible. The anonymous copy also suggests that the present, original version has been trimmed about an inch on each side and at the bottom.

Yarmouth Jetty was a favorite coastal motif of Crome. Of the twelve Yarmouth scenes he exhibited at the Norwich Society of Artists between 1807 and 1819, at least six featured the jetty, sometimes viewed

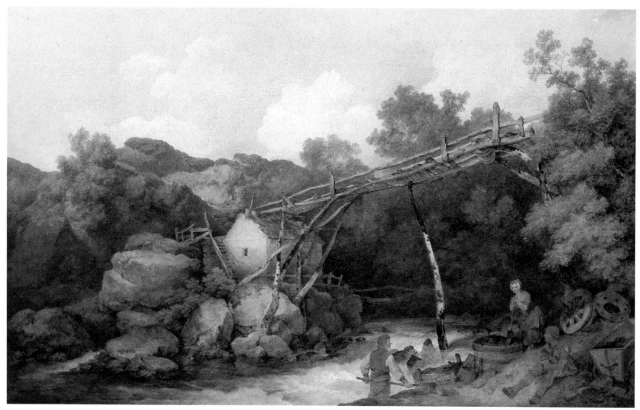

105. (V.2) De Loutherbourg, *View near Matlock, Derbyshire*

from the north, as in the superb version of *c.* 1809–10 (NCM), with its conspicuously silhouetted rectangular sails, so Cotman-like in their abstract flatness. The 'modernity' of his Yarmouth coastal scenes becomes apparent when we compare them with the occasional seacoast by his Norwich contemporaries (other than Cotman), such as Robert Ladbroke's *Mackerel Market, Yarmouth Beach* (1810; NCM), so conventionally Dutch looking both in its composition and its anecdotal emphasis.

William Henry Stothard Scott (1783–1850)
II.7. View of Brighton (1817)
Oil on canvas $21\frac{1}{4} \times 28\frac{1}{4}$ (54 × 71.75)
Inscr. Verso of original canvas: *William Scott 1817* (Dealer Note)
B1976.7.152 PLATE 106

In contrast to most late Georgian coastal views of Brighton, which focus on the fashionable Marine Parade and Esplanade, Scott's view shows part of the unfashionable east end of town as seen from a desolate, rocky spot on the coast, occupied by three locals. One would never guess from this work that Brighton was

at this time the supreme seaside resort and pleasure town in the British Isles. Be that as it may, the untypicality of the viewpoint in itself adds to the interest of the painting. One is also struck by the singular contrast between the dark, rugged foreground and the lightly-toned geometric shapes of the dense townscape in the middle distance. The artist's subtle sense of color likewise deserves mention, especially the very delicate atmospheric tones used in the skilfully drawn buildings. The wind-blown surf is well captured, and his rendering of highly varied clouds at different levels comes off rather better than is often the case with many other minor artists of the time.

We know very little about William Scott. He resided at Brighton during much of his life, painting mainly Sussex and Surrey views. Between 1810 and 1833, he exhibited eleven works at the Royal Academy, the majority being watercolors. In 1810 he was elected an associate of the Old Water-Colour Society, where he showed a total of two hundred and twenty nine works over the next forty years. In the 1820s and 40s, his subjects included some northern French scenes. He also published a set of six *Etchings on Stone* in 1813. Oil paintings by Scott are quite rare.

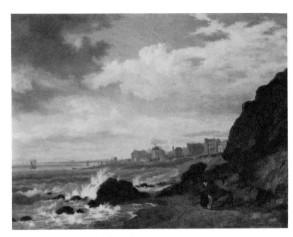

106. (II.7) Scott, *View of Brighton*

John Varley (1778–1842)
II.8. Harlech Castle and Twgwyn Ferry (1804)
Watercolor over pencil with touches of white body-
color $15\frac{5}{8} \times 20\frac{1}{4}$ (39.25 × 51.5)
Inscr. *J. Varley. 1804*, lower left
Lent by Mr Paul Mellon PLATE 22

This distant view of one of the major Welsh castles
built by Edward I in 1283–9, following his conquest
of Wales, exploits nearly the same vantage point as that
of Turner's twilight view painted five years earlier
(No. II.9). Varley, however, shows the Traeth Mawr
estuary at low tide instead of high, and does not
include any rocky promontory for the foreground. His
view is more a straight-forward, topographical one,
yet at the same time effectively simplified thanks to its
sweeping 'Girtinian breadth'. He does not aspire to
Turner's poetic evocativeness and softly luminous
atmosphere, offering instead a day-time scene with
several figures and animals going about their business
under a blustery sky. But the staffage is kept to a
minimum, and the over-all effect is one of expansive-
ness, consistent with a principle he was later to arti-
culate in his *Treatise on the Principles of Landscape Design*
(1816–21).

The watercolor is probably the work of the same
title shown at the first exhibition of the Old Water-
Colour Society in 1805. Another work with this title
appeared the very next year at the Old Water-Colour
Society, and in 1810 he exhibited a watercolor entitled
Harlech from near Twgwyn, both of these presumably
variants of the present view. Varley exhibited many
other views of the castle from different viewpoints;
those dating after 1810 are conventionally picturesque.
In 1805, William Delamotte painted – perhaps in

rivalry with Varley – a large watercolor, *Harlech Castle
from Traeth Mawr Sands* (Christie's, April 20, 1971, Lot
74), which adopted exactly the same viewpoint as that
of the present work, and similarly showed the estuary
at low tide. Delamotte, however, introduced more
foreground activity, which lessens the simplicity and
breadth that Varley valued.

Joseph Mallord William Turner (1775–1851)
**II.9. Harlech Castle, from Twgwyn Ferry,
Summer's Evening Twilight** (1799)
Oil on canvas $34\frac{1}{4} \times 47$ (87 × 119.5)
B1977.14.76 PLATE 21

When Turner exhibited this evocative coastal scene at
the Royal Academy in 1799, he appended to the title in
the catalogue an 'elevating' passage from Milton's
Paradise Lost (Bk. VI):

Now come still evening on, and twilight grey,
Had in her sober livery all things clad.
———————— Hesperus that led
The starry host brightest 'till the moon
Rising in clouded majesty unveiled her peerless light.

While no moon appears in the picture, one certainly
senses an expressive, poetic mood of twilit serenity and
benign calm pervading the whole scene. In this respect,
it sharply contrasts with the gaunt, rugged seacoast
(with castle ruin) that Turner exhibited the previous
year, *Dunstanborough Castle* (1798; National Gallery of
Victoria, Melbourne). The artist had sketched Harlech
Castle during his northern Wales tour in 1798; how-
ever, none of the seven extant on-the-spot pencil
sketches of the castle show this particular distant view.
The painting instead derives from a watercolor com-
positional study most probably made in the studio, con-
tained in the 'North Wales' sketchbook (TB XXXIX;
95) and inscribed on the back: 'Harlech Study for Ld.
Cooper's picture' (meaning the Fifth Earl Cowper).
One of the few noteworthy changes made in the paint-
ing is the introduction of a much more substantial
rocky outcrop in the foreground, a feature not present
in the actual scene which was a flat tidal estuary (see
Varley's 1804 watercolor of the same scene, No. II.8).
Perhaps Turner wanted more tonal and textural con-
trast in the foreground, as well as a more stable perch
for his very Wilsonian figure group. He also may have
had in mind the compositional effectiveness of that
added form, which sets up a zig-zagging sequence of
projecting triangular wedges in a rhythmic A–B–A
pattern. The highly unified character of the work owes
much to the warmly glowing light and atmosphere
that softly envelops everything.

At least one critic of the time, writing for the *Sun* (May 13, 1799) sensed the painting's individual character, observing that while there was a hint of Claude and Wilson, still, 'the landscape . . . wears an aspect of originality that shows the painter looks at Nature with his own eyes'. Certainly it stands apart from the popular Vernet-De Loutherbourg tradition of stormy, rocky coastal scenes as well as from the genresque seacoasts of Morland and Ibbetson, also much in vogue then.

Harlech Castle was one of four great royal strongholds in northern Wales designed by Edward I's remarkable French architect, Master James of St George, following the King's conquest of Wales in 1283. The other three are at Caernarvon, Conway and Beaumaris. Happily, Harlech was spared Cromwell's deadly artillery in the Civil War, as the cannons proved too unwieldy to negotiate the bad roads in the region.

Joseph Mallord William Turner (1775–1851)
II.10. Teignmouth, Devon (*c.* 1813)
Watercolor with some scratching-out
$5\frac{15}{16} \times 8\frac{3}{4}$ (15.1 × 22.2)
Inscr. *JMW Turner*, lower left
B1977.14.4716 PLATE 107

Like Nos. 11 and 12, this glowing, sunrise estuary scene was made for W. B. Cooke's *Picturesque Views on the Southern Coast* (1814–26). It dates from around 1813 (engr. in 1815), and was first exhibited nearly a decade later at the earliest of three annual watercolor shows held at Cooke's Gallery in 1822. The artist based the work on a two page on-the-spot pencil sketch ('Corfe to Dartmouth' sketchbook, TB CXXIV; 36–7) made

during his initial tour of Devon and Cornwall in 1811. The sketch, however, omits not only the foreground figures but also the ships on the left and the rising sun; further, it extends the view on the right. Turner also made an oil painting of the same scene, exhibiting it at his own gallery in 1812 (now at Petworth). This too includes less foreground staffage than does the slightly later watercolor, which offers a more picturesque effect.

Like Weymouth and Margate, Teignmouth had become in Turner's day a fashionable coastal resort. But again, the artist does not present this aspect, choosing instead a distant viewpoint that involves a workaday foreground with men unloading a boat on the left and a shipbuilding yard on the right, dominated by a prominently silhouetted skeletal hull that is almost apparitional in effect. The over-all spread of light is beautifully managed, and generates a 'poetic' atmosphere more subtle than that of the oil version or of several other contemporary paintings, such as *Hulks on the Tamar* (1812; Petworth).

Joseph Mallord William Turner (1775–1851)
II.11. Weymouth, Dorset (*c.* 1811)
Watercolor and scratching-out $5\frac{3}{4} \times 8\frac{5}{8}$ (14.7 × 22)
Inscr. *JMW Turner RA*, lower right
B1977.14.6297 PLATE 59

This luminous beach scene is one of forty coasts – possibly the earliest one – which Turner made for W. B. Cooke between *c.* 1811 and 1824, all of which were engraved for *The Picturesque Views on the Southern Coast of England* (1814–26). The view is towards the southwest, with Portland Bill in the distance. The text accompanying the print of this work in Cooke's publication enthusiastically describes Weymouth as:

> perhaps the finest shore for bathing in the world, a fine clear sea with a beautiful carpet of solid white sand, and an almost imperceptible declension; while its natural protection from the winds, by the surrounding hills, renders the sea so happily tranquil, as to invite the most timid to plunge into its waters.

Instead of emphasizing the resort town or the fashionable part of the beach with its 'bathing machines', Turner chose a stretch of shore removed from that tourist area, one occupied by a busy group of women tending fishing nets near a pair of beached boats (tilting gracefully). This work-a-day foreground, of course, pertains to a very different world than that of the elegant Regency buildings and Esplanade in the distance. The compositional structure of the scene is like a horseshoe on its side, accenting the evenly contoured, U-shaped

107. (II.10) Turner, *Teignmouth, Devon*

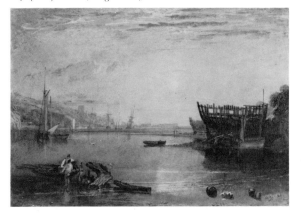

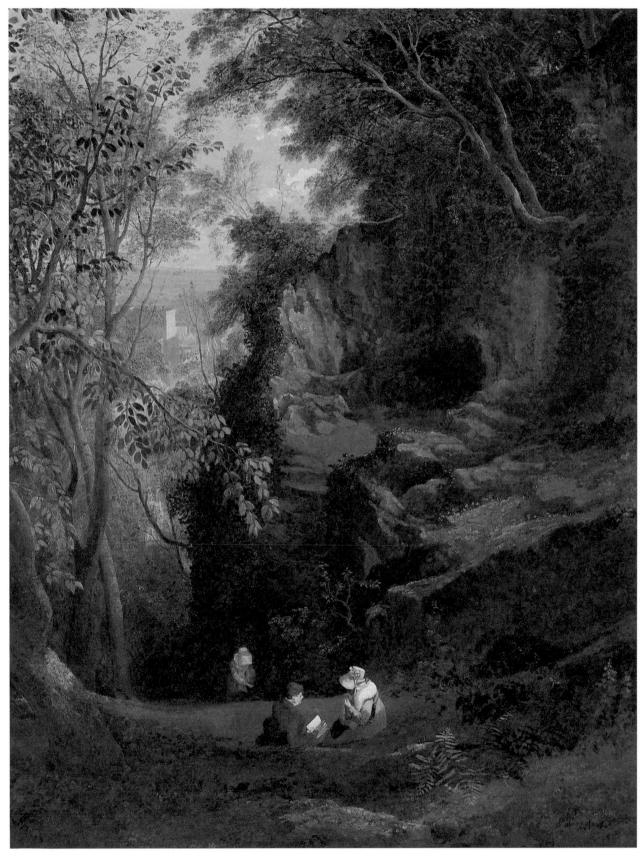

108. (IV.34) Danby, *Landscape near Clifton*

bay. The artist was to use much the same format in a later coastal scene of the same series, *Margate* (*c.* 1821–2; No. II.12).

Turner toured the varied coasts of Dorset, Devon and Cornwall in 1811, and his 'Corfe to Dartmouth' sketchbook (TB CXXIV) contains a pencil sketch on page 24 labelled 'Weymouth and Port' (the latter word probably meaning Portland Bill). The sketch was made from a different viewpoint than that of the present work, but surely was consulted by the artist when painting the watercolor. Turner exhibited the work, with twenty three other watercolors (mostly coasts), at W. B. Cooke's Gallery, Soho Square, in 1822.

Joseph Mallord William Turner (1775–1851)
II.12. Margate (*c.* 1821–2)
Watercolor with some scratching-out
$6\frac{1}{8} \times 9\frac{5}{16}$ (15.6 × 23.6)
B1975.4.965 PLATE 20

This particularly well-preserved watercolor is one of 40 which Turner made between *c.* 1811 and 1824 for W. B. Cooke, who with his brother George engraved all of them for his *Picturesque Views on the Southern Coast of England* (1814–26). As in his *Weymouth* of *c.* 1811, Turner places the viewer on a broad, curving beach at some distance from the brightly sunlit resort town which sprawls across nearly the whole horizon, above which is a thoroughly Turnerian, luminous sky. The foreground is full of bustling seamen who appear to be salvaging material from the battered hulk on the left. Once again we see Turner's penchant for working, rather than recreational, foregrounds in his Southern Coast series. His execution, in the ten years since *Weymouth*, has become freer and more spontaneous. The work derives from a double-page pencil sketch in the 'Hastings' sketchbook (TB CXXXIX; 16–17), datable *c.* 1816. Turner included the watercolor in the third and last exhibition of coastal scenes held at W. B. Cooke's Gallery in 1824.

Previously a port and fishing village, Margate in the late eighteenth century became a popular bathing resort, with all the requisite amenities, including assembly rooms, theater and lending library. Turner had visited Margate many times from an early age, and even bought property there in the early 1820s. By that time, Margate, owing to its convenient distance from the metropolis and easy access by steam packet, had become the preferred coastal resort of middle-class Londoners, being more 'adapted to the expenses of the intermediate than of the opulent classes of society', as William Daniell phrased it in 1824 (*Voyage Round Great Britain*, VII; 6).

Joseph Mallord William Turner (1775–1851)
II.13. Folkestone Harbour and Coast to Dover
(*c.* 1829)
Watercolor heightened with white with some scratching-out $11\frac{7}{16} \times 17\frac{7}{8}$ (28.8 × 45.4)
B1977.14.470 PLATE 25

Turner's blustery seacoast belongs to the most ambitious series of watercolors he ever made for engraving: *Picturesque Views in England and Wales*, issued by Charles Heath in twenty-four numbers (four views in each) between 1827 and 1838. J. Horsburgh engraved the present work in 1831. As in many views in the series, prominent figural activity animates the foreground, in this case, a group of men digging up kegs of contraband spirits under the supervision of coastguard officers (one of whom consults a map). Smuggling was still rife on Britain's southern shores in the early nineteenth century, even undergoing a resurgence in the late 1810s and 1820s, and Folkestone was particularly notorious. Turner's earlier watercolor, *Folkestone, Kent* (*c.* 1823; Taft Museum), part of his Southern Coast series, featured a group of smugglers about to bury kegs atop a cliff near the town. About the same time, he made two off-shore views of Folkestone for the abortive 'Marine Views' series, *Folkestone from the Sea* (*c.* 1822–4; BM) and *Twilight – Smugglers off Folkestone Fishing up Smuggled Gin* (1824; Private Collection), which again show smugglers in the foreground, now in boats. The present work is the only one of the four which sets the action on a sandy beach, with a series of receding chalk cliffs providing a dramatic backdrop. Turner's most recent sketching tour to the Kent coast was in 1821, when he made numerous pencil roughs of Folkestone and the nearby coast in his 'Folkestone' sketchbook (BM; TB CXCVIII), though as usual, none provided the full composition for the finished watercolor.

Joseph Mallord William Turner (1775–1851)
II.14. Port Ruysdael (1827)
Oil on canvas $36\frac{1}{4} \times 48\frac{1}{4}$ (92 × 122.5)
B1977.14.80 PLATE 26

Turner exhibited this dark, stormy seacoast – his first important marine (in oil) since *The Entrance of the Meuse* (TG) of 1819 – at the Royal Academy in 1827. The purely imaginary title was doubtless meant as a tribute to his Dutch predecessor, Jacob van Ruisdael, some of whose works (including marines) had attracted him since his 1802 visit to the Louvre (see his *Studies in the Louvre Sketchbook*, 1802, BM; TB LXXII; 22a–23). Turner would again honor the Dutchman in 1844,

when he exhibited *Fishing Boats bringing a Disabled Ship into Port Ruysdael* (TG). As for possible sources among Ruisdael's work, a coastal scene which is much closer in both subject and composition to the above picture than the oft-cited *Storm on the Dutch Coast* in the Louvre is *A Rough Sea* (*c.* mid 1650s; Private Collection; color reproduction in Seymour Slive's excellent exhibition catalogue, *Jacob van Ruisdael*, Fogg Art Museum, 1982). The work first entered an English collection in 1824, when Lord Liverpool (the Prime Minister) purchased it. Conceivably, Turner may have seen it sometime during 1824–7; in any case, the considerable degree of resemblance, with respect to the choice and layout of the main elements, would appear rather more than pure coincidence. Of course Turner's palette and brushwork is very much his own. Also, the intensely dynamic sky includes some unusually shaped clouds which exhibit a slightly 'phantasmagorical' look – an effect the artist will exploit more extravagently a decade later in his audacious *Hero and Leander* (1837; NG).

The painting was well received by the press, *The Literary Gazette* referring to it as in 'every way in the artist's best style . . . and excellent example in which the sober judgment of Turner is quite correct' (quoted by A. J. Finberg, *Life of J. M. W. Turner*, Oxford 1939; 301). A few years later, Ruskin, in Part II of *Modern Painters* (1846), went so far as to exclaim: 'I know of no work at all comparable for the expression of the white, wild, cold, comfortless waves of northern sea, even though the sea is almost subordinate to the aweful rolling clouds' (Sect. V, Ch. III; 37).

William Daniell (1769–1837)
II.15. Loch Scavig, Isle of Skye (*c.* 1815)
Watercolor $8\frac{1}{4} \times 12\frac{1}{4}$ (21 × 31.1) sight
Inscr. *W. Daniell*, lower left
B1975.3.815 PLATE 19

Daniell's frank pictorial record of a forbidding stretch of coastline in south-central Skye, near the Cuillin Hills, derived from the third of six sketching tours covering the entire coast of England, Wales and Scotland (1813–15; 1821–3). From the masses of on-the-spot sketches made, he selected three hundred and eight as bases for finished watercolors which in turn he engraved for his remarkably ambitious eight-volume work, *A Voyage Round Great Britain* (1814–25), the largest undertaking of its kind by one man at the time. A view of Loch Scavig appeared in Volume IV (1820; opp. p. 34), but was not based upon the present watercolor. The mood of the latter, however, is much the same as the engraved view, and Daniell himself vividly characterized this in his accompanying text:

Even with the advantage of bright and clear weather, the frowning grandeur of this savage and sterile scene spread a gloom over the spirits, which, for a time, was indescribably oppressive. It seemed as if nature had destined this spot for a solitude, which should defy the cheering influence of cultivation, and for ever mock the gladdening smile of a summer's sun. (p. 34)

In cloudy weather, 'every component feature . . . appeared so horrid, dark, dreary, cheerless, and inhospitable' as to seize a man 'with an access of melancholy which deprived him of all energy' (p. 35). In a subsequent passage, Daniell quoted Sir Walter Scott's apt lines: 'A scene so rude, so wild as this, / Yet so sublime in barrenness.'

Sir Augustus Wall Callcott (1779–1844)
II.16. Dead Calm: Boats off Cowes Castle
(*c.* 1817–18)
Watercolor $9\frac{3}{4} \times 18\frac{1}{2}$ (24.7 × 46.8)
B1977.14.5414 PLATE 109

Callcott's panoramic estuary scene, like much of his early work, recalls seventeenth-century Dutch painting in a general way, however much it was inspired by a specific locale. The artist painted this at a time when he was especially interested in estuaries and harbors, judging from the four major paintings he exhibited at the Royal Academy between 1816 and 1820: *Entrance to the Pool, London* (1816), *Mouth of the Tyne* (1818), *Rotterdam* (1819) and *Dead Calm on the Medway* (1820). Dr David Brown, of the Ashmolean Museum, Oxford, kindly informed the writer that the watercolor is a replica by Callcott of an oil painting made in 1817 for Sir Charles Heathcote, one which only came to light again in 1979 at a Sotheby auction when it was bought by a London dealer. A second oil version by the artist, now at the National Maritime Museum, Greenwich, dates from 1827 and was exhibited that year at the Academy.

109. (II.16) Calcott, *Dead Calm: Boats off Cowes Castle*

110. (II.17) Prout, *The Cornish Coast*

Brown believes that the present watercolor relates to the first version (of 1817), adding that Callcott several times made watercolor replicas of his oils.

This type of scene is analogous to some of the more panoramic of Turner's Rhine watercolors, made in 1817, such as *Mainz and Kastel* (Private Collection) and *Johannesberg* (BM), with their low, wide-angle viewpoint and mood of total calm. Callcott was an admiring friend of Turner and not infrequently influenced by him. We might add that Turner's magnificent *Dort* (1818; YCBA), in turn, was at least partly prompted by a competitive desire to 'outdo' Callcott's much admired *Entrance to the Pool of London* (Bowood), exhibited at the Royal Academy two years earlier.

Samuel Prout (1783–1852)
II.17. The Cornish Coast (*c.* 1812–18)
Watercolor $13\frac{1}{4} \times 20\frac{3}{16}$ (33.9 × 51.3) sight
B1975.4.1953 PLATE 110

Prout was fond of coasts, especially those of Cornwall and his native Devon, frequently sketching or painting them in his earlier years, before he began specializing in the picturesque architecture of old continental towns following his first tour abroad in 1819. Many of his coasts are modest, undramatic records of fishing boats and fishermen on a flat sandy beach, sometimes colored on the spot. The present example, however, is highly dramatic in effect, with its dark and massive grotto-like foreground through which one views a luminous seacoast with a large beached vessel unloading goods onto several carts. The exact location is unknown, but a version of this watercolor (Sotheby, 1981) is inscribed 'at Plymouth'. In 1814 the artist exhibited four Cornish coastal scenes at the Royal Academy. The Yale watercolor was not one of them, but probably dates from about that time or slightly later.

Anthony Van Dyke Copley Fielding (1787–1855)
II.18. Coast Scene with a Beached Boat
(*c.* 1819–22?)
Watercolor $7\frac{5}{8} \times 11\frac{9}{16}$ (19.4 × 29.4)
Inscr. *Copley Fielding*, lower left
B1975.4.1174 PLATE 111

135

111. (II.18) Copley Fielding, *Coast Scene with a Beached Boat*

Copley Fielding began to take a much more active interest in coastal scenes from 1816, when he visited Sandgate, near Folkestone, for the benefit of his daughter's health. The following two years, he spent some time at Hastings, and in 1829 he settled in Brighton, keeping a studio in London. In the 1819 exhibition at the Old Water-Colour Society fourteen of his entries were seacoasts, with such titles as *Sandgate Fishing Boats – from Nature*, or *Fishing Boats at Sandgate – from Nature*. Such coastal subjects continued to hold a prominent place in his oeuvre through the 1820s. On stylistic evidence, the present work could date as early as 1819 or 1820, though a slightly later date is equally possible.

The austere sparseness of the scene, painted with great economy of means, contrasts with Turner's pictorially richer and more dramatic Southern Coast watercolors which he produced in the 1810s and early 1820s. So too does it stand apart from the many coastal scenes by William Daniell. If our dating is not far wrong, the work anticipates some of the low-angle, flat beach scenes of Bonington and Francia, such as the former's superb *Coast at Picardie* (1826; Wallace Collection). At the same time, the broad, sweeping brushwork in the foreground shows a continuing debt to Girtin.

John Constable (1776–1837)
Assisted by John Dunthorne, Jr?
II.19. Harwich light-house (*c.* 1820–4)
Oil on canvas 13 × 20 (33 × 50.8)
B1981.25.140 PLATE 18

Constable's view of the old wooden lighthouse on the Essex coast near Harwich exists in three virtually identical versions. The other two, noticeably superior in quality to the present work, are in the Tate Gallery and

a Private Collection, one of which appeared at the Royal Academy in 1820. It is not known which was exhibited. The composition derives from an on-the-spot pencil sketch (V&A) made either in 1815 or 1817, or shortly before the lighthouse was rebuilt in a different form in 1817–18. The main new element in the painted versions is the active sky, full of bright, billowy cumulus clouds, which Constable had so delighted in from the later teens. He actually re-used this particular skyscape, cloud for cloud, in his three versions of *Yarmouth Jetty* (1822 and later; TG and Private Collections). In the present work, however, the rather dry, uninspired execution of the clouds and their lackluster surfaces suggest the possibility that it may not be by his hand and his studio assistant, John Dunthorne, Jr, may have had a part in it. The artist employed Dunthorne between May 1824 and 1829. In his Journal of 1824, he mentions offering as a gift to his Woodbridge patron, James Pulham, a view of Harwich Lighthouse and coast which Dunthorne packed and sent off on July 16th. (*JCC*, II, 363). The Yale version could well be the Pulham picture (see The Tate Gallery *Constable* Catalogue, 1976, for further discussion of the evidence).

The windmill-like lighthouse was maintained at the time by Constable's recent patron, General Rebow of Wivenhoe Park, whose house and landscaped grounds the artist had painted in 1816 (National Gallery, Washington). There is no evidence that Rebow was involved with any of the three versions.

Seacoasts never became a dominant theme in Constable's art, but an interest in such scenes emerged during his six-week honeymoon visit of 1816 to Osmington, on the Dorset coast, where he made several open-air oil sketches. In the mid 1820s, he painted many vivid oil sketches of the beaches at Brighton and Hove (see Nos II. 20 and 21), and in 1827, exhibited at the Royal Academy a 'six-footer', *Chain Pier, Brighton* (TG).

John Constable (1776–1837)
II.20. Hove Beach (*c.* 1824)
Oil on paper on panel $9\frac{1}{8}$ × $14\frac{1}{8}$ (23 × 36)
B1981.25.157 PLATE 27

Constable and his family made repeated visits to Brighton between 1824 and 1828, in the hope of improving the health of his wife, who suffered from pulmonary consumption (to which she succumbed late in 1828). He did not find Brighton very much to his liking, even referring to it in a letter of August 1824 as 'the recepticle of the offscouring of London. The magnificence of the sea, and its . . . everlasting voice is drowned in the din & lost in the tumult . . . and the beach is only

Piccadilly . . . by the sea-side.' (To John Fisher; *JCC*, VI; 171). However, he added later in the same letter that 'the breakers − & Sky − . . . have been lovely indeed and always varying'. This aspect of the place inspired a rich outpouring of open-air oil sketches painted directly on the beach at Brighton or nearby Hove, each one 'done in the lid of my paint box on my knees as usual' (Letter to Fisher, January 5, 1825; *Ibid.* VI; 189).

The present work is probably contemporary with two somewhat larger oil sketches of Hove Beach in the Victoria & Albert Museum, dated *c.* 1824 by Graham Reynolds in his 1960 catalogue (*op. cit.*; 170). As he states, Mr G. C. Beresford identified the scene as one looking from Hove Beach toward Worthing in the far distance, with Highdown Hill to the right and Cissbury on the far right. The Yale sketch, however, exhibits a warm sunset sky, while the execution in general is sketchier, with much scumbling in the foreground beach. No larger, finished version is known; in fact, Constable produced only one major Brighton scene for exhibition, his impressive *Chain Pier, Brighton* (1826−7; TG), shown at the Royal Academy in 1827.

John Constable (1776−1837)
II.21. Coast at Brighton, Stormy Day (1828)
Oil on canvas 6 × 10 (15.5 × 25.5)
Inscr. Verso, in the artist's hand:
> *Brighton, Sunday evening July 20 1828*
B1981.25.114 PLATE 112

This small but expressive oil sketch is one of many that Constable produced at Brighton between 1824 and 1828, working in the open air and using the lid of his paint box as a mini easel (see the preceding entry). Curiously, none of these brilliant on-the-spot oil sketches formed the basis for a larger, finished work, to our

knowledge. The majority appear to date from 1824, and generally stress the beach as much as the sea. Here, the sea and threatening sky − much of it slapped on with a palette knife − comprise most of the composition. Streaky strokes of blue-green in the middle of the sky create an illusion of falling rain, an effect played up still more in the well-known oil sketch, *Seascape with Rain Clouds* (*c.* 1824−8), now in the Royal Academy Diploma Gallery − a work which anticipates to an uncanny degree Courbet's *Marine* (1866; Johnson Collection, Philadelphia).

The ominous state of Maria Constable's declining health had become painfully apparent by the summer of 1828. Perhaps the artist's decision to sketch a stormy weather condition reflected his own dark anxieties and dread of the immediate future. The work is one of the last of Constable's Brighton oil sketches.

Richard Parkes Bonington (1802−28)
II.22. Near Quilleboeuf (*c.* 1826)
Oil on canvas $16\frac{1}{2} \times 20\frac{3}{4}$ (42 × 52.5)
B1981.25.49 PLATE 113

As in most of Bonington's numerous French coast paintings and watercolors of the mid 1820s, we view the scene from a very low angle, which has the effect of making 'our' space seem like an extension of the foreground. The artist lays out the sparse foreground parallel to the picture plane, keeping it − as so often − completely open ended. Three-quarters of the composition is allotted to the sky, one filled with bright, thinly spread-out clouds, skillfully managed. Below, several ships ride the calm surface of the Seine estuary, their sails beautifully rendered. The work is fairly close in style to the well known *On the Coast of Picardy* (1826; Wallace Collection). Bonington's penchant for an undramatic shore with minimal staffage is much in evidence here, and the result contrasts with the kinds of coastal scenes Turner celebrated, for example, in his Southern Coast series of forty watercolors (*c.* 1811−23) which the younger artist may have known via the engravings by the Cooke brothers (1814−24).

Bonington's many highly attractive seacoasts, usually executed with the greatest facility, struck a new note in European marine painting. Only Turner had painted anything remotely like them previously, around 1809 and 1810. A few of Bonington's late beach scenes such as his gloriously luminous *Pays de Caux* (1828; Wallace Collection) more clearly owe something to Turner, as well as to Copley Fielding (see the latter's Turnerian *Sunset off Hastings*, 1819; V&A).

112. (II.21) Constable, *Coast Scene at Brighton, Stormy Day*

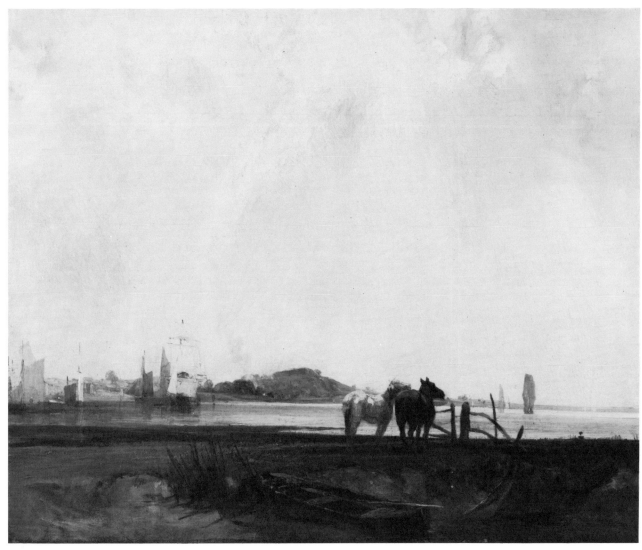

113. (II.22) Bonington, *Near Quilleboeuf*

Richard Parkes Bonington (1802–28)
II.23. Fish Market, Boulogne (*c.* 1824)
Oil on canvas 32 × 48 (81.25 × 122)
B1981.25.20 PLATE 60

Bonington's luminous coastal scene is one of many
paintings and watercolors that he made of the northern
French coast during his meteoric but tragically brief
career. He had made sketching tours of that area in
1821 and 1823, when he no doubt made one or more
on-the-spot sketches (untraced today) which formed
the basis of the present work. The size and careful finish
of the picture suggest the possibility that it was one of
the four oils exhibited at the epoch-making Paris Salon
of 1824, under the title, *Marine. Des pecheurs debarquent
leur poisson.* If so, then it contributed to the artist being
awarded a gold medal, along with Constable, Copley

Fielding and Charles Thomson of the eighteen British
artists represented that year with fifty-two works
(Lawrence was created a Chevalier du Légion
D'honneur).

Most of Bonington's French coast paintings are
sparsely populated beach scenes, like *Near Quilleboeuf*
(No. II.22). One of the few other seacoasts by the young
artist exhibiting a crowded foreground is *Coast Scene in
Picardy* (*c.* mid 1820s, Ferrens Art Gallery), also a fairly
large picture. Other versions of the Yale painting exist:
a small finished watercolor entitled *Retour de peche* (*c.*
1823–4) in the Louvre and an oil of about half the size
of the present work, in Lord Belper's collection. A
watercolor, attributed to John Thirtle, is in the Whit-
worth Art Gallery, University of Manchester and a
crudely painted variant appeared at Sotheby's of Bel-
gravia, October 3, 1972, Lot 162. All of these seem to

be copies after the Mellon painting, where the influence of his early master Francia is still evident.

George Vincent (1796–1832)
II.24. Harbour Scene, looking towards the Needles, Isle of Wight (1824)
Oil on panel $15\frac{3}{4} \times 22\frac{1}{4}$ (40 × 56.5)
Inscr. *GV 1824*, lower left, on stern of boat
(initials in monogram)

B1975.1.23 PLATE 114

Among the rich outpouring of coastal scenes by British artists in the 1820s, a number by the ill-fated Norwich artist, George Vincent, deserve to be more known, such as the present picture. This kind of subject interested him since 1817, when he exhibited a *Brighton Beach* (untraced today) at the Norwich Society of Artists. 1817 was also the year Vincent moved to London, for unlike most of his Norwich contemporaries, he spent his maturity in the metropolis, exhibiting there sixty-seven works (mainly at the British Institution) between 1814 and 1831, but continuing to show at the annual Norwich exhibitions (seventy-five works between 1811 and 1831). In 1821 he exhibited at Norwich his best-known coastal scene, the large *Dutch Fair, Yar-mouth Beach* (NCM), showing a dense array of varied figures interspersed among many beached fishing boats, rendered with much skill. The recently completed Nelson column in the background adds a contrasting touch of elegance. The Yale picture is a much more modest composition, but one nonetheless arresting in its frank and sober portrayal of an everyday dock scene. There is no record of any Isle of Wight scene being exhibited in Vincent's lifetime, but shortly after he died there appeared at the Society of Artists a small watercolor entitled, *The Needles from Christchurch* (1830; NCM). It remains uncertain just when Vincent visited the Isle of Wight. A seacoast quite similar in character to the present work is his *Fish Auction* (1828; NCM). The present view is taken from a point on the north-west coast of the Isle of Wight, looking over Alum Bay towards the Needles in the distance.

Vincent had studied with Crome, and was perhaps the most naturally gifted of that artist's many pupils. The latter part of his short life was plagued with acute financial difficulties. In fact, from December 1824 to February 1827, he resided in The Fleet, the debtor's prison in London. His health as well was less than robust. Even so, his output was large and included many commendable works which await a proper study.

114. (II.24) Vincent, *Harbour Scene, looking towards the Needles*

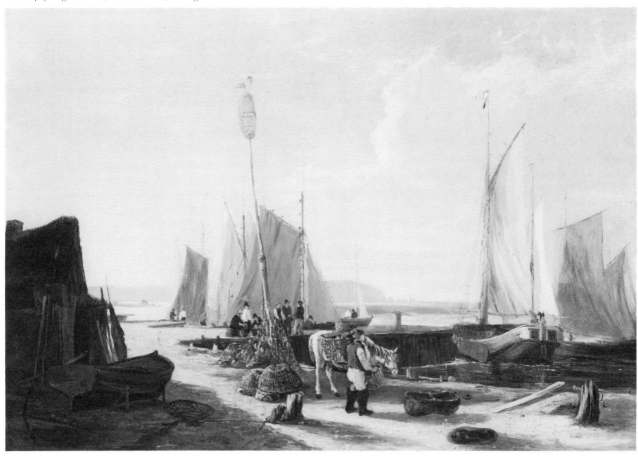

115. (II.25) Cotman, *Yarmouth Sands*

John Sell Cotman (1782–1842)
II.25. Yarmouth Sands (*c.* 1828–30)
Watercolor $11\frac{3}{4} \times 16\frac{5}{8}$ (29.8 × 42.2)
B1981.25.2418 PLATE 115

Cotman's low-angle view of a beached fishing boat (and two fishermen) on a lonely shore beneath a billowy sky derives from three pencil sketches (BM and ex P. M. Turner) made probably during his residence at Yarmouth, 1812–23. The finished watercolor, however, adopts a more close-up format. The liquid brushwork and relatively strong color point to the later 1820s (after the artist returned to Norwich at the end of 1823). As Christopher White observed (*op. cit.*; 103), the work is probably no later than 1830, when Cotman began adding a special paste to his watercolor medium – though by no means always. Although Cotman showed very little interest in coastal scenes during his early London years, 1798–1806, a fascination with this type of marine emerged in 1807, following his return to Norwich the previous fall. He exhibited several beach scenes at the Norwich Society of Artists between 1807 and 1810. Like the present work, these early examples – some

of them small oils such as *Boat on Yarmouth Beach* (*c.* 1807–10, NCM; a contemporary watercolor version in the V&A) or *Seashore with Boats* (*c.* 1807–10; TG), are boldly simple compositions focusing on one or two beached fishing boats. They stand apart from the more expansive coastal scenes by his Norwich contemporaries, such as Crome (see No. II.6) or Robert Ladbroke and others. During the 1810s, under the patronage of Dawson Turner, Cotman became preoccupied with delineating architectural antiquities, many of them engraved for his two most important publications, *Architectural Antiquities of Norfolk* (1818) and *Architectural Antiquities of Normandy* (1822). In the mid 1820s, however, his enthusiasm for coastal scenes revived, as beautifully evidenced by the impressive oil, *Dutch Boats off Yarmouth* (1824; NCM) and the luminous watercolors *Dutch Fishing Boats* (NCM) and *Yarmouth Beach* (NCM), both *c.* 1825. His talented elder son, Miles Edmund, shared this interest from the late 1820s, and Dr Miklos Rajnai has suggested that he may possibly have had some hand in the present work.

III. Ruin Landscapes

Richard Wilson (1713–82)
III.1. Caernarvon Castle (*c.* 1775–9)
Oil on canvas $25\frac{1}{2} \times 41\frac{1}{4}$ (65 × 104.8)
Inscr. *R. W.*, lower right
B1976.7.174 PLATE 116

As in a number of his other paintings of British scenery
– but by no means all – Wilson here reshapes the actual
topography and assimilates it to a neo-Claudean, 'classi-
cal' composition. Particularly traditional is the stage-
like foreground, complete with a curving tree and a cir-
cular body of water, beyond which looms a hill under
a serene sky – the whole scheme echoing a favorite
compositional layout of Claude Lorraine in the pre-
ceding century. Among the more obvious liberties
taken with the scene is the reshaping of the River Seiont
estuary into a circular inlet. Also, the hill east of Caer-
narvon appears larger and closer to the castle in the
painting than in reality. Typically, Wilson used the
same basic foreground in his so-called *Conway Castle*
(*c.* 1775–9?), also at Yale. In both, the artist is offer-
ing us a partly 'ideal' landscape – Wales seen through
Claudean eyes.

The present picture is one of two extant versions,
the other being in the National Museum of Wales. A
third version was last recorded in the collection of the
Hon. Mrs Walter Elliot of Hawick, Scotland. Wilson

116. (III.1) Wilson, *Caernarvon Castle*

had earlier exhibited a *Caernarvon Castle* at the Society
of Artists in 1766, a work untraced today. It remains
unknown whether it was compositionally similar to
the two extant versions. The Wilson scholar, David
Solkin, regards the Yale version as the latest one. If the
suggested dating is correct, then the painting is one of
Wilson's last efforts of high quality, much of his work
of the last five or six years of his life showing declining
powers.

Caernarvon Castle is the largest and least ruinous of
eight imposing castles built in north Wales for Edward
I, following his subjugation of the Welsh in the early
1280s. His architect was the remarkable Master James
of St George, from Savoy, who also designed the great
castles at Conway and Harlech. Most of Caernarvon
Castle was built between 1283 and 1291, with sporadic
work continuing until 1337. Some of the interior was
never actually completed. The fortress and town oc-
cupy the site of a former Roman town, Segontium.

Joseph Farington (1747–1821)
III.2. Caernarvon Castle (*c.* 1780?)
Oil on canvas $20\frac{3}{4} \times 28\frac{3}{4}$ (52.75 × 73)
Inscr. *Jos Farington*, bottom edge, right of center
B1976.7.118 PLATE 72

Caernarvon Castle was one of the most frequently repre-
sented of all British castles during the later eighteenth
and early nineteenth centuries, especially in the medium
of watercolor (often engraved). It was the most formi-
dable of the eight Welsh castles built by Edward I after
his subjugation of Wales in the early 1280s, and was
actually used by him on occasion as a royal residence.
Farington places the viewer right in the midst of the
vast, sprawling ruin, a viewpoint almost identical to
that of S. H. Grimm's large watercolor of the same
scene exhibited at the Royal Academy in 1778. Unlike
Grimm, Farington is more attentive to the varied
shapes, tones and textures of the surfaces, and also em-
phasizes more the creeping foliage which steadily over-
takes portions of the ruin.

141

The date of the painting is uncertain. In 1770, Farington exhibited at the Society of Arts *A View of the Great Tower at Caernarvon Castle*. While it is not impossible that the present work may be that painting, the title of the latter suggests a less general view, one concentrated more on the famed 'Eagle Tower' with its three intact turrets. Also, the very assured technique points to a date closer to *c.* 1780. In 1769–70, the unprecocious artist was enrolled as a student in the Royal Academy school, following several years with Wilson. In any case, the work is one of the earlier and more visually pleasing of the many representations of this most imposing ruin. It shows Farington at his best – more so than do the majority of his surviving oils.

Henry De Cort (1742–1810)
III.3. Chepstow Castle (*c.* 1790s)
Oil on panel 26½ × 33 (67.25 × 83.75)
B1981.25.163 PLATE 28

De Cort's view of the famous Norman castle is unusual in that it features the seldom represented western end of the stronghold. The normal view was from across the river, opposite the long north side of the sprawling fortress, as seen in works by Paul Sandby (1775, V&A; 1787, Private Collection), Michael Angelo Rooker (*c.* 1790s?; Sotheby's, November 20, 1969, Lot 54) or John Inigo Richards (1776?; National Museum of Wales), among others. De Cort's unorthodox viewpoint brings us closer to the ruin, with its patches of foliage and vine 'picturesquing' its stone surfaces here and there. The immediate foreground, with its large, slanting tree and curiously Flemish-looking figures, is surely the product of studio artifice, resorted to for additional picturesque effect.

Chepstow Castle is opportunely situated on a long, high bluff above the Wye, about two and a half miles north of its junction with the Severn. Its Norman core was begun about 1070 by one of William the Conqueror's chief lieutenants, William Fitz Osbern, Earl of Hereford. The fortress was massively enlarged in the early thirteenth century by William Marshall, Earl of Pembroke, and again at the end of the century by Roger Bigod III. It was never seriously besieged until the Civil War, when Cromwell's artillery breeched its walls.

After emigrating from his native Antwerp to London in 1790, De Cort spent much of his final twenty years of life touring and sketching many places in southern England and Wales, gathering material for numerous views painted back in his studio. We know that he visited Glamorganshire, South Wales, in 1791,

and as Chepstow is on the way, he could easily have visited and sketched the castle at that time. He also painted a panoramic, distant view of the whole area, *View of Chepstow, the River Wye and the Severn Estuary* (*c.* 1790s; David Barclay).

Paul Sandby (1730–1809)
III.4. Bothwell Castle, Clydesdale, Lanarkshire
(*c.* 1778–9)
Pen, ink, watercolor, body color
17¼ × 24⅝ (43.8 × 62.5)
B1977.14.6265 PLATE 117

Sandy exhibited four views of Bothwell Castle (eight miles southeast of Glasgow), the first in 1763 at the Society of Artists and the rest in the following decade at the Royal Academy (1771, 1774, 1779). Each of these depended on one of four pen and grey wash drawings made on the spot in 1748 (NGS and National Library of Wales), during the artist's four years' employment (1747–51) as official draughtsman for the Government Survey of the Highlands. The present view is from the south, like the similarly composed version in body color of 1770 (NGS), most probably the work shown at the Royal Academy the next year. The latter, however, includes a more flamboyantly picturesque tree filling half the space in the left foreground. The foreground trees in the Yale version also create a picturesque effect, to be sure, though in a less extravagant way. The style of the work points to Sandby's middle years, probably a little later than the Edinburgh version. Bruce Robertson has kindly suggested a date in the late 1770s. If correct, then the work may well be the one exhibited at the Academy in 1779. The size, careful execution and degree of finish certainly suggest an exhibition piece.

While the castle ruin is a focal point, it is not an overwhelming presence. Sandby in general was not interested in presenting ruins in a way that evoked awe or melancholy in the viewer. Ruins for him were purely pictorial elements to be manipulated for picturesque effect. He rarely, if ever, attempted a more romantic, evocative approach, such as we find in various ruin scenes by his contemporary De Loutherbourg.

Bothwell Castle was originally built in the late thirteenth century, with additions and alterations made during the fourteenth and fifteenth centuries. Late in the seventeenth century, parts of it were dismantled to supply building material for a nearby manor. Among its many lordly possessors was the Earl of Bothwell, husband of Mary Queen of Scots.

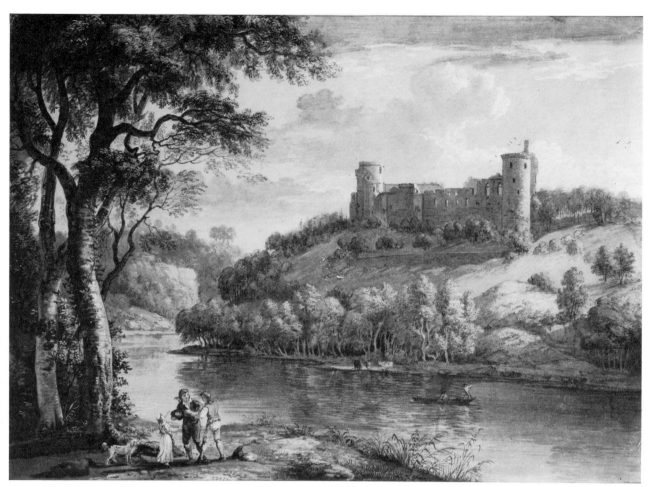

117. (III.4) Sandby, *Bothwell Castle, Clydesdale*

Paul Sandby (1730–1809)
III.5. Conway Castle, North Wales (1789)
Watercolor over pencil $18\frac{7}{8} \times 25\frac{7}{16}$ (47.9 × 64.6)
Inscr. *Conway Castle P Sandby 1789*, lower left
B1977.14.4405 PLATE 118

Sandby's view presents the massive Edwardian stronghold from the southeast, a viewpoint that highlights the castle's strategic coastal situation on the bay-like estuary of the Conway River. This contrasts with his earlier, more distant view of the castle and town walls as seen from the southwest (*c*. 1779–81; Walker Art Gallery), in which a very dominant foreground consisted entirely of sloping meadows and tree clumps – a view he repeated in 1802 (in gouache) with some variation (Whitworth Art Gallery). Sandby invests the scene with a marvellously luminous, morning sky. Its soft, warm light grazes the smooth surface of the water and distant hills, leaving the silhouetted castle in gentle shadow. As in most of his work, varied human activity

enlivens the foreground. The picturesquely irregular screen of trees is most probably a studio addition.

Conway Castle, one of the two foremost masterpieces of military architecture in Britain – the other being Caernarvon Castle – was built for Edward I in 1283–8, following his conquest of Wales. James of St George, from Savoy, was the Master Builder, as he was also of Caernarvon at the same time. The outer and inner wards together measure 130 yards, with an average wall thickness of 15 feet. Extending from the northern and western sides of the castle was a crenellated wall some 1,400 yards long (with twenty-one towers) that encompassed the whole town of Conway. Not surprisingly, the total structure proved the costliest of all British castles.

Many of the great names in British Romantic art painted Conway Castle, including Towne, De Loutherbourg, Turner, Girtin, Varley, Cotman, De Wint, Danby and Palmer. Sandby was certainly one of the first major artists to paint it, beginning with the views

143

118. (III.5) Sandby, *Conway Castle, North Wales*

he exhibited at the Royal Academy in 1779 and 1781, one of them possibly the above-mentioned view in the Walker Art Gallery. He had already made an aquatint view of the castle, published in his *XII Views in North Wales* (1776; Plate 11). The Yale watercolor derives from this engraved version; so too does the somewhat smaller and crisper version in the Rijksmuseum, which Bruce Robertson has kindly suggested may date around 1780, adding that it is also a likely candidate for being one of the two views shown at the Royal Academy in 1779 and 1781. At the end of the century, Turner adopted nearly the same viewpoint in his large, stormy watercolor view of the castle (*c.* 1799; Viscount Gage). Around 1816, Francis Danby similarly used the same vantage point in a magically luminous watercolor view (BM). The most impressive (and expressive) of all the Conway Castle views is Turner's large oil of *c.* 1803 (Grosvenor Estate), which once again exhibits Sandby's now classic viewpoint, while introducing a radically different, much more compelling foreground.

John Webber (*c.* 1750–93)
III.6. Goodrich Castle on the Wye, Herefordshire
(1788)
Pencil $11\frac{13}{16} \times 16\frac{3}{8}$ (30 × 41.6)
Inscr. *J. Webber del: 1788*, lower right
B1975.4.1503 PLATE 37

Webber's unusual interior view of Goodrich Castle, taken from a very low vantage point, totally immerses the viewer in a world of crumbling ruins smothered with creeping foliage. We are struck by the awesome array of many-faceted fragments and the perplexing variety of angles, making it difficult to orient ourselves

even though the castle as a whole has a relatively symmetrical, square plan. A musing figure seated in the upper-left slope is the sole occupant of the scene, and helps to offer a sense of scale. The work results from a tour of the archetypally picturesque Wye Valley which Webber made early in 1788. This was eight years after he had returned from Captain Cooke's fatal third voyage to the Pacific (1776–80), on which he served as the official artist. Webber's style was grounded in the 'tinted drawing' tradition dominant in England until the advent of John Robert Cozens, although there are some loose, free touches in the shadowy stonework and foliage on the left.

Goodrich Castle is ideally situated on a high outcrop of red sandstone overlooking the Wye, about seven miles northeast of Monmouth. It was begun in the twelfth century by the de Clares of Pembroke, whose three-storey square keep (*c.* 1160–70) still stands. The castle passed to the Marshall family, Earls of Pembroke, who completed the stronghold in the thirteenth century. From the fourteenth to the mid seventeenth century, it was the seat of the Talbots, Earls of Shrewsbury. As with so many British castles, its ruinous state dates largely from the Civil War period, the legacy of Cromwell's inescapable artillery. In this case, the chief culprit was a giant mortar called 'Roaring Meg', which fired 200 pound canon balls with devastating effect.

Thomas Hearne (1744–1817)
III.7. Gundulf's Tower, Rochester Cathedral, Kent
Pencil $10\frac{1}{16} \times 7\frac{3}{8}$ (25.6 × 18.8)
Inscr. *Hearne*, lower right
B1975.3.853 PLATE 119

Hearne's scrupulously objective and detailed pencil drawing, no doubt made on the spot, shows the remains of the massive Norman tower built in the early twelfth century by Gundulf, second Norman Bishop of Rochester. The ruined tower is located at the angle formed by the northwest transept and the choir. The Harrow art collection owns a finished watercolor based very closely on this drawing, including the solitary visitor peering into the lower depths. Hearne's choice of interior viewpoint, which totally immerses the viewer in the 'engulfing' ruin, results in an architectural composition very similar to his watercolor, *Lanercost Priory, Cumberland* (1778–9; Agnew's 1966), an interior ruin scene of much interest, which Girtin faithfully copied in the mid 1790s (BM). In both works, the walls and arches extend beyond the frame of the picture, inviting the mind to complete it.

In the late 1770s and 1780s, Hearne made many

119. (III.7) Hearne, *Gundulf's Tower, Rochester Cathedral*

drawings of ruins in connection with his and William Byrne's monumental *Antiquities of Great Britain* (1786 and 1807; 2 vols.), in which fifty-two of the eighty-three full-page engraved views are after his own drawings. The present work almost certainly relates to this project, but in the final publication, the subject was omitted. In the last decade of his long life, the artist made many views for Byrne's *Britannia Depicta* (1808). Dr Monro regarded Hearne as 'superior to everybody in drawing', and encouraged young artists, including Girtin and Turner, to copy his work.

Edward Dayes (1763–1804)
III.8. Buildwas Abbey, Shropshire (*c.* 1790s)
Watercolor 10½ × 15⅝ (26.5 × 39.75)
B1975.4.1136 PLATE 36

Dayes's choice of an almost axially symmetrical view of the interior of Buildwas Abbey was the standard one in his time for this much-represented monastic ruin, and indeed is very similar to several views by Michael Angelo Rooker (two oils, 1770 and 1772; two water-

colors, mid 1780s), by Paul Sandby (watercolor, *c.* 1778; print, 1779) and by Joseph Farington (watercolor, RA 1790) among others. Dayes, however, does not introduce nearly so much picturesque staffage as Sandby or Rooker, being satisfied with a solitary swineherd and a few of his charges. Also, his handling of the illumination differs, much light entering between each column and arch on the right, to good effect. His light and shade contrasts are more restrained than in the above works – in fact, a bit bland.

The Cistercian abbey was founded in 1135 by Roger, Bishop of Coventry and Lichfield. The nave today is little changed from Dayes's time, except for the removal of foliage and general tidying up. Dayes sketched and painted many ruined abbeys and castles during the final decade of his life, usually in a more distinctly picturesque mode.

Michael Angelo Rooker (1743–1801)
III.9. Kenilworth Castle (1794?)
Grey wash, pen and ink 9 × 11 (22.8 × 28)
Inscr. *M Rooker*, lower right
B1977.14.5714 PLATE 120

This charming ruin scene is one of at least half a dozen known views of Kenilworth Castle by Rooker, and may possibly be one of the four exhibited at the Royal Academy in 1794. Most of the others depict close-up interior views, with a few scattered figures. Here, the ivy-clad, ruined walls and towers share the stage with a carefree genre scene in the foreground, consisting of several men playing a game half way up a steep slope

120. (III.9) Rooker, *Kenilworth Castle*

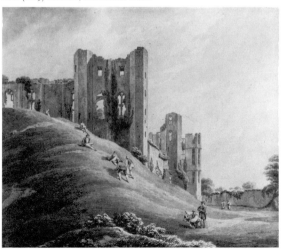

145

while two others at the bottom encourage a frisky dog. Melancholy ruin sentiment is certainly far from the artist's intent, his interest in the fabled castle remains being primarily visual. Or more precisely, he values the time-worn ruins mainly to the extent they appeal to 'the picturesque eye'. Picturesqueness, however, is still more played up in his interior views, wherein the crumbling remnants, rampant with foliage, present themselves in a more rambling, asymmetrical way. In the present, more chaste and understated portrayal, Rooker rather classically situates the ruin so that its main masses are either strictly parallel or perpendicular to the picture plane. The work derives from one of the artist's summer walking tours, begun in 1788, through central and western England and Wales.

Kenilworth Castle, made famous throughout Europe and America by Sir Walter Scott's novel so titled (1821), was begun about 1120 by Geoffrey de Clinton, Chamberlain and Treasurer of Henry I. His son or grandson built the great Norman Keep. In 1362, the castle came by marriage to John of Gaunt, who soon much enlarged it, building among other things a magnificent banqueting hall. Two centuries later Queen Elizabeth presented the vast complex to her favorite, Robert Dudley, the Earl of Leicester, who spent enormous sums altering and enlarging it still more. In the mid seventeenth century, Cromwell unfortunately awarded it to some of his officers, who proceeded to dismantle parts of it for the materials. In Rooker's view, we face the southwest corner of John of Gaunt's Hall, looking toward part of the Leicester buildings beyond.

John Inigo Richards (*c.* 1720–1810)
III.10. View of the Colosseum (1776)
Oil on canvas 15¾ × 20¼ (39 × 51.5)
B1981.25.527 PLATE 121

Richards' view presents the more intact northern half of the Colosseum, together with the Arch of Constantine. Beyond is a portion of the then semi-pastoral Palatine Hill. To enrich the scene further, he takes the liberty of including the coffered apse of the Temple of Venus and Roma, which actually is outside the view, to the right, situated at right angles to his placement of it. I know of no evidence indicating that Richards visited Rome, thus he probably based his view on a drawing or print by another artist. The work is almost certainly the one with the above title exhibited at the Royal Academy in 1776, along with a pendant, *View of the Castel S. Angelo*, also at Yale. Richards exhibited only one other view of Rome, a work shown at the Society of Artists the previous year and now untraced.

146

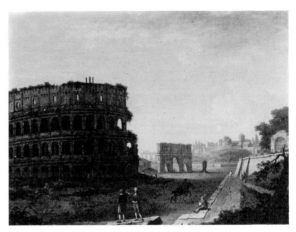

121. (III.10) Richards, *View of the Colosseum*

Normally he exhibited British scenes, frequently ruined castles and abbeys.

More than any other monument of ancient Rome, the Colosseum has continuously stirred the imagination of awed spectators – laymen and poets alike – from the time of Martial (80 AD) to the present. For many centuries the enduring ruin has been *the* symbol of 'the grandeur that was Rome'. Already in the eighth century, the Venerable Bede succinctly summed up the symbolic power that the Colosseum already possessed in a passage that Byron translated and included in *Childe Harold's Pilgrimage*, Canto IV (1818):

> While stands the Colosseum, Rome shall stand.
> When falls the Colosseum, Rome shall fall.
> And when Rome falls – the world.

John 'Warwick' Smith (1749–1831)
III.11. The Colosseum, Rome (1802)
Watercolor over pencil 20¼ × 31¾ (51.4 × 80.7)
Inscr. *J. Smith 1802*, lower left
B1977.14.6287 PLATE 122

Smith's large exhibition watercolor of ancient Rome's most celebrated monument (with the Arch of Constantine on the left) shows the more ruinous southern half of the great arena, in soft morning light. As Jane Bayard pointed out in her excellent catalogue, *Works of Splendor and Imagination* (YCBA 1980; 38), the work was most probably the one with the above title exhibited in 1807 at the Old Water-Colour Society, where it was the only exhibit that year admired by Sir George Beaumont. Two smaller, earlier versions of the composition exist, differing in minor ways (BM

and Sotheby's, March 26, 1975. Lot 165). All three presumably derive from one or more sketches that Smith made during his five-year residence in Rome (1776–81). Smith exploits the very same viewpoint that Francis Towne used to such advantage in his superb view of 1799 (Higgins Art Gallery, Bedford), which in turn was based on a sketch Towne made on site during his Roman visit, 1780–1, and now in the British Museum. We do not know which artist sketched the Colosseum first. Generally, however, Towne was more the initiator than Smith, who was typically the 'quick follower'. Unlike Towne, Smith here arbitrarily adds two large ruined arches and a hut in the right foreground. Moreover, his perfunctory rendering of the triumphal arch is inaccurate, the attic story being only half as high as it should be, while the pilfered Hadrianic medallions are too small and the engaged columns are flattened to pilasters. He places near the center two tiny, but immediately noticeable, figures musing before the silent, massive pile.

The Flavian amphitheater, as it was called in Roman times, dates from 72–82 AD, constructed largely during the reign of Vespasian (69–79 AD). Between the sixth and ninth centuries, several earthquakes considerably damaged the arena, yet it continued in use (periodically) until the mid fourteenth century. Unfortunately, during the fifteenth to the seventeenth century, it was exploited as a handy quarry for the building of various renaissance palaces, and today only about half of the original structure remains. The Arch of Constantine (312–15 AD) was the last of the great triumphal arches of ancient Rome, and is the best preserved. Most of its sculptural embellishment dates from the time of the 'model emperors': Trajan, Hadrian and Marcus Aurelius (second century AD).

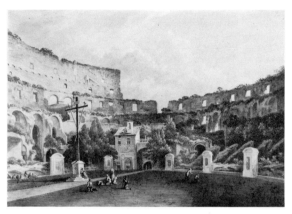

123. (III.12) Smith, *Interior of the Colosseum*

John 'Warwick' Smith (1749–1831)
III.12. Interior of the Colosseum (*c.* 1780–95?)
Watercolor over pencil $14\frac{9}{16} \times 21\frac{7}{16}$ (36.5 × 54.4)
Inscr. verso: *Inside of the Colloseo Rome J. Smith*
B1981.25.2717 PLATE 123

Smith's interior view of the east end of the Colosseum emphasizes the Christian additions to the arena made by Pope Benedict XIV in 1744, when he consecrated the great ruin to the memory of Christians martyred there. At that time, a large cross was erected in the center, along with fourteen stations of the cross (in free-standing niches) evenly distributed around the periphery of the oval arena. These remained for some one hundred and thirty years – until removed for excavations in the 1870s. Interestingly, Smith shows one of the kneeling pilgrims kissing the base of the central cross, which was believed to confer a hundred years' grace. Another contrast with the present appearance of the ruin is the jagged eastern end of the outer wall, which was buttressed in 1805–7 under Pope Pius VII. The western end was buttressed in 1825 under Leo XII. The abundant shrubbery and creeping foliage evident in Smith's picturesque (almost cosy) view temporarily disappeared in 1812, when the French 'weeded' the Colosseum. Further weedings were carried out in the middle of the nineteenth century.

Smith spent five years in Italy, 1776–81, his stay overlapping that of Thomas Jones, William Pars and Francis Towne, among others. The present work presumably derives from one or more sketches made at that time. If such a study were made in 1780–1, the choice of viewpoint may perhaps owe something to Towne's numerous interior views of the Colosseum of that year. Smith's view is earlier, on the basis of style, than his exterior view of 1802 (No. II.11), though how much earlier is uncertain.

122. (III.11) Smith, *The Colosseum, Rome*

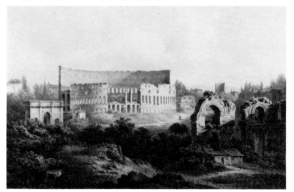

124. (III.13) Pars, *Temple of Venus and Rome*

William Pars (1742–82)

III.13. Temple of Venus and Rome (1781)
Watercolor, pen and ink $12\frac{1}{16} \times 16\frac{5}{16}$ (30.7 × 41.5)
Inscr. *Coliseo Rome 1781*, lower right
B1975.4.1571 PLATE 124

Pars' view focuses on the fragmentary coffered apse
of the extraordinary double temple designed by
Hadrian's great architect, Apollodorus of Damascus
(123–35 AD). Next to it is the church of Santa Fran-
cesca Romana, founded on part of the ruins of the
Temple of Venus and Rome and rebuilt several times.
On the right is the south side of the Basilica of Con-
stantine, while looming in the immediate foreground
on the far right is the edge of a massive pier of the
Colosseum, its towering size dwarfing the gentleman
tourist and his guide below. Most of the Roman
Forum lies outside the picture on the left, but we see in
the middle ground the eastern end of the 'Campo
Vacino', still a pasture in the eighteenth century – and
Pars has duly included a shepherd and some sheep.

Pars' approach to ruins is that of a landscape painter,
rather than architectural topographer. He is interested
in the setting as much as in the structures themselves,
and also bathes them in light and atmosphere, together
with providing a spacious cloudy sky overhead. He
had already encountered the classical world in the mid
1760s, when the Society of Dilettanti sent him to
Greece and Asia Minor with Dr Chandler and
Nicholas Revett. A number of his crisp and colorful
Greek watercolors were subsequently engraved in
Volumes II and III of Stuart and Revett's *Antiquities of
Athens* (1789, 1795). His later Roman watercolors, like
the present one, are looser and more atmospheric. The
same Society sponsored his stay in Rome, which ended
with his death in 1782, as a result of a chill caught while

sketching. None of his Roman drawings were ex-
hibited in his lifetime.

Thomas Jones (1742–1803)

III.14. The Claudean Aqueduct and Colosseum
(1778)
Pencil and watercolor on paper
$10\frac{3}{4} \times 16\frac{1}{4}$ (27.3 × 41.2)
Inscr. *part of the Antique Aqueduct that conveyed Water
to Mount Palatine*, center of sky. *the Collosseo*,
lower sky, right. *Vinyard*, middle ground, right.
May 1778
B1981.25.2637 PLATE 73

Jones offers a rather unusual view of the ruinous south
side of the Colosseum, partially blocked by an isolated
fragment of the famed aqueduct built largely during
the reign of Claudius (*c.* 40–50 AD) – the same massive
fragment which dominates Francis Towne's large,
close-up view of 1785 (No. III.14), though seen from
the opposite side. Rising on the left is the Palatine Hill,
while on the right we see the low, diagonal wall which
bounds the Via Gregorio. Jones made this on-the-spot
watercolor study, along with a similar one dated May
21, 1778 (Collection of Colonel J. H. Adams), during
his long, seven-year sojourn in Italy (1776–83), spent
half in Rome and half in Naples. So far as we know, no
larger, finished version of the composition exists.

Jones exhibited a total of eight Italian views at the
Royal Academy between 1784 and 1798, but none
were Roman subjects – all being views of southern
Italian scenery, particularly around Naples, Salerno
and Sorrento. Unlike his direct studies from nature, his
finished oils often exhibited neo-Wilsonian compo-
sitions, with much carefully executed detail. Today,
Jones is most admired for the fifty or so wonderfully
fresh and vivid open-air oil sketches he made in Wales
(1770–6) and Italy (1776–83), which happily surfaced
at Christie's in 1954, after having lain in oblivion for
one hundred and fifty years.

Francis Towne (1740–1816)

III.15. The Claudean Aqueduct, Rome (1785)
Watercolor, pen and ink over pencil
$12\frac{3}{4} \times 18\frac{9}{16}$ (32.2 × 47.2)
Inscr. *F. Towne delt/1785*, lower right
Verso: *No. 4 A View of the Claudean Aqueduct at Rome/
looking towards mount Palatine / Drawn by / Francis
Towne / 1785*
B1978.43.170 PLATE 125

Towne allots nearly the whole available space on his
large sheet to a rendering of a massive fragment of

125. (III.15) Towne, *The Claudean Aqueduct, Rome*

one of ancient Rome's greatest aqueducts – originally forty-six miles long – built to bring water to the imperial palaces on the Palatine Hill and completed in 50 AD under the Emperor Claudius. The view is from the Via Gregorio, which runs south from the Colosseum. Through the high sunlit arch we glimpse some distant remains of the Palace of the Caesars. The low, close-up viewpoint helps to make the formidable ruin appear all the more vast and sublime – an effect comparable to that of many Piranesi prints of Roman ruins, which Towne undoubtedly knew. But unlike Piranesi, Towne is not interested in setting up a deeply plunging architectural vista. Typical of his austere style is the use of flat color washes for much of the surface of the ruin.

Towne visited Italy in 1780–1, spending most of his time in Rome where he did much outdoor sketching, especially of ruins. The present work is an enlarged replica of a drawing made on site (but colored inside) early in 1781, and inscribed on the verso, 'From 10 till 12 o'clock' (BM; one of seventy-four Italian drawings mounted by Towne in three albums and left to the British nation). The Yale version, however, includes a small pair of figures on the left, accenting the vast scale of the ruin. In his large watercolor exhibition of 1805 held in London, No. 172 was entitled 'Claudean Aqueduct', most probably the British Museum version, as Towne stated in the catalogue that all one hundred and ninety one works exhibited were 'drawn on the spot'.

While in Rome, Towne was in close contact with several British contemporaries, particularly his old friend, William Pars, as well as John 'Warwick' Smith, who accompanied him on his return to England in September 1781. During a brief stay in Naples, the previous March, Towne encountered the precocious open-air oil sketcher, Thomas Jones. The watercolors he made on his 1780–1 Italian and Swiss tour are now generally regarded the high point of his career. Much

admired today, Towne enjoyed little acclaim in his lifetime.

Thomas Girtin (1775–1802)
III.16. St Cuthbert's Cathedral, Holy Island
(1797)
(Also known as *Interior of Lindisfarne Priory, Northumberland*)
Watercolor 10 × 12 (25.5 × 30.5)
Inscr. *Girtin 1797*, lower right; verso: *St Cuthbert Holy Island Northumberland/Girtin*
B1975.4.1215 PLATE 38

Girtin shows the mouldering but still impressive remains of the early twelfth-century Benedictine Priory located on the isle of Lindisfarne (Holy Island). It was a typically sturdy, Norman Romanesque edifice built on a site once occupied by an earlier abbey completed by St Cuthbert in the seventh century. The Norman builders actually aimed to emulate Durham Cathedral, though on a smaller scale. Girtin sketched the Priory during his summer tour to the north of England and Scotland in 1796. Over the next four years he produced at least five different watercolor views of the ruin, four of them upright compositions (BM, Cambridge, Oxford, Private Collection). In 1797, he exhibited at the Royal Academy two views with the above title. One or both may have been upright compositions, but the present horizontal view – omitted from the Girtin-Loshak catalogue (1954) – is equally a candidate.

The present watercolor is Girtin's only view of the ruin in which the onlooker is totally surrounded on all sides – and above – by ruinous walls, piers and arches. The closeness of the view precludes our orienting ourselves, making the interior space more mysterious and 'romantic', reminiscent of Piranesi's famous interior ruin scenes, *Hadrian's Villa, Tivoli: central room of the larger thermae* (1770) and *Interior of the Baths of Titus* (1756). Like Turner, Girtin much admired Piranesi, even copying a number of his prints. But Girtin was also interested in doing justice to the richly diverse textures and tones of weathered masonry as well as to the picturesque shapes of the rough and irregular, fragmentary forms.

Thomas Girtin (1775–1802)
III.17. Warkworth Castle, Northumberland
(1798)
Watercolor $16\frac{1}{2} \times 24\frac{3}{4}$ (41.8 × 55.2)
B1975.3.1178 PLATE 30

III.18. Warkworth Castle, Northumberland
(1796)
PENCIL $6\frac{3}{4} \times 9\frac{5}{8}$ (17 × 24.4)
B1975.3.1177 PLATE 31

126. (V.11) Girtin, *The Abbey Mill, Knaresborough*

In this composition, Girtin has completely discarded the various recipes for picturesque view-making that he had mastered in the early 1790s, confronting the viewer with a few bold, massive shapes, laterally disposed and painted with great breadth. Its sombre tonality, stark simplicity and sweepingly open-ended structure give the work an anti-picturesque character, comparable to that of his slightly later oil painting, *Guisborough Abbey* (*c.* 1801; No. III.19) and such later watercolors as *The Eildon Hills* (1800; Cambridge) and *Ilkley* (1801; Leeds City Art Gallery).

The on-the-spot pencil sketch dates from the summer of 1796, when Girtin toured the north of England and Scotland. In it, the artist skillfully outlines the main architectural features, with characteristic dot accents, while giving the landscape setting a much more summary, abbreviated treatment. Girtin maintains the very same viewpoint in the watercolor, and also closely follows the drawing in his rendering of the castle ruin and clustered houses. However, both the foreground and band-like middle ground – or entire lower half of the composition – is largely worked out for the first time in the final studio version. Besides enlarging the immediate foreground, Girtin unobtrusively intro-

duces a few scale-giving figures, including a nude bather (rare in his art). The broad stretch of middle ground is not only fleshed out with a variety of earthy tones and textures, but is considerably extended on the right, making it appear more as one continuous horizontal mass.

Around 1800, Girtin painted a second, smaller version of the present work (Sir Edmund Bacon Collection), but left it in a less than finished state. The viewpoint is exactly the same, though the lateral ground plane is somewhat extended on each side. It lacks the gaunt grandeur and somber expressive power of the Yale version.

Warkworth Castle was begun early in the twelfth century, becoming a serious stronghold a century later, after Robert Clavering received it from Henry II. The powerful Percy family took possession of it in 1332, and later in the century built the massive cruciform keep which dominates Girtin's view.

Thomas Girtin (1775–1802)
III.19. Guisborough Abbey (1801–2)
Oil on canvas $13\frac{3}{4} \times 19\frac{3}{4}$ (35 × 50.4)
Insc. verso: *This is the only known picture by T. Girtin painted in oils. It is a copy of one of his well known watercolors. It was painted at Coleorton Hall about 1798 for his friend and patron Sir George Beaumont, Bart.*
(old label)
B1978.20 PLATE 29

This still little-known work is accepted by current scholars as Girtin's only extant oil painting. Other candidates, such as a version of *The White House at Chelsea* (Private Collection), are considered anonymous copies today. Few Girtins better exemplify 'Girtinian breadth' than the present one, especially its open-ended and ruthlessly simplified foreground, executed with unusually broad, sweeping strokes. A few deftly placed dabs of brown, white and black pigment effectively create an unobtrusive array of cattle, sheep and a few figures. The artist refrains from loading the foreground with picturesque elements, and in fact has given us a boldly anti-picturesque view. The typical late eighteenth-century British view of an abbey ruin presented a rather busy, variegated foreground. Although he had been much exposed to that approach during his apprentice years with Edward Dayes, Girtin increasingly emancipated himself from it in the final six years of his brief life.

As the inscription notes, the painting was based on a watercolor, probably the one now in the collection of Sir Edmund Bacon, datable 1801–2. It would appear that Sir George Beaumont, who possessed over thirty Girtin watercolors by 1802, wanted a specimen in oil from his young protégé, presumably of the above subject. The oil version has even less descriptive detail in the foreground than the watercolor; also, the distant hills are still more simplified and the abbey tower less articulated. The pinkish sky, suggestive of early morning or dusk, is completely new. The execution is most assured, despite the artist's inexperience with the medium. The unusual white ground (rather than a tonal one) as well as the very thinly applied paint, betray a watercolorist's way of working.

The impressive quality of the work makes one wish Girtin had worked more often in oil, however much one admires his superb watercolors. He may well have intended to do just that, had he lived – especially if he harbored ambitions of winning election to the Royal Academy, as is likely. In 1801, he exhibited one oil at the Academy, the well-received *Bolton Bridge*, which apparently perished in the fire that destroyed his brother John's house in 1817.

John Varley (1778–1842)
III.20. Chepstow Castle, Monmouthshire (1802)
Watercolor $11 \times 19\frac{1}{2}$ (28 × 49.5)
Inscr. *J Varley 1802*, lower left
B1977.14.4339 PLATE 127

Varley presents a distant view of the sprawling castle ruins, taken from an unusually oblique angle, in contrast to the many views made directly opposite the main fragment, across the River Wye. This lessens the impact of the ruin, making it share in importance with the half-timber structure in the upper foreground. In fact, both the ruin and the intact building are simply two of a number of visually arresting features in a rich landscape, not least of which are the beached boats and laboring men in the austere foreground. No other Varley view of Chepstow Castle is like this one, which must derive from one of the artist's three early tours of Wales (1799, 1800 and 1802).

The uncluttered, sloping foreground is only lightly shadowed, consistent with a principle he was to stress in his subsequent *Treatise on the Principles of Landscape Design* (1816–21). There he writes that the landscape painter should beware of making his foregrounds too dark and heavy, so that the viewer does not have to 'wade through a mass of black rubbish with which many from ignorance and bad example load their foregrounds'. He goes on to say that the painter must avoid being 'too busy all over' and aspire to 'the great principles of breadth and repose'. Like much of Varley's early work (to *c.* 1810), this view does not drastically modify the actual scene, in contrast to many works of his middle and later years in which he imposes with monotonous predictability a Claudean or Wilsonian compositional scheme on the scene and also reduces individual forms to boring generalizations.

John Varley (1778–1842)
III.21. Llanberris Lake, with Dolbadern Castle (*c.* 1802)
Watercolor over light pencil $19\frac{3}{4} \times 26\frac{1}{8}$ (50 × 66.5)
B1977.14.4653 PLATE 33

This view of a solitary ruined tower in the heart of Snowdonia derives from one of Varley's three early tours of Wales made in 1799, 1800 and 1802. Unlike Turner's highly dramatic, 'sublime' rendering of the scene (RA, Diploma Gallery), exhibited at the Royal Academy in 1800, Varley's more distant and expansive view is utterly serene and contemplative in mood. We view the forlornly isolated tower remnant from across a broad lake. The basic structure of the work recalls that of Richard Wilson's *Dolbadern Castle and Llyn Peris*

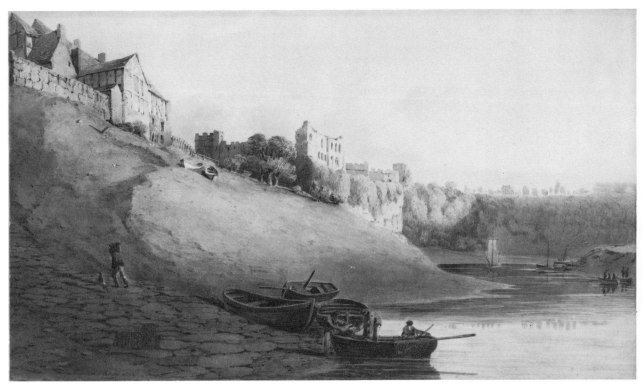

127. (III.20) Varley, *Chepstow Castle*

(*c.* 1760–3; National Gallery of Victoria, Melbourne), though starkly simplified. Varley's minimal foreground, to be sure, is not lacking its pair of Wilsonian figures. One also senses the impact of Girtin's art, which Varley knew well, evident here not only in the radical openness of the composition but equally in the broadly applied washes of dark near-monochrome tones.

Dolbadern Castle was built in the early thirteenth century by the Welsh, and consisted of a cylindrical keep enclosed within a two-towered curtain wall. It was well-situated on a bluff at the northwest end of Llyn Peris near the town of Llanberris. The mist-veiled mountain on the right is Moel Eilio and the faint peak on the far left is Snowdon. Varley's view is correct in showing these mountains at a considerable distance, in contrast to Turner's painting of 1800, in which the tower is hemmed in by imaginary mountains. Much of the castle, other than the tower keep, became ruinous not long after its completion, as a result of being quarried for material to build Caernarvon Castle in the 1280s for the victorious Edward I.

The watercolor was possibly the work of the same title included in the first exhibition held by the Old Water-Colour Society, in 1805. The ultra-prolific Varley painted many Welsh mountainscapes and ruin scenes in his middle and later years but few if any rival the austere grandeur and evocative power of the present work. In 1809, he exhibited a second watercolor with the same title at the Old Water-Colour Society.

John Sell Cotman (1782–1844)
III.22. Aberystwyth Castle (1801)
Watercolor $11\frac{3}{8} \times 19\frac{5}{8}$ (28.9 × 49.9)
Inscr. *J. S. Cotman*, lower right; verso: *Aberiwith*
Lent by Mr Paul Mellon PLATE 32

This impressive early Cotman watercolor derives from the artist's first trip to Wales, in the summer of 1800 (when he was eighteen). He was at Aberystwyth on July 18th and presumably made a sketch of the castle, untraced today. In this finished work Cotman dramatically silhouettes the ruined tower against a turbulent yet partly luminous sky. The composition as a whole recalls Turner's *Dunstanborough Castle* (National Gallery of Victoria, Melbourne), an oil painting which Cotman probably saw at the Royal Academy in 1798.

152

We know that the young artist much admired Turner and made numerous pencil copies of his work. In terms of style and technique, however, the watercolor owes more to Girtin, whose work Cotman equally admired. I refer particularly to the sweeping breadth of the foreground, the dark and narrow range of color (even allowing for fading) and the little dot-like deposits of color here and there.

Aberystwyth Castle, which occupies the site of a previous fortress founded by Gilbert de Strongbow at the beginning of the twelfth century, was one of eight imposing castles built for Edward I immediately following his subjugation of Wales (1277–83). It has inspired far fewer representations than the much better preserved Edwardian castles to the north, at Harlech, Caernarvon and Conway. Cotman, however, appears to have found it a stirring subject, and the result is one of his most powerful early works.

John Sell Cotman (1782–1844)
III.23. Howden Church, Yorkshire (1803)
Pencil $15\frac{5}{16} \times 11\frac{3}{4}$ (39.1 × 30)
B1975.2.507 PLATE 35

Cotman made this exquisite pencil drawing of the fragmentary east end of the fourteenth-century Howden Church during his first tour of Yorkshire (accompanied by P. S. Munn) in the summer of 1803. As in several versions of Castle Acre Priory made the following year (see No. III.24) or in his large watercolor of the west facade of Croyland Abbey (c. 1804; Ferens Art Gallery, Hull), the artist selects a very low and close-up, oblique viewpoint. As a result, the ruin awesomely looms above the viewer. Some of Girtin's ruin scenes come to mind, particularly his large, imposing *Guisborough Priory, Yorkshire* (1801; NGS; another version of 1801, TG), which presents the fragmentary east facade from a low, oblique angle, very much as Cotman presents his majestic ruin. A Cotmanian touch is the inclusion of two languid cows in the far right corner, a feature also present in his *Castle Acre Priory*.

No finished watercolor based on this drawing has so far appeared, and perhaps none was made. The artist did, however, produce a fine etching after it, published in his series, *Miscellaneous Etchings* (1811). In this public version he introduced three absorbed antiquarian tourists and replaced the mundane cattle with a pair of trim horses.

John Sell Cotman (1782–1844)
III.24. Castle Acre Priory (c. 1804)
Watercolor over pencil $14\frac{5}{8} \times 11$ (37.2 × 27.8)
B1975.2.508 PLATE 34

Cotman shows the inner side of the ruinous west facade of the Cluniac abbey. Although the work is undated, we know that the artist visited Castle Acre in 1804, a date consistent with the style of the watercolor. An on-the-spot pencil sketch of the same ruin, dated 1804, is in the RIBA Drawing Collection, and shows the inner side of the ruin from the northeast, instead of the southeast as in the present work. The RIBA drawing, in fact, adopts the same viewpoint (though closer) used by Thomas Hearne in a view engraved by John Landseer for Bowyer's *Historical Gallery at Pall Mall* (1801). The viewpoint employed in the present watercolor affords a more striking and powerful effect. As in his drawing of Howden Church (No. III.23), he abruptly juxtaposes the dramatically silhouetted, 'heroic' ruin with domesticated animals.

Around 1815, Cotman – or possibly a close follower under his guidance – made a simplified, flat-tone watercolor sketch of Castle Acre Priory from the same viewpoint as that of the present work, minus the animals but with the addition of a seated figure (location unknown). As far as we know, the artist did not produce a large finished watercolor of the priory comparable to his two magnificent contemporary views of Croyland Abbey (both 1804; BM and Ferens Art Gallery, Hull). For another view of the same ruin by Cotman's Norwich contemporary, John Thirtle, see No. III.25.

Attributed to John Thirtle (1777–1839)
III.25. Castle Acre Priory (c. 1804–8?)
Watercolor over pencil $15\frac{1}{16} \times 11\frac{9}{16}$ (38.2 × 29.6)
B1975.2.577 PLATE 128

Cotman's slightly elder Norwich contemporary, John Thirtle, the probable artist of this work, has chosen the same inner side of the west facade of Castle Acre Priory that Cotman himself had painted in c. 1804 (No. III.24). Thirtle, however, offers a precisely frontal view unlike Cotman's oblique one. Also, his vantage point is not as low as Cotman's, with the result that the ruin in his work does not seem to loom as much over the viewer. Finally, two horses replace Cotman's humbler cows and pig, while overhead, dark threatening clouds interplay with descending shafts of light. The highlit half of the ruin exhibits an eerie pallor, starkly silhouetted against a darkening sky. The tones, textures and brushwork remind one more of Girtin

128. (III.25) Attr. Thirtle, *Castle Acre Priory*

than Cotman, though both artists much influenced Thirtle during the first decade.

The attribution of this watercolor is reasonable on the basis of style. There exist numerous copies of his works by his pupils, but they rarely if ever approach the quality of the present work. Thirtle's career remains obscure, even though current scholars rank him second only to Cotman among the watercolorists of the Norwich School. He exhibited ninety-seven works at the Norwich Society of Artists between 1805 and 1830, about half of them landscapes (often river scenes) and half architectural subjects, like the present one. Probably a founder member of the society, in 1814 he served as its President. He also authored a manuscript treatise on watercolor (*c.* 1810–15), printed in full in Marjorie Althorpe-Guyton's *John Thirtle: Drawings in the Norwich Castle Museum* (1977).

Joseph Mallord William Turner (1775–1851)
III.26. St Augustine's Gate, Canterbury
(*c.* 1793–4)
Watercolor over pencil $13\frac{1}{2} \times 19\frac{1}{4}$ (34.25 × 48.75)
Inscr. *W Turner*, lower right
B1975.4.1962 PLATE 129

The present watercolor is the larger and more finished of two very similar views of the majestic if slightly ruinous old gate (*c.* 1300) of St Augustine's Abbey, Canterbury, which Turner painted in *c.* 1793, both of which are at Yale. The smaller, less strongly colored version may date slightly earlier. At the Royal Academy in 1793, the artist exhibited a third, now untraced, version of the gate which was the largest of the three, and apparently an upright composition. There is no known on-the-spot pencil sketch for the view. The version exhibited here differs from the smaller one in several ways; the ramshackle shed on the far right is reduced in size, the nearby tiled lean-to is much altered and the shrubbery on the far left is entirely different. All these changes are unquestionably improvements.

Earlier artists, such as Dayes and Rooker, had represented the more fully intact inner side of the gate. See, for example, Rooker's oil painting at the Yale Center (study collection), which first appeared at the Royal Academy in 1778. Turner prefers the less tidy but more picturesque outer side with its lively irregularities of contour and varied textures. The presence of the workman (absent from the smaller version) and the piled-up cut stone suggest possible preparations for repair of the gate. Turner at this time was especially fascinated with old, Gothic gateways, as evidenced by several contemporary watercolors, including three different views of *Christ Church Gate, Canterbury* (*c.* 1793, Cambridge; *c.* 1794, Whitworth Art Gallery; 1794 RA, Private Collection) and two nearly identical versions of *The Arch of the Old Abbey, Evesham* (1793; Rhode Island School of Design; 1793–94, Private Collection). Near replicas by Turner are rare after the mid 1790s.

Joseph Mallord William Turner (1775–1851)
III.27. Newark Castle, Nottinghamshire (*c.* 1796)
Watercolor over pencil $11\frac{7}{8} \times 16\frac{5}{8}$ (30.3 × 42.1)
Inscr. Verso: *Newark-upon-Trent J. M. W. Turner*
B1975.4.1619 PLATE 130

Turner shows the surviving west side of the largely twelfth-century castle built on the banks of the River Trent. He based the watercolor very closely on a pencil sketch made on the spot during his first Midland tour of 1794. As in his contemporary *Newport Castle, South Wales* (*c.* 1796; BM), he places the stronghold on a slight diagonal, its nearer portion extending beyond the frame. The artist often employed this compositional structure in his early watercolors dealing with architecture, whether ruinous or intact, such as *Malvern Abbey* (1794; Private Collection), *Magdalen Tower*

129. (III.26) Turner, *St Augustine's Gate, Canterbury*

130. (III.27) Turner, *Newark Castle, Nottinghamshire*

and *Bridge, Oxford* (1794; BM), *Old Bridge, Shrewsbury* (1794; Whitworth Art Gallery) or his romantic nocturne, *Dormitory and Transept of Fountains Abbey – Evening* (1798; Private Collection). Besides setting up a dynamic spatial effect, this beyond-the-frame placement of the main motif stirs our imagination, tempting us to 'complete' the ruin, or extend it, more or less according to what we see. This effective format contrasts with Thomas Hearne's more traditional, topographical portrait of the entire castle (*c.* 1780s; BM), neatly centered on the sheet – a view engraved and published in Hearne's and Byrne's *Antiquities of Great Britain* (1786–1807; Vol. II, Plate iii), and copied by Girtin in 1795 (Walker's Gallery, 1935).

The original core of Newark Castle was built in the later twelfth century for Bishop Geoffrey Plantagenet. Much rebuilding and enlargement was carried out under Henry III in the 1220s and later. In the sixteenth century, various alterations were made, such as the introduction of Tudor mullion windows. Like many British castles, it became a Royalist stronghold during the Civil War, and in fact successfully withstood three sieges by Cromwell's troops before Charles I was compelled to turn it over to the Lord Protector, who ordered its dismantling. The castle is also famed as the place where King John died in 1216, a year after he was forced to sign the *Magna Carta*.

Joseph Mallord William Turner (1775–1851)
III.28. Barnard Castle (*c.* 1825)
Watercolor bodycolor, pen and ink, with some scratching-out $11\frac{5}{8} \times 16\frac{1}{4}$ (29.5 × 41.25)
B1977.14.152 PLATE 39

This glowing view of Durham's most admired castle ruin was engraved for Charles Heath's *Picturesque Views in England and Wales* (1827–38). The collected edition (1838) comprised the most comprehensive single anthology of views of British scenery the artist ever produced. The engraved version of the present work, by R. Wells, appeared in the third number (Jan. 1827). A smaller engraving, by J. T. Willmore, was published four years later in *The Talisman* (1831). Turner long delighted in silhouetting castle ruins against luminous skies, as seen already in his magnificent early watercolor, *Caernarvon Castle* (1799; Private Collection) or more recently in several watercolors forming part of the Rivers of England series (1823–5), such as *Dartmouth Castle on the River Dart* (*c.* 1824; BM) or above all, the dazzling *Norham Castle on the Tweed* (*c.* 1823; BM). Turner, as often, exaggerated the height of the ruin. He freely based the work on an on-the-spot pencil sketch made over a quarter century earlier in his *North of England* sketchbook of 1797 (BM; TB XXXIV; 29).

The rugged castle ruin rests on a height above the River Tees, close by a town of the same name. The fortress was founded by Bernard Baliol, and constructed in *c.* 1112–32. The Keep, or 'Baliol's Tower', is 50 feet high. During the later sixteenth century, the castle gradually lapsed into disrepair, and in 1630, much of it was dismantled. Sir Walter Scott's *Rokeby* (1813) is partly set at Barnard Castle.

Alexander Nasmyth (1758–1840)
III.29. Hawthornden Castle, near Edinburgh
(*c.* 1820–2?)
Oil on canvas 18 × 24 (45.5 × 61)
B1981.25.482 PLATE 131

The remains of Hawthornden Castle and nearby Roslin Castle became a particularly popular tourist attraction during the Romantic era. They lay within walking distance of Edinburgh, each dramatically situated atop a lofty bluff overlooking the North Eske. Hawthornden possessed special literary associations, for it was once the residence of the foremost seventeenth-century Scottish poet, Drummond; and it was here that Ben Jonson paid his famous visit to Drummond in 1618. Like Hugh Williams and Ibbetson before him, Nasmyth shows us the castle from the northeast, placing the viewer low-down at the river's edge. However, he greatly enlarges the right-hand cliff, making it sublimely vast, such that it dwarfs the castle ruin. The foreground, indeed, recalls Rosa. This is probably no mere coincidence, for Nasmyth much admired Rosa, no less than Claude (whom he more often adapted). The ruggedness of the view sharply contrasts with the arcadian note struck by Ibbetson in his *Mermaids Haunt, Hawthornden* (*c.* 1800; V&A), which features numerous classically proportioned women bathers artfully posed in the foreground – an effect not unlike Francis Wheatley's more winning *Salmon Leap at Leixlip with Nymphs Bathing* (1783; YCBA).

Nasmyth visited and sketched Roslin Castle, and probably also Hawthornden Castle, at least as early as 1787. He made a painting of Hawthornden in 1797, a work last recorded in 1886. The present work, however, may well derive from a sketch made on one of his visits to the area after 1800. Our suggested dating is purely tentative, for the chronology of Nasmyth's oeuvre has yet to be worked out.

Alexander Nasmyth began his career as a portrait

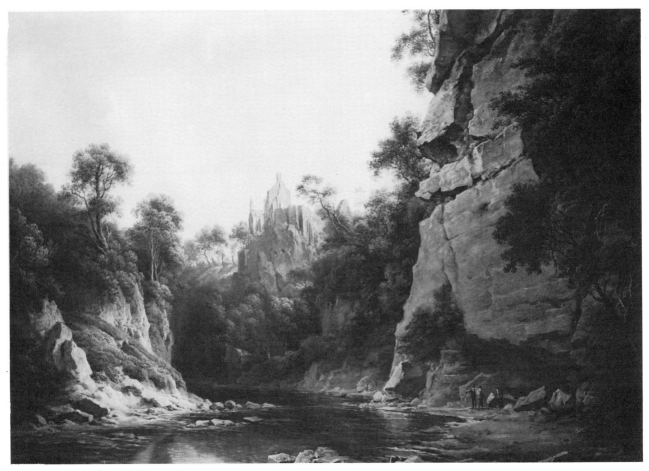

131. (III.29) A. Nasmyth, *Hawthornden Castle, near Edinburgh*

painter, after training with Alexander Runciman in Edinburgh (*c.* 1772–5) and with Allan Ramsay in London (1775–8). Upon returning from a tour of Italy (1782–4), he developed an interest in landscape, which became his dominant specialty by the end of the century. He is the first important Scottish artist to devote himself primarily to the painting of his native scenery, and rightly deserves the tag, 'Father of Scottish Landscape'.

John Constable (1776–1837)
III.30. Hadleigh Castle: The Mouth of the Thames – morning after a stormy night (1829)
Oil on canvas 48 × 64¾ (122 × 164.5)
B1977.14.42 PLATES 1 (detail) and 132

Constable's *Hadleigh Castle* is arguably the most impressive and expressive large-scale ruin painting ever produced by a British artist. The artist exhibited it at

the Royal Academy in 1829, its title in the catalogue accompanied by the following appropriate lines from James Thomson's *Summer* (165–70):

> The desert joys
> Wildly, through all his melancholy bounds
> Rude ruins glitter; and the briny deep,
> Seen from some pointed promontory's top,
> Far to the dim horizon's utmost verge
> Restless reflects a floating gleam.

Constable began preparations for the work late in 1828 or very early the following year. This was soon after the death of his young consumptive wife, Maria, in November 1828 – a blow from which he never fully recovered, according to his friends. His ensuing dark state of mind appears in a letter to his brother Golding, written December 19, 1828: 'hourly do I feel the loss of my departed Angel . . . I shall never feel again as I felt – the face of the world is totally changed to me . . .'

157

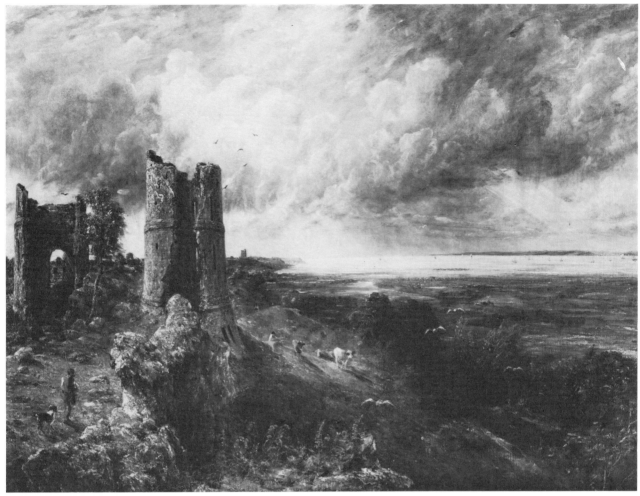

132. (III.30) Constable, *Hadleigh Castle: The Mouth of the Thames*

(*JC:FDC*; 81). Certainly the dark mood of the picture, the artist's first exhibited ruin scene, contrasts with the positive, benevolent mood of his previous landscapes. Instead of an invigorating celebration of a benign, sustaining nature, fully in harmony with man, the painting enshrines the desolate remnants of a once-proud royal stronghold, forlornly silhouetted against a turbulent sky.

Constable first saw the ruin during a two-week visit to Freering, Essex, in the summer of 1814. In a letter to Maria he explained that while there 'I walked on the beach at South End – I was always delighted with the melancholy grandeur of a sea shore – at Hadleigh there is a ruin of a castle which from its situation is really a fine place – it commands a view of the Kent hills, the nore and north foreland & looking many miles to sea. I have filled, as usual, a little book of hasty memoranda' (*JCC*, II; 127). A rapidly drawn pencil draft of the ruin

survives (V&A), exhibiting both the viewpoint and basic composition of the final work. When he began planning the latter fourteen years later, his first step was to try out the composition of the slight drawing in terms of a small but highly vigorous oil sketch (No. III.31), one incorporating several obvious new elements: an expressive sky, strong chiaroscuro contrasts, textural variety and an unobtrusive shepherd with a few sheep. As Graham Reynolds pointed out in his 1960 catalogue (*op. cit.*; 94), Constable also made about this time a small pen drawing which extended the composition on the right (ex A. M. Austin; untraced today). The next step, true to his normal procedure throughout the 1820s with respect to 'six-footers', was the ambitious production of a full-size oil sketch (TG), on the same scale as the final work – apparently the last time he did this. This large sketch, painted with cold blues and whites, is the most 'expressionistic' one he

ever made, with vehement, ferocious brushwork. Again, he incorporated more of the vast estuary on the right, which enhanced the grandeur of the composition. A small leafy tree has cropped up between the two towers, underscoring nature's continuing vitality in contrast to the time-worn ruin, while nearby the lonely shepherd keynotes the solitariness of the scene.

The final picture sharpens the focus on all the objects and more clearly articulates the deeply recessional coastline. Above all, the artist employs a full range of color with great resourcefulness. Finally, the cloud forms are much more fully worked-out, though still charged with an expressive energy. As in his previous finished versions, he has completely recomposed the whole sky, which normally (as here) comprised the most notable alteration in the final edition. The character of this glorious cloudscape does more justice to the latter part of the title – 'morning after a storm' – than did the predominantly stormy sky of the large sketch. Constable's stirring ruin scene is not unequivocally melancholy in effect, for there is a kind of heroic quality in the way the battered but stubbornly enduring towers are dramatically silhouetted against a luminous, dynamic sky. Or putting it another way, the picture has both a melancholy aspect, generated by the ruin-dominated foreground, and an exhilarating, affirmative aspect, conveyed by the exuberant cloud drama and its play of intense light. The result is one of the most 'sublime' paintings in western art. For further discussion, see Malcolm Cormack's recent illuminating article, 'In Detail: Constable's *Hadleigh Castle*', *Portfolio* (Summer, 1980); 36–40.

John Constable (1776–1837)
III.31. Study for Hadleigh Castle (c. 1828–9)
Oil on cardboard. $7\frac{7}{8} \times 9\frac{1}{2}$ (20 × 24)
Collection of Mr Paul Mellon PLATE 133

Constable's oil sketch for his only large ruin painting, *Hadleigh Castle* (1829; No. III.30), is based on a small on-the-spot pencil sketch made in June 1814 (V&A), when he was on a visit near Southend. Ruins did not at that time form part of his normal repertory of themes, and nothing resulted from the sketch for the next fourteen years. But following his wife's death in

133. (III.31) Constable, *Study for Hadleigh Castle*

November 1828, he suddenly took up the subject for a finished work. The desolate scene, to be sure, matched the artist's darkened, melancholy state of mind (see previous entry). He must have recalled and ferreted out the 1814 sketch, possibly because of family connections with the area. His next step was to paint the present small oil sketch, which closely followed the basic composition of the early drawing, while introducing various elements: a dynamic, partly luminous sky (setting off the battered towers), a thickly painted ground plane, brushed on with much intensity, and the addition of a solitary shepherd (with sheep) along with a few birds winging about the gaping towers. Very pronounced light and dark contrasts intensify the mood of the scene. Constable had not yet extended the composition on the right, which he did in the full-size oil sketch, now in the Tate Gallery.

The Mellon oil sketch was first published as recently as 1973, in Basil Taylor's *Constable*. Recently, Robert Hoozee cast doubt on the authenticity of the work by including it in the 'Opere Dubbie' section of his *Opera Completa di Constable* (1979; No. 658). However, Graham Reynolds and Charles Rhyne, accept the sketch as by Constable, and will include it as such in their forthcoming catalogue raisonné.

IV. Rural Landscapes

Thomas Jones (1742–1803)
IV.1. Vale of Pencerrig (1776)
Oil on paper laid on panel 9¼ × 12¾ (23.5 × 32.5)
B1981.25.381 PLATE 134

Before 1954, John Constable was considered the first British artist who practiced open-air sketching extensively. However, in July of that year there appeared at Christie's a group of forty-nine boldly executed landscape sketches in oil, painted from nature by Thomas Jones, a former pupil of Wilson (in 1763–5), whose *finished* works closely derived from his teacher. The sketches comprised views of his native Wales, dating between 1770 and 1776, and views of Italian scenery (around Rome and Naples), dating between 1777 and 1782. These were never exhibited or sold in the artists's lifetime, passing to his descendants with whom they remained in obscurity for a century and a half. The present work is one of several outdoor oil sketches Jones made at or near Pencerrig in his home county of Radnorshire during the first half of 1776, just before embarking for Italy. The work is very similar to *Extensive Landscape near Pencerrig* (*c.* 1776; National Museum of Wales). Both studies possess a freshness and

immediacy which anticipates Constable's oil sketches of a generation later. Above all, the sweeping breadth and forceful simplicity of the ground plane together with the skillfulness of the skyscape bring to mind a study such as *Dedham Vale: Evening* (1802; V&A). This is not to imply that Constable saw any of Jones' oil sketches; yet, it is possible that Sir George Beaumont may have mentioned their existence to Constable, Beaumont having been a rather close friend and supporter of Jones in the 1770s.

Jones was not the first British artist to practice open-air sketching. Jonathan Skelton (*c.* 1734–59), in a letter of September 1758, refers to finishing a 'painting in Oil after Nature', which apparently has not survived (Brinsley Ford, 'Letters of Jonathan Skelton from Rome, 1758', *Walpole Society* XXXVI 1956–8; 60). Basil Taylor has suggested, in a lecture at Yale (April 1965), that George Stubbs' two small paintings (or 'finished studies'?) of the Rubbing-down House on Newmarket Heath (TG and YCBA) of *c.* 1764–5 may well have been painted on the site. Among continental artists who painted from nature in the later eighteenth century, the most prolific practitioner was Pierre Henri de Valenciennes (1750–1819), who took up the practice during his second stay in Italy (1782–4), conceivably stimulated by the example of Jones' precocious oil studies, as Lawrence Gowing has observed (*Painting from Nature*, Arts Council of Great Britain, 1980; 5).

134. (IV.1) Jones, *Vale of Pencerrig*

Joseph Wright of Derby (1734–97)
IV.2. View of the Boathouse near Matlock, Derbyshire (*c.* mid 1780s)
Oil on canvas 23 × 30 (58.5 × 76)
B1981.25.718 PLATE 43

Wright's daytime view of a picturesquely rugged area along the Derwent River near Matlock (fifteen miles north of Derby) has a compositional structure very similar to his better known *Dovedale by Moonlight* (*c.* 1784–6) at Oberlin: a sloping mass of nearly vertical

135. (IV.3) Wright, 'Dovedale'

rocks and dense foliage on the left facing a smaller slope on the right, with a pair of criss-crossing trees silhouetted in the corner. The foliage in the Mellon painting, however, exhibits an odd, spongy appearance, more like that in Wright's daytime version of Matlock Tor (c. mid 1780s) in Cambridge. The peak in the distance is most probably Matlock High Tor. Unlike most contemporary landscape painters, who almost always included one or more figures in their landscapes, Wright leaves the scene completely unpopulated, though potential human presence is implied by the little boathouse in the lower left and the picturesque dwelling on the far right. This striking absence of any human figure (in a pre-1800 finished oil painting) is also the case with several other Wright landscapes of the mid 1780s, such as the above-mentioned Oberlin picture or *Dovedale in Sunlight* (c. 1784–8; Private Collection).

Joseph Wright of Derby (1734–97)
IV.3. 'Dovedale' (1786)
Oil on canvas $25\frac{3}{8} \times 33\frac{1}{4}$ (64.4 × 84.4)
Inscr. *I. W. Pinx^t 1786*, lower right
B1981.25.722 PLATE 135

No other landscape by Wright presents a scene of such dense and lush foliage. The viewer is hemmed in on both sides by rampant natural growth of an almost tropical luxuriance. There is even a spooky quality to the right-hand side, so full of enmeshed limbs and exposed, clutching roots. The effect is not unlike the strange wooded backgrounds of certain paintings by George Stubbs, such as *Lion and Lioness* (undated; Boston Museum of Fine Arts), though it is not known whether Wright saw such works. The two shadowy fishermen are kept subordinate to the rich setting. The inclusion of a fallen dead tree in the immediate fore-

161

136. (IV.4) Webber, *Pont-y-Pair on the River Llugwy*

ground may owe something to the aesthetic of the Picturesque, but the highly distinctive even idiosyncratic forms of the spindly dead trees on the far left show a purely Wrightian touch, and are a welcome contrast to the cliché tree types recommended by Gilpin.

A wash drawing study for this painting is in the Derby Museum, and in turn may be based on a sketch from nature, now untraced. The scene, however, may be partly imaginary, or possibly a composite view, for apparently it is not readily identifiable with any existing portion of Dovedale, even allowing for changed foliage. Nor has anyone so far related it to any part of the River Derwent. The style of the wash study makes one wonder if the initial starting point, now untraced, might perhaps have been a 'blot' *à la* Alexander Cozens, whose treatise on blotting, *A New Method*, appeared in 1785. Wright knew the fascinating publication and actually made several blot drawings himself, now in the Derby Museum.

John Webber (*c.* 1750–93)
IV.4. Pont-y-Pair on the River Llugwy near Betws-y-Coed, Denbigh (1791)
Grey and blue wash over pencil $13\frac{3}{8} \times 18\frac{3}{4}$ (34×47.5)
Inscr. *John Webber 1791*, lower right; *Ponte Pair Lanrust* (sic), lower left; color notes throughout
B1975.4.1966 PLATE 136

Nearly a decade after his return in 1780 from Captain Cooke's third voyage to the Pacific, the Swiss-born Webber made several sketching tours in search of picturesque scenery, including the Wye Valley in 1788, Derbyshire in 1789 and Wales in 1791. The Yale Center owns drawings from each of these tours. The present work depicts one of the many popular scenic areas near Betws-y-Coed, northern Wales: namely, a rocky waterfall overlooked by the venerable fifteenth-century stone bridge, Pont-y-Pair. As in a number of Webber's Derbyshire and Welsh drawings, rock structures dominate – a pictorial preference that owes

something to the artist's close friendship with William Day, a geologist and gifted amateur artist, who in fact accompanied Webber on both his Derbyshire and Welsh tours.

The work is fully characteristic of Webber's late drawing style which involved the application of pale washes over pencil. Normally he made the pencil outlines directly on the spot, applying his grey and pale blue washes later on. His Welsh tour is the last one we know of before his untimely death two years later. This drawing was possibly one of four Welsh scenes (two of them oils) he exhibited at the Royal Academy in 1792.

John Robert Cozens (1752–97)
IV.5. The Thames from Richmond Hill (*c.* 1791)
Watercolor over pencil $14\frac{1}{4} \times 20\frac{3}{4}$ (36.1 × 52.6)
B1975.4.1903 PLATE 137

Cozens renders a portion of the Thames near London which Turner will later celebrate on a monumental scale in his famous *England: Richmond Hill, on the Prince Regent's Birthday* (1819; TG). This watercolor and the contemporary *London from Greenwich Hill* (*c.* 1791; No. VI.16) are among the very few English scenes painted by the artist, whose oeuvre almost entirely comprises views of Switzerland and Italy, for his well-travelled, aristocratic patrons. However, there certainly was also a growing market for British scenes in Cozens's time, particularly with respect to parts of northern Wales and the Lake District, not to mention the continuing vogue for views of the many castle and abbey ruins throughout Britain.

Indicative of the late date assigned the watercolor is the way Cozens paints the foliage – somewhat more broadly, less subtly, than in earlier work. On the other

hand, as A. P. Oppé observed, he is still very resourceful in 'his power of weaving a composition into flat landscape – "without any predominant feature", as his father put it – in an evanescent atmosphere under a limitless sky'. (*Alexander & John Robert Cozens*, 1952; 152). Cozens here anticipates the approach of subsequent romantic-naturalist landscapists who extracted visual poetry from commonplace views.

138. (IV.6) Sandby *View of Maidstone from near the foot of Boxley Hill*

Paul Sandby (1730–1809)
IV.6. View of Maidstone from near the foot of Boxley Hill (1802)
Watercolor and gouache $21\frac{7}{8} \times 30\frac{3}{4}$ (55.6 × 78.1)
Inscr. *P Sandby 1802,* lower left
B1977.14.6272 PLATES 44 (detail) and 138

Sandby exhibited this large, panoramic view of the expansive Medway valley at Maidstone (seven miles south of Rochester, Kent) at the Royal Academy in 1802, under the above title. Boxley Hill lies about two miles northeast of Maidstone. The building in the middle ground is the Lower Bell Inn. As so often in his later work, the artist enlivens the foreground by inserting two stock trees on the far right and a meandering herd of cattle and sheep together with various assorted figures in the center. The general mood is one of benevolent rusticity – a healthy, properly functioning rural world.

In 1802, Sandby was an aging artist of seventy-two, but obviously still capable of producing an attractive picture. His handling of trees, meadows, architecture and figures – and their felicitous disposition – remains highly skillful. On the other hand, his rendering of the

137. (IV.5) Cozens, *The Thames from Richmond Hill*

clouds is very perfunctory – less accomplished than in his earlier work.

Philippe Jacques De Loutherbourg (1740–1812)
IV.7. Evening, with a Stage Coach (1805)
Oil on canvas $29\frac{1}{2} \times 46$ (75 × 117)
Inscr. *P. J. De Loutherbourg 1805*, lower left
B1981.25.219 PLATE 42

The locale of the scene is Blackheath, which in De Loutherbourg's time was still purely rural and full of picturesquely irregular terrain in contrast to neighboring Greenwich Park, with its smooth contours and elegant architecture. This rural setting affords an arresting contrast between the thoroughly rustic foreground and London's skyline. The foreground has a strong late eighteenth-century (nostalgic?) flavor to it, given the bustling Ibbetson-like coach party and the Morlandesque peasant or gypsy group on the left. This reflects the artist's periodic interest in juxtaposing different classes of 'commoners', which he had so brilliantly displayed in his early *Midsummer's Afternoon, with a Methodist Preacher* (1777; National Gallery of Canada) where we encounter a kaleidoscopic spectrum of social types.

In this late work, De Loutherbourg exhibits a rather smaller and tighter touch than he employed in earlier landscapes (see Nos. I.6 and V.2), in contrast to the frequent tendency of painters to become broader in their late years. Also, the basic compositional layout is quite traditional. As in several other late works, the sky is warmly toned. The artist exhibited the picture at the Royal Academy in 1806, along with *Morning, with an old Abbey*, a work today entitled 'Tintern Abbey on the River Wye' (Cambridge). His Academy exhibits frequently included morning and evening scenes, sometimes as pairs. These two paintings, being of different sizes, are not pendants.

Patrick Nasmyth (1787–1831)
IV.8. A Distant View of Edinburgh from the Braids (*c.* 1820)
Oil on canvas $27\frac{1}{8} \times 35$ (69 × 89)
Inscr. *Patk Nasmyth*, lower left
B1981.25.485 PLATE 139

Although Edinburgh looms on the horizon in Nasmyth's landscape, the emphasis is on the thoroughly rural scenery then found a few miles south of the Scottish capital near the base of the Braid Hills. The artist brings out its rustic character. This is not to regard the distant city as merely incidental; indeed, as with De Loutherbourg's *Evening with a Stage Coach*

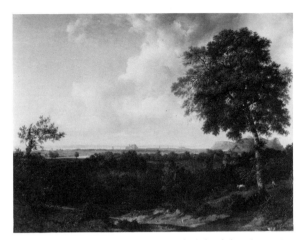

139. (IV.8) P. Nasmyth, *A Distant View of Edinburgh from the Braids*

(1806; No. IV.7), part of the effect of the picture involves the contrast between a rural foreground and a horizon of striking architectural landmarks. Nasmyth was fond of setting up this kind of contrast, as seen in his *Distant View of Bristol* (*c.* 1818–22; Wolverhampton Central Art Gallery) or especially his *Distant View of Greenwich from Charlton Wood near Woolwich* (1820; TG), most probably the work exhibited at the Royal Academy in 1820. This latter work, moreover, is very close in style and composition to the present work, with its Wijnants-like trees enclosing both ends of the foreground and its Ruisdael-like sky, full of bright and billowy cumulus clouds handled with great skill and subtlety. Like a number of British Romantic landscape painters, Nasmyth greatly admired his Dutch predecessors, and at times even produced pictures that border on being pastiches of Hobbema, Ruisdael and/or Wijnants. The above view is much less overtly derivative of such specific sources and for this writer is one of the artist's freshest and most attractive landscapes.

The Edinburgh landmarks appearing here include Castle Rock (near the center), the lantern tower of St Giles to the right, Carlton Hill with its Nelson Tower, Salisbury Craigs and Arthur's Seat, an imposing hill on the far right. The inclusion, and absence, of certain buildings help us date the work. The Nelson column was completed in 1816, whereas the tower of St John's Church (completed in 1822) does not appear in the painting. Hence, a date range between 1816 and 1822. The picture's close stylistic affinities with the dated Tate view favor a date around 1820.

Patrick Nasmyth (1787–1831)

IV.9. View of Cessford and Caverton, Teviotdale, Roxboroughshire (1813)

Oil on canvas 23 × 33½ (58.5 × 85)

Inscr. *Patk Nasmyth 1813*, lower left

B1981.25.486 PLATE 140

This unusually handsome early work by Patrick Nasmyth combines a distant townscape with a moderately close-up view of a manor house, Cessford, seat of the Ker family since 1430 (Earls of Roxborough from 1616, Dukes of Roxborough from 1707 to the present). However, the main emphasis is on the open, pastoral scenery surrounding the turreted manor house, making the picture essentially a country scene. We see the winding River Teviot flowing northward toward nearby Kelso, where it joins the River Tweed. To the south is Jedburgh and to the west is Abbotsford, i.e., Sir Walter Scott country. Young Nasmyth knew that part of his native land very well. Even after he moved to London in 1810, he continued to paint and exhibit Scottish scenes. Between 1811 and 1822, he showed twenty-six paintings of Scottish subjects at the Royal Academy and British Institution (the majority at the latter), but the present work was not one of them. Most likely it was a commissioned work, ordered perhaps by a member of the Ker family. The reigning Duke of Roxborough in 1813 was James Henry Robert Innes-Ker (*d.* 1823), who in the previous year had been awarded the title by the House of Lords in preference to the Fifth Duke's claim (after a seven-year dispute).

The landscape is particularly attractive in its freshness of color and purity of tones. The subtly luminous sky also deserves special mention; indeed, Nasmyth was almost as close an observer of atmospheric phenomena as Constable. In the autobiography of the artist's brother, James Nasmyth (the celebrated engineer), we read that 'of all the portions of landscape nature, the Sky was the one that most delighted him. He studied the form and character of clouds – the resting cloud, the driving cloud, and the rain cloud – and the sky portions of his paintings were thus rendered so beautifully attractive' (1883; 59). For an interesting comparison, see Turner's slightly later watercolor, *Lulworth Castle* (*c.* 1819; No. IV.32), which is precisely comparable in subject, including as it does a village and manor house in a predominantly rural landscape but with a livelier foreground.

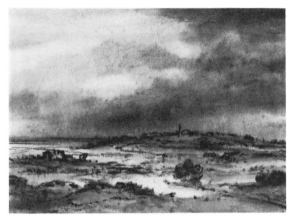

141. (IV.10) Monro, *Composition: Marshland*

Dr Thomas Monro (1759–1833)

IV.10. Composition: Marshland (*c.* 1790s?)

Charcoal and grey wash 6⅜ × 9 3/16 (16.3 × 23.3)

B1975.3.884 PLATE 141

Many of Dr Monro's drawings imitate Gainsborough, whom he had known in the 1780s, but the present work, in its bald simplicity and shorthand abbreviations of natural phenomena, brings to mind much more some of Alexander Cozens's 'ink blots', such as *An Open Landscape* (BM). Certainly Monro was aware of Cozens's treatise, *A New Method* (1785), which included sample blots. The drawing is one of the doctor's most austere productions; there are no figures, animals, cottages or special 'features'. There do exist, however, several quite similar drawings by Monro: at Oxford, Birmingham and in the collection of Brinsley Ford. These variously represent desolate moors, scrubby heaths or marshlands – generally shrouded by somber, overcast skies. Nature's forms are radically simplified and the foregrounds are as open-ended as in any Girtin

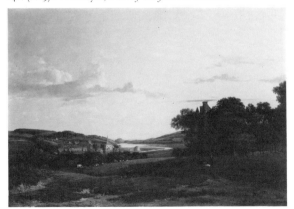

140. (IV.9) P. Nasmyth, *View of Cessford and Caverton*

165

composition, even though they may perhaps slightly pre-date the latter.

Dr Monro was a distinguished specialist in mental illness, and became Principal Physician at Bethlem Hospital in 1792. He was even called in consultation to King George III in 1811 and 1812. He devoted much time to sketching and to building up a fine drawing collection. After moving to the Adelphi in 1793–4 he ran a kind of informal drawing academy, where young artists were paid to copy works in his collection. Both Girtin and Turner worked there in the winters of 1794–7, and so too did Cotman around the turn of the century.

Thomas Girtin (1775–1802)
IV.11. Trees and Pond near Bromley, Kent (1798)
Watercolor $8\frac{1}{4} \times 12\frac{5}{16}$ (20.9 × 31.5)
Inscr. *Girtin*, lower right; verso of old mount: *A Pond nʳ Bromley/Kent/Colored from Nature/Girtin*
B1975.3.1194 PLATE 45

Along with many pencil sketches from nature, Girtin made a number of outdoor watercolor studies, like the present work, so characteristic in its free brushwork on rugged cartridge paper. The simple compositional layout very much recalls that of his larger and better-known *On the Wharfe* (V&A) of the same year, and also recurs in later work. Girtin's *penchant* for this format may owe something to Dr Thomas Monro, who employed it in several black chalk and grey wash drawings available to Girtin, such as *Trees on a Bank* (*c.* 1790–5?; Loshak Collection) or *Landscape with Trees* (*c.* 1790–5?; Courtauld Gallery).

Whether Girtin ever made a larger, more finished version of this composition is uncertain; none has come to light so far. At times, his intention may have been simply to make a semi-finished study on a small scale directly from nature, as an independent end, without regarding it necessarily as preparatory to a studio elaboration. Other cases in point are his richly toned *Denbigh Castle* (1800) and *View of Hills and River* (1801), both in the British Museum.

Thomas Girtin (1775–1802)
IV.12. Valley of the Conway (1800)
Watercolor over very light pencil $9\frac{1}{8} \times 20\frac{1}{2}$
(23.2 × 52.1) sight
Inscr. *Girtin*, lower left
B1975.3.959 PLATE 46

This panoramic view shows part of the long, gently serpentine valley formed by the River Conway as it flows northward to the Irish Sea. We look down the valley from some point between Trefiew and Dolgarrog, about seven miles south of Conway Castle, with Upper Gwydir House in the distance. The watercolor derives either from his second tour to northern Wales (with Sir George Beaumont) in 1800 or from his initial tour of two years earlier. No on-the-spot drawing for the work has been identified, though one probably existed.

A contemporary watercolor by Girtin which is especially close to the present one in choice of scene, style and compositional layout is the even wider panoramic view, *Winding Estuary* (*c.* 1800?; TG). The Conway view, however, admits a vestige of picturesqueness (however minor) to the foreground – the small pair of rickety trees barely supporting themselves near the solitary shepherd.

William Pearson (*fl.* 1798–1813)
IV.13. View from Boxley Hill, near Maidstone (1801)
Watercolor over light pencil $9\frac{1}{8} \times 14\frac{1}{16}$ (23.1 × 35.9)
Inscr. *Pearson 1801*, lower left
B1977.14.5323 PLATE 142

Like most of Pearson's work, this watercolor, in its breadth and simplicity, owes much to Thomas Girtin's art. Pearson, in fact, was Girtin's closest follower, though he never actually studied with the master. Also Girtinian is the resourceful color scheme, albeit cooler and considerably greener than Girtin's subtler palette. A very similar watercolor by Pearson, in terms of both composition and style, is an unidentified view formerly in the collection of C. E. Hughes, and probably closely contemporary with the present work.

Pearson's career remains obscure, apart from the titles of the seventeen watercolors he exhibited at the

142. (IV.13) Pearson, *View from Boxley Hill*

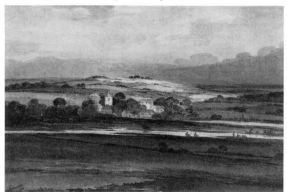

Royal Academy between 1799 and 1804 and the nineteen works shown at the Associated Artists in Watercolour between 1808 and 1812. Also, his sketchbook of 1808 is in the Victoria & Albert Museum. The artist was a friend of Louis Francia, as confirmed by an inscription on the back of Francia's *Mousehold Heath* (1808; No. IV.14). Finally, he is thought to have provided the views engraved in *Select Views of the Antiquities of Shropshire* (1807). Girtin and Loshak believe that Pearson may have produced some spurious 'Girtins' in his lifetime (*The Art of Thomas Girtin*, 1954; 123); certainly some of his watercolors have passed under Girtin's name in the last hundred years.

Louis Thomas Francia (1772–1839)
IV.14. Mousehold Heath, Norwich (1808)
Watercolor $12\frac{1}{2} \times 9\frac{1}{4}$ (31.8 × 23.5)
Inscr. *L Francia*, lower right; verso: *Done for his friend Wm. Peirson* [sic] *as a small return for his Imitation of Kobell's Etchings by L. Francia 1808*
B1977.14.4680 PLATE 143

Francia offers a sober view of a portion of the large, moor-like heath lying immediately northeast of Norwich, a region immortalized by John Crome who produced some half dozen paintings and a superb etching of the heath, mainly during the second decade of the century. John Sell Cotman also painted the heath at this time, showing watercolor views at the Norwich Society in 1809 and 1810. Francia's heath scene, unlike Crome's and Cotman's, is conspicuously devoid of human figures and is actually one of the earliest surviving finished views of Mousehold Heath by a noteworthy artist. He had previously exhibited a Norfolk scene at the Royal Academy in 1802, and the Cecil Higgins Art Gallery, Bedford, owns another Norfolk view – very Girtinian in style – dated 1802, *St Benet's Abbey*, showing a ruin not far from Norwich that subsequently much attracted Cotman, John Thirtle and Henry Bright. Both these works presumably derive from sketches made during a previous visit to Norfolk (*c.* 1800–1?). The present watercolor is also probably based on an earlier sketch from nature, made either on that initial trip or some subsequent visit between 1802 and 1808.

The Redgraves have aptly characterized the special quality of the kind of scenery represented here. 'Before the age of railroads, Norfolk and its capital city were outlying districts as it were; rarely visited by the curious – rarely subject to change or improvement . . . The banks of the river, the heaths, the commons, were wild, untrimmed, and picturesque' (*A Century of British Painters*, 1866; Phaidon edn, 1946; 37).

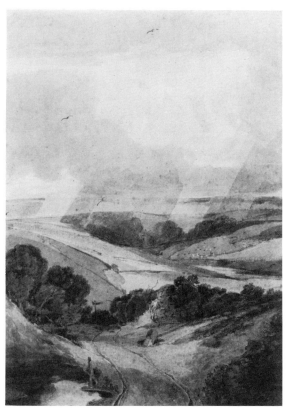

143. (IV.14) Francia, *Mousehold Heath, Norwich*

Stylistically, the work shows the ongoing impact of Girtin's art on Francia, who had enjoyed much contact with the recently deceased master, and in fact was co-founder in 1799 of Girtin's Sketching Club, 'The Brothers'. One notes in particular the bold simplicity and breadth of the main masses as well as the subdued, earthy color scheme (though the watercolor has much faded). On the other hand, the watercolor is less dependent on Girtin's influence than the work of the artist for whom it was made, William Pearson (see No. IV.13).

James Ward (1769–1859)
IV.15. Landscape with Cottages (*c.* 1804–6)
Oil on panel $9\frac{1}{2} \times 17\frac{1}{4}$ (24 × 44)
Inscr. *JW* monogram, lower right
B1981.25.660 PLATE 144

Ward's vivid little rural scene is one of a number of small oils on panel he painted during the first decade of the century, under the inspiration of Rubens, whose *Chateau de Steen* (1636; NG) was a revelation when he first saw it in 1803. The paint surface, in places, and the

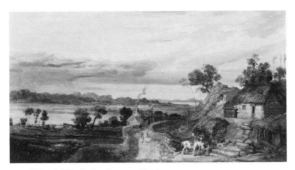

144. (IV.15) Ward, *Landscape with Cottages*

color scheme to some extent, recall this stimulus and reinforce our suggested dating. On the other hand, the dabs of thick 'coagulated' pigment comprising the surface of the right-hand wall and parts of the far-right shed are pure Ward. Whether the artist considered the work an oil sketch or a sketchy finished picture is difficult to say. It is also uncertain whether he ever exhibited this kind of work. Certainly he must have enjoyed working in this mode, given the number of surviving examples. A somewhat similar scene is *River Landscape with Cattle and Cottage*, also in oil on panel (undated) but slightly smaller, sold at Christie's (March 30, 1972, Lot 118).

The unidentifiable mountains in the background look at least partly improvised, whereas much of the earthy foreground probably relates to the artist's actual experience, however modified by his personal style. Possibly the subject derives from his visits to Wales in 1802 and 1805. The liveliness of the execution,.coupled with the portable size, may suggest an open-air origin, but to my knowledge there is no firm evidence that Ward worked in oil out of doors at this period.

William Delamotte (1775–1863)
IV.16. On the Isis, Waterperry, Oxfordshire
(1805)
Oil on panel $13\frac{3}{4} \times 16\frac{15}{16}$ (35 × 43)
Inscr. verso: *July 8 1805 On the Isis Waterperry Oxon Willm De La Motte on the Spot*
B1978.43.3 PLATE 58

IV.17. On the Isis, Waterperry, Oxfordshire
(1806)
Oil on panel $14\frac{1}{4} \times 17\frac{1}{4}$ (36 × 44)
Signed *WD*, lower center; Inscr. verso: *June 1806 On the Isis Waterperry Oxon Willm De La Motte* (smaller writing illegible)
B1978.43.4 PLATE 61

Although nearly identical in size and style, these two open-air oil paintings were apparently not originally made as pendants, given the dates inscribed on the backs. When painting the 1806 version, however, the artist surely was not unmindful of his slightly earlier view of what appears to be the same spot viewed from the opposite direction. The two works together form a closely related pair – in effect, upstream and downstream views – and have always remained together. Paired complementary views of this sort, as distinct from pairs differentiated by weather effect or time of day, are not uncommon in British landscape. A comparable instance is the pair of Dovedale views by Linnell (1814; Nos. IV.18 and 19), presenting a portion of the rugged dale from opposite directions.

In the years 1805–7, Delamotte was one of a small group of young artists centered around John Varley (including Havell, Hunt, Linnell and Mulready) who occasionally practiced open-air oil sketching along the Thames, sometimes producing more finished efforts. The present pair strikes one as more than sketches or studies. The presence of the artist's initials on the 1805 panel suggests that he may have considered it a finished work. If so, it would be among the earliest known finished landscapes painted in oil on the spot – nearly a decade before Constable's first recorded example, *Boat-building near Flatford Mill* (1814; V&A). All the known outdoor work in oil by such earlier artists as Thomas Jones, Valenciennes and A. F. Desportes are clearly sketches or studies. Delamotte's open-air painting, along with that of his above mentioned colleagues, seems to have greatly decreased after *c.* 1810, for reasons that remain unclear. In his case, one of them was probably his increasing duties as a drawing master for thirty-five years at the Royal Military Academy, Great Marlow.

John Linnell (1792–1882)
IV.18. Dovedale, Derbyshire (1815)
Oil on paper mounted on panel $7\frac{1}{2} \times 12\frac{1}{4}$ (19 × 31.1)
B1981.25.429 PLATE 55

IV.19. Dovedale, Derbyshire (1815)
Oil on paper mounted on panel $7\frac{5}{8} \times 12$ (19.4 × 30.5)
Inscr. *J. Linnell*, lower right
B1981.25.422 PLATE 56

Like Delamotte's two river scenes (Nos. IV.16 and 17), Linnell's pair of Dovedale views shows an upstream and a downstream version of nearly the same spot. In pairing these particular scenes, the artist follows a precedent set by Thomas Hofland and Thomas Barber in the first two prints of their series, *Six Views in Derbyshire* (1805). Linnell's views, however, are much more naturalistic than Hofland's and Barber's stagey,

decorative renderings. Linnell does not try to soften the distinctive irregularities of the scene, such as the curious pyramidal rock formations popularly known as 'the Brothers'. Again, like Delamotte, he includes a fisherman in each view, which is especially appropriate, as Dovedale had been a mecca for anglers since at least the time of Sir Isaac Walton and Charles Cotton, who devoted a chapter to it in *The Compleat Angler* (1676). In fact, when Linnell visited the region in 1814, he accompanied Samuel Bagster, the publisher, with the intention of providing illustrations for a new edition of *The Compleat Angler*, which duly appeared the following year. The five prints after Linnell in this edition do not include either of the present views. However, in a slightly revised reissue of this edition in 1839, Linnell's upstream view appeared on page 296, entitled 'The Rocks called the "Brothers"'. In the 'List of Embellishments', the editor associates this view with the following lines from Cotton's poem, *Retirement*: 'Oh, my beloved rocks! that rise / To awe the earth and brave the skies'.

An on-the-spot sketch exists for each view (Agnew's 1971, Colnaghi's 1973), and the finished pair follows the sketches closely. Linnell has simply sharpened the focus, intensified the color and added an appropriate figure and pair of cows. Although previously dated 1814, the pair was assigned to the year 1815 by Linnell in his chronological list of all his landscapes from 1807 to 1879, with accompanying mini sketches (Private Collection).

At this early stage of his career, the young artist (only twenty-three) was as naturalistic as his older contemporary, John Constable, though in a less painterly way. He gradually lost this unpretentious empirical approach after the mid 1820s, tending toward a more artificial style.

John Linnell (1792–1882)
IV.20. Evening Landscape with Boys Fishing
(1818)
Oil on panel 15 × 23 (38 × 58.25)
Inscr. *J. Linnell 1818*, lower left
B1981.25.419 PLATES 57 (detail) and 145

A warm mood of well-being and benign calm pervades Linnell's softly glowing rural scene. Everything seems at peace and in harmony – a kind of Virgilian mood embodied in a contemporary, naturalistic landscape. In the glimmering distance, numerous cottage chimneys have become active. Linnell realized a very similar mood in *Summer Evening, Boys Bathing* (c. 1818–20?; Harris Art Gallery, Preston). Like most of the artist's early pictures, this work was probably based on a study made from nature.

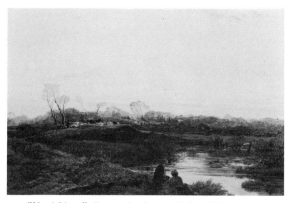

145. (IV.20) Linnell, *Evening Landscape with Boys Fishing*

Linnell states in his record book of 1879, that he retouched the present work in 1856. Just how much retouching he did is not easily determined, without resorting to technological analysis. The artist, in fact, retouched more than a few early works in his later years.

As with the majority of his landscapes, the present one was probably painted out of love of the subject, rather than commissioned. When we look at other work of the later 1810s, we see how varied Linnell can be at this time: highly naturalistic in his *River Kennett, near Newbury* (1816; Cambridge), strongly picturesque in the exactly contemporary *Landscape with Figures* (1816; YCBA) and subtly expressive of an evocative mood in the above work. Linnell's increasing desire to produce more than a straight likeness of nature – especially after he befriended Blake in 1818 – became truculently vocal when he replied to a visiting lady who asked 'from whence a landscape on his easel was taken, "Madame, I am not a topographer!"' (R. & S. Redgrave, *A Century of British Painters*, 1866; new edn., 1947; 386).

John Constable (1776–1837)
IV.21. Dedham Vale (c. 1802)
Oil on canvas $13\frac{1}{8} \times 16\frac{3}{8}$ (33.25 × 41.5)
B1981.25.131 PLATE 51

This early work by Constable, along with the similar *Road near Dedham*, also at Yale, is close in style to a group of four Stour valley views in the Victoria & Albert Museum, all datable 1802. They are among the earliest surviving works in oil by the artist and result from a very productive visit to his native East Bergholt in the summer and autumn of 1802. The previous spring he had announced in a manifesto-like letter of May 29th to John Dunthorne:

For these two years past I have been running after pictures and seeking the truth at secondhand . . . I shall shortly return to Bergholt where I shall make some laborious studies from nature – and I shall endeavour to get a pure and unaffected representation of the scenes that may employ me with respect to colour particularly and any thing else . . . There is room enough for a natural painture. The great vice of the present day is *bravura*, an attempt at something beyond the truth.

(*Corres.*, II; 32)

The present work is usually regarded as one of the fruits of the above resolution – i.e., an open-air painting. To this writer's eye, however, the degree of finish and compositional completeness evident warrant our asking whether it may have been painted in the studio, or at least finished there.

The exact view within the vale remains unidentified. The presence of a human figure, prominent in the left foreground, sets this landscape somewhat apart from the other five cited above, which are completely devoid of any visible human presence, as often the case with 'studies from nature'. The pose of this seated figure, as often pointed out, closely echoes that of the young peasant seated similarly in the left foreground of Gainsborough's *Wooded Landscape with a seated figure* (*c.* 1747; TG). Constable intensely admired his predecessor's early Suffolk landscapes. With at least equal intensity, however, he loved his native Stour valley, remarking to Dunthorne in May 1800, 'I even love every stile and stump, and every lane in the village, so deep rooted are early impressions . . .' *JCC*, II; 24).

John Constable (1776–1837)
IV.22. View toward the Rectory, East Bergholt
(1813)
Oil on canvas laid on panel $4\frac{1}{4} \times 5\frac{5}{8}$ (10.7 × 14.2)
Inscr. *19 Augst 1813*, lower left
B1981.25.143 PLATE 52

Constable made several small oil sketches of this particular scene in his earlier years, the first being the angular view (including a foreground tree) dated 1808, at Cambridge. Two years later he painted the glowing sunrise view in the Johnson Collection, Philadelphia, dated 30 September 1810, followed by a cloudy, windswept version recently with the Richard Green Gallery, dated 18 Augst 1813, just one day before the present, smallest oil sketch. A year later, the same scene formed part of the background of his finished pencil drawing, *Golding Constable's Garden* (V&A), and in 1815 it reappeared as part of the center horizon of his superb finished oil, *Golding Constable's Kitchen Garden*

(Christchurch Mansion, Ipswich). Its first appearance as a background element, actually, was in one of his earliest surviving finished landscapes, *View from Golding Constable's House, East Bergholt* (*c.* 1800; Downing College, Cambridge).

The artist's heightened interest in the scene during the years 1810–15, as Parris and Fleming-Williams have rightly stressed (*Constable*, TG, 1976), related to his fiancée, Maria Bicknell. She was the granddaughter of the Rector, Dr Rhudde, and often visited him at the rectory; moreover, she and Constable first fell in love in the nearby fields, and subsequently met in them during their long, uneasy courtship (1809–1816), which Dr Rhudde vigorously opposed. This view could be seen from a back window in Constable's family home. In a letter to Maria written in the summer of 1812, he remarked:

From the window where I am writing I see all those sweet fields where we have passed so many happy hours together. It is with a melancholy pleasure that I revisit those scenes that once saw us so happy – yet it is gratifying to me to think that the scenes of my boyish days should have witnessed by far the most affecting event of my life. (*JCC*, II; 78)

Two years later, in another letter to Maria, he returned to this scene:

I can hardly tell you what I feel at the sight from the window where I am now writing of the fields in which we have so often walked. A beautiful calm autumnal setting sun is glowing upon the gardens of the Rectory and on adjacent fields where some of the happiest hours of my life were passed. (*JCC*, II; 132)

John Constable (1776–1837)
IV.23. A View from Hampstead Heath, looking towards Harrow (1821)
Oil on canvas $10\frac{1}{4} \times 12\frac{1}{4}$ (26 × 31.1)
Inscr. verso: *Hampstead 31st Oct. 1821. Very fine afternoon of a beautiful day, it began with rain – Wind fresh from the West*
B1976.7.103 PLATE 53

This open-air oil sketch dates from Constable's third annual late summer – early autumn stay at Hampstead in 1821, when he painted many of his celebrated sky sketches. A favorite view that year was one looking northwest toward Harrow. The Royal Academy owns three vibrant examples, including one of the same title which shows the same distant hill and spire of Harrow church in the same relative positions, while differing in

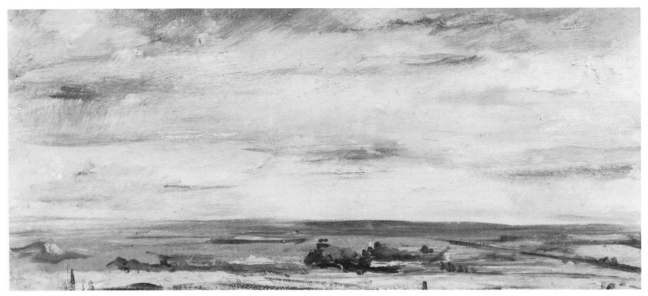

146. (IV.24) Constable, *Study of a Sky over Hampstead Heath*

its open, figureless foreground and stormier sky. The same view also appears in *Sunset Study of Hampstead Heath, looking towards Harrow* (1821; Private Collection) as well as in the slightly more finished (or less sketchy) variant in the Manchester City Art Gallery, again dated 1821. The Yale sketch is stylistically close to all of these, though is a bit warmer and more varied in its color scheme. Compositionally, it differs in one respect from the others, its foreground being enclosed on the right by tall trees, beneath which stand a pair of fairly prominent figures (unusual in Constable's oil sketches of the time). The compelling vividness of the scene and the sense of spontaneous, impromptu vision owe much to the artist's remarkably free yet utterly deft brush strokes.

Curiously, neither this work nor any of the others mentioned above, to our knowledge, led to a larger, finished landscape, the way his seminal *Branch Hill Pond, Hampstead Heath* (1819; V&A) did.

John Constable (1776–1837)
IV.24. Study of a Sky over Hampstead Heath, looking east (*c.* 1821)
Oil on paper laid on panel 5¾ × 12¾ (14.8 × 32.5)
Inscr: verso, *¼ p. 5 a.m. 19th July looking East*
 Day beautiful at noon plain blue sky
B1981.25.117 PLATE 146

Constable's many sky sketches and cloud studies (in oil) have long fascinated viewers in our century. While numerous landscape painters of the Romantic era – in central Europe as well as in Britain – made occasional studies of cloudy skies in various media, no other artist pursued this practice nearly so intensively as Constable, and none achieved such stunning results. As is well known, the majority were painted at Hampstead Heath in the late summer and fall of 1821 and 1822. Those of the earlier year usually included some reference to the ground, if only treetops, whereas most of the 1822 studies were of clouds exclusively and considerably larger and more finished. The artist referred to this activity in several letters of the time to John Fisher. On October 23, 1821, he wrote: 'I have done a good deal of skying – I am determined to conquer all difficulties and that most arduous one among the rest . . . It will be difficult to name a class of Landscape – in which the sky is not the "*key note*" – *the standard of* "*Scale*" – and the chief "*Organ of sentiment*" . . . The sky is the "*source of light*" in nature – and governs every thing . . . Their difficulty in painting both as to composition and Execution is very great, because with all their brilliancy and consequence – they ought not to come forward or be hardly thought about in a picture . . .' (*JCC*, VI; 76–7), In October the following year, he remarked: 'I have made about 50 carefull studies of *skies* tolerably large, to be carefull' (*Ibid.* VI; 98).

Dr John Thornes, in his useful article, 'The Weather Dating of John Constable's Cloud Studies', *Weather*, August 1979, assigns the work to 1821, pointing out that Constable's description of the weather on the

back agrees well with that of several London weather observers, for the date, July 19, 1821. Typical of Constable's inscribed weather data is his adding how the weather turned out at noon. He clearly experienced weather as a dynamic, unfolding *process* and probably wanted his cloud studies to convey some sense of an ongoing process. This aspect of his work has long interested twentieth-century meteorologists; see, for example, L. C. Bonocina's 'John Constable's position as a painter of Weather', *Quarterly Journal of the Royal Meteorological Society*, London, 63 (1937); 483–90; or more recently, J. B. Tyldesley's 'Weather in Constable's Paintings', *Weather*, 23 (1968); 344–6. One unusual aspect of the present study is the fact that it was made (or begun) so early in the morning (5.30 a.m.). Generally, the time of day cited in other sky sketches is around noon or a little later. The dawn light, however, is convincingly rendered with touches of pink and yellow.

Robert Hoozee adds a question mark after this work in his recent *L'Opera Completa di Constable* (Milano, 1979); No. 526. However, Graham Reynolds has stated in a letter to the compiler (January 11, 1982) that the study is unquestionably by Constable, and will appear as such in his forthcoming oeuvre catalogue (co-authored by Charles Rhyne). The study differs from contemporary Hampstead oil sketches by the artist, its viewpoint facing east.

John Constable (1776–1837)
IV.25. Cloud Study: Sunset (*c.* 1822)
Oil on panel. $6 \times 9\frac{1}{2}$ (15.3 × 24)
B1981.25.128 PLATE 147

This glowing study of a partly cloudy sunset sky is one of many sky sketches which Constable painted at Hampstead Heath, where he waged a veritable campaign of 'skying' in the late summers of 1821–2 (see the previous entry for his own comment on this). The sketch probably dates from 1822, the year that most of the studies of skies exclusively were made, two exceptions being in the Mellon Collection. Unlike the majority of the pure cloud studies, which are 'tolerably large, to be carefull' in the artist's words (*JCC*, VI; 98), this one is small but just as impressively executed. Also unusual is the absence of any inscription on the back citing the date, time of day, wind direction and general weather conditions, as Hoozee points out (*op. cit.*; 123). Furthermore, most of the 1822 studies show masses of voluminous clouds, often richly modelled, with the emphasis as much on their volume, as on their transient shapes and elusive textures. In the present work, a horizontal layer of dark cloud intercepts and spreads

147. (IV.25) Constable, *Cloud Study: Sunset*

out the warm light of a setting sun, not unlike some of the sunrise and sunset sky effects (in watercolor) which Turner collected in his remarkable Skies *Sketchbook* (*c.* 1817–18; BM, TB CLVIII), a series of skies Constable presumably never saw.

Speculation regarding the possible motivation for Constable's unprecedentedly extensive sky sketching at Hampstead in the early 1820s is involved and complex. Suffice it to say that meteorological science, the usual 'source' stressed since the appearance of Kurt Badt's provocative *Constable's Clouds* (1950), is simply one of a number of factors having either probable or possible relevance – and not necessarily the most important one. For example, one must not underestimate the artist's early experience working in one of his father's two windmills, which necessarily heightened his consciousness of weather (and the sky). It is also revealing that in his later years, whenever referring to clouds and weather conditions in his correspondence and letterpress to *English Landscape Scenery*, he habitually employed traditional colloquial terms long used by millers and mariners, rather than the Latin classifications of current meteorological science – though sometime after 1815 he acquired a second-hand copy of Thomas Forster's *Researches about Atmospheric Phaenomena* (2nd edn., 1815) which would have exposed him to these classifications, devised by Luke Howard and first published in Tilloch's *Philosophical Magazine* (1803–4). Constable probably also had some awareness of sky studies by earlier artists, whether by Alexander or John Robert Cozens, Wright of Derby, Girtin or Turner. We know that at some point he copied Alexander Cozens's twenty sky 'samples'. A more immediate prod for the 1821–2 sky sketches was press criticism of the skies in several landscapes he exhibited in 1819–21. His celebrated letter on 'skying' to Fisher (October 23, 1821; see the previous entry) dwells on the crucial importance of the sky in any landscape and voices his anxious concern about im-

proving his skill in painting skies – something he very soon achieved to a degree unequalled in the history of art. The fact remains, however, that he produced more studies than was arguably necessary for improving his skill, implying that for a few months in the late summer and fall of 1822 he developed an independent interest in (or obsession with?) on-the-spot cloud painting. None of the studies provided the basis for the sky in a finished landscape. Still, they surely were at least indirectly useful to his practice, constituting in effect a handy repertory of painted samples of actual cloud forms – executed with a compelling naturalism, both convincing and expressive – which he could readily consult in the studio as convenient standards of truthfulness (in paint) regarding such phenomena. A full 'explanation' of Constable's uniquely intensive skying activities is probably not possible, touching as it does on the 'mysterious centers' of the creative process, which may always elude any complete understanding. For a rewarding discussion which usefully places Constable's cloud studies in a broad context, see the exhibition catalogue, *The Cloud Watchers' Art & Meteorology 1770–1830* (Herbert Art Gallery, Coventry, 1975).

John Constable (1776–1837)
IV.26. Hampstead Heath (*c.* 1820–2)
Oil on canvas $12\frac{7}{8} \times 19\frac{3}{4}$ (32.7×50.1)
Yale University Art Gallery
B1949.235 PLATE 54

Between 1819 and 1836, Constable painted and sketched many different views of Hampstead Heath, his favorite rural area near London. He exhibited at least nine of these views at the Royal Academy. There is no record of the still little-known present work being exhibited in the artist's lifetime, but its style is fairly close to that of *Hampstead Heath: The House called 'The Salt Box' in the Distance* (*c.* 1820; TG), and its sweepingly open composition closely recalls that of *'The Spaniards,' Hampstead* (Johnson Collection, Philadelphia), dated 1822. Hence the above suggested dating. The particular locale represented is probably East Heath, near the inn called 'The Spaniards'. No oil or pencil sketch for this composition has yet appeared.

A rather unusual aspect of the picture is the straightness of the horizon on the left, which laterally divides the canvas into two nearly equal halves. A close look will show that here as always Constable avoids any simple 50/50 division, allotting a bit more space to the sky in this case. This highly dynamic, volatile sky – at once convincing and expressive – is fully characteristic of the artist in his maturity, as is also the vigorous brushwork and scumbling in the foreground. Both the

tonality and texture of the foreground recall in particular the Tate 'Salt Box' view, cited above.

Constable's Hampstead Heath scenes of the 1820s are among his most naturalistic and satisfying achievements. He no more tried to idealize that area than his native Stour valley, and once even remarked that '*ideal art . . . in landscape is sheer nonsense*' (letter of September 1835; *JCC*, V; 27). He deeply felt that a landscape painter must continually steep himself in nature, 'the Mother of all that is valuable in poetry, painting or anything else' (letter of May 1824; *JCC*, VI; 157), and often decried those artists who 'wandered into the vacant fields of idealism'. (Lecture at Hampstead, June 1833; C. R. Leslie, *Memoirs of the Life of John Constable*, ed. J. H. Mayne, 1951; orig. edn., 1843; 293).

John Constable (1776–1837)
IV.27. View of Old Sarum, Wiltshire (1829)
Pencil $9 \times 13\frac{11}{16}$ (22.9×33.4) sight
Inscr. *July 20th. 1829. noon. Old Sarum*, lower left
B1977.14.4631 PLATE 148

Constable first sketched a distant view of the ancient mound of Old Sarum and the surrounding expansive terrain during a visit to his Salisbury friend, John Fisher in 1820. A drawing formerly in the Haseltine Collection, dated July 26, 1820, presents the mound from a different viewpoint than does the present work. A second pencil sketch of the site made from another vantage point (Royal Institute of Cornwall, Truro) dates either from the same time or from nine years later, when the artist returned to the area, again during a summer visit to Fisher. Two further on-the-spot drawings bear the date July 20, 1829: the Yale sketch and a slightly more finished one (Victoria Art Gallery, Bath), made from a viewpoint further to the right. Of these four sketches, Constable chose the present one as

148. (IV.27) Constable, *View of Old Sarum, Wiltshire*

173

the basis for both a small oil sketch of late 1829 (V&A) and a sizable, highly finished watercolor (V&A) exhibited at the Royal Academy in 1834. The oil sketch, in turn, was mezzotinted by David Lucas at the end of 1829 and included in the second number of *English Landscape Scenery* (1830; a revised print by Lucas replaced it in the second edn., 1833).

Parts of the site date back to the Iron Age, subsequently built upon by the Romans, Saxons, Danes and Normans. The latter, under Bishop Osmond (a nephew of the Conqueror), built an imposing Norman cathedral and castle, around which a town prospered, until the early thirteenth century. Due to an increasingly inadequate water supply, the Episcopal See was transferred two miles south to New Sarum (Salisbury) in 1220. Old Sarum declined and was gradually abandoned. In his unpublished letterpress intended to accompany Lucas' print, Constable wrote: 'The present appearance of Old Sarum – wild, desolate and dreary – contrasts with its former greatness. This proud and "towered city" . . . can now be traced but by vast embankments and ditches, tracked only by sheepwalks. "The plough has passed over it."' (full text in Andrew Wilton, *Constable's English Landscape Scenery* 1979; 44). As the artist's friend and biographer, C. R. Leslie observed in his 1843 biography (*edn. cit.*; 196), 'A city turned into a landscape, independently of the historical associations of Old Sarum, could not but be interesting to Constable.'

Peter De Wint (1784–1849)
IV.28. Harvest Time (*c.* 1816)
Watercolor $12\frac{7}{16} \times 18\frac{1}{4}$ (31.6 × 46.5)
B1975.4.1503 PLATE 47

The style and technique of this sunny, rural scene is comparable to that of watercolors by De Wint which are usually dated around the mid 1810s, such as *The*

Bridge (*c.* 1815; YCBA). David Scrase has pointed out (orally) that the present work is close in style to sheets in the artist's sketchbook of 1816 (Private Collection). Like some of his other early watercolors, it is freely painted and possibly executed outdoors. There is an improvisational look to some of the passages, though on the whole the work is rather more finished and complete than his typical outdoor studies, but not as richly finished as many of his exhibited watercolors. Especially attractive is the rich blending of colors, the artist already on his way to becoming one of the foremost colorists in the medium.

In terms of composition, the work resembles *Landscape with a Woman and Cattle* (undated; Leamington Spa Art Gallery), as well as *The Wayside* (undated; Mr Paul Mellon). Unlike most of his harvest scenes, which are set in an open grainfield, this work shows a later operation: stacking hay near a farmhouse. The two children playing in the foreground, however, are much more prominent than the tiny haymakers in the distance.

Peter De Wint (1784–1849)
IV.29. Harvest Time, Cumberland (*c.* 1824–5)
Watercolor over pencil $6\frac{5}{8} \times 17$ (16.8 × 43.2)
Inscr. Verso: 3017 and an illegible inscription
B1981.25.2578 PLATE 149

De Wint visited the Lake District in the late summer of 1824, and the following year he exhibited three views of that region at the Society of Painters in Watercolours – his first appearance there since 1818. The present work was not one of the watercolors shown, but could well date from about the same time. It appears to be a finished work, for his on-the-spot sketches of the 1820s were still freer in style and the forms of nature more abbreviated – as seen in two sheets from a sketchbook in use during 1824, now

149. (IV.29) De Wint, *Harvest Time, Cumberland*

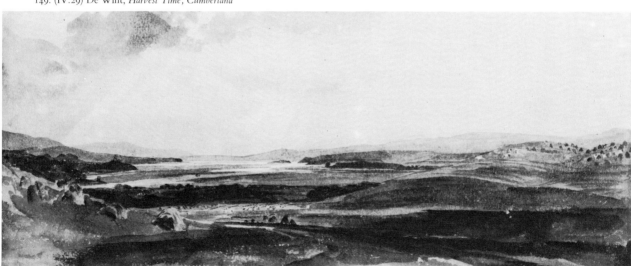

in the Usher Gallery, Lincoln (reproduced in David Scrase's *Drawings and Watercolors by Peter De Wint*, Fitzwilliam Museum 1979; No. 38). As in other watercolors from De Wint's middle years, the color was swiftly applied on slightly damp paper in long, free-flowing strokes, one tone overlapping another. The markedly panoramic and open-ended compositional format is also very characteristic of the artist. A similar view of nearly the same size, *Harvesting in Westmorland*, was with Agnew's in 1976. Unlike his many Lincolnshire harvesting and haymaking scenes, the present farmland view is devoid of laboring farmhands in the foreground. The subtle visual poetry of gently rolling grainfields under luminous skies suffices.

Joseph Mallord William Turner (1775–1851)
IV.30. On the Washburn (*c.* 1815)
Watercolor over pencil with some scratching-out
$10\frac{3}{4} \times 15\frac{3}{8}$ (27.2 × 39.1)
Inscr. *JMW Turner RA*, lower left center
B1977.14.4700 PLATE 48

IV.31. Sketch for On the Washburn (*c.* 1815)
Watercolor and pencil $11\frac{1}{4} \times 18$ (28.6 × 45.7)
B1975.4.1620 PLATE 49

This view of a wooded embankment along the Washburn River in Yorkshire is one of a number of watercolors Turner made in the 1810s near Farnley Hall, the country seat of his friend and generous patron, Walter Fawkes. Like some of the others, it strikes a strongly naturalistic note, in contrast to his neo-Claudean oil paintings of the same period, showing the flexibility of his art. But unlike most of the other Farnley scenes, which tend to be fairly deep vistas, this one exhibits an unusually close-up, confined, lateral format. Also unusual for a finished work in this group of watercolors is the complete absence of any human figures or sizable animals, the sole 'occupant' being a kingfisher perched on the largest rock – perhaps a punning symbol of Turner, an avid angler. In both style and subject, the work is especially close to the contemporary *Rocky Pool with a Heron and Kingfisher* (*c.* 1815; Leeds City Art Gallery), another Yorkshire scene, probably nearby.

The sketch for *On the Washburn* is apparently a leaf from the 'Large Farnley' sketchbook (TB CXXVIII), in use mainly in 1815. For a change, the sketch is on the same scale as the finished work – in fact, slightly larger – and includes many watercolor touches, instead of being a small 'pencil rough' in a pocket-size sketchbook, as usually the case. The final version closely follows the main elements of the rough and rapid study, though of course is much enriched as to detail

and color. Turner, however, does enlarge the scale of the trees, and fully particularizes them in a way that is persuasively natural-looking, even though he is working partly from memory in his studio.

Joseph Mallord William Turner (1775–1851)
IV.32. Lulworth Castle, Dorset (*c.* 1818–19)
Watercolor with some scratching-out $6\frac{1}{8} \times 9\frac{5}{16}$
(15.5 × 23.5)
B1975.4.749 PLATE 50

This watercolor is one of a series of forty coastal scenes which Turner painted between *c.* 1811 and 1824, each of which was engraved for W. B. Cooke's *Picturesque Views on the Southern Coast* (1814–26). The scene represents a portion of the extensive estate of the Weld family, near Weymouth, including the Elizabethan castle, built in 1588–1609 (destroyed by fire in 1929). It is the only completely inland scene in the whole series. Turner offers a distant, rural view of the castle and parish church, emphasizing a rustic foreground of varied trees, cattle, reclining fisherman and an inquiring traveller. He freely derived the work from an on-the-spot pencil sketch in his 'Corfe to Dartmouth' sketchbook (TB CXXIV; 19), which he used during his six hundred-mile tour of Dorset, Devon, Cornwall and Somerset in the late summer of 1811, a tour which resulted in over two hundred sketches from nature. The view was one of twenty-four Turner watercolors exhibited in 1822 at W. B. Cooke's Gallery, Soho Square, the first of three annual exhibitions of coastal scenes made for Cooke's *Southern Coast* (also including works by Francia, Cristall, Owen, Clennell, Collins, De Wint and Prout).

Francis Danby (1793–1861)
IV.33. The Avon Gorge (*c.* 1818)
Oil on canvas $13\frac{1}{16} \times 9\frac{11}{16}$ (33.1 × 24.6)
B1976.7.181 PLATE 150

The awesome gorge of the Avon River near Clifton very much attracted artists 'in search of the Picturesque and the Sublime', particularly during the last years of the eighteenth century and first two decades of the next – largely a time when the Napoleonic Wars prevented continental travel by the British. Fuseli declared the gorge to be 'the finest scenery in the kingdom – sublime *et cetera*' (Joseph Farington, *Diary*, 1808), while the Poet Laureate, Robert Southey, described the region as 'rich with fantastic foliage, the sublime and the beautiful by the boatload'. In Danby's view we are looking south, downstream, towards Sea Walls and across Nightingale Valley. By making the

150. (IV.33) Danby, *The Avon Gorge*

rugged, shadowy cliff on the left much higher and vaster than it actually is and also having it rise abruptly out of the picture – inviting our imagination to continue it – Danby ends up with a dramatic view that partakes of the Sublime as much as the Picturesque. He achieves this heady effect within a very small picture space. The composition in general recalls certain of Gaspard Dughet's upright Tivoli views, such as one at Petworth, which similarly includes a dark foreground slope on the left, albeit smaller and less bold than Danby's.

This writer finds Francis Greenacre's dating of this work, *c.* 1816–18 (*The Bristol School of Artists*, 1973; 42) much more convincing than Eric Adams's dating, *c.* 1822 (*Francis Danby*, 1973; 171). If the earlier date is correct, then the painting is one of the earliest surviving works in oil by Danby, who spent most of the 1810s working in watercolor. The ratio changed after 1820. Danby also made a large, highly finished watercolor of the gorge, viewed from a little further south, *The Avon Gorge looking towards Clifton* (*c.* 1820; Mr Paul Mellon). Such works ceased after the artist moved from Bristol to London in 1823, when he became caught up in the taste for the 'phantasmagorical sub-

lime' and began producing grandiose biblical and historical landscapes in competition with John Martin.

Francis Danby (1793–1861)
IV.34. Landscape near Clifton (*c.* 1821)
Oil on canvas 36 × 28 (91.5 × 71)
B1981.25.194 PLATE 108

The present work is one of Danby's finest Bristol landscapes, and richly exhibits the notable degree of naturalism he achieved in his early years. This is especially evident in the closely observed, precise rendering of the foliage, which almost seems Pre-Raphaelite at first sight. Following his move to London in 1823, he was to pursue less naturalistic ends. Part of the novel effect of the composition derives from the arresting contrast between the very close-up, intimate foreground, with its interplay of deep shadows and scattered highlights, and the sudden luminous vista shining through an opening on the left. The contrast is a multiple one, involving elements of color, light and scale. Anne French relates this picture with the work of Gaspard Dughet, in her fine exhibition catalogue of that artist (Kenwood, 1980; 93). However, the compositional layout is not very like that of any Dughet known to the writer, and the sense of intimacy definitely sets it apart from Dughet's work.

The work is close in style to other paintings made around 1820–1, such as *Children by a Brook*, also at Yale, or *Clifton from Leigh Woods* (Bristol City Art Gallery). Eric Adams dates these works a year or two later in his 1973 monograph on Danby (171–2), but Francis Greenacre's slightly earlier datings are more convincing (*The Bristol School of Artists*, 1973; 42ff).

Samuel Palmer (1805–81)
IV.35. Ancient Oaks, Lullingstone Park (*c.* 1828)
Pencil 10½ × 14⅝ (26.5 × 37.2)
Inscr. Verso: *Lullingstone Park Kent*, perhaps in the artist's hand
B1977.14.308 PLATE 62

This unforgettable study of two enormous oaks in a park near Shoreham is contemporary with a number of closely observed nature studies in watercolor and bodycolor which Palmer made on commission from John Linnell, who sought to moderate his visionary bent. At least two of the latter were studies of oaks in the same park (National Gallery of Canada and a Private Collection). Palmer appears to have pursued the commission with zeal, despite protesting at the time to George Richmond that 'tho' I am making studies for Mr. Linnell, I will, God help me, never be a

naturalist by profession' (September 1828; in Geoffrey Grigson, *Samuel Palmer's Valley of Vision*, 1960; 19). In a letter to Linnell of December 1828, he alludes to the challenging task of coming to grips with 'the grasp and grapple of the roots, the muscular belly and shoulders, the twisted sinews' of the wonderfully rugged and long-enduring Lullingstone oaks (*Ibid*.; 22). The immense girth of these venerable trees also stirred him. In the same letter, he remarked: 'Milton, by one epithet, draws an oak of the hugest girth I ever saw, "Pine and *monumental* oak": I have just been trying to draw a large one in Lullingstone; but the poet's tree is huger than any in the park' (*Ibid*.; 22). Palmer's drawing style was fully up to the task. One is especially struck by the variety of his pencil technique. The massive, centuries – old trees – the central one wildly irregular in shape – possess a creature-like quality which Palmer has captured with uncanny vividness.

Samuel Palmer (1805–81)
IV.36. The Valley of Vision (*c*. 1828)
Pen and brown ink with grey and brown wash over pencil heightened with white 11 × 17½ (27.9 × 44.5)
B1975.4.1835 PLATE 63

Palmer's most inspired years came very early in his career, between the ages of twenty and twenty-seven, when he lived at Shoreham in the quietly pastoral Darent valley, Kent. There he created a new kind of pastoral landscape, one more intensely personal and 'poetic' than the rural landscapes of his contemporaries (see Ch. IV). The present work presents a portion of the valley which includes Sepham Barn, a mile southwest of Shoreham, near 'The Pilgrim's Way' from Winchester to Canterbury. A different view of the barn appears in *Barn in a Valley* (1828; Oxford), one of a group of drawings made 'from nature' and commissioned by John Linnell in 1828.

The drawing nicely blends naturalistic observation with a free suggestiveness. The rather dream-like quality, in this case, owes something to the slightly strange effect of the pale buff paper, accented by ghostly whites. The foreground shepherd is phantom-like in his partial translucency. Still, the work is distinct from the more overtly visionary drawings of his Shoreham years, including several at Yale, such as *A Shepherd and his Flock under the Moon and Stars* (*c*. 1827) or *Moonlit Scene with Winding River* (*c*. 1827). The latter – pictorial 'inscapes', to coin a term of Gerard Manley Hopkins – are more in line with Palmer's Blakean remark that 'Nature is not the standard of art, but art is the standard of Nature. The visions of the soul, being perfect, are the only true standards by which nature must be tried' (1825; in Geoffrey Grigson, *Samuel Palmer's Valley of Vision* 1960; 19). Christina Payne sees the moderating influence of Linnell in the present work ('John Linnell and Samuel Palmer in the 1830s', *The Burlington Magazine*, CXXIV, March 1982; 132).

V. Landscapes with Laborers

William Ashford (1746–1824)

V.1. Landscape with Haymakers and a Distant View of a Georgian House (*c.* 1780–5)

Oil on canvas 30 × 42 (76 × 106.5)

B1981.25.21 PLATE 151

The precise locale represented here remains unidentified, other than being somewhere in Ireland, where Ashford worked during his adult life and where he was regarded as the leading landscape painter after *c.* 1780. The artist animates the foreground with several haymakers busily performing their chores amidst pleasantly sprawling grainfields surrounding a distant manor house. One rustic is resting with his dog in the shade of a large and beautifully executed tree. Ashford, indeed, was especially admired for his adept handling of trees. The picture throughout indicates that he is at this point a fully accomplished landscape painter, suggesting a date not much earlier than *c.* 1780. As Anne Crookshank and the Knight of Glin point out in *Painters of Ireland 1660–1920* (1978), Ashford began his career painting still lifes, and was not heard of as a landscape painter until 1772, becoming fully competent in that field only by the end of the 1770s. On the other hand, the precision and tightness of touch, along with the dress of the laborers suggest a date not much later than *c.* 1780–5.

151. (V.1) Ashford, *Landscape with Haymakers*

Ashford painted many Irish country houses, which provided a steady source of income, and most probably the present work resulted from such a commission; however, I know of no other example by the artist which so prominently features haymakers laboring in the foreground. Most of his 'house portraits,' such as *Mount Kennedy, Co. Wicklow* (1785) at Yale, or *Belan House, Co. Kildare* (*c.* 1780; untraced), make the house the main subject. But wholly typical of the artist is the accent on prosperous, well cared-for farmlands and parklands. The mood is one of pastoral peace and plenty, of man and nature in harmony. Such a work reveals 'a distinctly English quality', the above authors feel, in contrast to the more strenuous landscapes by some of Ashford's Irish-born contemporaries, such as George Barret.

Philippe Jacques De Loutherbourg (1740–1812)

V.2. View near Matlock, Derbyshire (1785)

Oil on canvas 35⅝ × 57 (90.5 × 144.75)

Inscr. *P. J. De Loutherbourg 1785*, lower left.

B1981.25.225 PLATE 105

De Loutherbourg first visited Derbyshire in 1778, when he gathered material for his stage sets to 'The Wonders of Derbyshire', which ran at the Drury Lane Theater where he was chief scene painter (until 1781). Five years later, in 1783, he made an extensive tour of Derbyshire and the Lake District, and the present large oil is one of the more impressive results. Presumably it derives from one or more sketches made on the tour, untraced today. In 1800, J. C. Stadler made an aquatint engraving of the picture, which Bowyer published that year under the above title. The site, with its rickety wooden conveyor spanning a rushing stream and leading to a mill, is very similar to that represented in Rowlandson's *Water-wheel Driving a Transporter* (*c.* 1780; No. V.3), while not actually the same scene. De Loutherbourg includes a trio of laborers engaged in washing lead ore, an activity common around Matlock, one of the leading lead mining centers in England. The artist's portrayal of the process is remarkably accurate, as born out by the following comments of John

Pickin, Assistant Keeper of Industry and Technology, Derby Museums:

> Lead, taken from the mines, was crushed at the surface and then 'washed' to separate the ore from any waste minerals. The woman . . . is washing with a sieve and vat. The crushed ore was placed on a sieve and plunged repeatedly into a water-filled vat; the heavier ore rested on the sieve and the lighter waste rose to the surface as a scum . . . The scraper or 'limp' in her hand was used to remove the scum. Washing was nearly always carried out by women and boys and was so arduous that it was common for them to vomit blood as they worked. The man to the left of the vat is 'buddling', a method used when the ore was too fine to be sieved. The ore was placed in a sloping wooden trough, similar to the one illustrated, and a stream of water played over the material to form a slurry. The water carried the lighter waste away to leave the heavy lead ore at the top of the trough. The slurry was pulled across the water with the hoe-like tool the man has; this was known as a 'jagger'. (letter of Dec. 18, 1981).

We catch the three lead-washers during a momentary pause in their work, as they exchange glances. Like Gainsborough, Wheatley and Morland, De Loutherbourg invests the faces of his laborers with a mildly contented look.

Rather surprisingly, De Loutherburg did not exhibit this singular work at the Royal Academy, even though between 1782 and 1786 he sent to the Academy five landscapes in which laboring activity dominated the foreground: *A Sand Pit* (1782; Horton-Fawkes), *Labourers near a Lead Mine* (1783; Marquis of Hamilton), *An Engine to Draw Water out of a Lead Mine near Matlock Bath, Derbyshire* (1785; untraced), *Slate Quarry near Rydal Water, Cumberland* (1785; Mrs D. Boulton) and *Brick Kilns at the Entrance to Keswick with a View of Skiddaw* (1786; untraced). He was the first major painter in England to exhibit such subjects on a large scale (in oil) at the Royal Academy. In the final twenty-six years of his life, he exhibited only one 'working landscape', but that one a masterpiece, his *View of Coalbrookdale by Night* (1801; Science Museum, London).

Attributed to Thomas Rowlandson (1756–1827)
V.3. A Water-Wheel Driving a Transporter
(*c.* 1780?)
Pen, ink and watercolor 11¼ × 18¼ (28.5 × 46.4)
Verso: study for *A Sailor's Farewell*
B1977.14.5474 PLATE 152

This picturesque 'working landscape' of a watermill and makeshift conveyor may represent a scene in

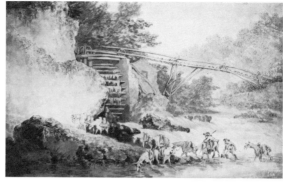
152. (V.3) Attr. Rowlandson, *A Water-Wheel Driving a Transporter*

northwest Devon, for according to Baskett and Snelgrove, the type of pack-saddle worn by the donkeys was used to carry slate and culm from Barnstaple to Bideford (*The Drawings of Thomas Rowlandson in the Paul Mellon Collection*, 1977; 25). However, the same type of pack-saddle appears on several horses in Rowlandson's *View in Caernarvon, North Wales* (*c.* 1790s; V&A). The work provides an interesting comparison with De Loutherbourg's painting of an old mill and conveyor in Derbyshire (No. V.2). Even in this early landscape, made before the artist had formed a mature, characteristic style, a touch of caricature crops up in the treatment of the two little, almost dwarf-like men accompanying the straggly procession of donkeys. Unlike the lighter, more colorful drawings of his mature years, this work is largely monochromatic, with the addition of a little pale green, ochre and mauve. Although always attributed to Rowlandson since its reappearance in the twentieth century, this writer feels a bit uneasy about the attribution, despite the presence of a study for *A Sailor's Farewell* on the reverse which is closer in style to Rowlandson's documented works.

Thomas Hearne (1744–1817)
V.4. Unloading Pit Props at Coalbrookdale
(*c.* 1790s)
Pencil with some grey wash 8½ × 7½ (21.7 × 19.1)
B1975.4.1244 PLATE 153

Hearne records here, with care and sensitivity, a routine activity near a typical horse gin located at the mouth of a coal shaft in the Coalbrookdale coalfield. He undoubtedly made the drawing on the spot, though it is not known just when he visited the area. No finished watercolor or print based upon the drawing has been traced. Hearne is one of over fifty British artists who sketched or painted various industrial scenes in or near Coalbrookdale and Madeley between 1750 and 1830. The Severn Gorge region, with its

153. (V.4) Hearne, *Unloading Pit Props at Coalbrookdale*

fascinating assemblage (in Georgian times) of iron foundries, forges, furnaces, limekilns as well as coal shafts, was among the earliest and most important centers of the new coal and iron technology that provided the basis of the Industrial Revolution which England pioneered. In fact, by the early nineteenth century, Coalbrookdale was accounted 'the largest ironworks in England'.

Horse gins also appealed to Cotman and P. S. Munn when they visited Coalbrookdale together in 1802, and made several drawings of the mechanisms and their desolate surroundings. Gins also appear in Ibbetson landscapes around the turn of the century, such as *Rustic Landscape with Peasants and a Horse Gin* (1799; Georgetown University). None of Hearne's exhibited works dealt with industrial or laboring subjects. The bulk of his oeuvre, like that of other predominantly topographical artists, is devoted to picturesque scenery, and views of castle ruins and crumbling abbeys.

John White Abbott (1763–1851)
V.5. Slate Quarry at Widdecombe, Devon (1792)
Pen, brown ink and watercolor $9\frac{7}{16} \times 7\frac{1}{2}$ (24 × 19.1)
Inscr. in pencil verso: *Slate Quarry at Widdecombe July 18. light fr 9 × Morning*; inscr. pen and ink, verso of original mount: *The Slate Quarry at Widdecombe − Devon/JWA July 18.1792*
B1975.3.1082 PLATE 154

Rather than representing an actual quarrying scene, Abbott's view focuses on a later phase of the industry, with three workmen dressing already-cut slabs of slate outside a workshop. The work is close in style and type of paper to other watercolors by Abbott dating from the 1790s, such as a slightly later quarrying scene dated May 1797, *A Quarry near Chepstow Castle, Monmouthshire* (Royal Albert Memorial Museum, Exeter). The pen outlines and general manner of drawing trees and foliage along with the use of a few pale colors very much recalls the work of his teacher Francis Towne. One subtly distinguishable difference is that nature's forms here are not quite so radically simplified as they are in a characteristic Towne. Also, the subject is not one that the older artist typically chose.

Abbott was an amateur artist, albeit a highly accomplished one, who spent most of his life in Exeter practicing as a surgeon. Between 1793 and 1826, he exhibited sixteen works (about half, oils) at the Royal Academy as an 'Honorary Exhibitor'. Throughout his life he made numerous sketching sorties into the countryside around Exeter. Besides an occasional quarry scene, Abbott's oeuvre included a few limekiln scenes, such as his 1795 Academy exhibit, *Landscape,*

154. (V.5) Abbott, *Slate Quarry at Widdecombe, Devon*

155. (V.6) Copley Fielding, *Landscape with Lime Kiln*

limekilns and figures (location known) or his *Old Lime-kilns near Topsham* of 1808 (Exeter).

Anthony Van Dyke Copley Fielding (1787–1855)
V.6. Landscape with Lime Kiln (1809)
Watercolor $9\frac{1}{8} \times 12\frac{5}{8}$ (23.2 × 32.1)
Inscr. *C. V. F. 1809*, lower left
B1977.14.4678 PLATE 155

Copley Fielding painted this rather desolate industrial scene under dramatic skies in the year following his important first tour of Wales. Presumably it derives from one of his on-the-spot sketches, now untraced. The precise locale is uncertain, but the mountain in the background might possibly be Cader Idris. Like his contemporary *Rhuddlam Bridge* (1809; V&A), the composition is quite Girtinian in its sweeping breadth and boldness. The little dabs of separately applied color in the lower right and distant trees also recall Girtin. Then too there is a hint of John Varley, with whom Fielding enjoyed much contact upon his move to London in 1809. Four years later, in fact, he married Varley's sister-in-law. On the other hand, the remarkable sky with its somewhat eccentrically shaped clouds, brings to mind Cotman, who had departed London for his native Norwich three years before Fielding arrived. Varley, however, knew his work well. Both the Yale and Victoria & Albert Museum watercolors show a marked advance over Fielding's disappointing previous work, especially in technical facility and expressive power.

Many critics and collectors today prefer Copley Fielding's sterner early work, like the present watercolor, to his softer and richly colored later work, which tended toward formulaic compositions. Perhaps the latter tendency inevitably resulted from his phenomenally prolific output – one thousand, seven hundred and fifty-eight works exhibited in his lifetime

at the Society of Painters in Watercolours, of which he was president during his final twenty-four years.

Joseph Mallord William Turner (1775–1851)
V.7. Limekiln at Coalbrookdale (*c.* 1797)
Oil on panel $10\frac{3}{4} \times 15\frac{7}{8}$ (27.5 × 40.3)
B1981.25.636 PLATE 64

This dramatic night view of a fiery kiln in the Lincoln Hill area of Coalbrookdale, Shropshire, is one of Turner's earliest surviving works in oil, a medium he did not take up until the mid 1790s. Nocturnal settings must have fascinated him at this time, as two of the first three oils he exhibited at the Royal Academy were night scenes: *Fishermen at Sea* (1796; TG) and *Moonlight: A Study at Millbank* (1797; TG). But after 1799, he painted few night scenes in oil until the 1830s. Turner presumably witnessed some such scene as that represented here during his visit to Shropshire in 1794, which he may also have passed through the following year on his way to or from Wales. I am unaware of any earlier night view (other than sketches) of this particular kind of industrial subject by any British artist of note. Such a setting, of course, makes the flaming kiln a much more dramatic sight. About two years later, Turner made a watercolor of a less fiery kiln at night, *Limekiln by Moonlight* (*c.* 1799; Herbert Art Gallery, Coventry), his only other finished work of such a subject.

Coalbrookdale was a cradle of the Industrial Revolution which began in England, and Turner was one of over fifty artists who painted or sketched various parts of the region between 1750 and 1830. Among other artists drawn to this intriguing area were George Robertson, Rooker, Farington, De Loutherbourg, P. S. Munn and Cotman. In 1801, De Loutherbourg produced by far the most 'sublime' painting of the site, *Coalbrookdale by Night* (Science Museum, London), showing 'Bedlam Furnace' operating flat out at Madeley Dale – a scene of utter inferno, truly worthy of Blake's prophetic phrase, 'those dark Satanic mills'.

Turner's limekiln painting differs in character from Wright of Derby's famous industrial night scenes, like his serene *Arkwright's Cotton Mills at Cromford, by Night* (*c.* 1783; Private Collection). As Butlin and Joll point out (*The Paintings of J.M.W. Turner*, 1977; 19), this work probably owes a debt to a small night scene by Rembrandt, *Holy Family resting on the Flight into Egypt* (1647; National Gallery of Ireland), which Turner would have seen at Stourhead in the collection of his patron, Sir Richard Colt Hoare, whom he may have visited as early as 1795. Rembrandt was to remain a recurring stimulus for Turner, cropping up again most conspicuously in several paintings of the late 1820s and early 1830s.

Joseph Mallord William Turner (1775–1851)
V.8. Dartmoor: the Source of the Tamar and the Torridge (*c.* 1813)
Watercolor $7\frac{7}{8} \times 12\frac{5}{8}$ (20.3 × 32)
B1977.14.4690 PLATE 65

This watercolor is one of four by Turner engraved in the mid 1810s for a projected (but never published) set of views, 'The Rivers of Devon', sponsored by W. B. Cooke, who had commissioned the artist's Southern Coast series of views. The print of *Dartmoor* was finally published separately in 1850. The work derives either from Turner's 1811 or 1813 Devon tour, though none of the surviving pencil sketches made on those tours relate to the present work. The artist makes the scene a 'working landscape', with several laborers burning material on the hill, a man accompanying three burdened Dartmoor ponies and in the immediate foreground, another laborer performing some operation at the edge of the headwaters. Turner's approach is utterly direct, a frank, naturalistic rendering of a scene which most contemporary artists would have considered too plain or featureless a subject for a picture. He achieves a comparable effect in his contemporary *Grouse Shooting* (*c.* 1813; Wallace Collection), an austere moorland scene of equally compelling naturalness.

The title and hence the locality of the work is misleading, for the Tamar and the Torridge rise about four miles south of Clovelly, which is some thirty miles from Dartmoor.

John Varley (1778–1842)
V.9. Boat Building (1806)
Watercolor over pencil $13\frac{1}{2} \times 21\frac{9}{16}$ (34.4 × 54.7)
Inscr. *J. Varley. 1806.*, lower left
B1975.3.151 PLATE 156

Varley's portrayal of a rural boat-building yard in operation is one of the more striking images of work in early nineteenth-century British art. This kind of subject continued to be relatively uncommon with respect to finished watercolors and oils on a sizable scale. The artist vividly captures the sense of effort which a row of workmen put into their chore of slowly prying a log into a boat-building pit. A high-roofed, airy shed looms large behind them, housing a nearly completed barge. The arresting quality of the watercolor very much lives up to Varley's dictum that 'Every picture should have a *look-there*'.

As in other early watercolors by the artist, certain aspects of this work result from Varley's close and discerning study of Girtin's art, in particular the use of subdued, earthy tonalities, the sensitivity to varying

156. (V.9) Varley, *Boat Building*

textures, and the great breadth of effect. The picture as a whole, however, is very much Varley's own achievement, and surely one of his strongest works. After *c.* 1812–13, Varley's art became less empirically grounded and gradually more formulaic. Some of his watercolors of the 1830s have been justly termed 'flagrently artificial'.

One would normally expect a work of this size, quality and degree of finish to have been exhibited by the artist. However, the subject does not correspond with any of the titles of the many works he showed at the Old Water-Colour Society from 1806.

John Seguier (1785–1856)
V.10. Excavating the Regent's Canal, with a view of Marylebone Chapel (*c.* 1812–13)
Oil on canvas 10 × 12 (25.4 × 30.5)
Inscr. *J. Seguier*, lower right
B1976.7.153 PLATE 157

John Nash, the reigning Regency architect, proposed construction of a canal in 1811, while engaged in developing Regent's Park. Work commenced the following year, and after many vicissitudes, the eight and a half-mile canal (including two tunnels) was finally completed in 1820, at great expense. This important waterway connected the Grand Junction Canal at Paddington Basin with the Thames at Limehouse, which greatly facilitated the flow of goods to and from various parts of London. Seguier's modest little pictorial record clearly represents an early stage of construction. The work exhibits an unflinching directness of vision comparable to that of John Linnell's contemporary *Kensington Gravel Pits* (1812; TG), one of the classic laboring scenes in British art. Some of the early work of William Mulready also comes to mind, such as *The Mall Kensington Gravel Pits* (1811–12; V&A). The small, portable

size of Seguier's picture, along with its impromptu quality suggests that it may have been painted largely or partly on the spot.

Between 1811 and 1822, Seguier exhibited twelve works at the Royal Academy, including a *View of the Alpha Cottages near Paddington* (untraced) in 1812. During the final thirty-four years of his life, he showed nothing, devoting himself instead to advising art collectors and dealers as well as to serving as superintendent of the British Institution, a post turned over to him by his older brother William, who was Keeper of the Royal Pictures and the first Director of the National Gallery.

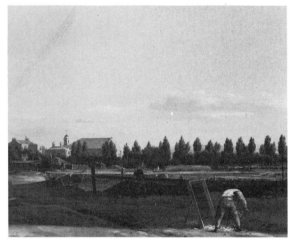

157. (V.10) Seguier, *Excavating the Regent's Canal*

Thomas Girtin (1775–1802)
V.11. The Abbey Mill, Knaresborough (*c.* 1801)
Watercolor over pencil, touched with body color
$12\frac{5}{8} \times 20\frac{5}{8}$ (32.2 × 52.3)
Inscr. Verso, pencil: Mr Reynolds Poland Street Soho
B1975.4.1925 PLATE 126

As was his usual practice, Girtin based this watercolor very closely on a preliminary pencil drawing, in this case one made on a visit to Harewood House in Yorkshire during the summer of 1800. The sketch appears in the artist's only surviving sketchbook (Whitworth Art Gallery), datable 1800–1. Girtin has simply added a laborer and a horseman, in addition to fleshing out the forms and introducing a cloudy sky. In general, when preparing a finished work in the studio, he wrought far fewer changes upon the initial sketch than did his imperious rival, Turner. He is first and foremost a

thoroughly empirical artist, whose work remained closely tied to his initial experience of observing and recording a particular scene. This is not to regard him as a sheer topographer. The essentializing power of his selective and probing eye (and mind), his oft-praised 'sweeping breadth' and his unusually strong compositional sense very much raised his art above the level of purely descriptive topography.

James Ward (1769–1859)
V.12. An Overshot Mill with Workmen Thatching a Roof (*c.* 1806)
Oil on panel $10\frac{7}{8} \times 13\frac{1}{8}$ (27.75 × 33.25)
B1977.14.102 PLATE 158

This rustic little laboring scene is one of a number of small oils on panel painted by Ward in the middle of the first decade, most of them showing the impact of Rubens. The artist came under Rubens's spell in 1803, after intensively studying *The Château de Steen* (1636; NG), on view in the studio of Benjamin West, who had borrowed it from Sir George Beaumont, its recent purchaser. Ward soon responded with his large, consciously Rubensian picture, *Bulls Fighting, with a View of St Donat's Castle* (1803–4; V&A). In the present work, the vigorous, wiry trees on the right reflect this stimulus; so also does the thin, liquid brushwork in the lower left. The choice of theme owes something to George Morland, the artist's brother-in-law. More particularly, the mode of picturesque rusticity recalls Morland, though stylistically the picture is not nearly so Morlandesque as Ward's works of the 1790s. The

158. (V.12) Ward, *An Overshot Mill*

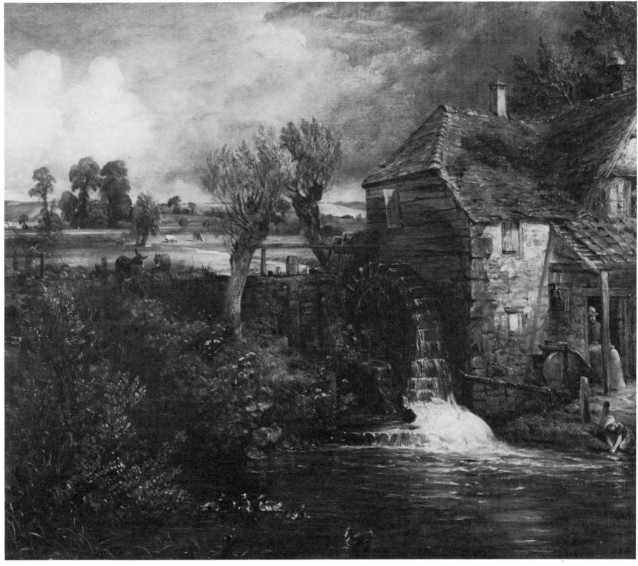

159. (V.13) Constable, *A Mill at Gillingham, in Dorsetshire*

artist's touch is now even freer than Morland's, more painterly, and the paint surface more varied as to thickness or thinness. Also, direct observation of nature appears to play a greater role here than it does in most of Morland's work.

Ward exhibited at the British Institution in 1807 a small oil entitled *Thatching a Mill*, and the present work might very well be that picture – the measurements fit approximately, allowing for the frame. Probably a drawing from nature lay behind the work, or part of it. Most of Ward's drawings, however, have yet to be published. The Yale Center owns a fine on-the-spot pencil drawing of another overshot watermill, *Mr Thompson's Wire Mill, Tintern*, dated 1807.

John Constable (1776–1837)
V.13. A Mill at Gillingham, in Dorsetshire (1826)
Oil on canvas $19\frac{3}{4} \times 23\frac{3}{4}$ (50.2 × 60.4)
B1981.25.133 PLATE 159

Constable loved watermills and knew them intimately, being the son of a miller who owned two watermills (at Flatford and Dedham) which he often sketched and painted, especially between 1810 and 1820. He first saw the mill at Gillingham – then known as Perne's or Parham Mill – during a brief visit in June 1820 to his friend, John Fisher, Vicar of Gillingham. He returned in the late summer of 1823 for a three-week stay, when he 'made one or two attacks on the old mill' (letter to

Maria, August 29, 1823; *JCC*, VI; 130). In a slightly earlier letter to Maria, he described the mill as 'wonderful old & romantic' (August 24, 1823; *Ibid*. II; 283). A small oil painting dating from this time is in the collection of Lord Binning, a fine replica of which Constable made in June 1824 for Fisher (now at Cambridge). There is no known pencil or oil sketch. The larger, fully finished version at Yale dates from January 1826, and was commissioned by a Mrs Hand. The artist painted it during a two-week stay with his family at Brighton, as we know from a letter to Fisher. 'I . . . did there one of my best pictures – the subject was the Mill (Perne's) at Gillingham – it is about 2 feet, and is . . . very rich & pleasing . . .' (January 14, 1826; *Ibid*. VI; 212). The work appeared at the Royal Academy in 1826 and the British Institution the following year, while an engraving of it embellished William Yarrell's *A History of British Fishes* (1836); I; 59.

The richly worked Yale painting closely follows the small versions, except for the introduction of a gable roof (topped by trees) and the addition of a pair of donkeys and a few floating ducks. As in other works of his middle and late years, the buff ground shows through in many places, though not in any distracting way. This makes the surface seem to 'breathe' more. In 1827, Constable showed an upright version of the mill at the Royal Academy (V&A). All these mill scenes bring to mind the artist's oft-quoted remark: 'The sound of water escaping from Mill dams . . . Willows, Old rotten Banks, slimy posts, & brickwork. I love such things . . . As long as I do paint I shall never cease to paint such Places. They have always been my delight . . .' (Letter to Fisher, October 23, 1821; *Ibid*. VI; 77). As it turned out, he did not again paint a mill (in oil) until his very last work, *Arundel Mill and Castle* (1837; Toledo Art Museum), left partly unfinished.

Perne's Mill, then owned by Matthew Parham, was an undershot watermill worked by a branch of the Wiltshire and Dorset Stour, located about a mile north of Gillingham near the road to Mere. It burned to the ground in 1825, and was later rebuilt in a different form.

John Constable (1776–1837)
V.14. Landscape: Ploughing Scene in Suffolk (A Summerland) (*c*. 1824–6)
Oil on canvas $16\frac{3}{4} \times 30$ (42.5 × 76)
B1977.14.41 PLATE 66

The present work is a replica by Constable of a landscape exhibited at the Royal Academy in 1814 and now in a private English collection. The original version was bought by the wine merchant and collector, John

Allnutt, apparently in 1815 at the British Institution. In a letter of February 1843 to Constable's biographer, C. R. Leslie, Allnutt explained that he became unhappy with the sky and asked John Linnell to repaint it. 'Some years later', however, Allnutt asked Constable to restore the sky and also reduce the height of the picture by three inches so that he could pair it with a landscape by Callcott, a work now titled *Open Landscape: Sheep Grazing* (1812; York Art Gallery). Instead, Constable painted (gratis) a new version for Allnutt, the Yale picture. Constable, apparently, felt grateful for Allnutt's initial support. This version follows the original one very closely, though its general tonality is cooler and the greens are less tender, perhaps deliberately, in order to harmonize more with Callcott's landscape. Two minor additions are the buzzard-like bird hovering on the right and the distant tower. The one significantly altered area is the densely cloudy sky, where the cumuli not only differ in shape but are much more emphatically rendered. Constable has also introduced a new weather effect on the far left, where we see a skilful illusion of rain falling in the distance. This suggests that the replica was not made before the artist's intensive sky sketching campaigns of 1821–2, which heightened his powers of sky painting generally. In a 1963 article on this painting, R. B. Beckett reasonably proposed a dating of *c*. 1824 (*Art Quarterly* XXVII; 176–82); very recently, David Brown has suggested a slightly later but equally plausible dating of *c*. 1826 (*Augustus Wall Callcott*, TG, 1981; 75–6). A mid 1820s date, however, raises the question whether Constable's assistant, John Dunthorne, had any hand in the work, for he was employed precisely during the years, 1824–9 – in particular to assist the master in making replicas of various compositions, especially for the sudden Paris market. On the other hand, we are not warranted in assuming that Dunthorne necessarily played a role in every replica produced in the mid 1820s. The execution and overall quality of the Yale version favors attributing it wholly to Constable.

The view is taken from just beyond the park pales of Old Hall, East Bergholt, not far from the artist's own home. Langham Church appears in the distance on the left, while Stratford Church rises from the wooded valley on the right. Constable based the landscape on an on-the-spot pencil sketch made in July 1813, in a still intact pocket sketchbook (V&A, No. 121; 12) which also contains several studies for the ploughman (52, 71, 72). No oil sketch for the composition is known, as is also the case with several finished landscapes contemporary with the original version, such as *Boat Building* (1814; V&A) or the delightful pair devoted to Golding Constable's flower and kitchen gardens (Christchurch Mansion, Ipswich), painted the following year. The

artist did not always make an oil sketch for each finished painting.

The composition was a favorite one with Constable, even in his late years, for he included a print of it in his highly selective anthology of twenty-two landscapes, *Various Subjects of Landscape, Characteristic of English Scenery* (1830–2; mezzotints by David Lucas). There he titled the work 'A Summerland', a term synonymous with 'summer fallow', meaning a ploughed field left unsown during the summer months. As so often in Constable's landscapes, we find at least one figure busily engaged in hard work, rather than caught during a moment of pastoral ease. The artist himself specifically drew attention to the ploughman when he appended to the title printed in the Royal Academy catalogue of 1814 two lines from Robert Bloomfield's *The Farmer's Boy* (1800; 'Spring', lines 71–2): 'But unassisted through each toilsome day, / With smiling brow the ploughman cleaves his way' Although the poet was considered almost a peasant, the sentiment he expresses here is quite in harmony with the comforting belief of many a rural Tory that farm laborers were a contented lot. Constable's laborer, however – here and elsewhere – is too small in scale (and his face too averted) to allow us to make any inferences about his mood.

David Cox (1783–1859)
V.15. Haymaking (*c.* 1814)
Watercolor over pencil 18⅛ × 25 (46.3 × 63.5)
B1977.14.135 PLATES 88 (detail) and 160

Cox here tries his hand at a subject which soon became a favorite one with his close contemporary, Peter De Wint (see No. V.16). Unlike De Wint's haymaking scenes, which usually feature a deeply recessional field

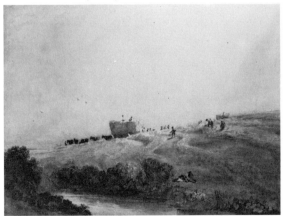

160. (V.15) Cox, *Haymaking*

contained within a broad, panoramic format, Cox in this fresh early work boldly confronts the viewer at close range with the segment of a seemingly vast sloping hayfield seen from a low vantage point. The heaving land mass looms above us, not unlike the spatial effect of Turner's similarly composed *Dartmoor and the Source of the Tamar* (*c.* 1813; No. V.8). The scale of the foreground space dwarfs the busy hay-gatherers, who are admirably well caught. Further, the rows of cut hay form interesting zig-zag patterns.

Stylistically, this work is similar to watercolors produced during the artist's Dulwich years, 1808–12 – in other words, soon after Cox's years of close contact with John Varley and his talented circle (including De Wint), 1805–7. The open-ended, uncluttered composition, to be sure, was a marked feature of much of Girtin's best work, which Cox greatly admired, as did all the Varley circle, especially during the first decade of the century. The imposing scale and impressive execution of the work suggest that it was possibly made for exhibition, raising the question whether it may have been the watercolor entitled 'Stacking Hay', exhibited at the Old Water-Colour Society in 1814.

Peter De Wint (1784–1849)
V.16. Harvesters in a Landscape, Sussex (*c.* 1820)
Watercolor 26 × 38¾ (66 × 98.4)
B1977.14.140 PLATE 161

De Wint delighted in painting haymaking scenes, especially during the 1810s – in oil no less than in watercolor. Perhaps the best know example is his large oil, *The Cornfield* (1815; V&A), one of the masterpieces of 'the decade of naturalism'. The present work is among his most impressive large-scale watercolors of the subject, and like the Victoria & Albert Museum oil, includes a close-up group of deftly drawn figures in thoroughly convincing poses. The varied foreground foliage is also painted with virtuoso skill. The size and degree of finish suggest that the work was made for exhibition, though it cannot with certainty be identified with the titles of any works exhibited. De Wint almost never dated or signed his work, and is reported to have said, 'my pictures are signed all over'. Dating his works on the grounds of style is not easy; the above approximate date is purely tentative. He made numerous sketching tours and could easily have visited Sussex on a number of occasions. We know that he passed through parts of that county in the early 1810s, when he was commissioned to make several small coastal views for Cooke's *Picturesque Views of the Southern Coast of England* (1814–26). The precise locale represented has yet to be identified. He presumably made use of one or

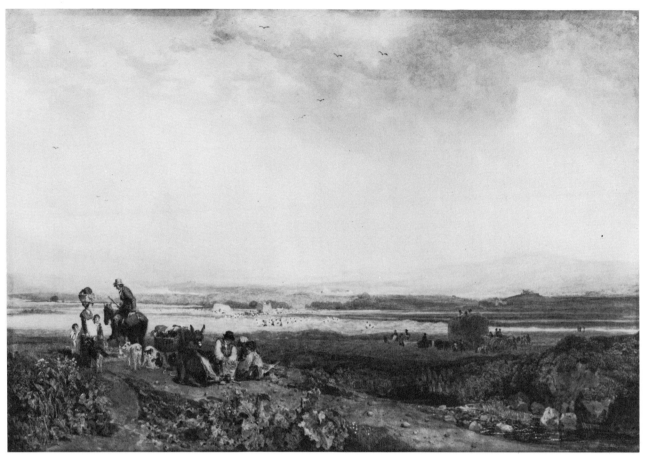

161. (V.16) De Wint, *Harvesters in a Landscape, Sussex*

more on-the-spot sketches, but the compiler has not yet come across any.

The notably low vantage point is typical of De Wint, whether he is painting a wheat field, a distant view of Lincoln Cathedral or a Foss Dyke (see a superb example in the collection of Mr Paul Mellon). The viewer feels that he or she is standing (or sometimes sitting) on the same ground and is part of the same scene as the fore- ground figures, which of course heightens the sense of immediacy. The dominant characteristic of the land- scape as a whole is its compelling naturalism. Small wonder that De Wint was so intensely admired by the poet John Clare, who especially delighted in his 'living freshness of open air', or that his great contemporary, Constable, liked his work enough to buy a watercolor in 1827.

VI. Townscapes

William Marlow (1740–1843)
VI.1. A View of Whitehall (*c.* 1775)
Oil on canvas $27\frac{5}{8} \times 35\frac{3}{8}$ (70 × 90)
B1976.7.132 PLATE 70

Marlow's sunny view of Whitehall (looking northeast) is not only one of his finest London views but stands out among the best townscapes by any eighteenth-century British artist. He chooses an advantageous viewpoint near Inigo Jones's masterpiece, the Banqueting Hall, which appears on the right in skilfully foreshortened perspective. The crisp upper surfaces of its southern side boldly intercept the bright morning sunlight. Further down the street, a pearly haze softens the appearance of the receding buildings. Marlow's handling of color is exquisitely nuanced. He is also adept at capturing the busy life of the street, which involves a broad spectrum of social types, including several street pavers hard at work on the right – closely juxtaposed to a strolling dandy. The artist is at the height of his powers in this work and proves himself a worthy successor to his teacher, Samuel Scott.

The picture is very likely the one with the above title exhibited at the Society of Arts in 1775, a date perfectly consistent with the style of the painting and the dress of the figures. Marlow subsequently exhibited a second work with the same title at the Royal Academy in 1791. This lively street scene stands apart from the majority of his London paintings, which were Thameside views, usually including one of the three great bridges then spanning the river. He exhibited only four other London street scenes, all at the Royal Academy: *View of Charing Cross* (in 1791), *View of Ludgate Hill* (in 1793 and a second one in 1796) and *View of Fish-street Hill* (in 1796).

Edward Dayes (1763–1804)
VI.2. Queen's Square (1786)
Watercolor $14\frac{9}{16} \times 20\frac{7}{8}$ (37.2 × 53.2) image
Signed and dated, lower left: 'E Dayes 1786'
B1977.14.4639 PLATE 74

Dayes was one of the first notable watercolorists to celebrate the urban charms of some of the distinctive 'squares' which so much enhanced the beauty of eighteenth-century London. His handsome version of Queen Square, an area laid out in the reign of Queen Anne, is one of a group of four views of London squares he produced in the mid 1780s, the others being *Grosvenor Square, Hanover Square* and *Bloomsbury Square*. The first of these, along with *Queen Square*, he exhibited at the Royal Academy in 1787. The complete series won further fame through the widely circulated set of four prints published by R. Pollard, two appearing in 1787 and the remaining pair two years later. Finally, Dayes made oil versions of all four views, indicating that they were among his most admired works.

Queen Square was actually a three quarter square, being open on the north toward Highgate, while the other three squares mentioned above were fully enclosed by Dayes's time. In the present work, Dayes chose to have the viewer face the open end, which results in the square looking more like a broad avenue. Certainly the deep perspective vista sets this view somewhat apart from the others.

Dayes also painted about this time still another square, *Leicester Square*, an oil once in the Pitt-Rivers collection but now untraced. Lastly, his watercolor, *A View looking towards Hanover Square* (*c.* 1785–90; formerly F. Sabin), is a wonderfully bustling street scene which has few Georgian rivals. Unfortunately, the quality of Dayes work tended to decline during the final unhappy years of his life, which ended in suicide.

John Inigo Richards (1720–1810)
VI.3. York Watergate and Westminster Bridge (1796)
Watercolor, pen, over pencil $13\frac{13}{16} \times 20\frac{1}{8}$ (35.2 × 51)
Inscr. Verso: *J I Richards R.A. Terrace York buildings – 1796 – for a scene*
B1977.14.5459 PLATE 162

162. (VI.3) Richards, *York Watergate and Westminster Bridge*

The terrace at York Watergate afforded a grand view of the gradually curving Thames, attracting many artists from the mid eighteenth century on. Often a pair of views – upstream and downstream – were made from the same spot, as was also the case with the still more popular terrace of Old Somerset House a little to the east, which inspired splendid paired views by Canaletto and Sandby. Richards' view is very similar (in reverse) to Theodosius Forrest's *London from the Terrace of York Buildings* (Courtauld Gallery), exhibited at the Royal Academy in 1770. The imposing baroque watergate, which still stands today, was built in 1626, probably to designs of Balthasar Gerbier. The waterworks buildings were originally constructed in 1676. The present Victoria Embankment, built in 1864–70, lies about a hundred yards beyond the watergate, making the latter a stranded anomaly.

According to the inscription on the back of the drawing, Richards made the watercolor as a study 'for a scene', that is to say, in connection with his employment as a professional scene painter. The use of ready-made figure-group cutouts pasted on the main sheet probably reflects procedures used in his theater work. This type of terrace scene interestingly anticipates the compositional layout of Turner's famous *Mortlake Terrace Summer's Morning* (1826; Frick Collection).

Joseph Farington (1747–1821)
VI.4. Westminster Abbey and Old Westminster Bridge (*c.* 1792)
Oil on canvas 36¼ × 28 (92 × 71)
Inscr. *Jos Farington*, on the oar.
B1976.7.28 PLATE 75

Farington offers a somewhat unusual upright view of one of the most frequently rendered sites: Westminster Bridge, Hall and Abbey – an imposing complex which had generally received a panoramic format. It follows fairly closely the right half of his drawing, *Westminster Bridge including Westminster Hall and the Abbey* (1790; Museum of London), which was engraved by J. C. Stadler and published in 1790. In 1792, the artist exhibited at the Royal Academy an oil entitled, *Part of Westminster Bridge, the Abbey, etc.*, which was either the present work or the more panoramic view once in the Pitt-Rivers collection (untraced today), which also followed very closely the 1790 drawing. The presence of the word 'Part' in the title would seem to favor the upright version at Yale, which includes less than a third of the bridge. Farington here varies the disposition of the boats and in particular gives special prominence to the foreground boat on the right, containing two gentlemen. We naturally wonder if one of them may be the artist, especially the one holding the oar on which the artist's signature appears. The precise delineation of the varied architectural forms and their smooth surfaces is fully characteristic of Farington's rather tight, topographical style, as is also the modified Canalettesque convention adopted in representing slightly rippled water. On the other hand, the Hall and Abbey are softened by an effective illusion of pearly haze.

Farington also made several close-up, low-angle views of London Bridge from the southwest in the years 1790–5, including an oil exhibited at the Academy in 1792 and two drawings that were engraved by Stadler, one in 1790 (published by W. Byrne) and the other in 1795, appearing in Volume II of Boydell's *History of the River Thames* (1796; Plate 62).

John Gendall (1790–1865)
VI.5. North-east view of Westminster Hall and Abbey (1818)
Watercolor and opaque white over pencil
14 1/16 × 18¾ (35.7 × 47.8)
B1975.4.1923 PLATE 76

The present watercolor is surely one of the most impressive close-up views ever made of London's two foremost medieval monuments, albeit by an artist little known today, even in England (excepting his native Exeter). Gendall takes his view from the southwest corner of the bridge – keeping in mind the Thames flows north-south at that point for a stretch – and admits only a few feet of its elegant balustrade into the immediate foreground. This contrasts with the many more distant views made from north or northeast of

the bridge, such as Farington's view (No. VI.4). On the other hand, Thomas Malton's *Westminster from the Bridge*, reproduced in his *Picturesque Tour through London and Westminster* (1792–9), similarly shows the Abbey and Hall from the same southwest corner of the bridge, but the emphasis is on the bridge and its traffic rather than on the buildings, as in Gendall's view.

Part of the impressiveness of this watercolor stems from its stunning light and dark contrasts, coupled with the artist's subtle handling of color and textural contrasts. Particularly striking is the beautifully managed illusion of descending light rays. This was Gendall's earliest exhibit at the Royal Academy. And on January 1, 1819, a full-size color engraving by Daniel Havell was published by Ackermann, at whose large and famous print shop on The Strand Gendall had worked since 1811.

Daniel Turner (*fl.* 1782–1805)
VI.6. Lambeth Palace with a View of Westminster Abbey (1802)
Oil on canvas 18⅛ × 24 (46 × 61)
Inscr. *Dan¹ Turner 1802*, lower left
B1976.7.157 PLATE 77

Instead of showing the long west side of Lambeth Palace from across the river – the more usual viewpoint – Daniel Turner focuses primarily on the early Tudor, two-towered gatehouse of the Archbishop's palace (1490) and the adjacent fourteenth-century rag-stone tower of St Mary's (the parish church). This viewpoint is fairly close to the slightly angular one used by the precocious, fifteen-year old J. M. W. Turner in his first exhibited watercolor, *The Archbishops' Palace, Lambeth* (1790; Indianapolis Museum of Art), except that he includes the entire tavern (The Swan) on the right and part of a building on the left, while omitting any glimpse of the Abbey. Daniel Turner's view is more a straight-forward portrait of the palace entrance and its flanking riverside scenery. He painted at least two other versions of the same scene: a sizable oil last recorded with F. Partridge in 1932 (wrongly attributed to Cotman), and a very small oil formerly in Colonel Grant's collection. The former includes numerous figure groups in the foreground, in contrast to the almost empty forecourt in the Yale version. Actually, the very sparseness of the open foreground in the present work is one of its more original features, setting it somewhat apart from the popular London views in aquatint that Thomas Malton produced throughout the 1790s, which were usually well populated with lively figures.

The artist exhibited at the Royal Academy two views of Lambeth as seen from across the river, in 1798 and 1801, and a third as viewed from the Bishop's Walk, also in 1801. In 1796, he showed a *View of Westminster from Lambeth*, but the title implies that Westminster was the main focus.

Daniel Turner (*fl.* 1782–after 1807)
VI.7. York Watergate and the Adelphi from the West (*c.* 1798–1802)
Oil on panel 8½ × 13½ (21.5 × 34.25)
B1976.7.158 PLATE 78

This view of the Adelphi and adjacent buildings stands out among paintings of the site not only because of its close-up, western viewpoint – instead of the standard eastern one from a distance – but also because of the way it accentuates the density of the packed-in architecture, represented within a very small frame and resulting in a kind of claustrophobic composition. The viewpoint, however, is identical to that of Joseph Farington's on-the-spot outline drawing of 1791 (Private Collection), made in connection with William Byrne's *Series of Thames Views* (1790–1; engr. by J. C. Stadler), which Turner must have known. Dominating the foreground is the ruggedly baroque York Watergate, a massive, triple-arch stone gate with boldly rusticated engaged columns, built in 1626 (attributed to Gerbier). The long elegant building beyond, on an arched terrace, is Robert Adam's most ambitious creation in London, The Adelphi, a row of town houses incorporated within a unified facade, with a large house at each end, built in 1768–72 and demolished in 1937.

The artist's crisp, precise style is well suited to the scene, with its challenging array of diverse architecture. He is painstakingly attentive to every feature of each building. An interesting touch of realism is the occasional open window. The few figures seem appropriate enough, if fewer than one would expect. Also, the command of perspective appears reasonably adequate, as indeed it must be for this kind of view.

Not averse to painting replicas and variants of a given composition, Turner made several versions of the present view, including a yet smaller oil (ex Camperdown Collection) as well as a sizable canvas last recorded in the Leger Gallery, in 1968. A watercolor study for the view is in the Paul Mellon Collection. Finally, the artist re-used the view on the far left of his *Lord Nelson's Funeral Barge at the Duke of York's Steps on the way to St Paul's Cathedral* (1807; Sotheby's, June 18, 1976).

163. (VI.8) Anderson, *Londong Bridge from the East*

William Anderson (1757–1837)

VI.8. London Bridge from the East (1815)
Oil on panel 6 × 12½ (15.25 × 31.75)
B1976.7.90 PLATES 69 (detail) and 163

VI.9. Westminster Bridge from the East (1815)
Oil on panel 6 × 12½ (15.25 × 31.75)
B1976.7.89 PLATE 68

Anderson's pair of Thames views celebrate two of the most frequently represented landmarks of Georgian England. The vantage point in each case, however, is rather unusual. Most eighteenth and early nineteenth-century views of Westminster were taken from the northern side of the bridge, often at an angle, while most views of London Bridge (with St Paul's) show it from the west. Also unusual is the distinctly mundane character of the foreground in each view, in contrast to the more 'presentable' embankment foregrounds of many comparable views of the time. This sets up a striking contrast between the humble workaday world and the majestic panorama of noble structures in the distance, handsomely silhouetted against a luminous sky. A similar contrast appears in the artist's much earlier *Pool of London looking towards St Paul's from Rotherhithe* (1790; Private Collection).

Anderson had earlier painted at least two slightly varied, larger versions of the Westminster scene: one dated 1805, last recorded at Christie's sale, May 27, 1921 (Camperdown sale) and the other dated 1807, last recorded at Sotheby's sale, November 26, 1975. The former was engraved by John Pye and published in John Britton's *Beauties of England and Wales* (1815).

The St Paul's view was presumably taken from a boat. True to his natural bent toward marine painting, Anderson features shipping as much as architecture. Also, the boats and their rigging receive rather more detailed rendering than the buildings.

William Daniell (1769–1837)
VI.10. London Bridge (*c.* 1803–4)
Watercolor, pen and ink, over pencil
15⅛ × 25⅜ (38.4 × 64.4)
B1975.4.1990 PLATE 79

Daniell's watercolor is one of a series of six London views he made in 1803–4, all of which he engraved for his *Views of London* (1805). His bird's-eye view contrasts with the many water-level views taken from Southwark, usually west of the bridge, such as several by William Marlow from the 1770s to 80s, or Joseph Farington's well-known view engraved for Boydell's *History of the River Thames* (1794–6; Plate 62). His viewpoint as well as his emphasis on bridge traffic actually anticipates Monet's *Waterloo Bridge* paintings of 1899–1904, though of course stylistically there is no resemblance. Daniell may owe something to Henry Barker's *Blackfriar's Bridge* (watercolor and print, 1792), in which the dominating bridge recedes at nearly the same angle as in the present work. Certainly Daniell was aware of J. C. Stadler's famous large color print after N. R. Black's *View of London from Albion Place, Blackfriar's Bridge* (1802), which compositionally is almost a mirror-reversal of Barker's view. Daniell's vantage point, however, is much higher up, allowing his bridge a more majestic sweep. The overall result is both bolder and more compelling.

In his contemporary watercolor, *Westminster Bridge from the Terrace of Somerset House* (Spink's, 1973), exhibited at the Royal Academy in 1804 and part of the above-mentioned series, Daniell offers a contrastingly distant prospect, with much more emphasis on the Thames and its profusion of diverse boats than on the bridge. Moreover, there is little of the marked light and shade contrasts so effectively used in *London Bridge*. Daniell at this time was also working on a second series of six watercolors which he engraved for his *Views of London Docks* (1802–13).

John Constable (1776–1837)
VI.11. A Fire in London, from Hampstead
(*c.* 1826)
Oil on paper on panel 3¾ × 6 (9.5 × 15.25)
Lent by Mr Paul Mellon PLATE 164

This arresting little distant view of a London fire, southeast of St Paul's, was until 1961 attached to an extra illustrated copy of C. R. Leslie's *Memoirs of the Life of John Constable* (1843), once belonging to the miniature painter, Alfred Tidey, and now at Yale. Tidey spoke of the sketch as one given to him by the

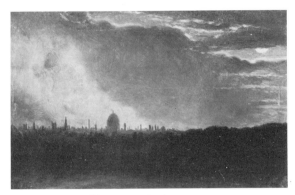

164. (VI.11) Constable, *A Fire in London*

artist's daughter, Isabel. Constable made at least one other sketch of a London fire viewed from Hampstead, namely, a work with the above title, dated 1826 and sold at Christie's sale of the remaining Constables in Isabel's collection, June 1892 (Lot 223). The position of the fire with respect to St Paul's rules out identifying the scene as the burning of the Houses of Parliament (October 16, 1834), which Constable actually witnessed from Westminster Bridge, sitting in a hackney coach with his two eldest sons (Leslie, *edn. cit.*; 237; small watercolors of the 1834 fire are still in the family collection).

While Constable explored all variety of daylight conditions, he rarely painted or sketched a moonlit landscape. Among the very few known is his earliest recorded oil painting, *Moonlit Landscape with Hadleigh Church in the Distance* (1796; Private Collection), a practice effort in the manner of the minor artist, John Cranch. Dating from the early or mid 1810s is *A Moonrise* (*c.* 1812–16?; Johnson Collection, Philadelphia) and *A Scene at East Bergholt, Evening* (*c.* 1810–16; V&A). The only extant night scene from the 1820s is *Moonlit Sea near Brighton* (*c.* 1824–8; Christie's June 23, 1972; Lot 92), attributed to Constable. A small oil and a watercolor of Netley Abbey, both of *c.* 1833 (TG and Private Collection), comprise his only other known moonlit landscapes.

David Cox (1783–1859)
VI.12. Charing Cross with the Statue of King Charles (*c.* 1818)
Watercolor $5\frac{5}{8} \times 9$ (14.3 × 22.8)
Lent by Mr Paul Mellon PLATE 165

We view this lively hub of west-end London from the southeast, at the top of Whitehall, with the Strand leading off to the right and Cockspur Street receding

on the left. Cox features the famous bronze equestrian statue of Charles I, which the immigrant French sculptor, Hubert Le Sueur, began in 1633, but which was not erected until 1675 (on a pedestal attributed to Wren). This thriving area of London included several much-patronized taverns and inns, above all the Golden Cross Inn, one of the best-known coaching inns in Georgian London (demolished in the later nineteenth century). Cox's charming view was made not long before construction began on Trafalgar Square (1826–40), which involved removing acres of stabling and other buildings, some of them seen immediately behind the statue. Charing Cross became merely one corner of the spacious new square. In 1828, George Bolton Moore made an enlarged replica of Cox's view, with the addition of a few cattle and a drover in the right foreground (Sotheby's, November 29, 1973; No. 117).

Most paintings of Charing Cross from the time of Canaletto's influential view of 1752–3 (Alnwick Castle; engr. by Bowles, 1753) show the busy intersection from the northwest, with the emphasis on the imposing Jacobean facade of Northumberland House (demolished in 1876). The Yale Center owns a copy (in oil) of the Canaletto view attributed to William James (*c.* 1760s?), who was Canaletto's assistant during the Venetian's London stay. Also at the Center (Reserve Collection) is a larger view attributed to a follower of Samuel Scott. Unlike these views, Cox's watercolor (from an opposite vantage point) focuses more on the statue of Charles I. His viewpoint, interestingly, revives that of Thomas Pennant's engraved view of 1751–2 (slightly pre-Canaletto). Cox, however, offers a street-level view, inviting the onlooker to feel more like a participant in the scene. He also fills the street with atmosphere, enhancing its reality.

165. (VI.12) Cox, *Charing Cross with the Statue of King Charles*

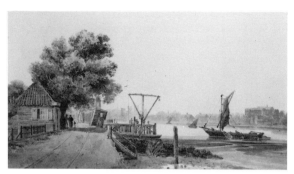

166. (VI.13) Cox, *Millbank*

David Cox (1783–1859)
VI.13. Millbank (*c.* 1813–14)
Watercolor $11\frac{1}{2} \times 21\frac{1}{4}$ (29.2 × 54.1)
B1977.14.134 PLATE 166

Cox's brightly luminous and crisp morning view of a
rather mundane stretch of the Thames – just coming to
life with routine activity – is both impressive and
refreshing in the utter frankness of its portrayal, totally
devoid of any cliché, idealizing frills. Its style points to
the artist's early years in London, not long after his
close contact with John Varley (*c.* 1805–8). One also
feels that Cox has gained an enriching awareness of
Girtin's work as well as some of the early watercolors
of Cotman and De Wint. The latter, like Cox, was part
of the Varley circle for a time. Actually, Varley himself,
a few years later, made a studio watercolor of the very
same scene, also entitled *Millbank* (1816; Winchester
College). He straightened out the road, however, and
somewhat generalized the architecture and tree,
making the overall impression less vividly forthright
and natural. Relevant for Cox is the fact that Varley
almost certainly based the work on one of his many
earlier on-the-spot sketches of the Thames near Mill-
bank, made between 1804 and 1808. Thus, Cox's
choice of subject may have been inspired by a Varley
sketch.

No. 10 may well be the work exhibited at the Old
Water-Colour Society in 1814 under the title, *Mill-
bank, Thames Side*. The forceful, unprettified directness
of the present work well exemplifies Cox's 'forcible
effect'. As the artist himself stressed in the opening
sentence of his important *Treatise on Landscape Painting
and Effect in Watercolours* (1813): 'The principal art of
Landscape Painting consists in conveying to the mind
the most forcible effect which can be produced from
various classes of scenery.'

John Feary (*c.* 1745–88)
**VI.14. A View from One Tree Hill in
Greenwich Park** (1779)
Oil on panel $27\frac{1}{2} \times 48$ (69.7 × 122)
Inscr. *John Feary pinxt. April 5 (1779)*, lower right
B1981.25.286 PLATE 80

Feary tackles a subject which had attracted view
painters since at least the early seventeenth century.
Moreover, many later artists (and visitors) to Green-
wich delighted in this classic distant prospect of the
metropolis which the top of Greenwich Hill offered.
We see in the center of the composition the two
elegant cupolas and roof of Wren's Royal Hospital,
while on the far left appears the Royal Observatory,
with the steeple of St Alphege Church in between.
Dominating the foreground is a group of fashionably
dressed Londoners on an outing, arranged *à la*
Zoffany. This results in a kind of double subject pic-
ture, unlike most other portrayals of this scene, where
the view dominates. The work compares interestingly
with George Samuel's later view from nearly the same
spot (1816; No. VI.15).

Very little known today, Feary, who had studied
with Wilson, exhibited four works at the Free Society
in 1770 and 1771, and twenty-six works at the Royal
Academy between 1772 and 1788, including the present
picture in 1779. Views of 'Gentlemen's Seats' were
among his preferred subjects, along with views in
Somerset, Cornwall, the Lake District and the en-
virons of London. Hardly any of his paintings are
today in known collections. His earliest exhibited pic-
ture was closely comparable in theme to the present
work, being a distant prospect of London entitled, *A
View from Maise Hill in Greenwich Park* (1770; untraced).

George Samuel (*fl.* 1784–1823)
VI.15. London from Greenwich Park (1816)
Oil on canvas $54\frac{3}{8} \times 72\frac{1}{8}$ (138.2 × 183.2)
Yale University Art Gallery PLATE 85

Samuel exhibited this large, impressive view of
London at the Royal Academy in 1816 and at the
British Institution the following year. This particular
viewpoint, on the hill above Inigo Jones's Queen's
House and a little east of the Royal Observatory (out-
side the picture), was one frequently chosen by artists
since the seventeenth century. Perhaps the most
notable example is Turner's *London* (TG), shown at his
own gallery in 1809 and engraved two years later (for
his *Liber Studiorum*), a work surely known to Samuel.
Unlike Turner, who kept his foreground completely
open on both sides, Samuel introduced two large,

gracefully curving trees on the left, their upper three-quarters prominently silhouetted against a luminous sky. But however traditional their placement is within the composition, these trees are highly individual in shape, and not mere stock props. The work invites comparison with John Feary's earlier view from nearly the same spot, *The Thames and Greenwich from One Tree Hill* (1779; No. VI.4). Feary treats the foreground as a setting for a Zoffany-like 'Conversation Piece,' vying in importance with the view, whereas Samuel's smaller-scaled, more informal figure group is subordinate to the view. But on close inspection, it is not unfair to characterize Samuel's charming and nicely executed group as a Regency counterpart of Feary's Georgian group.

John Robert Cozens (1752–97)
VI.16. London from Greenwich Hill (*c.* 1791)
Watercolor over pencil $14\frac{15}{16} \times 21\frac{1}{8}$ (37.5 × 53.5)
B1977.14.4703 PLATE 81

The distant prospect of London which greets the viewer standing atop Greenwich Hill is a sight that charmed the eyes of artists since the early seventeenth century. In that century, however, most landscape painters were from the lowlands, such as Vorstermans, Griffier or the anonymous artist who painted *Greenwich* (*c.* 1675) at Yale. Most often, these earlier views were made from a point further up the hill and more to the east than Cozens's view, permitting the inclusion of Flamstead Observatory and also allowing one to see Inigo Jones's elegant Queen's House in the lower center. The only Greenwich architecture which Cozens admits are the lofty twin domes and some of the rooftops of Wren's Royal Hospital. The hazy London landmarks on the horizon, such as St Paul's Cathedral and Westminster Abbey, are skilfully rendered, as is the sharply bending Thames with its profusion of shipping. John Feary's earlier *London from One Tree Hill* (1779; No. VI.14) and George Samuel's later *London from Greenwich Park* (1816; No. VI.15) – both made from nearby viewpoints – offer revealing comparisons.

The watercolor is one of six known versions, indicating it was one of Cozens's most admired compositions in his time. The slightly mannered style of the foliage supports the late date usually assigned the work. The artist's career came to a premature end not long after he painted this view, when in 1794 he lapsed into incurable insanity.

Thomas Hearne (1744–1806)
VI.17. View of Bath from Spring Gardens (1790)
Watercolor $12\frac{1}{8} \times 18\frac{3}{16}$ (30.8 × 46.2)
Signed and dated, lower right: '1790 T H.'
B1975.3.152 PLATE 83

This watercolor is probably the work Hearne exhibited at the Royal Academy in 1792. The viewpoint is from the southeast corner of town, with John Wood's South Parade on the left and Robert Adam's splendid Pulteney Bridge in the center. Jutting out in the immediate foreground is Spring Gardens, a favorite spot for 'people of fashion' to take a stroll after an early morning bath or drink of the waters. Hearne's view offers a welcome contrast to the numerous distant prospects of the elegant spa, such as Edmund Garvey's painting, *View of Bath* (*c.* 1778; Private Collection) or Edward Dayes's large watercolor, *Bath* (1787; V&A), with its elaborately pastoral foreground shadowed by stock picturesque tree clumps. Hearne's foreground is refreshingly light and airy, and far less contrived. The choice of Spring Gardens as the vantage point may owe something to Thomas Malton's aquatinted view, *The River Front from Spring Gardens* (1777), but the latter focuses mainly on Pulteney Bridge and possesses none of the grandeur of Hearne's ambitious composition.

The warm, pale tonality is characteristic of the artist at this time, and especially effective here. Moreover, the figures are happily placed and resourcefully varied, while the delineation of the nearer buildings is impeccably precise without being labored. Indeed, this is Hearne's most impressive townscape, eclipsing his more conventionally picturesque *Richmond* (1770; V&A), *Durham* (1783; V&A) and other examples.

Thomas Girtin (1775–1802)
VI.18. The Ouse Bridge, York (1800)
Watercolor $12\frac{7}{8} \times 20\frac{9}{16}$ (32.8 × 52.4)
Inscr. *Girtin 1800*, lower center
B1977.14.363 PLATE 84

The old bridge over the river Ouse at York (rebuilt in 1566) attracted numerous artists in the late Georgian era. The York Art Gallery contains examples by Joseph Farington (1784), P. S. Munn (1815), Henry Cave (1816) and David Cox (*c.* 1812–15?), among others. None of these, however, rival the powerful visual impact of Girtin's rendering. Instead of playing up the picturesque possibilities of the scene, as his contemporaries did, Girtin as usual aimed at breadth, simplicity and a sense of monumentality. Confining himself to a few subdued tones, he achieved a rich range of

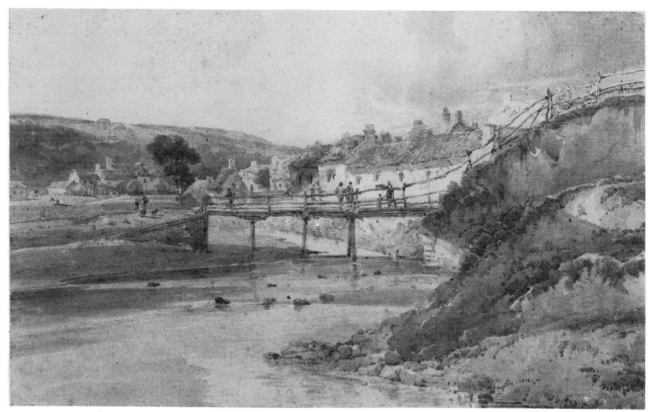

167. (VI.19) Girtin, *Sandsend, Yorkshire*

gradation within each. Particularly impressive is his simulation of weathered masonry surfaces. Also, color in certain areas sings out in a striking way, such as the yellow hull of the two-masted vessel or the pink rim of the nearby row-boat. The scattered figures, moreover, appear perfectly appropriate and natural. He most probably based the watercolor on an on-the-spot drawing made during one of three visits to York (1796, 1798 and 1800), though none have been identified.

Particularly fond of York, Girtin had earlier painted two nearly identical views of the Ouse Bridge from the opposite, northeast side (1796; BM and Oxford). One of these was probably the work exhibited at the Royal Academy in 1797. He also produced about this time a distant view of the bridge (1796–7; York), followed in 1798 by another distant view, *The New Walk, York* (YCBA), which he repeated in 1801 using a different color scheme (V&A). The Ouse Bridge was just one of a number of old stone bridges, in an urban setting, which inspired Girtin in his last years. Impressive examples include his majestic *Durham Cathedral and Bridge from the River Weir* (1799; Whitworth Art Gallery), his novel *Wetherby Bridge* (1800; BM), through the arches of which one glimpses a receding townscape, and two watercolors from the final year of his

tragically short life, *Bridgnorth* (BM) and *Morpeth Bridge* (Private Collection).

Thomas Girtin (1775–1802)
VI.19. Sandsend, Yorkshire (1802)
Watercolor with some light pencil
$12\frac{7}{16} \times 20\frac{13}{16}$ (31.6 × 52.9)
Inscr. *Girtin 1800*, lower right
B1977.14.365 PLATE 167

This casual view of part of a small village in northeast Yorkshire, near Whitby, is one of Girtin's last watercolors, executed in the year of his death, 1802. It derives directly from an on-the-spot pencil sketch in his sketchbook of 1800–1 (Whitworth Art Gallery), used during a tour to the north of England. Besides adding a few skillfully rendered, unobtrusive figures to the bridge in the finished watercolor, Girtin has also lessened the steepness of the embankment on the right and introduced a sky with light, non-threatening clouds – in contrast to the more turbulent skies of some of his other late works.

Unlike a number of his other townscapes, such as *Jedburgh* (1800; Private Collection), *Godalming* (1800; Whitworth Art Gallery) or the contemporary *Morpeth*

Bridge (1802; formerly Mrs N. D. Newall), which immerse the viewer in the heart of the village, Girtin here sets us on the edge of a hamlet, giving as much emphasis to the natural setting as to the receding chain of buildings.

Samuel Prout (1783–1852)
VI.20. Monnow Bridge, Monmouth (*c.* 1813–15)
Watercolor $15\frac{3}{4} \times 20\frac{5}{16}$ (40 × 51.8)
B1975.4.19.54 PLATE 86

Like John Varley, in his *Under the Bridge, Bathing* (*c.* 1803–4; No. VI.21), Prout chooses a low-lying, close-up viewpoint for portraying the venerable bridge, which contributes to the powerful sense of monumentality the composition exhibits. Prout's bridge, however, is more picturesque than Varley's massive, uncluttered structure, due to the presence of a rather dilapidated dwelling half supported by an incongruously sturdy masonry pier and a spindly upright timber. This boldly projecting building largely hides the renowned two-towered stone gatehouse built in 1260 and still standing today.

Prout's oblique viewpoint, looking northward toward town, is nearly the same as that used by Cotman in his slightly more distant view of the bridge made in 1802 (present location unknown), though there is no certainty that Prout knew that unexhibited work. One also wonders whether he knew certain of Turner's early bridge scenes, such as *Old Bridge, Shrewsbury* (1794, RA 1795; Whitworth Art Gallery), which is similarly a close-up, oblique view of a multi-arched stone bridge partly surmounted by a ramshackle, projecting cottage. Girtin's several imposing bridge views around 1800, like *The Ouse Bridge, York* (1800; No. VI.18), surely provided a prime inspiration for Prout, who greatly admired the recently deceased watercolorist. Not only is the breadth of handling and sense of monumentality Girtinian but even some of the brushwork, especially that used for the foliage on the far left. Other touches particularly in the stonework and windows, strongly recall Cotman. Indeed, in a number of ways, the work is a creative amalgam of Girtin and Cotman, with a hint of Varley. This points to a date no later than the mid 1810s. None of the titles of Prout's Royal Academy and Old Water-Colour Society exhibits fit this work, though in 1814 he did show at the Royal Academy *A View in Monmouth* (untraced), relating to a tour of South Wales he made probably the previous year. The watercolor may have been among the thirty works he exhibited at the Associated Artists in Water-Colours in 1810–12 or the twenty-eight works shown in Bond Street in 1814–15.

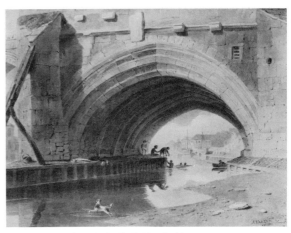

168. (VI.21) Varley, *Under the Bridge, Bathing*

John Varley (1778–1842)
VI.21. Under the Bridge, Bathing (*c.* 1803–4)
Watercolor over pencil $16\frac{1}{2} \times 21\frac{5}{16}$
Inscr. *J. Varley*, lower right
Lent by Mr Paul Mellon PLATE 168

Varley here exploits a subject which Turner and Girtin had slightly earlier made an important one in British landscape: the close-up view of an old stone bridge in a provincial town. See for example, Turner's *Warwick Bridge and Castle* (*c.* 1794) or his *Old Bridge, Shrewsbury* (*c.* 1794), both in the Whitworth Art Gallery, or Girtin's majestic *Durham Cathedral and Bridge* (1799; Whitworth Art Gallery) as well as *The Ouse Bridge, York* (1800; YCBA, No. VI.18) and *Wetherby Bridge, Yorkshire* (*c.* 1800; BM). Varley would have known at least some of these, given his strong admiration for both artists. The massive masonry bridge in the present work has not been identified, though its style suggests a Welsh locale; if so, then the artist presumably saw it on one of his three sketching tours through Wales in 1799, 1800 and 1802. Possibly it is a composite of several bridges. In 1805, Varley included in the initial exhibition of the Old Water-Colour Society a work entitled *Llangollen Bridge*, along with *A View of Beddgellert Bridge*. The previous year he showed at the Royal Academy *View of a Bridge at Brecknock*. Whether any of these titles relate to the above watercolor has yet to be worked out.

This unusually fine early Varley watercolor is very close in style to another large, impressive bridge scene in the Mellon Collection, *The Bridge*, dated 1804. Both these, as well as the other three early works by Varley in this catalogue, show the artist at his best, before he became preoccupied with abstract aesthetic principles and compositional formulae, ending up as a facile sys-

tematizer who overworked his dictum, 'Nature wants cooking'. In his early Girtinian phase, he relied more on direct, first-hand experience of nature, which kept his work from becoming excessively artificial.

John Baptist Malchair (1729–1812)
VI.22. Broad Street, Oxford, Full Moon (1790)
Watercolor over charcoal and pencil
$12 \times 17\frac{7}{8}$ (30.5 × 45.5)
Inscr. Verso: *Clarendon Street Oxford. Jan 1ˢᵗ – 1790 – 16*
B1977.14.5452 PLATE 169

Malchair's unusual moonlit view of Oxford's famed Broad Street effectively captures the misty and mysterious atmosphere of that place on a winter night. The work, in fact, is one of the earliest moonlit townscapes in British art. One is struck by the eerie emptiness of the piazza-like foreground, occupied only by a few faint, shadowy figures in the distant left corner (and a figure-like shape on the right, oversize in scale). The precise information on the verso citing place, date and even hour is typical of Malchair's work; sometimes he added weather information, anticipating some of Constable's inscriptions. He also made at this time a smaller, more distant nocturnal view of the same scene (V&A).

Malchair spent most of his long career in Oxford, where from 1759 he was Leader of the Music Room (and a violin teacher) as well as the first resident drawing teacher of importance. Some of his many pupils included Sir George Beaumont, Lord Aylesford, Oldfield Bowles and John Skippe. He laid great stress on working directly from nature, and his own work frequently showed a close attentiveness to atmospheric effects (e.g., spreading mist) and the impact of sunlight.

He apparently produced no work in oil and exhibited only once in London, at the Royal Academy in 1773 (a landscape).

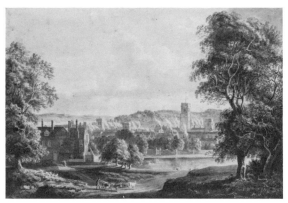

170. (VI.23) After Sandby, *Ipswich from Christchurch Mansion*

After Paul Sandby (1730–1809)
VI.23. Ipswich from the Grounds of Christchurch Mansion (*c.* 1780–5?)
Watercolor over light pencil
$11\frac{7}{8} \times 18\frac{1}{8}$ (30.1 × 46.1) sight
B1975.3.980 PLATE 170

The present work is one of two nearly identical versions of the subject, the other – considered the original – being that at Christchurch Mansion, Ipswich (on permanent loan from the Norwich Castle Museum). This replica is probably by one of Sandby's many pupils. The rendering of the buildings, rooftops and the delightful puffs of smoke is actually rather masterly; on the other hand, one detects a certain blandness in the execution of some of the foliage. In any case, it is one of the more charming of late eighteenth-century provincial townscapes, however conventional its picturesque foreground.

The viewpoint is near the southern end of Christchurch grounds, looking southward across the pond toward the civic church of St Mary-le-Tower, with its stately 176-foot bell tower. Flanking this crenellated tower, in piquant contrast, are two distant windmills. The back of Christchurch mansion appears on the left. Sandby's many exhibited works included a number of townscapes, but his *Ipswich* was not among them.

Ipswich, the country town of East Suffolk (and birthplace of Cardinal Wolsey), is an ancient port on the Orwell estuary, already important enough by the late

169. (VI.22) Malchair, *Broad Street, Oxford, Full Moon*

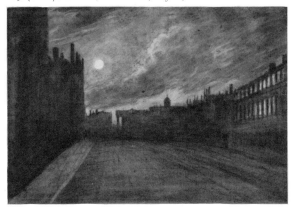

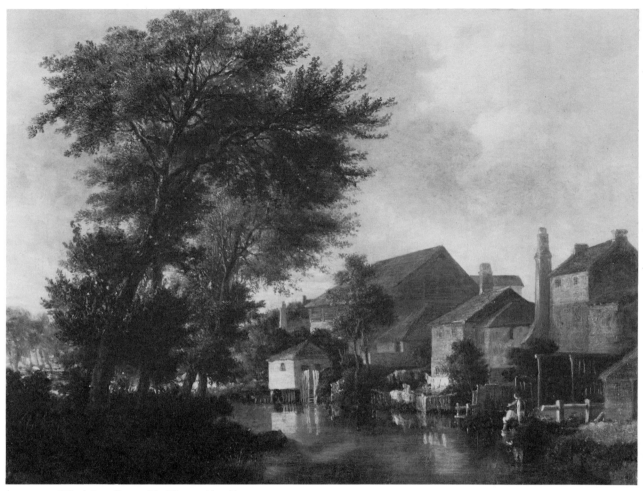

171. (VI.24) Attr. Crome, *The Wensum, Norwich*

tenth century to have been pillaged twice by the Danes (991 and 1000). It received its first charter from King John in 1199, and reached its zenith as a wool port in the sixteenth century, declining over the next two centuries. Harbor improvements revived the town in the 1840s, and much of its present appearance dates from the Victorian era.

Attributed to John Crome (1768–1821)
VI.24. The Wensum, Norwich (*c.* 1816–17?)
Oil on panel 14½ × 19 (37 × 48)
B1981.25.182 PLATE 171

This painting is one of two extant versions attributed to Crome, the other being that in the Norwich Castle Museum. Nearly identical in composition and size, the Norwich version is less sensitively executed, particularly the trees, which exhibit an unpleasant tightness of touch. It also lacks the pearly atmosphere of the Mellon version. The fine quality of the latter certainly does not

weaken its claim to being a Crome, despite Dr Norman Goldberg's rejection of the attribution for reasons that strike this writer as unconvincing (see his *John Crome the Elder*, 1978; 95–7). Perhaps a slight degree of doubt may arise due to the less than typical tone and texture of the foreground tree foliage. Compositionally, it recalls (in reverse) several urban views undoubtedly by Crome, above all, *Norwich River: Afternoon* (*c.* 1818–19; Max Michaels, Esq.). In this and other works, such as *View on the Yare* (*c.* 1812–14; Rt. Hon. Malcolm Macdonald) or *New Mills: Men Wading* (*c.* 1812; NCM), Crome shows his delight in embodying close-up glimpses of the picturesquely irregular backs of town buildings and houses lining a river. No other major Norwich painter was quite so drawn to this type of intimate townscape.

Thomas Webster (1772–1844)
VI.25. Watergate Street, Chester (1807)
Pencil and grey wash $10\frac{3}{4} \times 17\frac{1}{4}$ (27.8 × 43.9)
Inscr. *T. Webster 1807*; on old label
 Watergate Street, Chester / Thomas Webster
B1975.4.1872 PLATE 172

This crisp pencil outline drawing of one of the famous
and picturesque 'Rows' in the heart of Chester was
made by an architect who was also an enthusiastic
draughtsman and founding member of the Sketching
Society early in 1808 (with the Varleys, the Chalons,
Cristall and Turner of Oxford). The viewpoint is near
the center of the old walled town, looking west, with
Watergate Row on the left. The overhung, half-timber
buildings go back to Tudor times. Webster's plunging
street perspective recalls not only Cornelius Varley's
large *The Rows at Chester* (1802; V&A) but also John
Varley's pair, *Looking up the High Street, Conway* and
Looking down the High Street, Conway (c. 1803; V&A) as
well as his *Butcher's Row, Hereford* (c. 1803–5; ex Man-
ning Gallery). Webster had accompanied both Varleys
on their 1802 tour of Wales. His drawing style, how-
ever, is more painstakingly precise and topographical
than that of either Varley.

We know very little of Thomas Webster, other than
his above affiliations and the fact that he designed the
lecture room at the Royal Institution, which was re-

puted for its acoustics and fitness. Two Welsh views
by him, one dated 1804, are in the Victoria & Albert
Museum.

Chester was founded in 79 AD as a major Roman fort
for the Twentieth Legion, then known as Deva. Much
of the still-intact two-mile town wall – the best pre-
served enclosing ramparts in Britain – goes back to
Roman times. Deva became an important trading port
in the second to fourth centuries. Following a steep
decline after the Romans departed in *c.* 400, the town
revived in Norman times. The Rows were in place by
the fourteenth century, and are still flourishing today.

Joseph Mallord William Turner (1775–1851)
VI.26. Leeds (1816)
Watercolor with scratching-out $11\frac{1}{2} \times 17$ (29 × 43.2)
Inscr. *JMW Turner RA 1816*, lower left
B1981.25.2704 PLATE 87

Turner's panoramic view of the highly industrialized
city of Leeds – England's foremost textile center – is
based on several pencil sketches he made in his 'Devon-
shire Rivers No. 3 and Wharfedale' sketchbook (TB
CXXXIV) during his visit in 1815 to Walter Fawkes's
estate, Farnley, near Leeds. The most pertinent sketch
appears on pages 79–80 and records most of the middle-
distance buildings, while omitting any foreground forms

172. (VI.25) Webster, *Watergate Street, Chester*

or figures. Page 38 contains a rough sketch of this view, while two small composite studies are found on pages 37 and 45. Turner apparently made the watercolor in connection with T. D. Whittaker's history of Leeds, *Leidis and Elmete* (1816–20), for which he produced several other views, but in the end no print of *Leeds* was included. A lithograph by J. D. Harding did appear in 1823.

Turner gives us not only a sweeping prospect of smoking factories and church towers but also, in the foreground, a varied cross-section of daily activities, including laborers repairing a stone wall, a pair of milkmen on donkeys, a butcher carrying a pig's carcass, and on the left side, two men setting up a stall (for a fair?) while two others pick mushrooms. This stress on human activity, which 'gives life to a place', will become more characteristic of Turner's finished watercolors of the next two decades, especially those belonging to his largest topographical series, *The Picturesque Views of England and Wales* (1825–38). Specifically industrial townscapes are not common among the artist's finished works, though we know that he was fascinated by various aspects of industrialism and steam technology. One of his few later watercolor views of an intensely industrial town is his stunning night scene, *Dudley, Worcester* (c. 1830–1; Lady Lever Art Gallery), its foreground furnaces and machines brazenly operating full blast.

Joseph Mallord William Turner (1775–1851)
VI.27. High Street, Edinburgh (*c.* 1818)
Watercolor with some scratching-out
$6\frac{1}{2} \times 9\frac{3}{4}$ (16.5 × 24.8)
B1977.14.6298 PLATE 71

Turner places us in the heart of the Old City, the 'Lawnmarket', facing east with St Giles (the High Kirk of Edinburgh) and the County Hall on the right. The watercolor is one of twelve Scottish scenes which the artist made between 1818 and 1825, all of which were engraved for Sir Walter Scott's *Provincial Antiquities of Scotland* (1819–26). In portraying the famous street and its market in full swing, Turner expended much of his creative energy on filling the foreground with a lively and comprehensive array of characteristic activities. He captures the dynamism and life of the street in a way that is marvelously vivid. No less striking is his painting of the buildings and their varied surfaces. Our viewpoint is left of center, on the axis of High Street itself, which sets up a deeply receding vista. Scott described the street as 'one of the finest in Europe . . . and the most magnificent in Great Britain, excepting perhaps the High Street of Oxford'.

Turner made four rough pencil sketches of High Street in his 'Scotch Antiquities' sketchbook (1818; TB CLXVII), three of them looking west, which he did not subsequently use. The remaining sketch, a two-page view facing east, provided the basis for the present work, but only in the sense of establishing the general contours of some of the buildings. Like many Turners, the final result owes a great deal to the artist's famously retentive memory coupled with a vital imagination solidly grounded in and nourished by first-hand experience.

The urban topographer, T. H. Shepherd, made in the late 1820s a view of High Street from the very same vantage point, and engraved it for John Britton's *Modern Athens Displayed, of Edinburgh in the Nineteenth Century* (1829). Shepherd's view, however, has little of the charm or pictorial poetry of Turner's watercolor, and the contrast demonstrates the difference between topography in the strict, literally descriptive sense and the art of landscape.

Francis Nicholson (1753–1844)
VI.28. Edinburgh from Calton Hill (1811?)
Watercolor $18 \times 23\frac{5}{8}$ (40 × 60)
B1977.14.6230 PLATE 82

Nicholson's view includes both the Old Town from St Giles to the Castle and the monumental North Bridge (1763–72), which spanned the recently drained North Loch between High Street (Old Town) and the newly laid-out Princes Street (New Town). We view this largely man-made world from an irregular, rocky foreground, part of the then still 'wild' southwestern slope of Calton Hill. This abrupt juxtaposition of untamed nature and man's handiwork provides a fascinating contrast, different in character from Turner's earlier large watercolor of the same title (BM), exhibited at the Royal Academy in 1804 – a view taken from below the southwest corner of the hill and including an elaborate foreground full of laboring figures and cattle.

Nicholson exhibited a watercolor with the above title at the Old Water-Colour Society in 1811, which may be the present work. It must derive from his 1806 tour of Scotland, when he made many sketches that he subsequently used in preparing finished watercolors. The warm, pinkish tonality appears in other Nicholsons of the time. The National Gallery of Scotland owns a very similar watercolor version of the same scene (slightly wider), which they list as by an anonymous artist – probably one of Nicholson's numerous pupils.

173. (VI.29) A. Nasmyth, *View of Edinburgh from the West*

Alexander Nasmyth (1758–1840)
VI.29. View of Edinburgh from the West
(*c.* 1822–6)
Oil on canvas 24¼ × 36¼ (61.5 × 92)
B1976.7.134 PLATE 173

The 'Father of Scottish Landscape', Alexander Nasmyth, frequently painted views of his capital city – 'The Athens of the North' for proud residents. They range from an early picturesque oval view of 1789 (Private Collection) to a number of more forthright views – some very large – produced in the 1820s. At least eleven of these he exhibited between 1812 and 1832, either in Edinburgh or London. One of the largest, also a view from the west, is at Yale (exhibited in 1977) and is almost certainly the work shown at the British Institution in 1822. There is no record of the present view being exhibited in the artist's lifetime. Its style as well as the costume of the figures points to a date in the early or mid 1820s. Unlike the large view at Yale, this one – slightly more distant – is not burdened with any stock, conventional tree clump in the left foreground.

The whole view seems more direct and less obviously the product of studio artifice and manipulation. The foreground, while exhibiting a degree of picturesque ruggedness, has a believable naturalness about it, even though it may well have been partly improvised. I have so far not come across any sketch for the work; however, his sketchbooks (NGS) await publication.

Where Nasmyth is most topographically precise is in the delineation of Edinburgh's skyline, punctuated with various architectural landmarks, all recognizable. For example, atop Calton Hill (left of center) we see the old and new observatories and the Nelson column. To the right, and closer, appears the imposing domed church of St George's, modelled on St Paul's. A little to the left of Castle Rock, the foremost landmark, rises the distinctive late gothic lantern of St Giles Cathedral, while Heriot's Hospital (a school for fatherless boys) appears on the right side of the Rock. A misty Arthur's Seat looms up behind the Old City (on the right) – rather more majestic in scale than the actual hill, but reasonably accurate in outline.

201

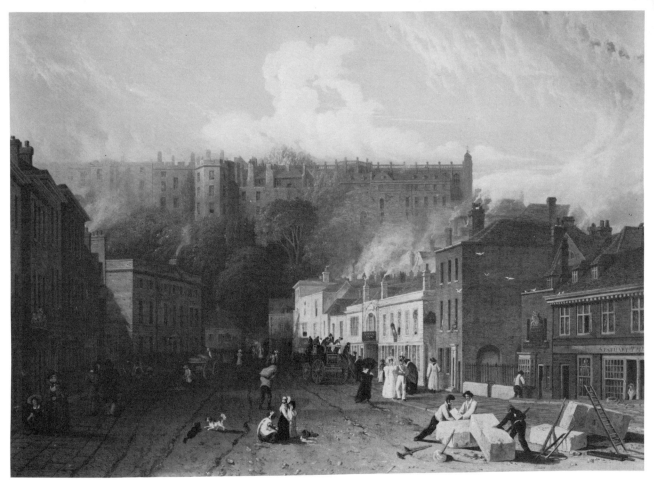

174. (VI.30) Vincent, *View of Thames Street, Windsor*

George Vincent (1796–1832)
VI.30. View of Thames Street, Windsor
(*c.* 1827–30)
Oil on canvas 26⅝ × 36¾ (67.6 × 93.3)
B1981.25.646 PLATE 174

Vincent's lively townscape shows the broad thorough-fare leading from the Thames (opposite Eton) toward the western end of the great royal castle. The emphasis here is clearly on the busy activity of the street and its diverse Georgian buildings (their multitude of chimneys vigorously spouting smoke). A wide variety of figures appear, ranging from hard-working stone-cutters in the immediate foreground (handling giant blocks of stone) to leisurely strolling, fashionably dressed men and women. The work can be enjoyed both as an informative pictorial document of Windsor in the 1820s and as an attractive picture. Vincent exhibited a *View at Windsor* (untraced) in 1816 at the Norwich Society of Artists, but the present painting could not possibly be that work, as it definitely dates from the 1820s, on the grounds of style and types of costume shown. Just when in the 1820s is less certain. Vincent spent over two years

in debtors' prison (from late 1824 to early 1827) and did not paint any sizable works at that time. A tentative dating of *c.* 1827–30 seems reasonable.

In both earlier and contemporary art, views of Windsor (in oil) generally meant views of Windsor Castle. Vincent's colorful street scene stands apart from these in its striking urban emphasis. The only portion of the enormous castle appearing in the picture is the Canon's Residence, which mostly hides the beautiful, late Gothic St George's Chapel (its roof line just visible).

Windsor Castle, the largest inhabited castle in existence – covering thirteen acres – has a long history going back to William the Conqueror, who fortified the mound (in wood). Henry II ordered the first stone construction, and following this, almost every succeeding monarch down to Queen Victoria, had some hand in it. Much of its present-day appearance dates from the very extensive rebuilding and alterations made for George IV by Sir Jeffrey Wyatville in 1824–8. The architecture of the town itself is largely Georgian and Victorian, like that of many English towns (excepting their suburbs).

202

Notes

I. Mountain Landscapes

1. Marjorie Nicolson, *Mountain Gloom and Mountain Glory* (Ithaca, 1959); 2.

2. *Ibid.*; 2.

3. Thomas Burnet, *Sacred Theory of the Earth* (reprint of 1691 edn., Southern Illinois Univ. Press, 1965); 109–10

4. This phrase provides the subtitle of Nicolson's book, *op. cit.*, and is also the title of Ch. 7. She credits the phrase to her former student, Ernest Tuveson. The poetic title of her book, incidentally, derives from the last two chapter headings (19 and 20) of Vol. IV of Ruskin's *Modern Painters* (1856).

5. *Miscellanies in Verse and Prose* (1693); *The Advancement and Reformation of Modern Poetry* (1701); *The Grounds of Criticism in Poetry* (1701). These works are conveniently available in *The Critical Works of John Dennis*, ed. E. N. Hooker (Baltimore, 1939–43); 2 Vols.

6. Letter of October 25, 1688; *Ibid.*; II, 380.

7. Shaftesbury *The Moralists* (1709) reprinted in *Characteristics of Men, Manners, Opinions, Times Etc.* (1711); conveniently available in J. M. Robertson's edition (New York, 1900); III, 123.

8. For further discussion, see Nicolson, *op. cit.*, Ch. 8, as well as John Barrell's illuminating study, *The Idea of Landscape and the Sense of Place 1730–1840* (Cambridge, 1972), especially Ch. I, on the eighteenth century.

9. Wilson's beautiful *Snowdon from Llyn Padern* (c. 1766; versions at Nottingham and Liverpool), one of the earliest large-scale mountainscapes in British art, is a partial exception. The famed peak, though distant, does dominate our interest; on the other hand, the arbitrary foreground, with its traditional corner trees and figures, is thoroughly Claudean in layout – which very much softens the visual impact of the rugged scenery.

10. All of Pars's known alpine views are reproduced and discussed in Andrew Wilton's lavish *William Pars: Journey through the Alps* (Zurich, 1979), which includes a number of superb color plates.

11. Lines 127–8. The poem was included at the end of Shelley's *History of A Six Week's Tour* (1817); *Shelley's Poetical Works*, ed. T. Hutchinson and G. M. Matthews (London, 1970); 534. Shelley himself spoke of the poem as an attempt to express 'the untamable wildness and inaccessible solemnity' of Mont Blanc and its surroundings – in other words, an exercise in The Sublime.

12. Stanza 62; *Lord Byron Selected Poems and Letters*, ed. W. H. Marshall (Boston, 1968); 102–3.

13. Ellis Waterhouse, *Painting in Britain 1530–1790* (London, 1953; 4th edn., 1978); 262.

14. Letter to C. R. Leslie, early Sept., 1834; *John Constable's Correspondence*, ed. R. B. Beckett (Ipswich, 1962–8); III, 116.

15. *Philippe Jacques De Loutherbourg* (London, 1973); section on topography (no pagination). The text of this very informative but under-illustrated exhibition catalogue is by Dr Rudiger Joppien.

16. See especially pages 53–4.

17. Nicolson's invaluable *Joseph Wright of Derby: Painter of Light* (London, 1968) is justly considered one of the richest and most stimulating monographs ever devoted to a British artist. His sections on the subject pictures and Italian landscapes are especially strong. However, his discussion of the English landscapes is considerably less intensive and his passing comments on the late Lake District mountain landscapes are both thin and excessively harsh.

18. Andrew Wilton's impressive exhibition catalogue, *Turner and the Sublime* (London, 1980), includes an ambitious and rewarding discussion of the subject.

19. The dozen watercolorists who founded the Society of Painters in Watercolour, in 1804, similarly believed that watercolor was a medium no less valid and important than oil painting. To help make their point, they often used elaborate gold frames similar to those used for exhibited oils. For a full discussion, see Jane Bayard's excellent exhibition catalogue, *Works of Splendor and Imagination: The Exhibition Watercolor 1770–1870* (New Haven, YCBA, 1981), especially pp. 25–33.

20. Martin Butlin and Evelyn Joll, *The Paintings of J. M. W. Turner* (London, 1977); I, 33.

21. *The Spectator* No. 412 (July 23, 1712); conveniently available in D. F. Bond's edition (Oxford, 1965); III, 540. This number forms part of Addison's celebrated essay, 'Pleasures of the Imagination'.

22. John Baillie, *Essay on the Sublime* (London, 1747); 7, 9.

23. Turner's justly famed later alpine paintings and watercolors (1836–45) lie beyond the scope of this exhibition and introductory essay. Suffice it to say that the Yale Center owns one of the few late examples in oil, *Monte Rosa* (c. 1840), a work radically high keyed in color and so atmospheric as to seem painted with 'tinted steam' (Constable's apt phrase). The thin paint, on a white ground, possesses a watercolor-like translucency. The overall effect is one in

which the world appears homogenized into one universal substance of varying density, color-light.

24. C. R. Leslie, *Memoirs of the Life of John Constable*, ed. J. Mayne (London, 1951; orig. edn., 1843); 18.

25. The oil sketch, *View near Keswick* (YCBA), long attributed to Constable, is now considered a work by the artist's son, Lionel, painted *c.* 1849–51.

II. Coastal Scenes

1. See Christopher Marsden's succinct discussion in his well-illustrated *The Englishman at the Seaside* (London, 1947), especially pp. 9–24. Also useful is Edmund Gilbert's *Brighton* (London, 1954), particularly Ch. II, 'The Rise of English Seaside Resorts'. More recently there is John Whyman's 'A Hanoverian Watering Place: Margate before the Railway', in *Perspectives in English Urban History*, ed. Alan Everitt (London, 1973); 138–60. Sarah Howell's *The Seaside* (London, 1974) also deserves mention. An extensive bibliography appears in J. A. R. Plimlott's excellent *The Englishman's Holiday* (London, 1947).

2. Ann Radcliffe, 'Journal' (1797); quoted in *The English Scene*, ed. F. A. Walbank (London, 1941); 109.

3. *Childe Harold's Pilgrimage* (1812–18); Canto IV (1818); Stanza 178.

4. Vol. I (1814), iii–iv.

5. W. T. Whitley, *Artists and their Friends in England 1700–1799* (London, 1828); II, 380.

6. An excellent discussion of smuggling in eighteenth-century England appears in Cal Winslow's 'Sussex Smugglers', in *Albion's Fatal Tree: Crime and Society in Eighteenth Century England*, ed. Douglas Hay (London, 1975); 119–66.

7. Quoted by T. S. R. Boase, 'Shipwrecks in English Romantic Painting', *Journal of the Warburg and Courtauld Institutes*, XXII (1959); 332. Boase's packed article remains essential reading on the subject.

8. For a fuller discussion, see T. S. R. Boase's key article of 1959, cited in note 7.

9. *Elegiac Stanzas* (1805), written not long after the death of the poet's brother, Captain John Wordsworth, who went down with the Abergavenny off the Dorset coast near Portland Bill in February 1805.

10. The Yale Center owns a robust later painting by Turner dealing with a related subject, *Wreckers – Coast of Northumberland, with a Steamboat assisting a Ship Off Shore*, shown at the Royal Academy in 1834.

11. Courbet, however, said he visited London in 1848 (sometimes questioned); even if he did, he would not have seen any of the Brighton oil sketches on public view then. On the other hand, C. R. Leslie may have enjoyed continuing access to them, and if so, would probably not have been averse to arranging for a visiting artist to see them.

12. Accounts of Turner's zealous competitiveness are abundant. Constable, however, was probably not deemed a serious rival before 1824. In that year, the previously underrated East Anglian was lionized in Paris as a result of his three much admired landscapes in the Salon. He was even awarded a gold medal by King Charles X. Turner, who never exhibited in Paris, may conceivably have begun looking on his upstart contemporary as at least a potential rival. Interestingly, he for once adopted Constable's practice of painting a full-size oil study for the above final version, along with similar large studies for its three pendants at Petworth – the only time he resorted to this extra preparation, to my knowledge. All four highly luminous studies are in the Tate Gallery.

13. Quoted by Marion Spenser, *R. P. Bonington* (Nottingham, 1965); 4. The best recent, short discussion of Bonington's art is John Ingamell's *Richard Parkes Bonington* (1979), which is both thoroughly reliable and highly readable.

III. Ruin Landscapes

1. Chateaubriand, *Genie du Christianism* (Paris, 1802); Pt. III, Bk. V, Ch. 3.

2. Richard Jago, 'Edge-Hill' (1767); in Alexander Chalmers' *Works of the British Poets from Chaucer to Cowper* (London, 1810); 21 Vols.; XVI, 295.

3. *Poems of Robert Southey*, ed. M. H. Fitzgerald (Oxford, 1909); 415

4. Thomas Whately, *Observations on Modern Gardening* (1770); 131–2. Part of Whately's important section on ruins is conveniently accessible in the excellent critical anthology of British writings on landscape gardening edited by John Dixon Hunt and Peter Willis, *The Genius of the Place: The British Landscape Garden 1620–1820* (New York, 1975); 301–7.

5. *Ibid.*; 135.

6. Georg Simmel, 'Die Ruine,' in *Zur Philosophie der Kunst* (Potsdam, 1922); 127–8. The early romantic French writer, Bernardin de Saint Pierre, voiced a comparable view when he wrote that some of man's deepest emotions are evoked by meditation on 'ruins in which nature combats the art of man', 'Plaisir de la Ruine,' *Etudes de la Nature* (Paris, 1784); Pt. 12; in *Oeuvre Complets* (Paris, 1818); V, 81–8.

7. *Op. cit.*; 126. Both Bernardin de Saint Pierre (in 1784) and Chateaubriand (in 1802) similarly stressed that overgrown ruins harmonize best with their surroundings, especially Gothic ruins, for their intricate forms appear more readily to intermingle with creeping foliage and weeds than do ruins of other styles.

8. Jean Starobinski, 'Melancholy among the Ruins' in *The Invention of Liberty 1700–89* (Geneva, 1864); 180. His brief section on ruins and ruin sentiment in the eighteenth century is the most rewarding introductory discussion in English of this still understudied but important subject. See also Michel Le Bris' recent *Romantics and Romanticism* (Geneva, 1981); 21–4, and Jean Clay's *Romanticism* (Paris, 1981); 58–64, 264–70.

9. In Alexander Chalmers' anthology, *op. cit.*; XIII, 250.

10. *Ibid.*; XIII, 223.

11. Thomas Warton, 'The Triumph of Isis' (1749); *Ibid.*; XVIII, 90.

12. *Poems by Samuel Rogers* (London, 1834); 8.

13. *Sonnets* (Bath, 1789); 13.

14. *Ibid.*; 29.

15. See Duncan Bull's very informative exhibition catalogue, *Classic Ground* (New Haven, YCBA, 1981).

16. The contrary was the case on the continent during the eighteenth century. Most artists who dealt with ruins, such as Panini, Piranesi or Hubert Robert, were drawn almost exclusively to classical ruins. Caspar David Friedrich, in the early nineteenth century, was one of the first major continental artists to take a marked interest in medieval ruins, which indeed provided the subject of some of his greatest paintings, such as *Abbey Ruin in an Oakwood* (1810; Schloss Charlottenberg, Berlin) or *Monastery Graveyard in Winter* (1819; formerly Berlin; destroyed in 1945).

17. Ed. G. Underwood (London, 1921); 1st Eng. edn., 1795; 3.

18. *Ibid.*; xi–xii, 19.

19. *Ibid.*; 5–6.

20. For a rich discussion of the ruin theme in British Augustan and Romantic literature, see Laurence Goldstein's *Ruins and Empire* (Pittsburgh, 1977).

21. Adele Holcomb, 'The Bridge in the Middle Distance: Symbolic Elements in Romantic Landscape', *Art Quarterly*, Vol. 37 (1974); 31–58.

IV. Rural Landscapes

1. Letter Press for 'Summer Morning', *Various Subjects of Landscape, characteristic of English Scenery* (London, 1833). The full text is conveniently available in R. B. Beckett's *John Constable's Discourses* (Ipswich, 1970); 16–19.

2. Letter Press for 'Summer Morning' and 'Spring', R. B. Beckett, *Ibid.*; 6, 17. The latter phrase is from James Thomson's *Seasons* ('Spring', lines 103–4), a favorite poem of Constable and many Romantic landscapists.

3. Some of Wilson's few surviving pre-Italian landscapes, such as *London: Westminster Bridge* (1745; Philadelphia Museum of Art) or *Dover* (c. 1747; National Museum of Wales; a small version at Yale) also exhibit a boldly forthright directness.

4. This phrase provided the title of John Gage's pioneering exhibition (and catalogue) held in 1969 at the Norwich Castle Museum and the Victoria & Albert Museum. One only wishes that Gage had written a book-length text. The term 'decade' was sensibly employed loosely, embracing a somewhat larger time span, c. 1805–20.

5. Letter to John Fisher, October 23, 1821; R. B. Beckett, *John Constable's Correspondence* (Ipswich, 1962–8); VI, 77–8.

6. Letter to John Dunthorne, May 29, 1802; *Ibid.*; II, 32.

7. C. R. Leslie, *Memoirs of the Life of John Constable*, ed. J. Mayne (London, 1951; orig. edn., 1843); 5. Constable copied this Claude in 1800.

8. Letter to John Fisher, November 17, 1824; *Ibid.*; VI, 182.

9. Letter to John Fisher, April 1, 1821; *Ibid.*; VI, 65.

10. In his *Lakes Tour* (1786), Gilpin maintained that 'The hedge and the furrow, the waving cornfield, and rows of ripened leaves . . . all these the picturesque eye . . . looks at with disgust' (II, 44). Later in his *Western Tour* (1798) he stressed that 'on canvas, hedge-row elms, furrowed lands, meadows . . . and hayfields adorned with mowers have a bad effect . . . Of all species of cultivation, cornlands are the most unpicturesque. The regularity of corn-fields disgusts' (328–9). This catalogue of forbidden rural scenery includes some of Constable's favorite landscape motifs. In another tour book, while describing the largely agricultural country between Canterbury and Rochester, he remarked, 'I speak only of rural nature. It is not adorned with any of the great material of landscape' (*Observations on the Coasts of Hampshire, Sussex and Kent*, 1804; 106). Moreover, Gilpin was also averse to the inclusion of farmhands at work in a landscape. 'The peasant cannot be admitted if he be employed in the low occupations of his profession; the spade, the scythe and the rake are all excluded' (*Lakes Tour*; II, 44). By contrast, the less precious and more genial Uvedale Price, in his *Essay on the Picturesque* (1794), did not denigrate rural scenery (and laboring peasants). One factor was his higher regard for Flemish and Dutch landscape.

11. Crome may have painted a replica of certain of his works, but their attribution remains uncertain.

12. The Yale Center owns the large *Woodland Scene near Norwich* (c. 1810–12?).

13. Another woodland landscape of comparable quality which creatively adapts Hobbema is Crome's *The Grove Scene* (NCM), exhibited at the Norwich Society of Artists in 1820.

14. Samuel Palmer's *Valley of Vision* (1960); 1.

15. Letter to George Richmond, November 14, 1827; *Ibid.*; 21.

16. Robert Melville, *Samuel Palmer 1805–1881* (London, 1956); 4. Melville's packed introduction is still one of the best short essays on Palmer's art.

17. Letter to John Linnell, December 21, 1828; in Grigson, *op. cit.*; 22.

18. *Ibid.*; 19. Palmer made the comment in 1825.

19. Quoted by Melville, *op. cit.*; 2. Of Blake's art, Palmer was particularly drawn to the seventeen woodcut illustrations to Thornton's *Virgil*, accompanying the *Eclogues*. His vivid description of them is most revealing. 'They are visions of little dells, and nooks, and corners of Paradise; models of the exquisitest pitch of intense poetry. I thought of their light and shade, and looking upon them I found no word to describe it. Intense depth, solemnity, and vivid brilliancy only coldly and partially describe them. There is in all such a mystic and dreamy glimmer as penetrates and kindles the inmost soul, and gives complete and unreserved delight, unlike the gaudy daylight of this world' (Grigson, *Samuel Palmer The Visionary Years*, 1947; 24).

20. Letter to John Linnell, December 21, 1828; in Grigson, *op. cit.*; 22.

21. *Ibid.*; 19.

22. *Ibid.*; 23.

V. Landscapes with Laborers

1. Wright of Derby's famous industrial scenes of the early 1770s, such as *An Iron Forge* (1772; Private Collection) or *The Blacksmith's Shop* (1771) at Yale, are not landscapes and thus lie beyond the scope of this essay. On the subject of industrial themes in British Romantic art, the key work remains Francis Klingender's *Art and Industrial Revolution* (London, 1947;

rev. edn. by Arthur Elton, London, 1968). Also useful is the exhibition catalogue, *Art and the Industrial Revolution* (Manchester City Art Gallery, 1968). An excellent and profusely illustrated recent work is Asa Briggs' *Iron Bridge to Crystal Palace: Impact and Images of the Industrial Revolution* (London, 1979). Usefully supplementing this is Stuart Smith's *A View from the Iron Bridge* (Ironbridge, 1979). General studies of the Industrial Revolution are legion. The most readable is E. J. Hobsbawn's masterly *Industry and Empire* (London, 1968). Eric Pawson's recent *The Early Industrial Revolution* (New York, 1979) also deserves mention, and includes a bibliography.

2. The subtitle of Barrell's challenging study is 'The Rural Poor in English Painting 1730–1840', and the author focuses primarily on Gainsborough, Morland and Constable. His comments on the former two, especially Morland, are most rewarding. The Constable chapter, while stimulating, is open to debate in places.

3. This point finds support in E. P. Thompson's fundamental study, *The Making of the English Working Class* (London, 1963).

4. In the mid 1830s, Turner painted several marvellous night scenes involving fire, notably *Keelmen heaving Hot Coals by Night* (1835; National Gallery, Washington) and the two versions of *The Burning of the Houses of Lords and Commons* (1835, in Philadelphia and Cleveland respectively). Among his finished watercolors, two very striking nocturnal scenes with fiery foregrounds – both involving industrial labor – are *Shields on the River Tyne* (1823; BM) and *Dudley, Worcestershire* (c. 1830–1; Lady Lever Art Gallery).

5. Letter to John Dunthorne, February 22, 1814; R. B. Beckett, *op. cit.*; I, 101.

6. Included in R. B. Beckett's *John Constable's Discourses* (Ipswich, 1970); 14–15.

7. Regarding figures in a landscape, C. R. Leslie tells us that Constable much valued some early advice he received from J. T. Smith (c. 1796–7), namely: 'Do not . . . set about inventing figures for a landscape taken from nature; for you cannot remain an hour in any spot, however solitary, without the appearance of some living thing that will in all probability accord better with the scene and time of day than will any invention of your own' (*edn. cit.*; 6). The compelling plausibility of the figures and occasional animals and birds in Constable's drawings and oil sketches from nature suggest that the artist long kept this worthy advice in mind.

VI. Townscape

1. Before Canaletto's arrival, an enduring topographical tradition had flourished in England since the early seventeenth century, implanted by visiting artists from the Lowlands, such as Claes Jansz Visscher and Claude de Jongh, or the prolific print-maker from Bohemia, Wenceslaus Hollar, who produced a famous 'Long View' or panorama of London from the south bank in 1647.

2. The last Lord Mayor's Procession to take place on the Thames was that of 1856.

3. Horace Walpole, *Anecdotes of Painting in England* (London 1872; orig. edn., 1765–71; 350).

4. Like Canaletto, Scott seldom painted a street scene, one of the few being *Whitehall from near Charing Cross* (c. 1750s?; ex Marquis of Sligo) which, however, is among his best works. Scattered throughout the broad, piazza-like thoroughfare are vividly observed little pictorial vignettes of travelling carriages, strolling or chatting pedestrians, a workman, and two dogs sizing each other up – giving posterity a revealing glimpse of mid-Georgian street life in the capital.

5. In contrast to Scott's *Whitehall from near Charing Cross* (c. 1750s?), cited in the preceding note, Marlow takes his view from the opposite, southern end of the street. The two would make interesting pendants.

6. Other works with an urban setting include *Arrested for Debt* (c. 1733; scene IV of *The Rake's Progress*; Soane Museum) and the first two prints in the series *Four Stages of Cruelty*. The majority of Hogarth's subject pictures and prints, however, are interior scenes.

7. In the Victorian era, one occasionally encounters partially analogous urban scenes, but in a more naturalistic vein than Hogarth's. See, for example, E. J. Niemann's *Buckingham Street, off the Strand* (1854; London Museum) or Arthur Boyd Houghton's *Holborn in 1861* (1861; Private Collection) or Phoebus Levin's *Covent Garden Market* (1864; London Museum).

8. More than a few subsequent Victorian writers denounced London's general appearance and the quality of the environment in the later nineteenth century. William Morris, for one, remarked in 1883 that 'London and our great commercial cities are mere masses of sordidness, filth, and squalor, embroidered with patches of pompous and vulgar hideousness . . . whole counties of England, and the heavens that hang over them, have disappeared beneath a crust of unutterable grime . . . and every little market town seizes the opportunity to imitate, as far as it can, the majesty of the hell of London and Manchester' ('Art under Plutocracy', lecture at Oxford, November 14, 1883; Ruskin in the Chair. Included in *Architecture, Industry and Wealth*, London, 1902). Contemporary with Morris' lecture is W. L. Wylie's large, unflinching portrayal of the grimy Pool of London of late Victorian times, *Toil, Glitter, Grime and Wealth on a Flowing Tide* (TG).

9. William Whitley, *Artists and their Friends in England* (London, 1928); II, 106.

10. *Ibid.*; II, 107.

11. Letter to John Dunthorne, May 23, 1803; R. B. Beckett, *op. cit.*; II, 34.

12. Girtin did have time to produce a series of twenty etched views of Paris in 1802. These were also on view with the *Eidometropolis*.

13. The full text appears in Hubert Pragnell's *The London Panoramas of Robert Barker and Thomas Girtin* (London, 1968); 17.

14. *Ibid.*; 21.

15. Allen Stalley, *Romantic Art in Britain 1760–1860* (Philadelphia 1966); 177.

16. We might add, however, that his magnificent *Dort* (1818;

YCBA) was his 'answer' to Augustus Wall Callcott's much acclaimed *Pool of London* (Bowood), shown at the Royal Academy two years earlier.

17. The National Gallery of Ireland owns a very dramatic distant view of the Scottish capital taken from the southern end of Arthur's Seat, *Edinburgh from above Duddingston* (*c.* 1801–2). The forceful light and dark contrasts, along with the compositional layout (including a bucolic foreground) very much anticipate the large watercolor view of 1804 (BM).

18. *Collected Correspondence of J. M. W. Turner*, ed. John Gage (Oxford, 1980); 52. Turner had earlier made a distant prospect of Oxford (from a different viewpoint) in watercolor, his *Oxford from the South Side of Headington Hill* (1803–4; Oxford). This was one of ten commissioned watercolors made by the artist between 1798 and 1814, all engraved as head pieces for the Oxford Almanack. The other views were of individual colleges. Turner's interest in The High Street revived in the early 1830s when he made five ethereal 'color beginnings' of the scene, presumably in preparation for a finished watercolor to include in his England and Wales series, but none ever materialized.

19. This is equally true of Shrewsbury. Paul Sandby, for example, painted at least twelve views of the old Welsh bridge, including a version (in bodycolor and oil) at Yale. The young Turner produced a striking angular view of the bridge in 1794 (Whitworth Art Gallery), exhibited at the Royal Academy the following year.

20. Letter to George Constable, May 12, 1836; R. B. Beckett, *op. cit.*; V, 32.

Bibliography

Monographs on individual artists are omitted.

The bibliography is arranged according to the following headings:

I *Primary Sources*
 A. *Correspondence, Diaries, Recollections*
 B. *Essays on Landscape Painting*
 C. *Essays on Aesthetics, Taste and The Picturesque*
 D. *Georgian Nature Poetry*
II *General Works on Eighteenth and Nineteenth Century British Landscape Painting*
III *Works relevant to particular Landscape Subjects*
 A. *Mountains*
 B. *Coasts*
 C. *Ruins*
 D. *Rural Landscape*
 E. *The Working Landscape*
 F. *Townscape*
IV *Works on British Scenery*
V *Interdisciplinary Works on Georgian Literature and Landscape Painting*
VI *Modern Works on Georgian Aesthetics, Taste and The Picturesque*
VII *Selected Reference Works relevant to Georgian Landscape Painting*
VIII *Works on Georgian England (Historical, Social and Cultural Aspects)*

Unless otherwise cited, London is the place of publication.

I SELECTED PRIMARY SOURCES
(excluding the vast travel literature of the Georgian era)
A. *Correspondence, Diaries, Recollections*

Constable, John, *John Constable's Correspondence*, ed. R. B. Beckett (Ipswich, 1962–8) 6 Vols.
——, *John Constable: Further Documents & Correspondence*, ed. L. Parris, C. Shields, I. Fleming-Williams (Ipswich, 1975)
Farington, Joseph, *Diary* (1793–1821), ed. K. Garlick and A. Macintyre (New Haven and London, 1978 onwards) 8 Vols. pub., 6 (?): Vols. in progress
Leslie, C.R., *Autobiographical Reflections*, ed. T. Taylor (1860) 2 Vols.
Smith, J. T., *Book for a Rainy Day: Recollections of the Events of the Last Sixty-Six Years* (1833)
Turner, J. M. W., *The Correspondence of J. M. W. Turner*, ed. J. Gage (Oxford, 1980)
Ward, James, *Conversations with Northcote*, ed. E. Fletcher (1901)

B. *Essays on Landscape Painting*

Constable, John, *Discourses* (c. 1830–6), ed. R. B. Beckett (Ipswich, 1970)
Cox, David, *Treatise on Landscape Painting and Effect in Watercolours* (1813)
Cozens, Alexander, *A New Method of Assisting the Invention in Drawing Original Compositions in Landscape* (1785). Reissued 1977 (Paddington Press)
Dayes, Edward, *Drawing and Colouring Landscapes*. Included in *The Works of the Late Edward Dayes*, ed. E. Brayley (1805)
Gessner, Salomon, *Letter on Landscape Painting* (1770). Included in *New Idylls*, tr. W. Hooper (1776)

Knight, R. P., *The Landscape A Didactic Poem* (1794)

Nicholson, Francis, *The Practise of Drawing and Painting Landscape from Nature in Water Colours* (1820)

Richter, Henry, *Daylight: A Recent Discovery in the Art of Painting* (1817)

Pott, J. H., *Essay on Landscape Painting* (1782)

Turner, J. M. W., 'Backgrounds: Introduction of Architecture and Landscape' (*c.* 1810–16) Turner's sixth (concluding) lecture on Perspective, delivered at the Royal Academy. Transcribed and introduced by Jerrold Ziff, *Journal of the Warburg and Courtauld Institutes* XXVI (1963); 124–47

Varley, John, *Treatise on the Principles of Landscape Design* (1816–21)

Varley, William, *Observation on Colouring & Sketching from Nature* (1820)

Taylor, Charles, *The Landscape Magazine: Preceptive Principles of Landscape: A Complete System of that Delightful Art* (1793)

The Artists' Repository Vol. III: *Landscape* (1808)

C. *Essays on Aesthetics, Taste and The Picturesque*

Alison, Archibald, *Essays on the Nature and Principles of Taste* (1790; 2nd enl. edn. 1810)

Burke, Edmund, *A Philosophical Enquiry into the Origin of our Ideas of the Sublime and Beautiful* (1757). Best modern edn. ed. J. T. Boulton (1958)

Gerard, Alexander, *An Essay on Taste* (1959)

Gilpin, William, *Observations on the River Wye and Several Parts of South Wales Relative Chiefly to Picturesque Beauty* (1782)

———, *Observations, Relative Chiefly to Picturesque Beauty, on the Mountains and Lakes of Cumberland and Westmoreland* (1786)

———, *Observations, Relative Chiefly to Picturesque Beauty, on the Highlands of Scotland* (1789)

———, *Observations on the Western Parts of England, Relative Chiefly to Picturesque Beauty* (1798)

———, *Observations on the Coasts of Hampshire, Sussex and Kent, Relative Chiefly to Picturesque Beauty* (1804)

———, *Observations on Several Parts of the Counties of Cambridge, Norfolk, Suffolk and Essex Relative Chiefly to Picturesque Beauty* (1809)

———, *Remarks on Forest Scenery and other Woodland Views, Relative Chiefly to Picturesque Beauty* (1791)

———, *Three Essays: On Picturesque Beauty; On Picturesque Travel; On Sketching Landscape; with a Poem, On Landscape Painting* (1792)

Hazlitt, William, *Essays on the Fine Arts*, ed. W. C. Hazlitt (1873). The essays appeared between 1814 and 1824.

Knight, R. P., *An Analytical Inquiry into the Principles of Taste* (1805)

Price, Sir Uvedale, *An Essay on the Picturesque, as Compared with the Sublime and the Beautiful* (1794; much enl. edn. 1810)

———, *Dialogue on the Distinct Character of the Picturesque and the Beautiful* (1801)

Reynolds, Sir Joshua, *Discourses on Art*, ed. R. Wark (San Marino, 1959). Originally delivered at the Royal Academy, 1769–90

D. *Georgian Nature Poetry*

Blair, Robert, *The Grave* (1743)

Bloomfield, Robert, *The Farmer's Boy* (1800)

Bowles, William Lisle, *Sonnets, Written chiefly on Picturesque Spots* (Bath, 1789)

Byron, Lord George Gordon, *Childe Harold's Pilgrimage in Italy* (1812–18)

Clare, John, *Poems Descriptive of Rural Life and Scenery* (1820)

Cowper, William, *The Task* (1785)

Crabbe, George, *The Village* (1783)

———, *The Borough* (1810)

Cunningham, John, *Poems, Chiefly Pastoral* (1766)

Dyer, John, *Gronger Hill* (1726)

———, *The Country Walk* (1726)

———, *The Ruins of Rome* (1740)

Falconer, William, *The Shipwreck* (1762)

Goldsmith, Oliver, *The Deserted Village* (1770)

Gray, Thomas, *Elegy in a Country Churchyard* (1751)

Keate, George, *The Alps* (1767)

Scott, Sir Walter, *Lay of the Last Minstrel* (1805)
———, *Marmion* (1808)
———, *The Lady of the Lake* (1810)
Shelley, Percy Bysshe, *The Poetical Works of Percy Bysshe Shelley* (1837) (Most of the poems first
appeared between 1813 and 1822)
Sotheby, William, *Poems* (Bath, 1790)
Thomson, James, *The Seasons* (1726–30)
Wharton, Joseph, *The Enthusiast, or The Lover of Nature* (1744)
Wordsworth, William, *Lyrical Ballads* (1798)
———, *The Prelude* (1799–1805; pub. 1850)
———, *The Excursion* (1814)

II General Works on Eighteenth and Nineteenth Century British Landscape Painting (emphasis on the last fifteen years)

Arts Council of Great Britain, *The Shock of Recognition: The Landscape of English Romanticism & the Dutch Seventeenth-Century School* (1971)
Bayard, Jane, *Works of Splendor & Imagination: The Exhibition Watercolor 1770–1880* (YCBA, New Haven, 1981)
Bicknell, Peter, *Beauty, Horror and Immensity: Picturesque Landscape in Britain 1750–1850* (Cambridge, 1981)
Brooke-Hart, Denys, *British Nineteenth Century Marine Painting* (1974)
Bull, Duncan, *Classic Ground: British Artists & the Landscape of Italy 1740–1830* (YCBA, New Haven, 1981)
Cordingly, David, *Marine Painting in England 1700–1900* (1974)
Day, Harold, *East Anglian Landscape Painters* (1968–69) 3 Vols.
Egerton, Judy, *English Watercolour Painting* (Phaidon, Oxford, 1979)
Einberg, Elizabeth, *The Origins of Landscape Painting in England* (Kenwood, 1967)
Gage, John, *A Decade of Naturalism* (Norwich, 1969)
Goldberg, Norman, *Landscapes of the Norwich School* (Jacksonville, Florida, 1967)
Grant, Col. M. H., *Old English Landscape Painters* (2nd edn., Leigh-on-Sea, 1957–61) 8 Vols.
Hamilton, Jean, *The Sketching Society 1799–1851* (1971)
Hardie, Martin, *Water-Colour Painting in Britain* (1966–8) 3 Vols.
Herrmann, Luke, *British Landscape Painting of the 18th Century* (1973)
Hemmingway, Andrew, *The Norwich School of Painters 1803–33* (Phaidon, Oxford, 1979)
Lemaitre, Henri, *Le Paysage Anglais a l'Aquarelle 1760–1851* (Paris, 1955)
Mallalieu, Huon, *The Norwich School* (1974)
Murdoch, John, *Forty-two British Watercolours from the Victoria & Albert Museum* (1977)
National Museum of Western Art, Tokyo, *English Landscape Painting of the Eighteenth and Nineteenth Centuries* (Tokyo, 1970)
Parris, Leslie, *Landscape in Britain 1750–1850* (1973)
Pierpont Morgan Library, *English Drawings & Watercolors 1550–1850 in the Mellon Collection* (New York, 1972)
Rajnai, Miklos, *Painters of the Norwich School* (1978)
Reynolds, Graham, *A Concise History of Watercolours* (1971)
Rhode Island School of Design, Museum of Art, *British Watercolors and Drawings*, ed. and intro. by Malcolm Cormack (Providence, 1972)
Roget, J. L., *A History of the Old Water-Colour Society* (1891) 2 Vols.
Roe, F. Gordon, *Sea Painters of Britain* (Leigh-on-Sea, 1947–8) 2 Vols.
Rosenthal, Michael, *British Landscape Painting* (Ithaca, 1982)
Somerville, Stephen, *British Watercolors A Golden Age 1750–1850* (Louisville, 1977)
Stucky, Charles, 'Temporal Imagery in Early Romantic Landscape' (University of Pensylvania, Ph.D. Dissertation, 1977)
Taylor, Basil, *The Old Watercolour Society and its Founder Members 1804–12* (1973)
Virginia Museum of Fine Arts, *Painting in England 1700–1850 Collection of Mr & Mrs Paul Mellon* (Richmond, 1963) 2 Vols.
Warner, Oliver, *Introduction to British Marine Painting* (1948)
White, Christopher, *English Landscape 1630–1850: Drawings, Paintings & Books from the Paul Mellon*

Collection (YCBA, New Haven, 1977)

Williams, Iolo, *Early English Watercolours* (1952)

Wilton, Andrew, *British Watercolours 1750–1850* (Phaidon, Oxford, 1977)

III WORKS RELEVANT TO PARTICULAR LANDSCAPE SUBJECTS

A. *Mountains*

Abbot Hall Art Gallery, *The View Finders: An Exhibition of Lake District Landscapes* (Kendal, 1980)

Bicknell, Peter, *British Hills and Mountains* (1947)

Birkett, Sir Norman, *The English Lake District in Pictures* (1951)

De Beer, Sir Gavin, *Early Travellers in the Alps* (1930)

Lunn, Sir Arnold, *Englishmen among the Alps* (1913)

Smith, Kenneth, *Early Prints of the Lake District* (Nelson, 1973)

B. *Coasts*

Gilbert, Edmund, *Brighton* (1954)

Howell, Sarah, *The Seaside* (1974)

Marsden, Christopher, *The Englishman and the Sea* (1947)

Plimlott, J. A. R., *The Englishman's Holiday* (1947).

C. *Ruins*

Barton, Stuart, *Castles in Britain* (Worthing, 1973)

Cram, Ralph Adams, *Ruined Abbeys of England* (Boston, 1906)

Felmingham, M. and Graham, R., *Ruins* (1972)

Gascoigne, Christine, *Castles of Britain* (1975)

Goldstein, Lawrence, *Ruins and Empire: Evolution of a Theme in Augustan and Romantic Literature* (Pittsburgh, 1977)

Haferkorn, Reinhard, *Gotik und Ruine in der Englischen Dichtung des 18 Jahrhunderts* (Leipzig, 1924). Includes excerpts from many Georgian ruin poems

Macaulay, Rose, *The Pleasure of Ruins* (1953) Wide-ranging study, but parts are very relevant to the present exhibition and catalogue.

Simmel, Georg, *Die Ruine*, included in *Philosophische Kultur* (Potsdam, 1922)

Volney, Comte de, *The Ruins of Empires*, tr. G. Underwood (1921); orig. edn., Paris, 1791

Zucker, Paul, *Fascination of Decay: Ruins* (Ridgewood, N. J., 1968)

D. *Rural Landscape*

Barrell, John, *The Dark Side of the Landscape: The Rural Poor in English Painting 1730–1840* (Cambridge, 1980)

Bates, H. E.; Clark, G. and others, *Rural England* (1939)

Buckle, E. and Lord, E., *In the Country: Two Hundred and Fifty Years of Country Life in Paintings, Prose and Poetry* (1979)

Bovill, E. W., *English Country Life 1780–1830* (1962)

E. *The Working Landscape*

Briggs, Asa, *Iron Bridge to Crystal Palace: Impact & Images of the Industrial Revolution* (1979)

Hughes, P. & Keen, R., *Industrial Wales in Art* (Cardiff, 1975)

Klingender, Francis D., *Art & the Industrial Revolution* (1947; rev. edn. 1968)

Manchester City Art Gallery, *Art & the Industrial Revolution* (Manchester, 1968)

Smith, Stuart, *A View from the Iron Bridge* (Ironbridge, 1979)

Note: There exist no studies, so far, of the agricultural landscape in British art of the Georgian Era.

F. *Townscape*

Chancellor, E. Beresford, *The XVIIIth Century in London* (1920)

George, M. Dorothy, *London Life in the XVIIIth Century* (1925)

Guildhall Art Gallery, *London Pictures in the Guildhall Art Gallery* (1951)
———, *English Landscapes in the Guildhall Art Gallery* (1952)
———, *Pictures from the Collection* (1968)
———, *London Bridge in Art* (1969)
Guildhall Library, *Selected Prints & Drawings in the Guildhall Library* (1964)
Hayes, John, *London: A Pictorial History* (1969)
———, *Catalogue of the Oil Paintings in the London Museum* (1970)
Hill, Douglas, *Georgian London* (1970)
Howgego, J. L., *The City of London through Artists' Eyes* (1969)
Margetson, Stella, *Regency London* (1971)
Mingay, G. E., *Georgian London* (1975)
Nadel, I. B. & Schwarzbach, F. S., *Victorian Artists & the City* (New York, 1980). Includes material on Georgian views of London
Phillips, Hugh, *Mid Georgian London* (1964)
Preston, Harley, *London & the Thames: Paintings of Three Centuries* (1977)
Wriston, Barbara, *Rare doings at Bath* (Chicago, 1978)

IV WORKS ON BRITISH SCENERY

Abbey, J. R., *Scenery of Great Britain and Ireland 1770–1860* (1952)
Anderson, J. P., *The Book of British Topography* (1881)
Baedeker, Karl, *Baedeker's Great Britain* (6th edn., Leipzig, 1906)
Bell, David, *The Artist in Wales* (1957)
Eyre, F. & Hadfield, C., *English Rivers and Canals* (1947)
Fedden, R. & Joekes, R., ed., *The National Trust Guide to England, Wales & Northern Ireland* (1973)
Hadfield, John, ed., *The Shell Guide to England* (1970)
Green, K. C., *The English Landscape in Picture, Prose & Poetry* (1932)
Grigson, Geoffrey, *Britain Observed: The Landscape through Artists' Eyes* (1975)
Haskins, W. G., *The Making of the English Landscape* (Harmondsworth, 1955)
Holloway, J. & Errington, L., *The Discovery of Scotland: Scottish Scenery through Two Centuries of Painting* (Edinburgh, 1978)
Moir, Esther, *The Discovery of Britain: The English Tourists 1540–1840* (1964)
Russell, Ronald, *Guide to British Topographical Prints* (1979)

V INTERDISCIPLINARY WORKS ON GEORGIAN LITERATURE AND LANDSCAPE PAINTING

Barrell, John, *The Idea of Landscape & the Sense of Place 1730–1840* (Cambridge, 1972)
Binyon, Lawrence, *Landscape in English Art and Poetry* (Tokyo, 1931)
Clark, Lord Kenneth, *English Romantic Poets & Landscape Painting* (1945)
Hunt, John Dixon, *The Figure in a Landscape: Poetry, Painting & Gardening in the Eighteenth Century* (Baltimore, 1975)
Kroeber, Karl, ed., *Images of Romanticism: Verbal & Visual Affinities* (New Haven, 1980)
Noyes, Russell, *Wordsworth and the Art of Landscape* (Bloomington, 1978)
Paulson, Ronald, *Emblem and Expression: Meaning in English Art of the Eighteenth Century* (1975)
Quennell, Peter, *Romantic England: Writing and Painting 1717–1851* (1970)
Tinker, Chauncey, *Painter and Poet* (Cambridge, Mass., 1938)
Watson, J. R., *Picturesque Landscape and English Romantic Poetry* (London, 1970)

VI MODERN WORKS ON GEORGIAN AESTHETIC THEORY, TASTE AND THE PICTURESQUE (EXCLUDING THE VAST LITERATURE ON ROMANTICISM)

Barbier, Carl, *William Gilpin & his Theory of The Picturesque* (Oxford, 1963)
Bate, W. J., *From Classic to Romantic Premises of Taste in Eighteenth-Century England* (Cambridge, Mass., 1946)
Hipple, Walter, *The Beautiful, The Sublime & The Picturesque in Eighteenth-Century British Aesthetic Theory* (Carbondale, 1957)
Hunt, J. D. & Willis, P., *The Genius of the Place The English Landscape Garden 1620–1820* (1975)
Hussey, Christopher, *The Picturesque* (1927)
Manwaring, Elizabeth, *Italian Landscape in Eighteenth-Century England* (New York, 1925)

Monk, Samuel, *The Sublime* (New York, 1935)

Nicolson, Marjorie, *Mountain Gloom and Mountain Glory The Development of the Aesthetics of the Infinite* (Ithaca, 1959)

Ogden, H. & Ogden, M., *English Taste in Landscape in the Seventeenth Century* (Ann Arbor, 1955)

Lovejoy, A. O., *Essays in the History of Ideas* (Baltimore, 1948)

Willey, Basil, *The Eighteenth-Century Background: Studies on the Idea of Nature in the Thought of the Period* (1940)

VII Selected Reference Works relevant to Georgian Landscape Painting

Grant, Col. M. H., *A Dictionary of British Landscape Painters* (Leigh-on-Sea, 1952)

Graves, Algernon, *The British Institution 1806–67: A Complete Dictionary of Contributors* (1875)

——, *The Royal Academy of Arts: A Complete Dictionary of Contributors 1769 to 1904* (1905–06) 8 Vols.

——, *The Society of Artists of Great Britain 1760–91* and *The Free Society of Artists 1761–83* (1907)

Jacobs, M. & Warner, Malcolm, *The Phaidon Companion to Art & Artists in the British Isles* (Phaidon, Oxford, 1980). Revealing topographical arrangement – emphasis on the impact of Place

Lambourne, L. & Hamilton, J., *British Watercolours in the Victoria & Albert Museum: An Illustrated Summary Catalogue* (1980)

Mallalieu, Huon, *British Watercolour Artists up to 1920* (Woodbridge, 1976–79) 2 Vols

Rajnai, Miklos, *The Norwich School of Artists 1805–33: A Dictionary of Contributors* (Norwich, 1976)

Redgrave, Samuel, *A Dictionary of Artists of the English School* (1874)

Waterhouse, Ellis K., *A Dictionary of British Eighteenth-Century Painters* (Woodbridge, 1981)

Whitley, W. T., *Artists and their Friends in England 1700–99* (1928) 2 Vols.

——, *Art in England 1800–37* (1930–2) 2 Vols.

Wilson, Arnold, *A Dictionary of British Marine Painters* (Leigh-on-Sea, 1967)

VIII Selected Works on Georgian England (Historical, Social & Cultural Aspects)

Bulwer, Edward Lytton, *England and the English* (1833)

Briggs, Asa, *The Making of Modern England 1783–1867* (1959)

Gilbert, Martin, *British Historical Atlas* (1968)

Huggett, F. E., *Dictionary of British History 1815–1973* (Oxford, 1974)

Pike, E. R., *Human Documents of Adam Smith's Time* (1974). A rich collection of excerpts from primary sources

Plumb, J. H., *Georgian Delights* (1980)

Quinlan, Maurice J., *Victorian Prelude: A History of English Manners 1700–1830* (New York, 1941)

Richardson, A. E., *Georgian England: Social Life, Trades, Industry & Art* (1931)

Trevelyan, G. M., *Illustrated English Social History: The Eighteenth Century; The Nineteenth Century* (New York, 1942) Vols. 3–4

Turberville, A. S., ed., *Johnson's England* (Oxford, 1933) 2 Vols.

Williams, E. N., *Life in Georgian England* (1962)

Index of Artists

References are to catalogue numbers.